AT HOME IN THE

PRESIDENT'S
NEIGHBORHOOD

——◆——

A PHOTOGRAPHIC TOUR

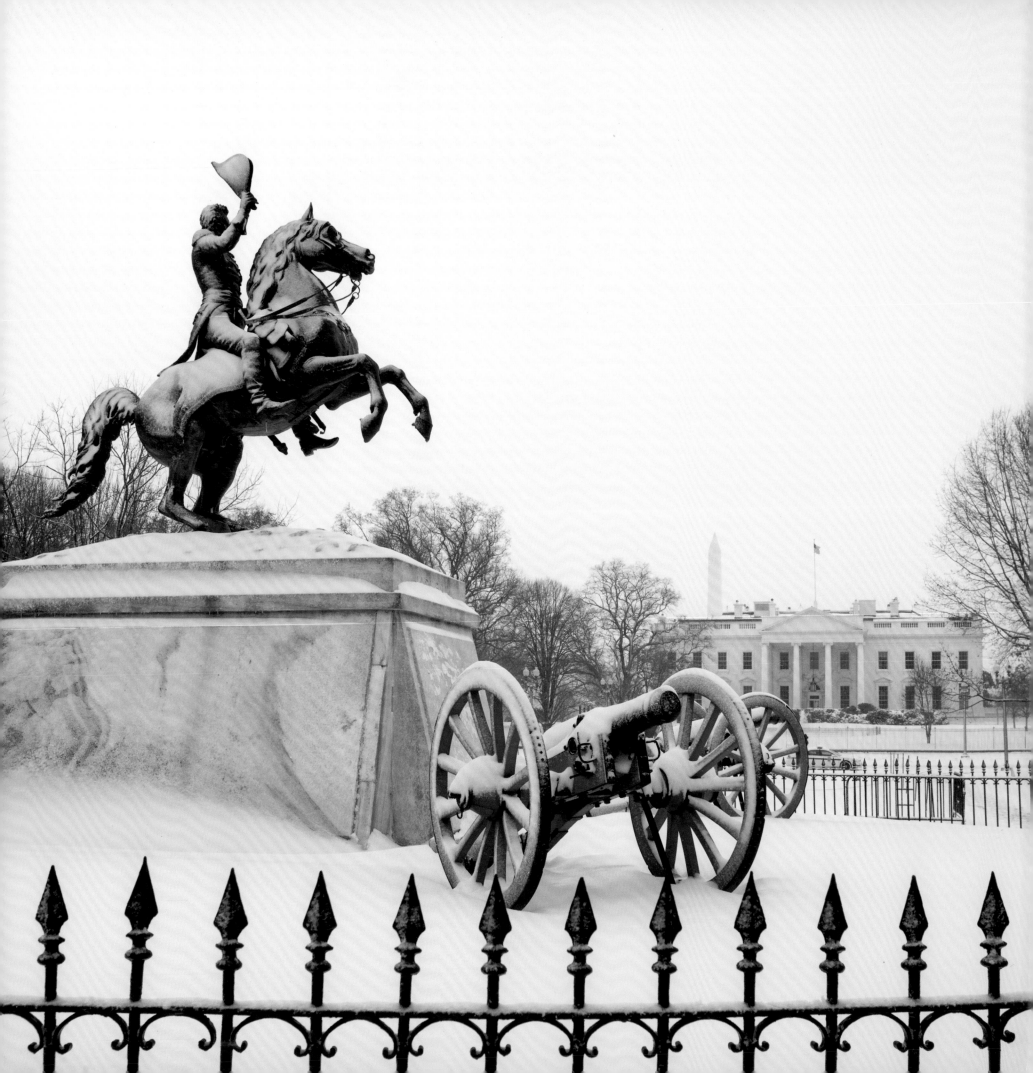

AT HOME IN THE

PRESIDENT'S NEIGHBORHOOD

———◆———

A PHOTOGRAPHIC TOUR

BY BRUCE M. WHITE

WITH COMMENTARY BY WILLIAM SEALE

WHITE HOUSE HISTORICAL ASSOCIATION

WASHINGTON, D.C.

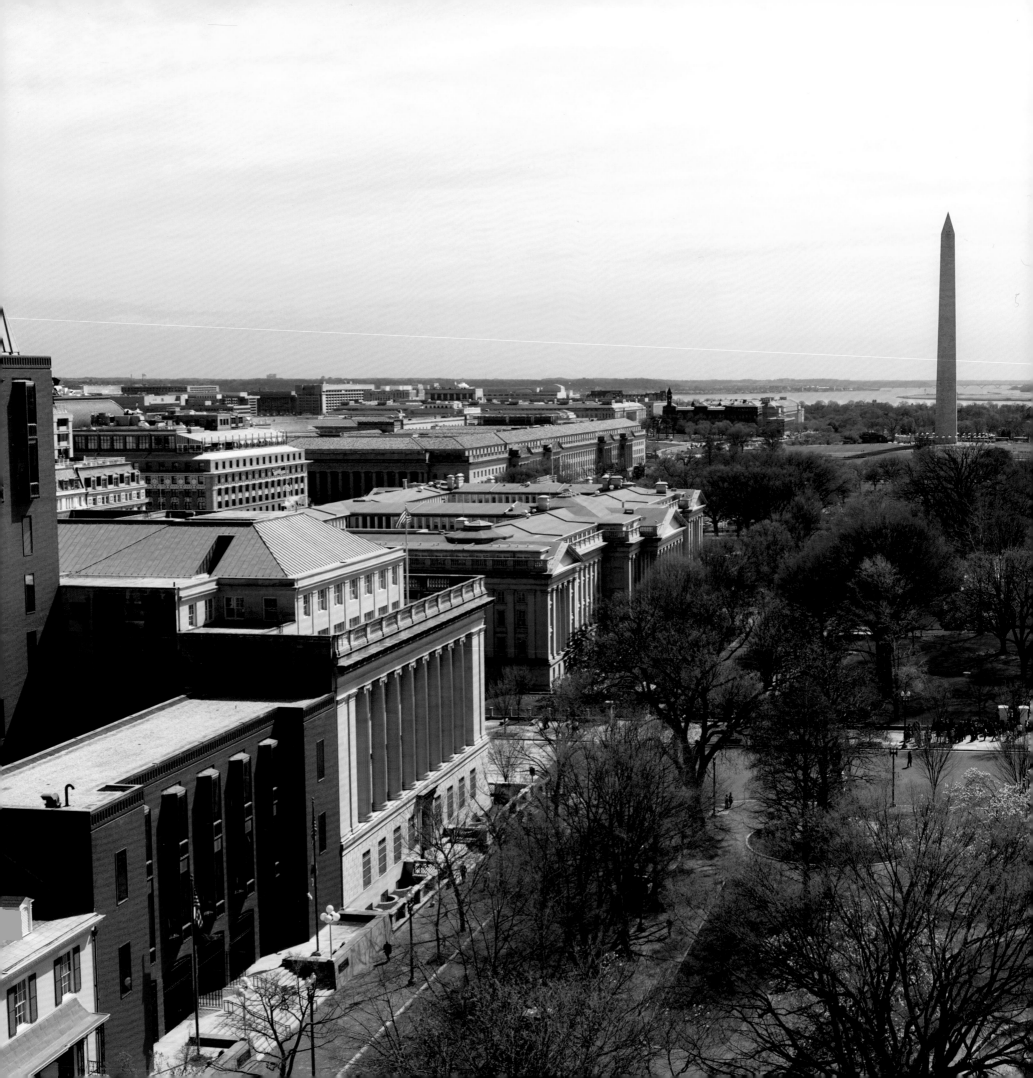

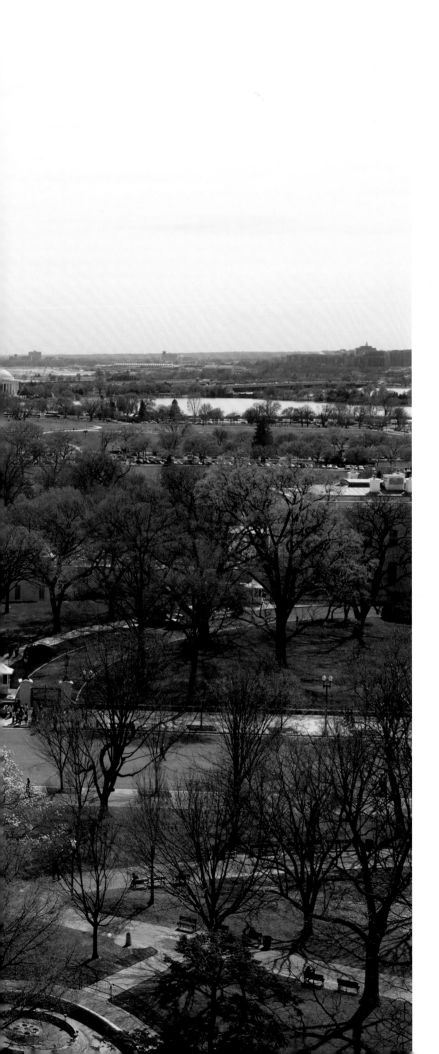

This book is dedicated to the memory of
Pierre Charles L'Enfant,
designer of the plan of the District of Columbia,
whose sophisticated, uncompromising vision
gave us this beautiful city.

The WHITE HOUSE HISTORICAL ASSOCIATION is a nonprofit organization, chartered on November 3, 1961,
to enhance understanding, appreciation, and enjoyment of the historic White House.
Income from the sale of the association's books and guides is returned to the publications program
and is used as well to acquire historical furnishings and memorabilia for the White House.

This book has been brought to publication through the generous assistance of the
Hon. Walter H. Annenberg White House Publications Fund.

First Edition
10 9 8 7 6 5 4 3 2 1
Library of Congress Control Number: 2015955617
ISBN 978-1-931917-46-9
Printed in Italy

CONTENTS

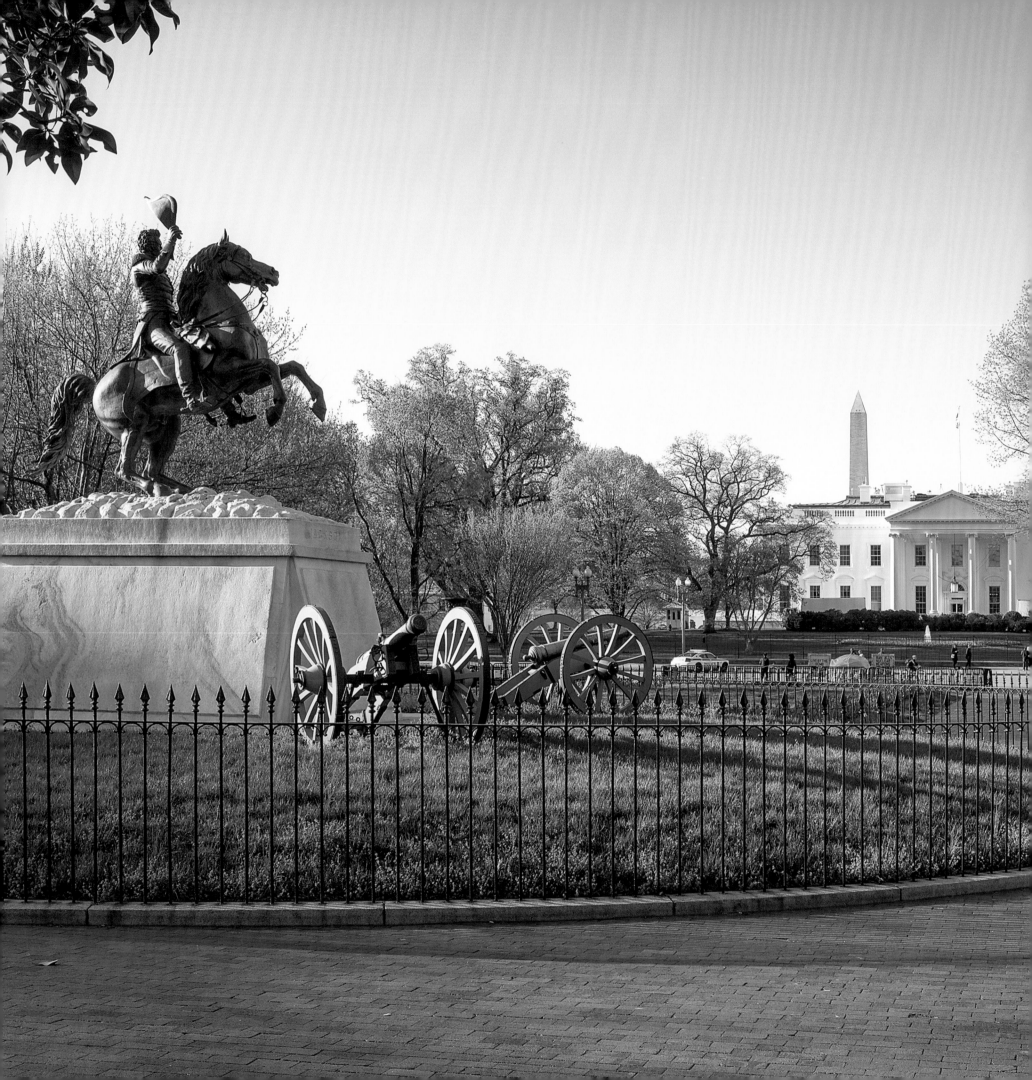

FOREWORD

The White House Historical Association is pleased to bring the White House neighborhood to a broad audience through the work of Bruce White and William Seale. Bruce, formerly a staff photographer at the Metropolitan Museum of Art, has been one of our principal photographers for nearly twenty years, first working with us to photograph the objects in the White House collection for *The White House: Its Historic Furnishings and First Families.* Since that time he has photographed White House interiors and exteriors, and gardens and grounds. In this book he steps outside the gates of the White House to walk the neighborhood, presenting for your perusal views of its parks and streets, its town houses and Beaux-Arts buildings, its monuments and memorials. Enhancing your enjoyment of these places is text by American historian William Seale, another longtime associate of the Association. Bill's engaging descriptions and stories offer insights into ways the neighborhood has changed in the past two centuries and the ways those who have lived and worked here have invested it with lasting meaning.

It is particularly fitting that we should at this time publish this collaborative portrait of the White House neighborhood, because it is our neighborhood, too, and we at the Association are venturing out to embrace it in new ways. Our David M. Rubenstein National Center for White House History, located in the Historic Decatur House on our campus across Lafayette Park from the White House, invites visitors for tours, lectures, symposiums, and special exhibitions. In addition, *At Home in the President's Neighborhood* sets the stage for in-depth studies of individual properties that we will publish in the coming years. Books on Blair House: The President's Guest House, Tudor Place, and the Decatur House, as well as articles in *White House History,* the Association's quarterly journal, will examine the architectural and cultural history of places with strong connections to the presidency and the President's House.

The president's neighborhood is a walkable neighborhood. We invite you to walk with us as we explore the presidential community. We hope this book, *At Home in the President's Neighborhood,* will guide you as you make this neighborhood your own. Whether you experience the neighborhood "on the ground" or in the views and commentary presented here, you will find it a remarkable place, a livable and workable community within our monumental national capital. This neighborhood speaks to the essence of our democracy that we can all walk where our presidents and first families have walked.

STEWART D. McLAURIN
PRESIDENT, WHITE HOUSE HISTORICAL ASSOCIATION

ACKNOWLEDGMENTS

I would like to thank my family, friends, and loyal clientele for their encouragement during the many years I've pursued this photographic project. My list of thanks continues with Stewart D. McLaurin, president of the White House Historical Association, for invaluable support and advice on the selection of buildings to be included. This book would not have seen the light of day were it not for the expert team of publication professionals at the association. Special thanks go to Marcia Mallet Anderson, vice president for publications and executive editor, for first entertaining the idea of this book and for adroitly guiding it through the process of concept and production. Fiona Griffin, editorial director, Lauren Zook, production manager, and Olivia Sledzik, editorial specialist, produced the book to their usual, sublime standards. Editor Ann Hofstra Grogg guided the final manuscript to perfection.

William Seale, American historian, gave his unique perspective on the neighborhood through a delightful, lively, and compelling commentary that frames the images and expands on their subjects in his inimitable fashion. Invaluable historical support for the project began with William Bushong, vice president and chief historian of the White House Historical Association, who provided helpful insights on Decatur House, and Evan Phifer, research historian, who proficiently assisted the publications team with researching quotes.

Washington, D.C., is a city humming with the activity of historians, curators, and museum professionals, many of whom inspired or informed my work: in the White House Office of the Curator, William Allman, Lydia Tederick, Melissa Naulin, Donna Hayashi Smith, and Jill DeWitt; current and former White House employees Dale Haney, Betty Monkman, Gary Walters, and Roland Mesnier; at the Diplomatic Reception Rooms, U.S. Department of State, Marcee Craighill and Virginia Hart; at Blair House, The President's Guest House, U.S. Department of State, Randall D. Bumgardner and Candace Shireman; at Blair House Restoration Fund, Andrea L. Metzger; at Tudor Place Historic House and Gardens, Leslie Buhler and Wendy Kail. Independent historians James M. Goode and Skip Moskey, and artist Peter Waddell are to be thanked for sharing their vast knowledge of the history of the District of Columbia. Thanks also to those at the Arts Club of Washington, June Hajjar, Judith Viggers Nordin, Nichola Hays, Jenna Beebe, and Bernadin Jean Baptiste, who inspired me with knowledge, history, and hospitality over many years.

My thanks also go to James Brooks, Debbie Buckey, and David Blysma at Peake-Delancey who provided the top quality prepress, and Verona Libri, which expertly printed this book at the highest standards.

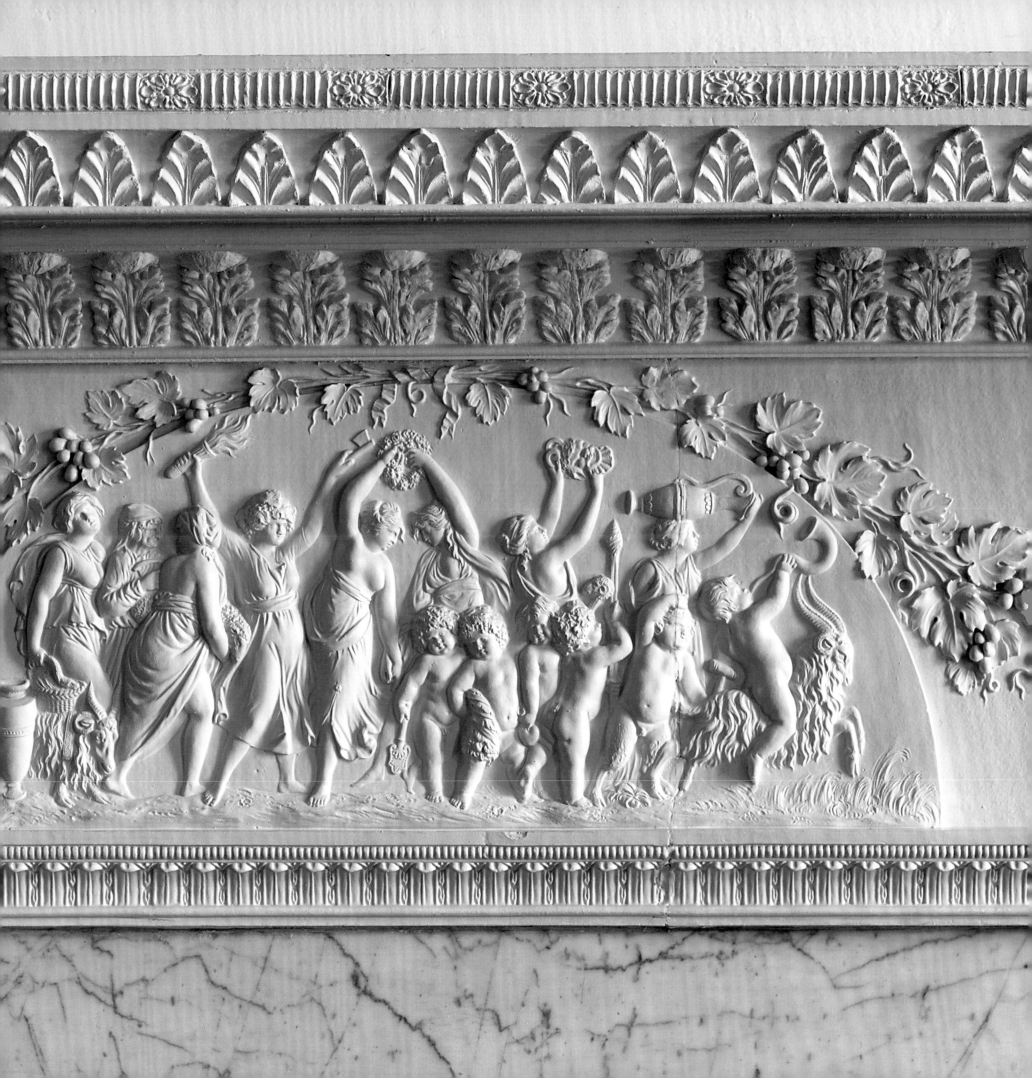

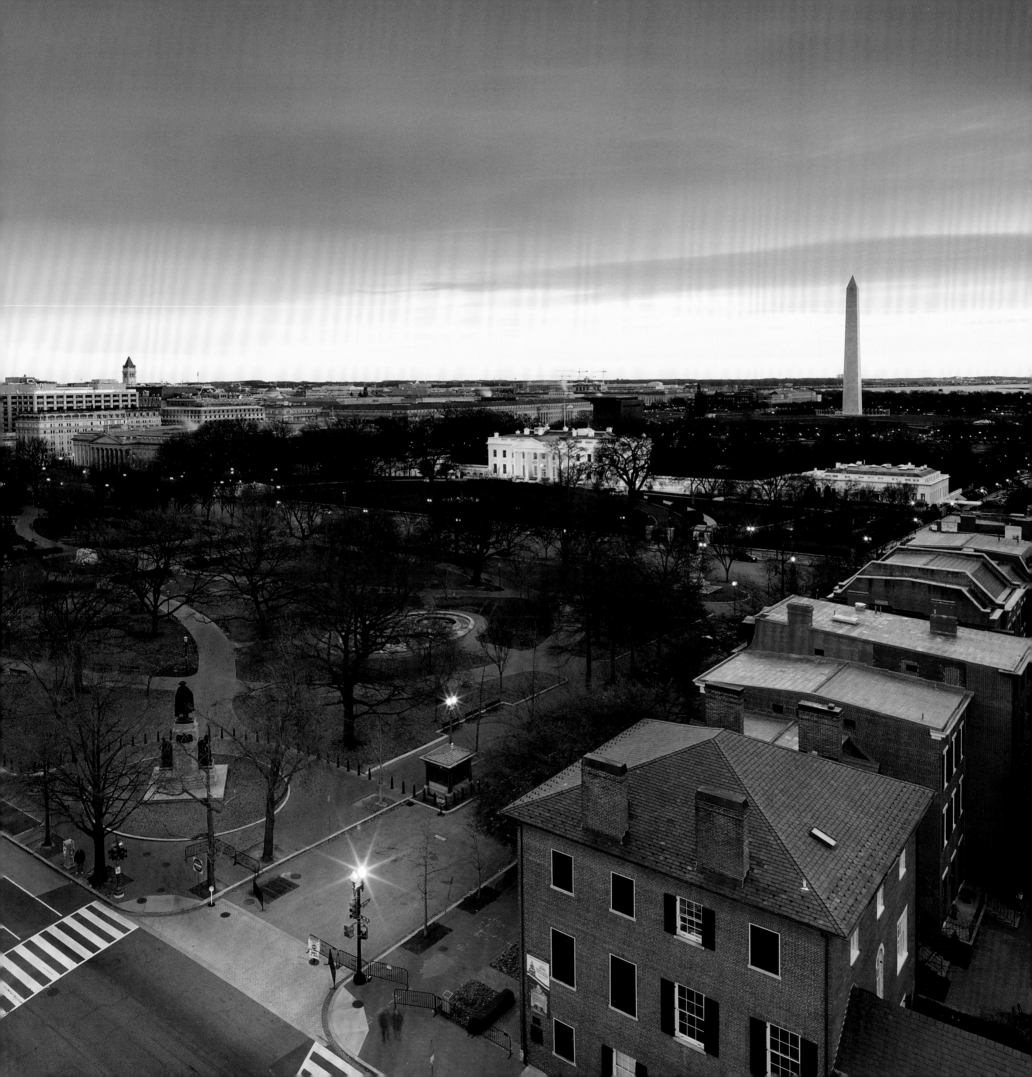

INTRODUCTION

At Home in the President's Neighborhood is the culmination of many years of photographing at the White House and the neighborhood within the surrounding blocks, a zone rich with the history of the nation and the institutions that developed along with it. I realized that so many beautiful and historic buildings and parks were within arm's reach of 1600 Pennsylvania Avenue but somehow seemed overlooked in the modern literature.

Inspiration to photograph here came to me from earlier photographers who have documented these subjects. Frances Benjamin Johnston, one of the first working female photographers in America, captured images of the White House, the presidents, society figures and swells in the late nineteenth and early twentieth centuries (my connection to Johnston runs even deeper, as both she and I have resided at the Arts Club of Washington while on assignment for the White House, albeit some hundred years apart!). In the 1930s, Volkmar Kurt Wentzel created his masterful series of black-and-white images *Washington by Night,* inspired in turn by an earlier master of photography, Brassaï.

Taking out my camera and tripod and walking the streets to make pictures in any city, late at night or at early daybreak, even sometimes in a light rain or snowfall, have always been my idea of a pleasurable way to spend my time. Historians may look at the world they study and see a vision of the past in their mind's eye, in turn writing vivid impressions of same for their audience, but we photographers have to work with what actually exists in physical form and interpret that to portray events and people of the past. Through my time photographing in the president's neighborhood I've gained an appreciation for what it is that makes this capital unique, and I hope the essence of that experience comes through in the images presented here.

What brought me to photograph in Washington, D.C., initially is a story that is a bit circuitous and somewhat magical and is as follows: In the early 1990s John P. O'Neill, editor in chief and general manager of publications at the Metropolitan Museum of Art, asked me to photograph all of the furniture created by French-born cabinetmaker Charles-Honoré Lannuier for a new book the museum was slated to publish. Lannuier, working out of a shop in New York City in the early 1800s, created beautiful, high-style Empire furniture and had been commissioned to make pieces by many of the most prominent families and institutions of the new republic, including the President's House. John O'Neill told me that permission had been granted for me to photograph the Lannuier furniture in the Red Room at the White House. I was thrilled at the idea and set about making preparations, including filling out the government forms for the various security clearances that one would have to meet. John was a larger-than-life figure in the international art world. With a doctorate in English literature from Harvard, he was a consummate globe-trotting opera fan and an art connoisseur par excellence.

After my second day of work at the National Gallery, I arrived back at my hotel to see that there was a message waiting for me. Marcia Anderson, then director of publications at the White House Historical Association, had called to ask me if I might be in touch about a project photographing objects and architecture for a book about the collections of the White House! Needless to say I was ecstatic at the idea of being able to return to work on a groundbreaking book—the first definitive reference to the decorative arts collection in the White House. *The White House: Its Historic Furnishings and First Families*, by Betty C. Monkman, is the result of our work. Originally published in 2000 and rereleased in 2014, it remains the definitive history of the collection. The project began my association with the White House Historical Association, a wonderful and productive relationship amidst the president's neighborhood.

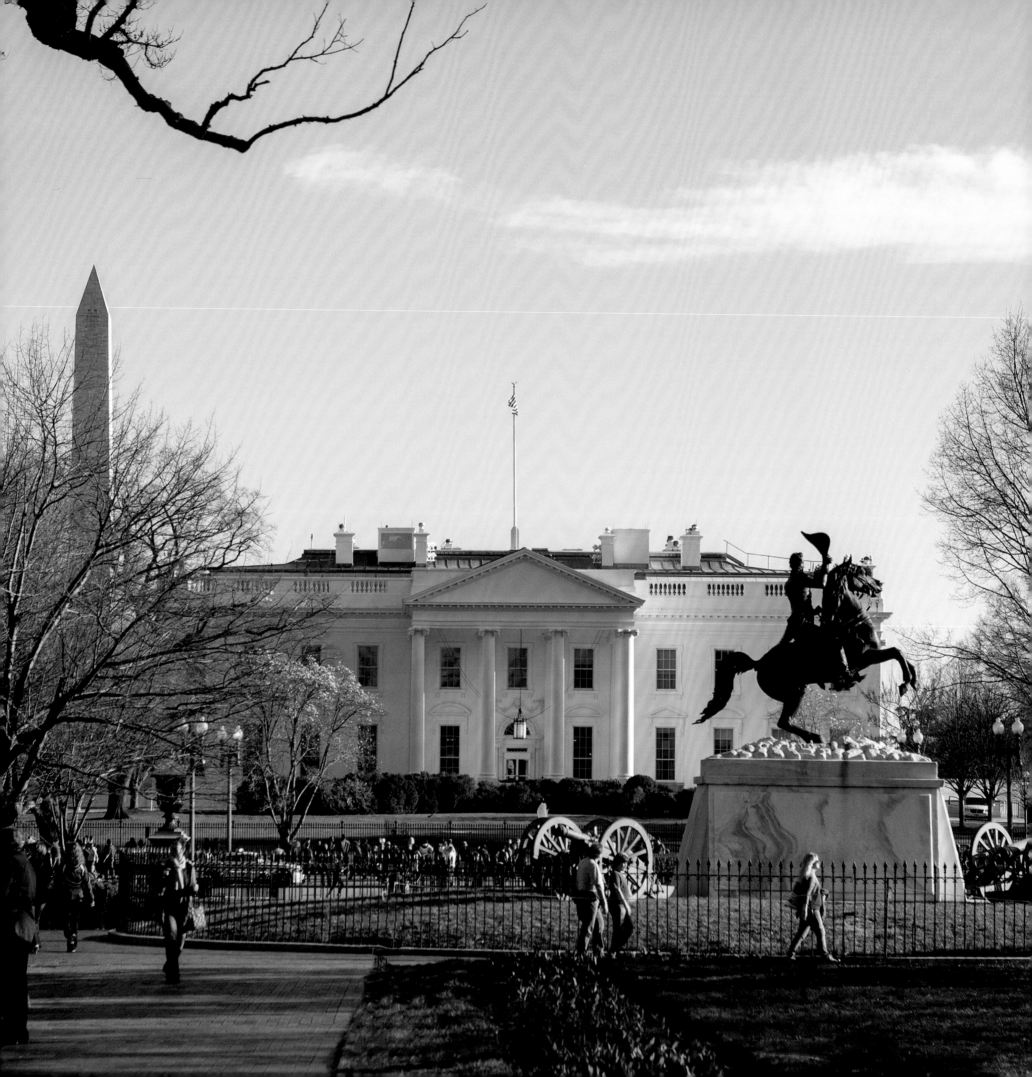

1600 PENNSYLVANIA AVENUE

THE WHITE HOUSE

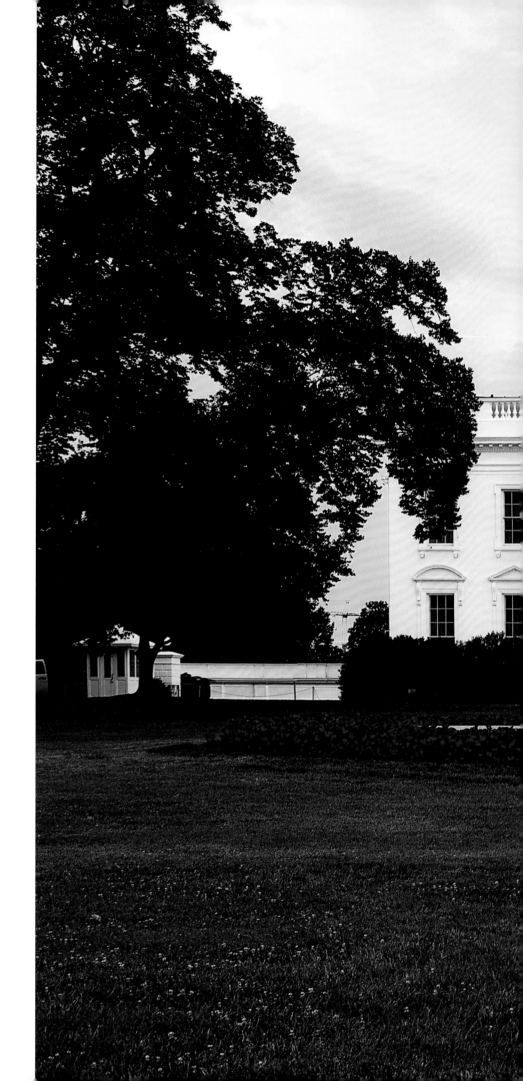

NEITHER DIGNITY, NOR AUTHORITY
CAN BE SUPPORTED IN HUMAN
MINDS . . . WITHOUT A SPLENDOR
AND MAJESTY, IN SOME DEGREE
PROPORTIONED TO THEM.

PRESIDENT JOHN ADAMS
SPEAKING OF THE PRESIDENT'S HOUSE

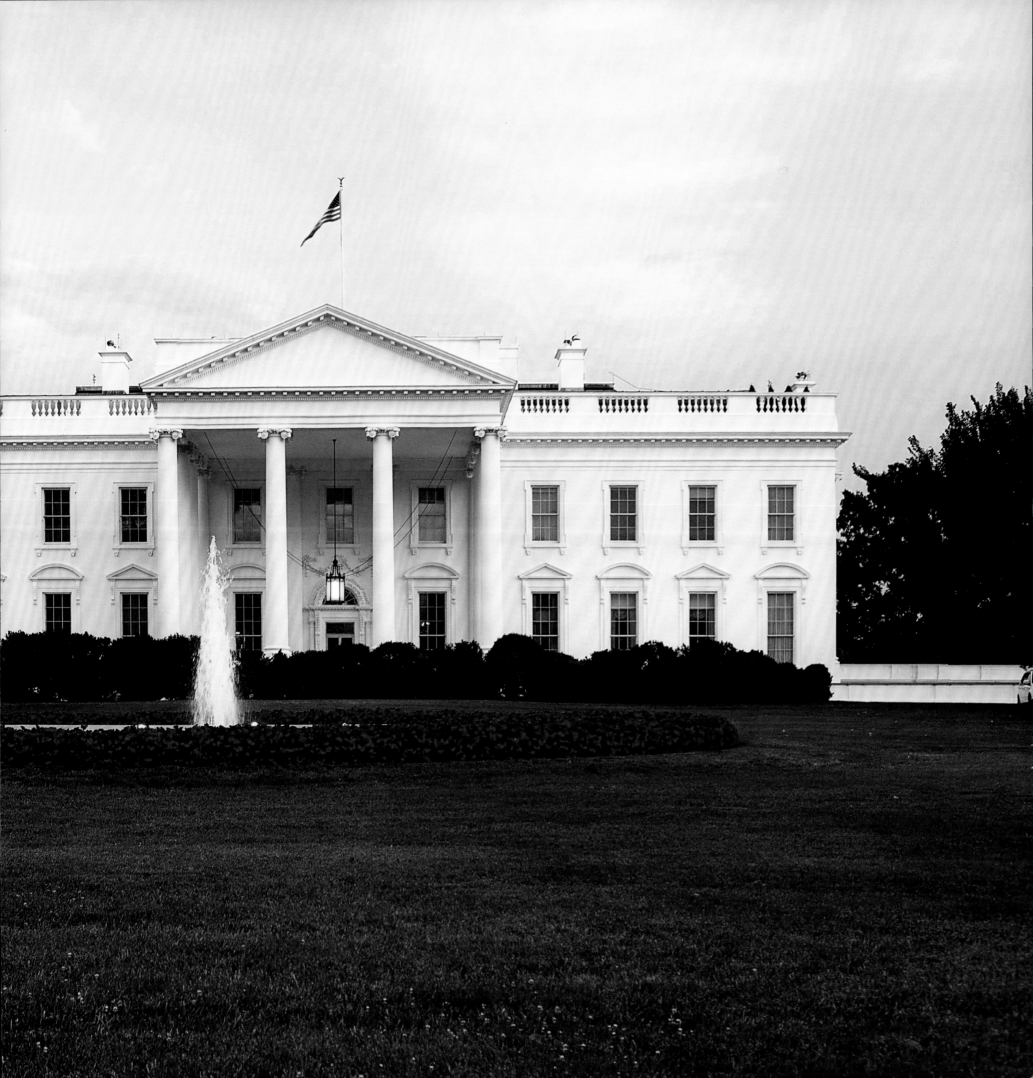

WITH THE WHITE HOUSE, THE VISIT TO THE NEIGHBORHOOD BEGINS

It is one of the most historic neighborhoods in the nation. Buildings and sites are visible around the corners. The neighborhood extends to side streets. Vigorous life has gone on here for two centuries, warmed by the proximity to the great power represented in the White House.

Long ago this was largely a residential neighborhood of town houses clustered around the President's House. Many of the houses were rented out, their rental fees staggering, thanks to the location. A house here was more profitable for owners to rent than occupy. The neighborhood was a mirror of life's transient character in Washington, as in any capital in the world. But all through the neighborhood most of the original houses today are gone, replaced by commercial and institutional buildings. Only

one building still serves as a residence. That is the White House, the timeless house of state, technically still occupied by tenants.

The White House forces its great stone bulk into a ridge at the south end of the neighborhood, across Pennsylvania Avenue from Lafayette Square, leaving the basement out of sight and the upper stories in full view. It is a big house, composed of more than one hundred rooms and many lesser spaces. There are the famous State Rooms—Red, Blue, and Green—and the unforgettable white ballroom called the East Room. The Oval Office is in the West Wing, to the right of a dead-on front view. Service rooms are everywhere, even under the front lawn and all the way to the attics. They frame and serve the residence of the president as well as his life and activities as long as he holds the office.

The Residence Act of 1790 ordered this house built for the president, and now, 225 years—and forty-four presidents—later, there she remains.

Only when walking in Lafayette Park is one fully aware of how definitively the house commands the neighborhood. From the outset it was George Washington's house to build. As the first president of the United States, the charge was his. Listening to Pierre Charles L'Enfant, his gifted, if erratic, French designer, he agreed to build a European-size president's palace on this site to symbolize by its scale and presumed elegance the power of the chief executive under the new Constitution. Although the cellars were dug for the palace, practical considerations of labor, materials, and money caused the first president and his build-ings commission to reduce the size of the house to what you see. Yet for at least half a century after the last brushstrokes turned its natural stone walls white, the resulting president's residence was to be the largest house in the United States. Already by 1803 it was known by its nickname, "The White House."

James Monroe built the stone gate piers in 1817 and Andrew Jackson rolled them to their present locations in 1833 to better accommodate the North Portico, which was added to the house earlier in his presidency. Modern security considerations have spared only the piers, for the iron fence has been protectively modified many times, the most recent in 2015.

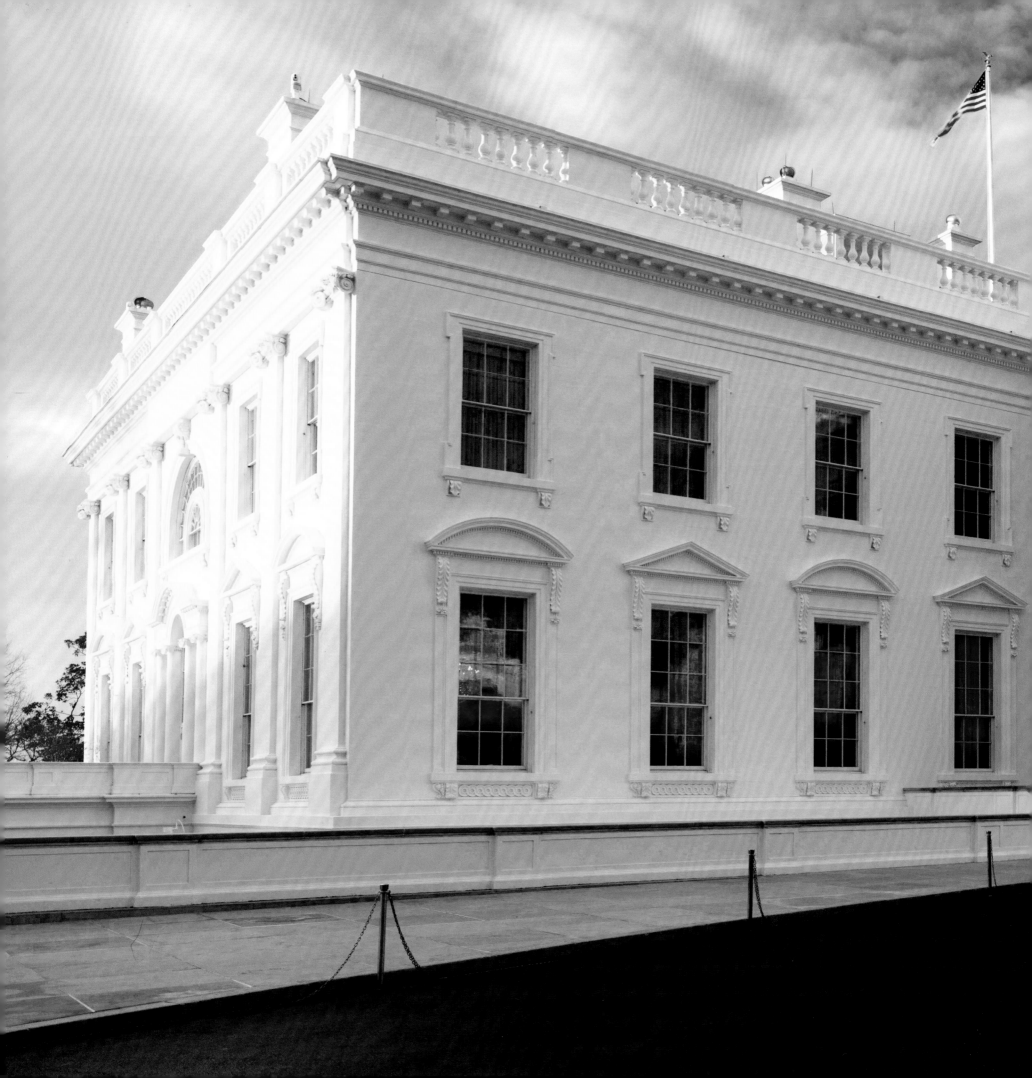

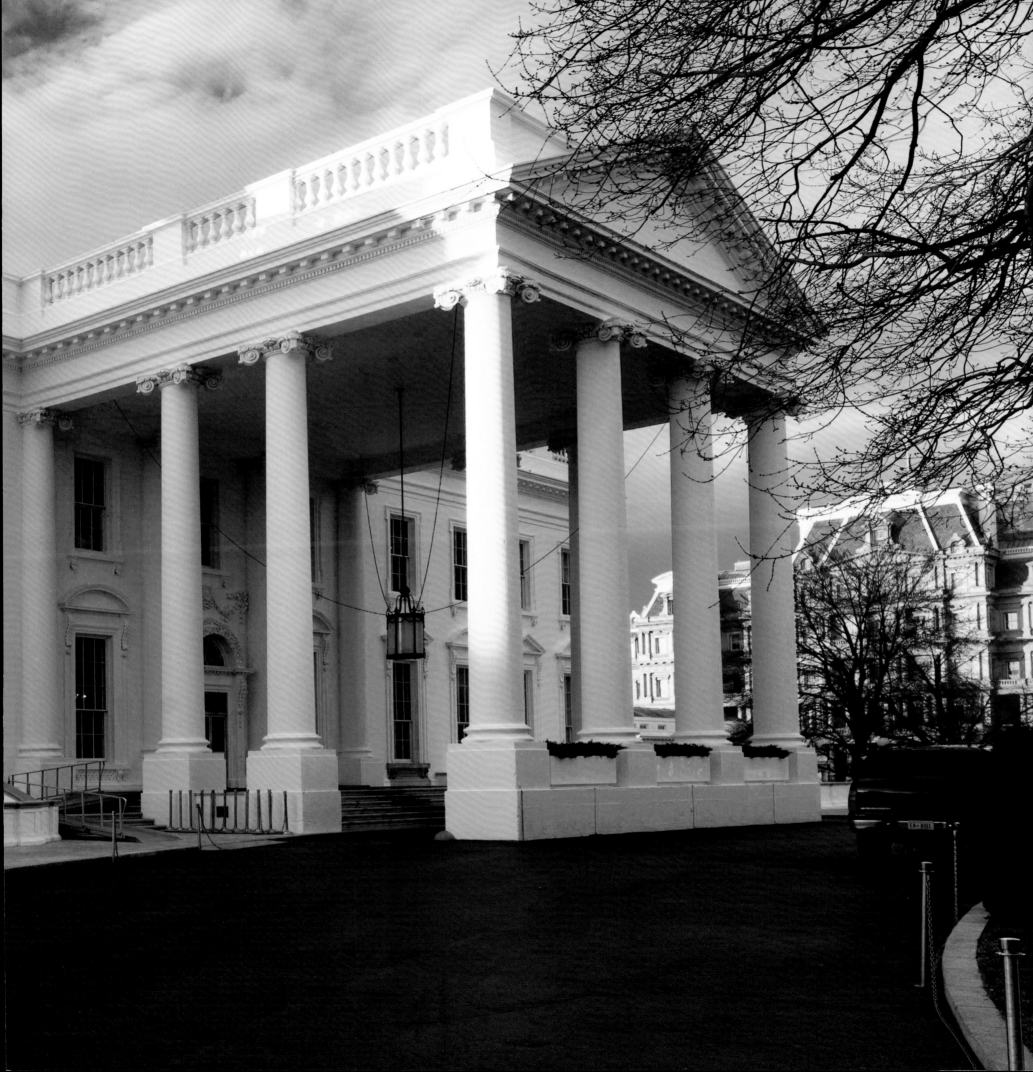

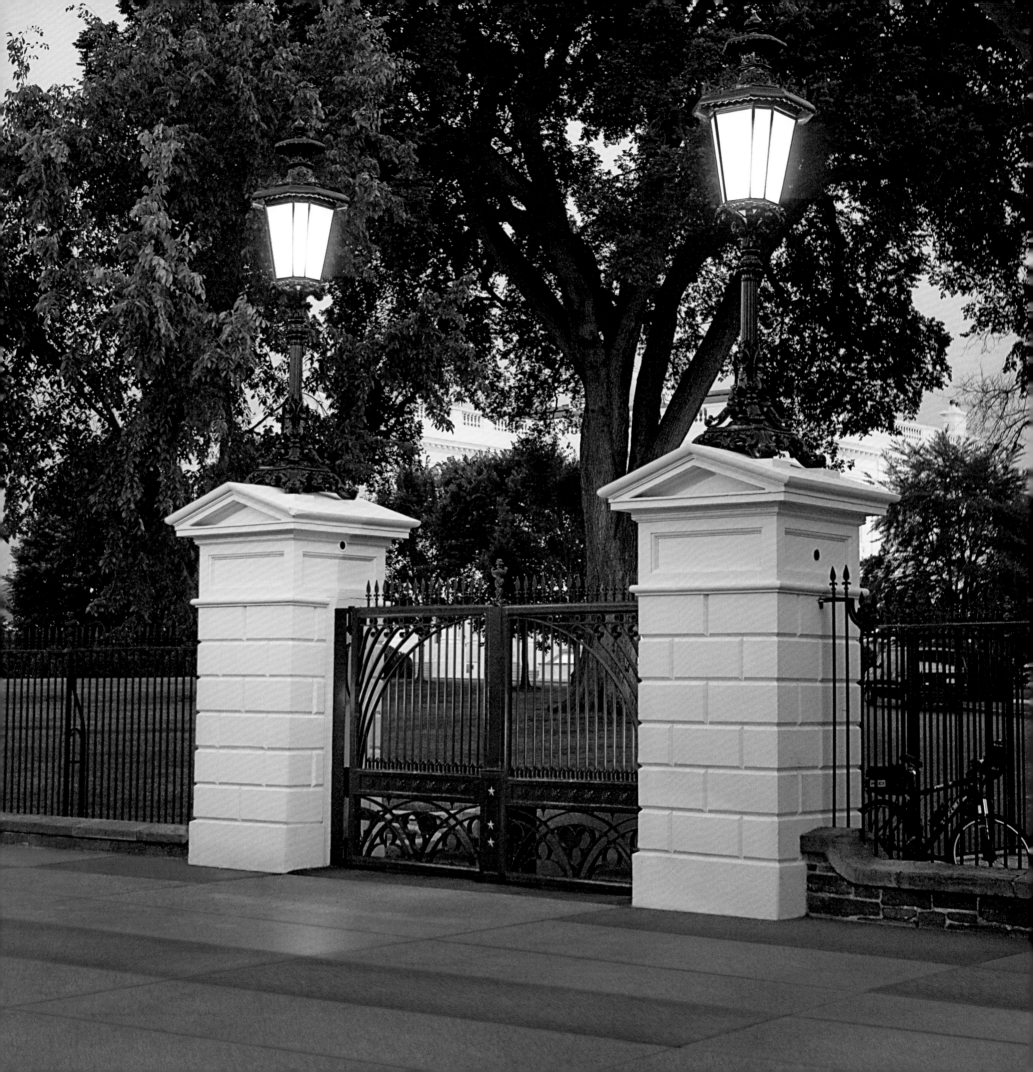

To me the home of the presidents is
sacred ground hallowed with
the memories of those men whom
our country has chosen to
the high office. To live in it
is to live in a shrine.

First Lady Grace goodhue Coolidge

EVEN AFTER ONLY A SHORT TIME,
THE WHITE HOUSE BECAME A HOME
FOR MY FAMILY.

PRESIDENT JIMMY CARTER

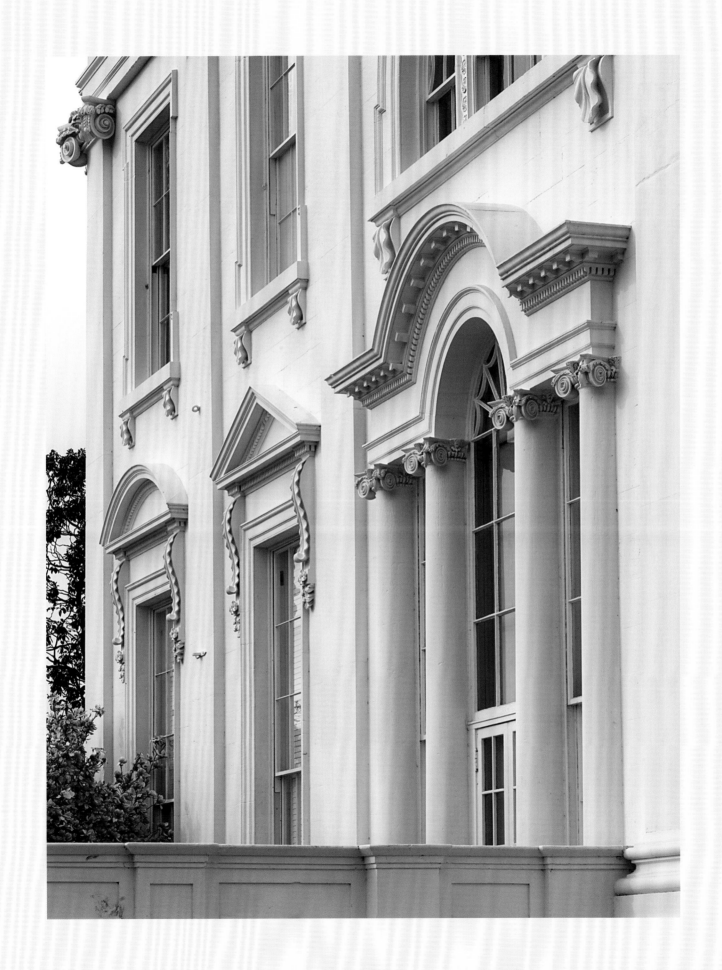

I AM A STRONG ADVOCATE FOR
THE PUBLIC TO HAVE ACCESS
TO THE PUBLIC PARTS OF
THE BUILDING. . . . I THINK THERE
IS AMPLE ROOM FOR EVERYBODY.

PRESIDENT GERALD R. FORD

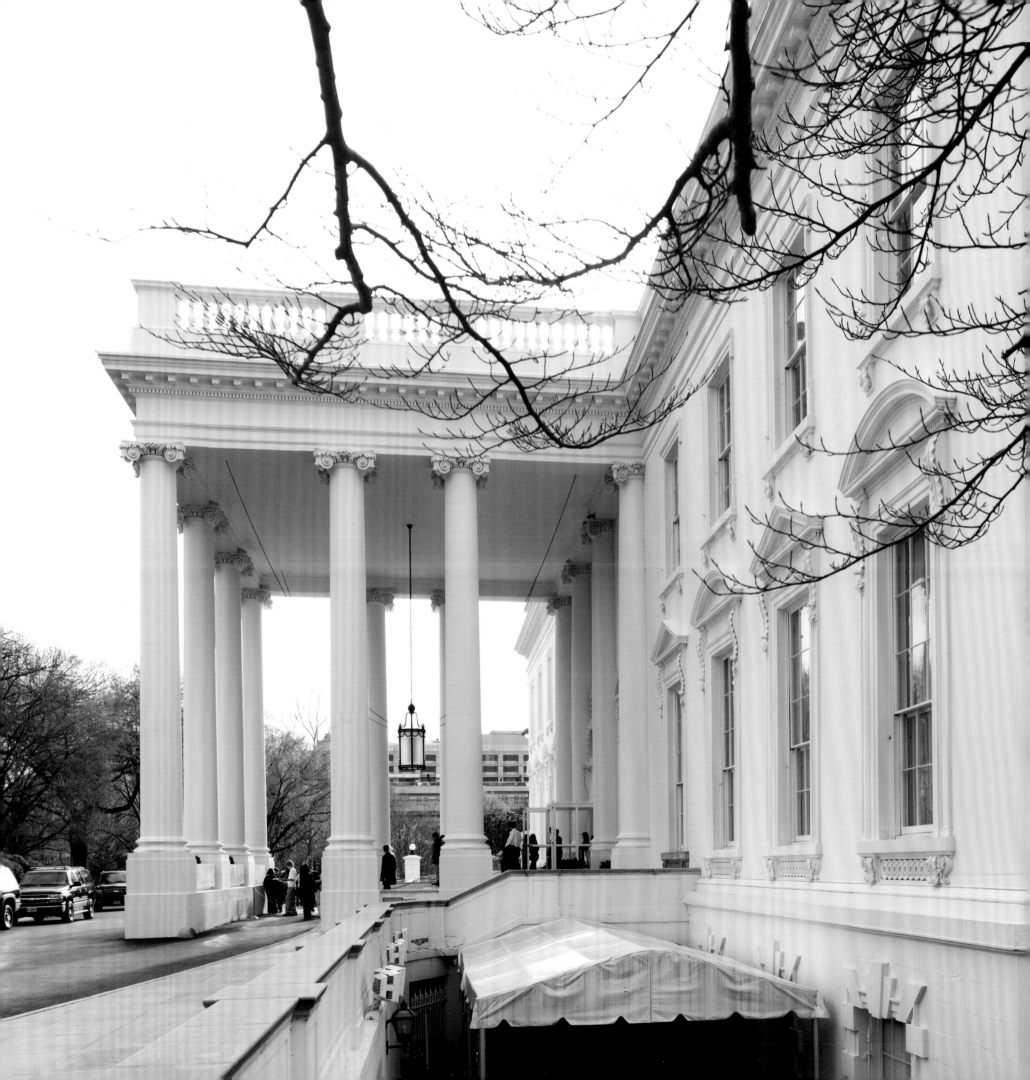

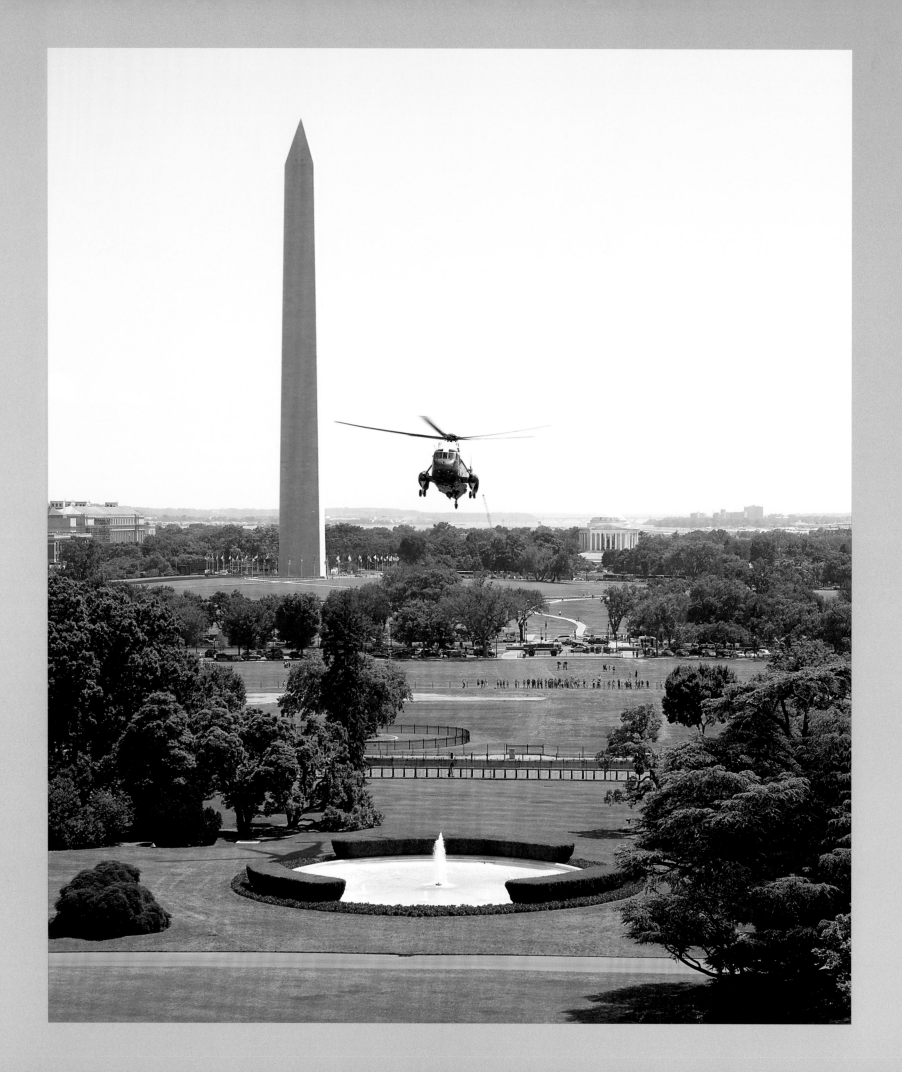

THE WHITE HOUSE WAS ATTRACTIVE
FROM ALMOST ANY ANGLE,
BUT COMING IN BY HELICOPTER
FROM THE SLOPING SOUTH LAWN
WAS THE MOST BEAUTIFUL VIEW. . . . WHEN
THE SPRING AND SUMMER COME, ALL THE
FLOWERS AND TREES BLOOM BELOW.

PRESIDENT RONALD REAGAN

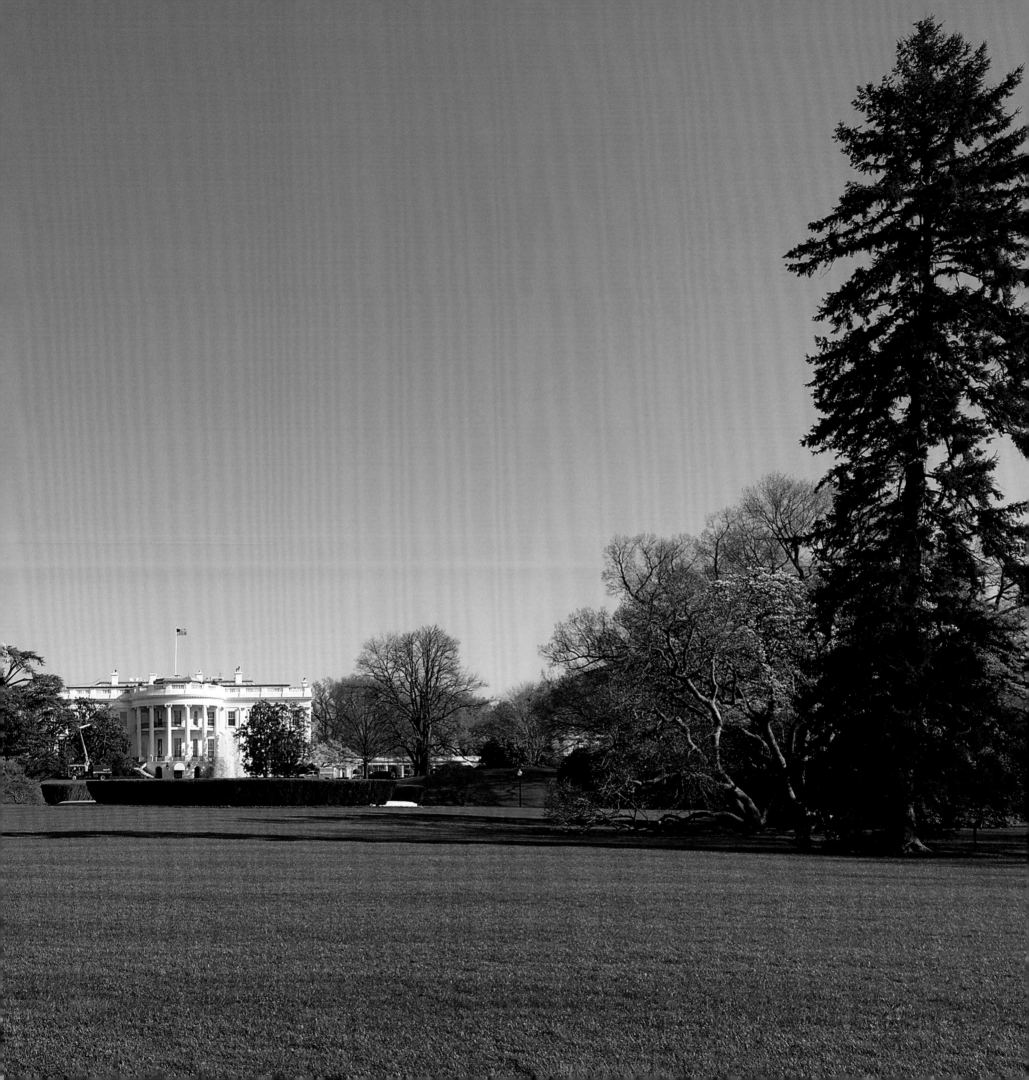

We have the most beautiful
flowers & grounds imaginable.

I am beginning to feel
so perfectly at home.

First Lady Mary Todd Lincoln

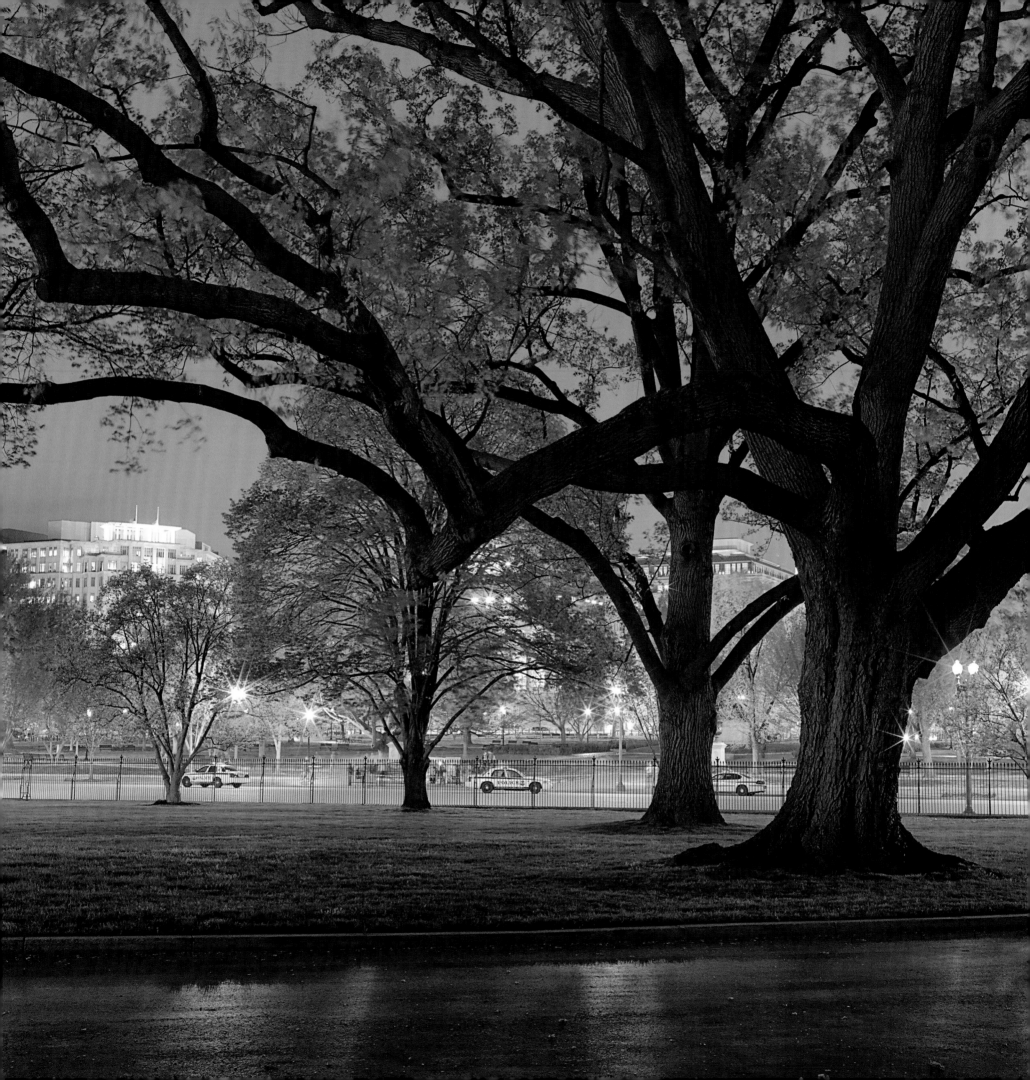

LIVING AT THE WHITE HOUSE WAS A
BEAUTIFUL EXPERIENCE. ALL OF IT. MAYBE
ONE OF MY MOST MOVING MEMORIES
IS FROM LATE AFTERNOONS AT THE
WHITE HOUSE AS THE SUN WAS GOING
DOWN AND LIGHTS STARTED COMING ON.

PRESIDENT GERALD R. FORD

THIS MORNING
I WOKE UP TO A WHITE WORLD—
SNOW FALLING OUTSIDE OF OUR BEDROOM
WINDOWS, SO THICK AND WHITE. . . .
LATER IN THE DAY THE SKY CLEARED
AND IT WAS THE MOST GORGEOUS,
WHITE, SUNNY WORLD.

FIRST LADY CLAUDIA TAYLOR (LADY BIRD) JOHNSON

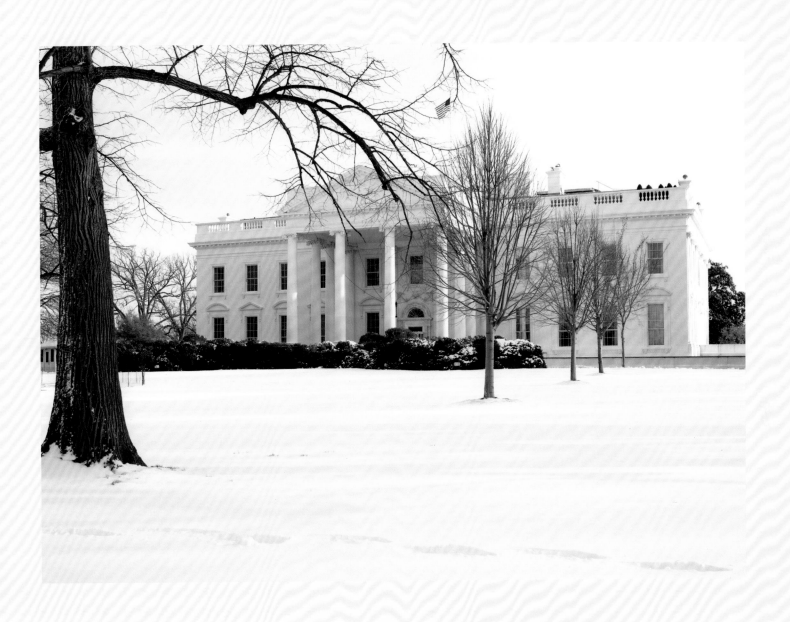

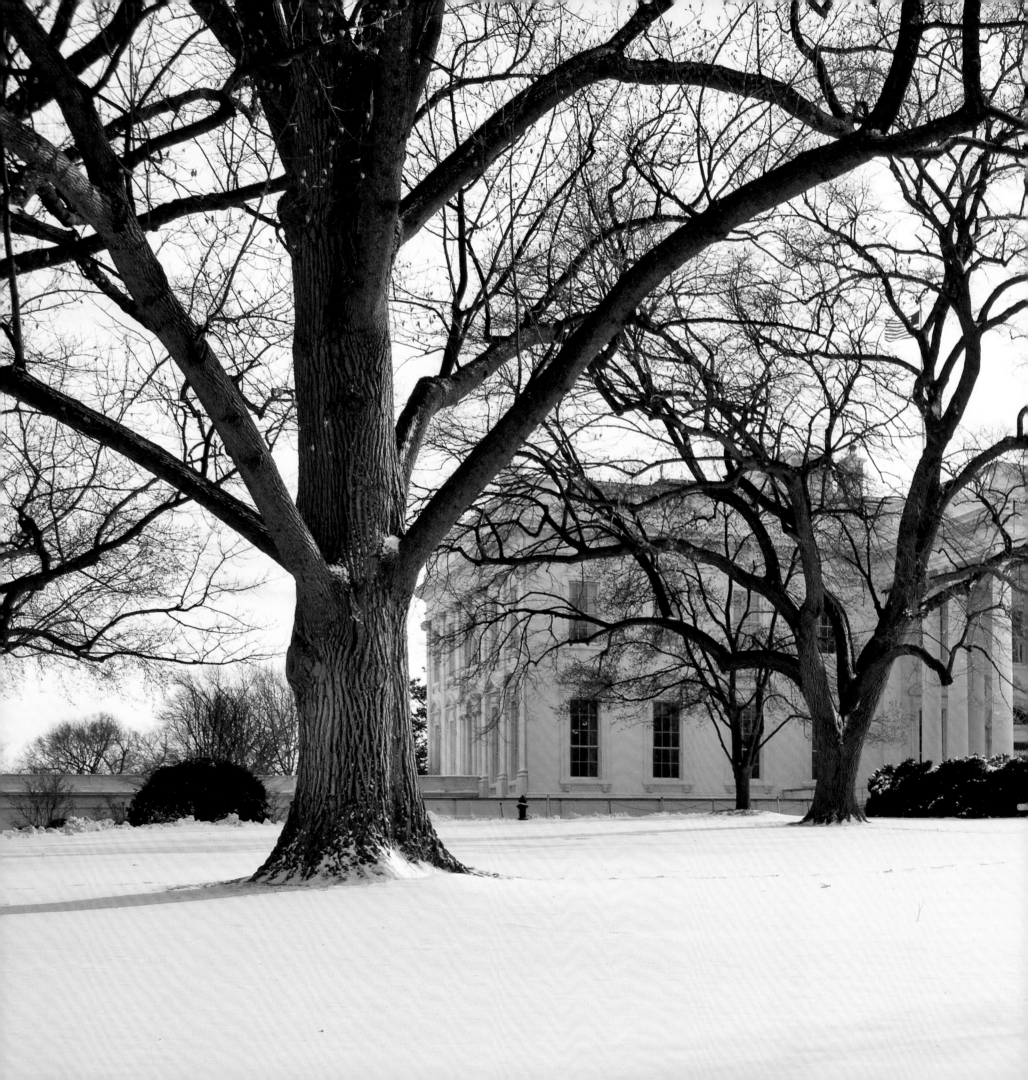

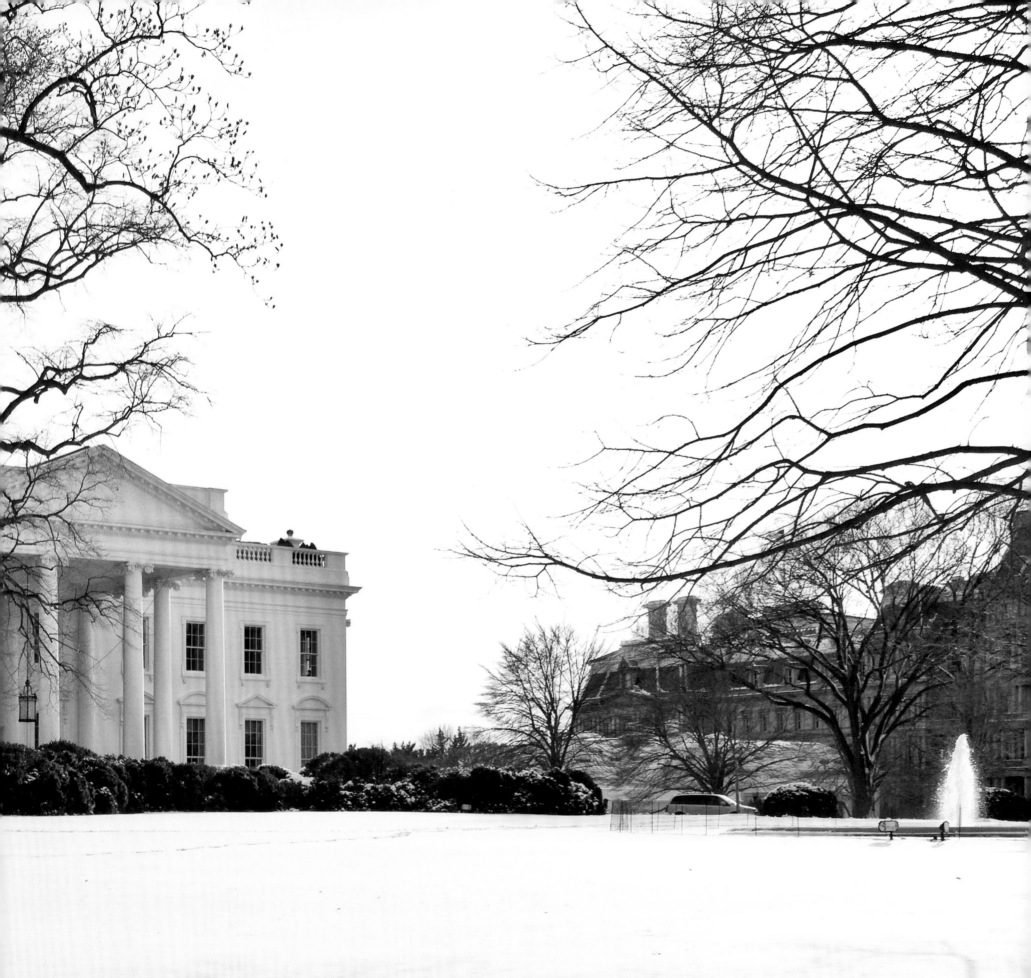

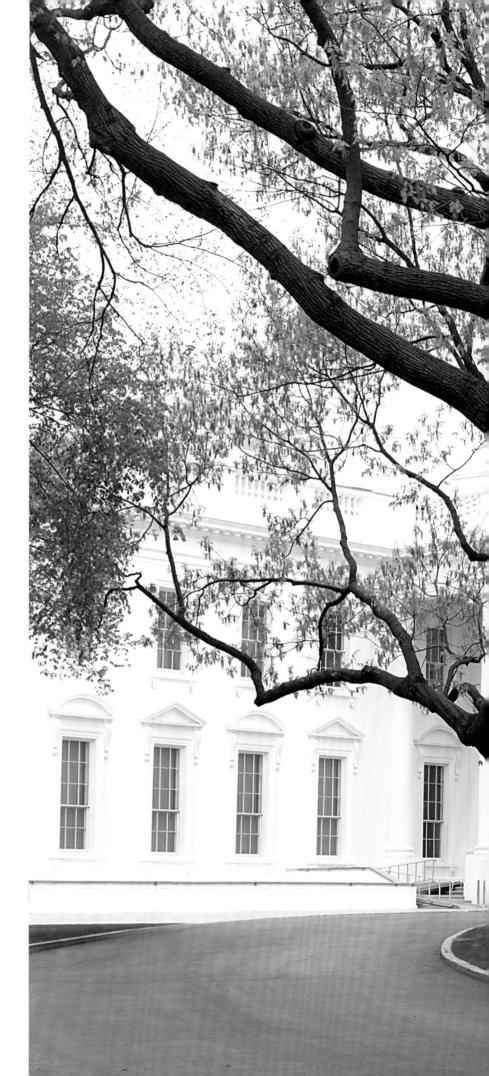

THE BEST PART IS ALWAYS OF COURSE THE
TIME WITH THE CHILDREN
AND THE DRIVE WITH G.C. WHICH
IS STILL ALMOST A DAILY OCCURRENCE
AND THE DAYS ARE GETTING SO
BEAUTIFUL NOW—AND THE TREES
BECOMING COVERED SO RAPIDLY
WITH THE FIRST EXQUISITE
FEATHERY GREEN.

FIRST LADY FRANCES FOLSOM CLEVELAND

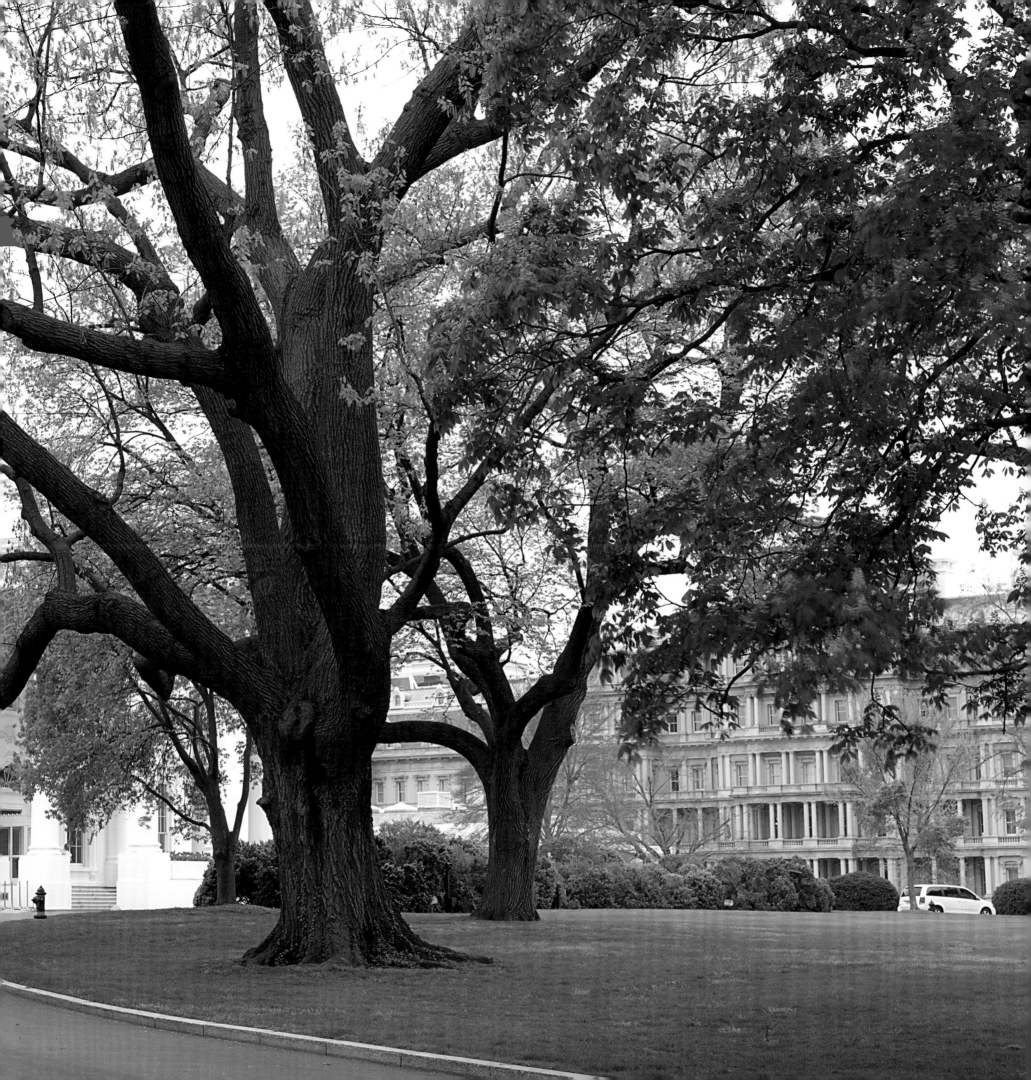

The north veranda of the White House
is pleasant enough, but it lacks the
charm of seclusion peculiar to
the south portico which runs around
the oval Blue Room and looks out
upon the broad south garden with
its great fountain, and with Potomac
Park, the River and Washington's
Monument in the background. . . .

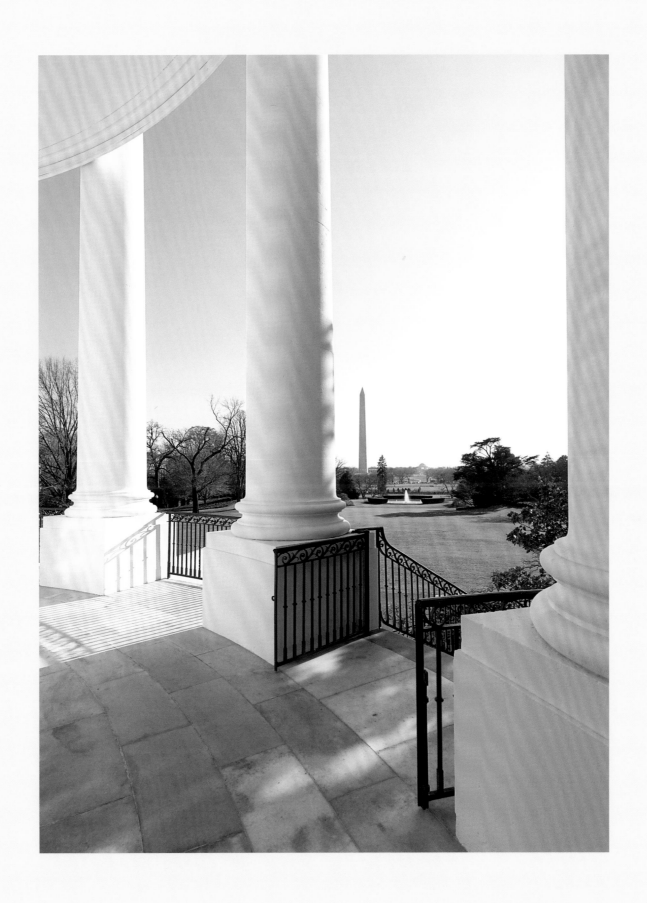

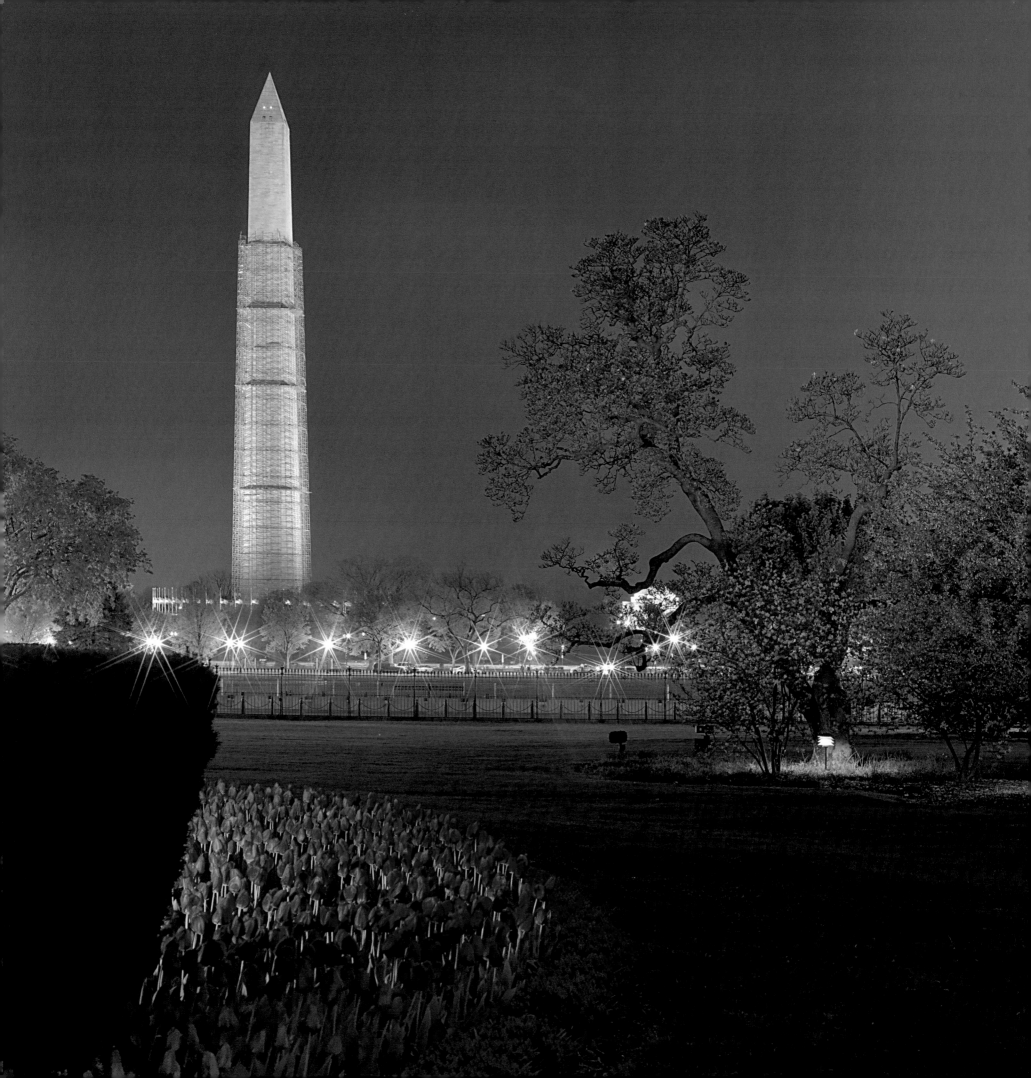

. . . This soon became our favourite retreat and we used to sit there in the ever lengthening spring evenings, breathing the perfume of magnolia blossoms, watching the play of lights on the tree-dotted lawns and on the Monument—which is never so majestic as in the night— and realising to the full the pleasant privileges of living in this beautiful home of the Presidents.

First Lady Helen Herron Taft

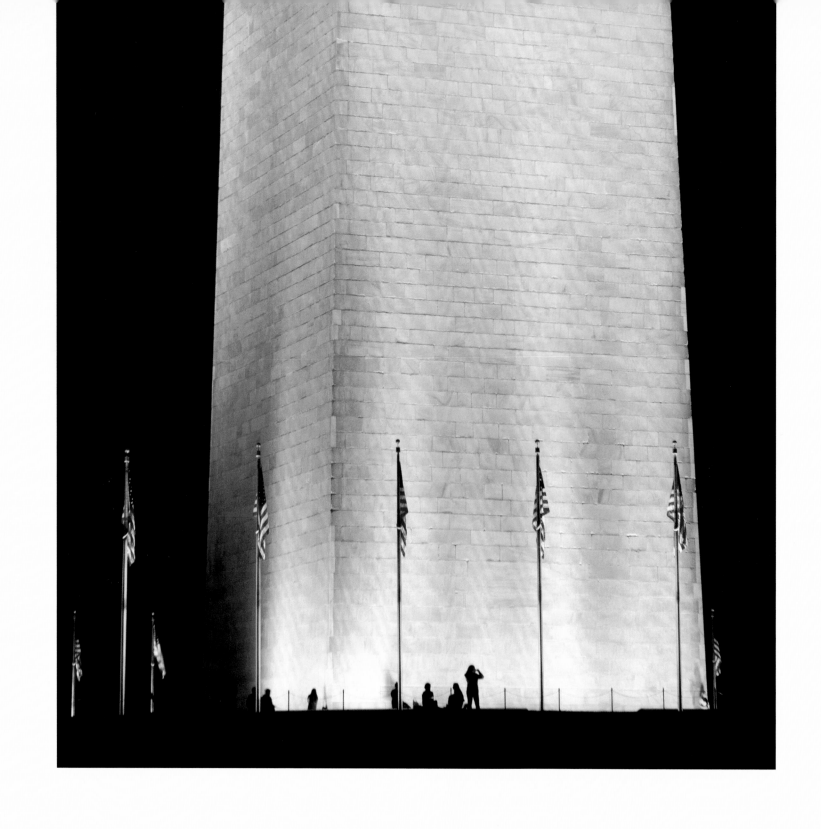

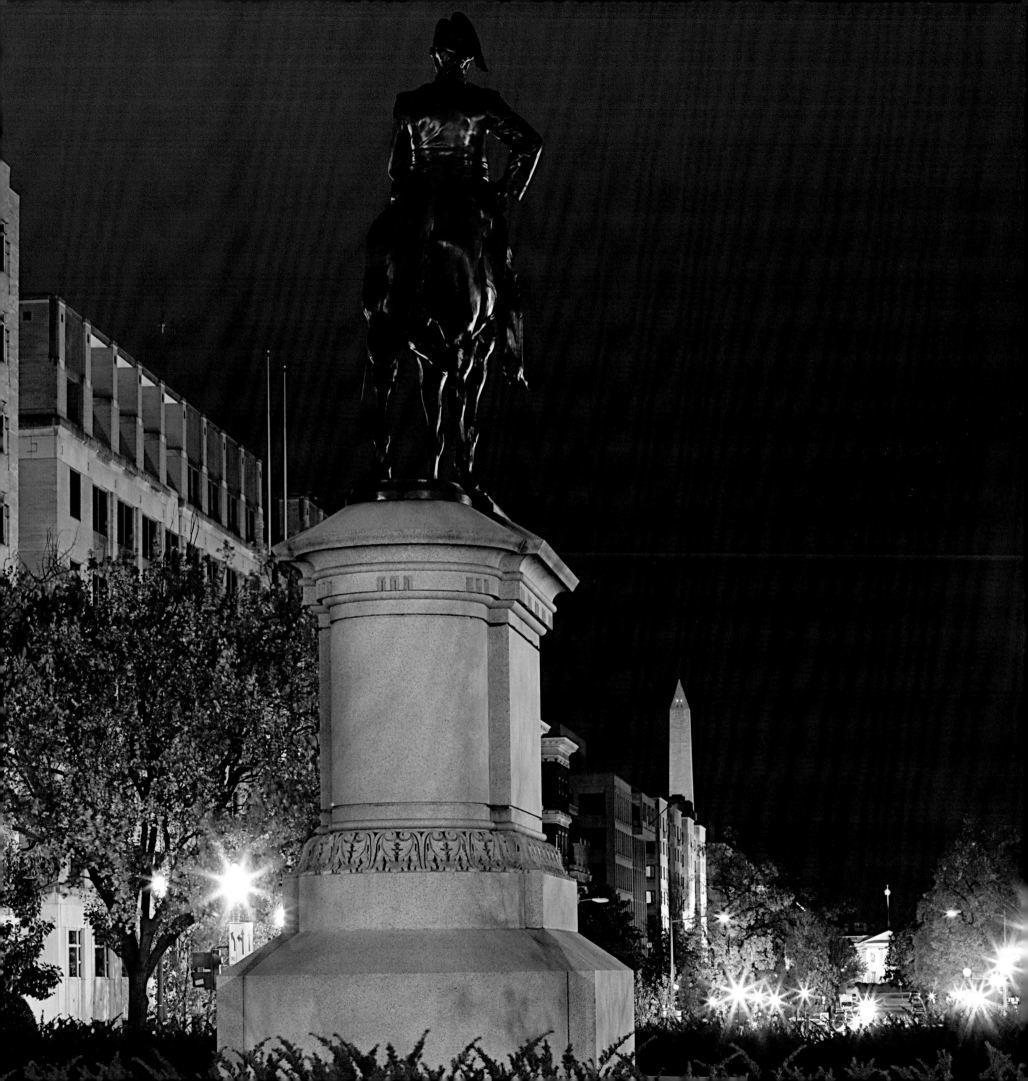

I'm a sort of amateur horticulturist;
I guess "silviculturist"
is the right word. I liked trees, so I
learned the variety of species
and the origin of all the trees
on the White House grounds,
which are quite extensive.

President Jimmy Carter

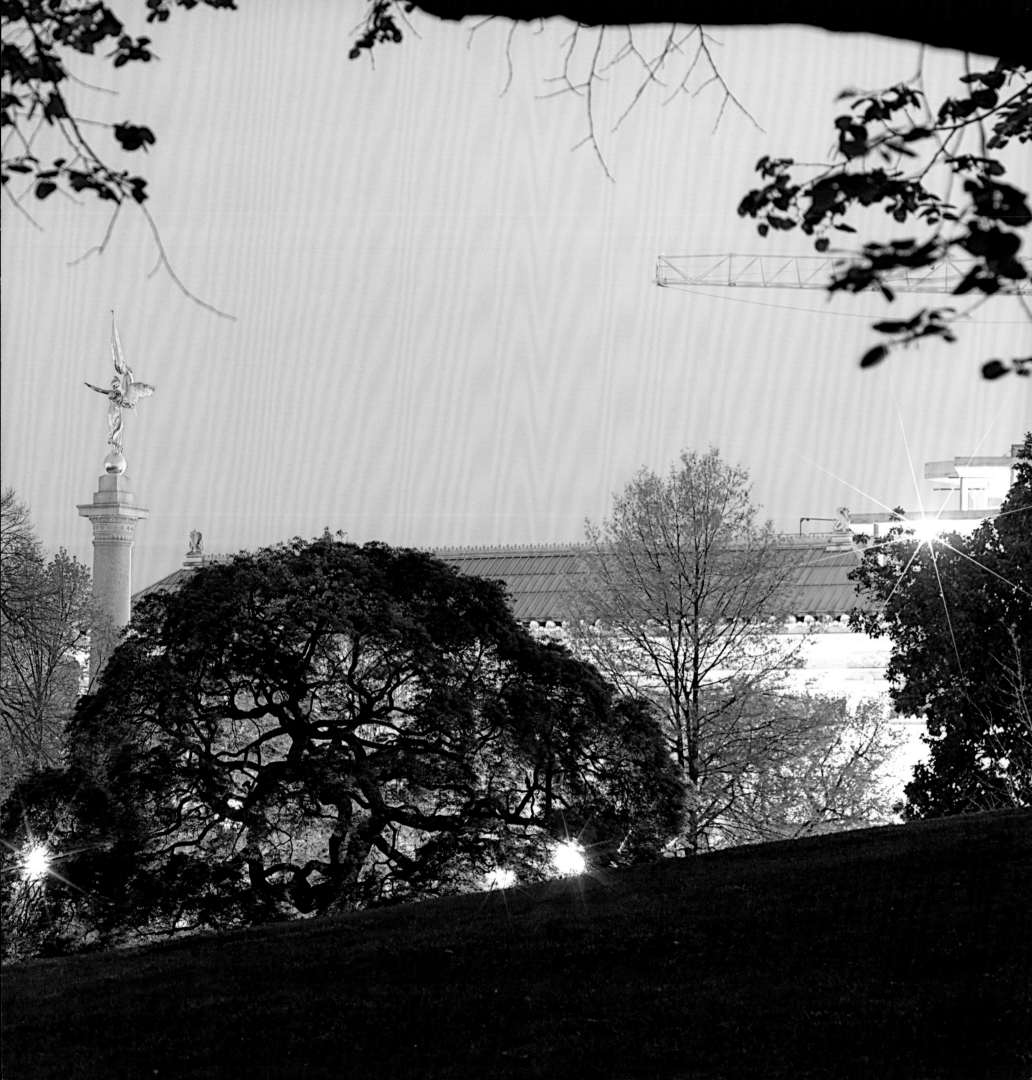

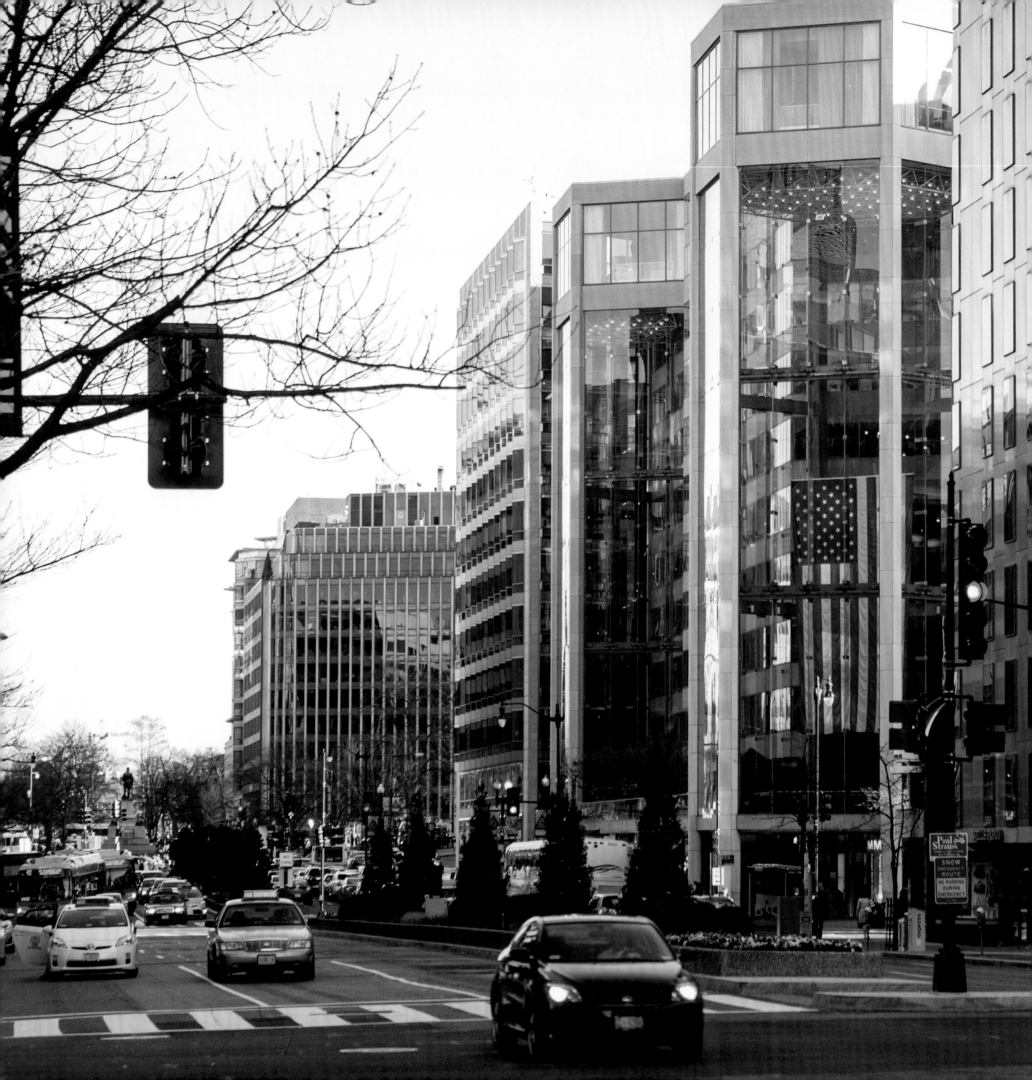

THE NEIGHBORHOOD TO THE NORTH

DEAR WASHINGTON,
HOW I LOVE YOU, WITH
YOUR BEAUTIFUL, BROAD,
GENEROUS STREETS AND
BLUE SKIES! THE SUN SHINES
ALWAYS THERE FOR ME.

FIRST LADY JULIA DENT GRANT

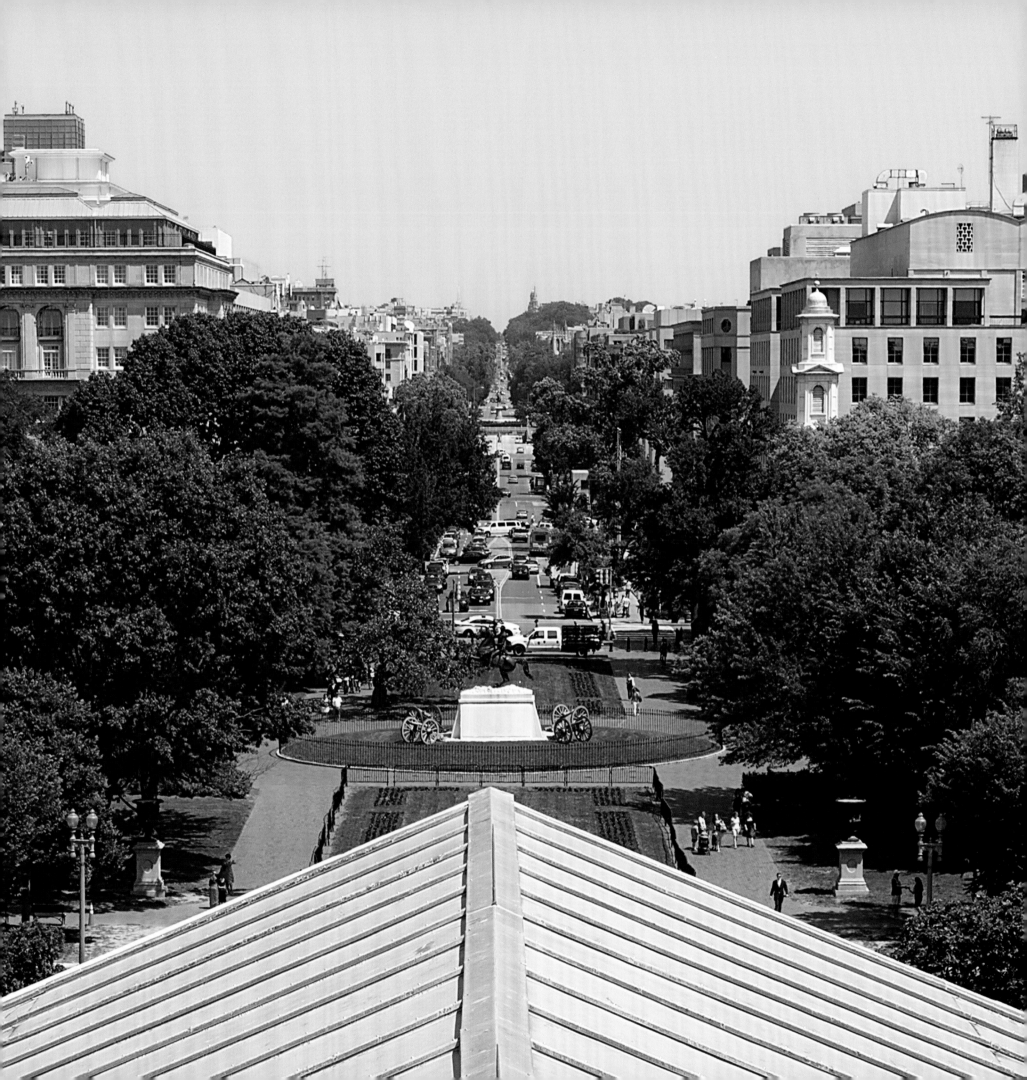

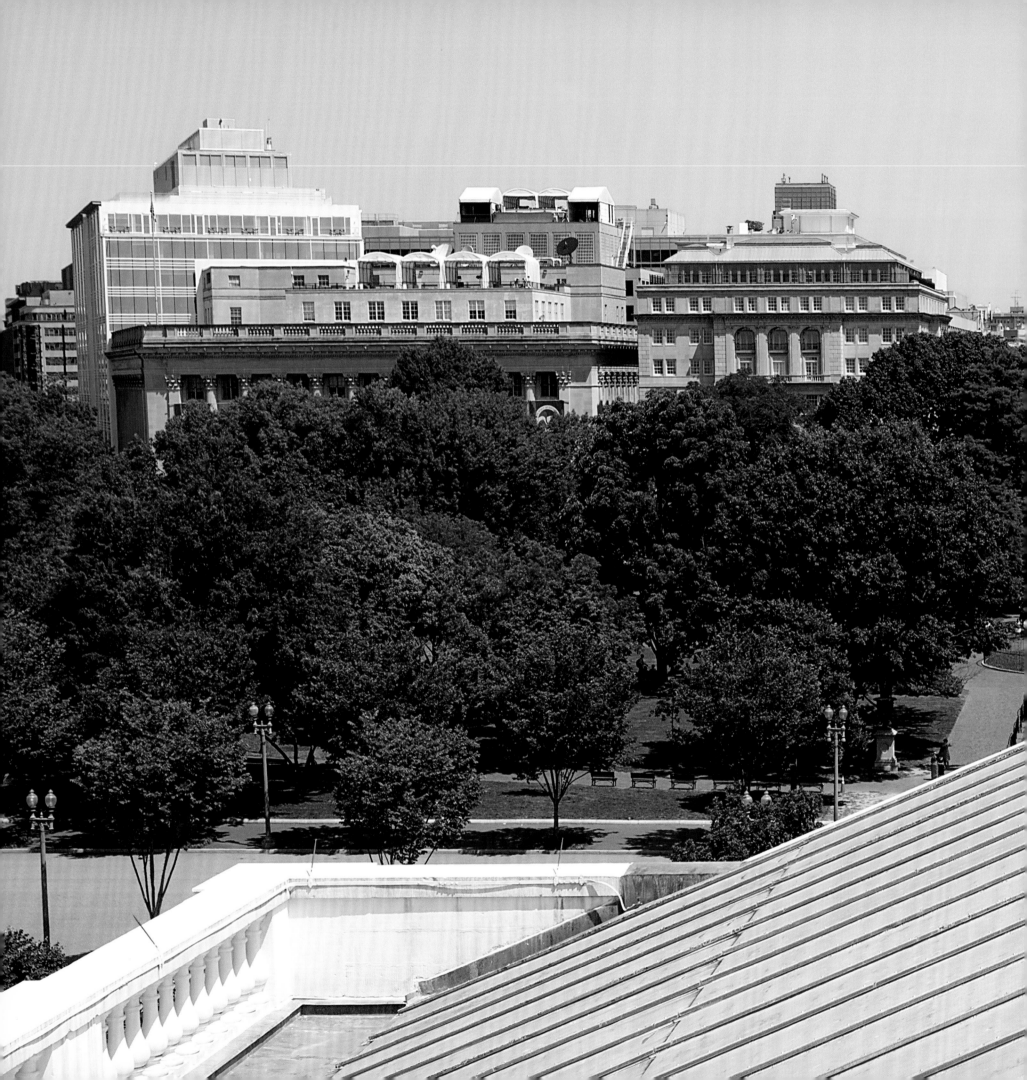

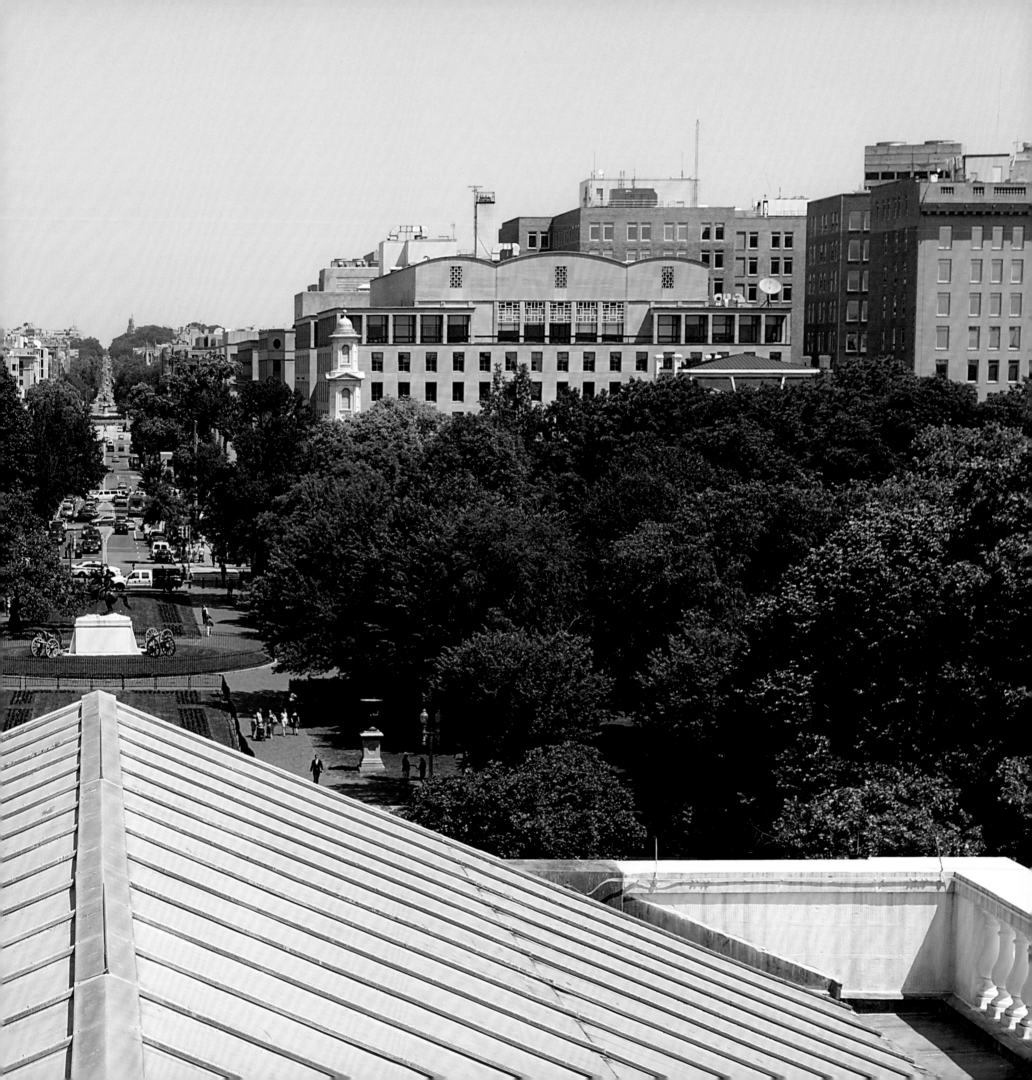

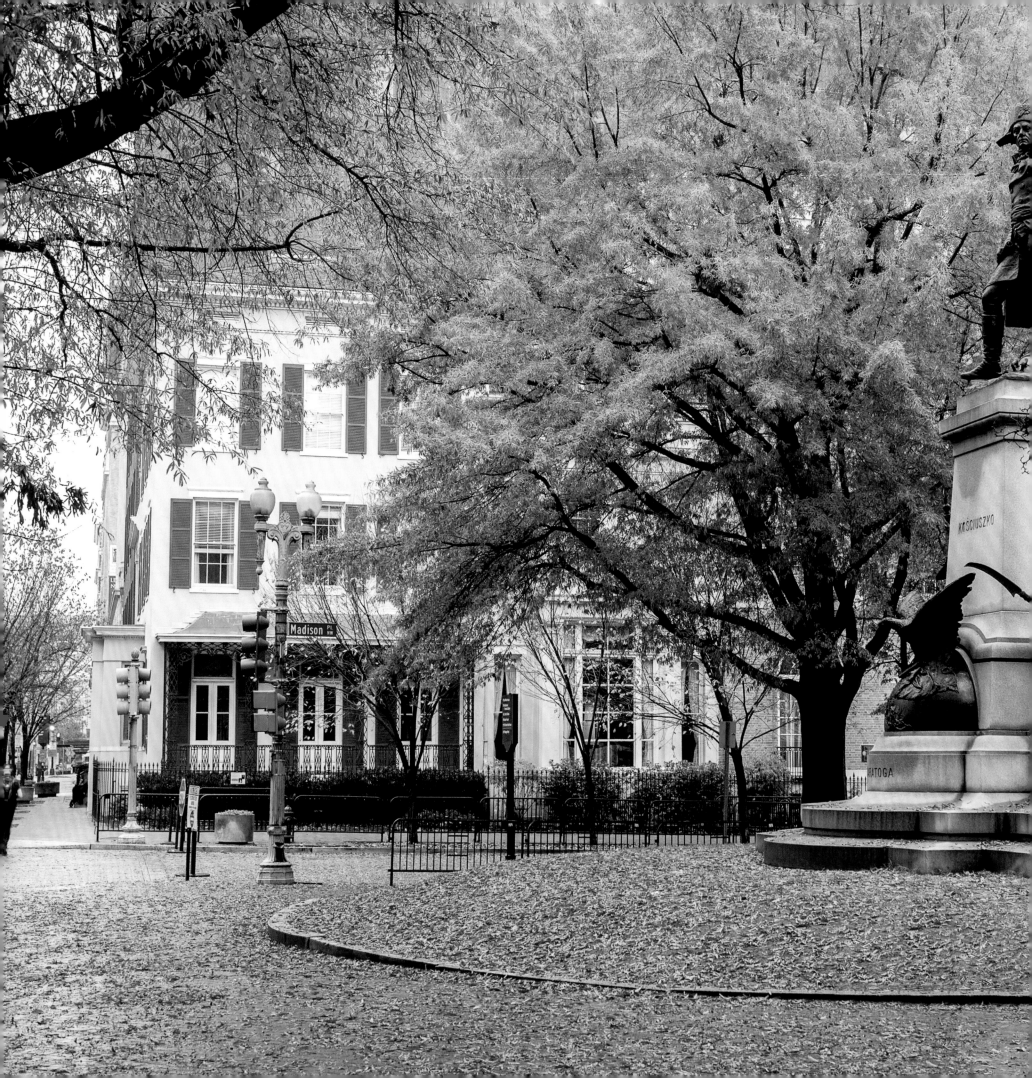

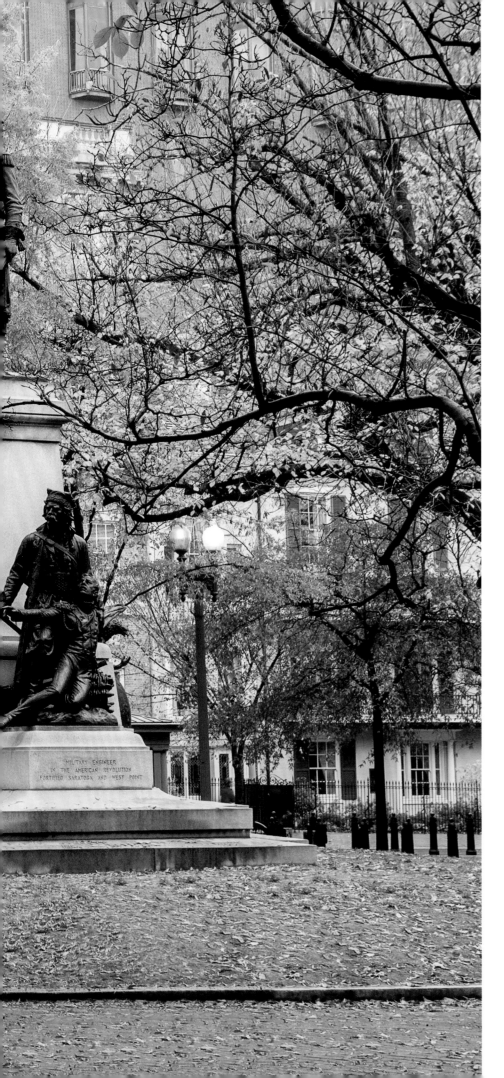

IN THE COLORFUL DAYS AND WEEKS WHEN
THE AUTUMN OF THE YEAR BRINGS RIPE
AND FRUITFUL HARVEST ACROSS OUR
LAND, AMERICANS GIVE THANKS FOR
MANY BLESSINGS.

PRESIDENT WILLIAM JEFFERSON CLINTON

ONCE THERE WAS A RESIDENTIAL NEIGHBORHOOD

Long ago the White House from the north looked over a regular residential neighborhood of town houses clustered at its feet. A cook in private employ might think nothing of borrowing a cup of sugar from the basement kitchen of the White House, nor might the White House steward hesitate to borrow extra chairs or sub extra hands from a neighbor for a presidential event.

As the 1960s dawned, the White House neighborhood, especially its climactic feature, Lafayette Square, faced total demolition. Most of the old houses were gone already. The most notable that remained were the Decatur, Madison, and Blair Houses. A mishmash spread of commercial and governmental architecture had virtually erased the residential quality of the area. On the west side of Lafayette Square, a large new Department of State headquarters was envisioned that would have risen seven stories and wholly filled that side of the square. Similar plans were called for on the east side.

The Boston architectural firm of Perry, Shaw & Hepburn, creators and restorers of Colonial Williamsburg, had been given the job of designing this structure. It was planned in white marble to fit the site sidewalk to sidewalk. President Dwight D. Eisenhower had hesitated in the late 1950s, but there was dire need for the new office space and the project moved along in its preliminaries.

President John F. and Mrs. Kennedy were not happy with what they saw, but felt helpless to derail a project that had involved so much expenditure of federal money and people who were eager for it to take place. Although the loss of the residential setting of the White House seemed to them too major to overlook, even presidents have to cope with red tape, and stopping this well-established scheme seemed impossible.

Then an idea and a man appeared to guide President and Mrs.

Kennedy through what had seemed darkness. It happened that an old acquaintance of Kennedy's, John Carl Warnecke, was in town one day in 1962 and the three met on the subject. Warnecke, who at the time captained the largest architectural firm in the world, had a plan that would satisfy the need for space and still preserve the White House neighborhood. With a few sketches, a model, and the blessing of President Kennedy, he went out politicking for the new idea—with a skill he had that few could match. Opposition from government officials was strong. But when the day came for the Commission of Fine Arts to pass on the proposed "skyscraper," Warnecke brought drawings for a new idea. Mrs. Kennedy appeared to give moral support, and the tide was turned. The neighborhood that you see on Lafayette Square today is the happy result.

Alas President Kennedy, to whom Warnecke's program had become a deep personal commitment, did not live to see bricks and mortar. All the presidents who followed supported the program. In retrospect it seems simple enough, a solidly thought out project that began with a good idea. The centers of the blocks to the west and east were cleared. High, red-brick buildings were erected for the offices along the street, vanished town houses were replicated. Offices thus rose in rear courts—all made into one garden-like open area—with appropriate entrances from the sidewalks, along which a screen of "historical" facades, carefully constructed with period windows and high stone steps, dormer windows, and slate roofs, brought to visual life again the long-abandoned residential character of Lafayette Square. The work was completed in 1972.

The human scale of the White House neighborhood was thus reborn, in a poetic sort of compromise between necessity and a respect for what had been. One might wonder if it could have happened in any other time.

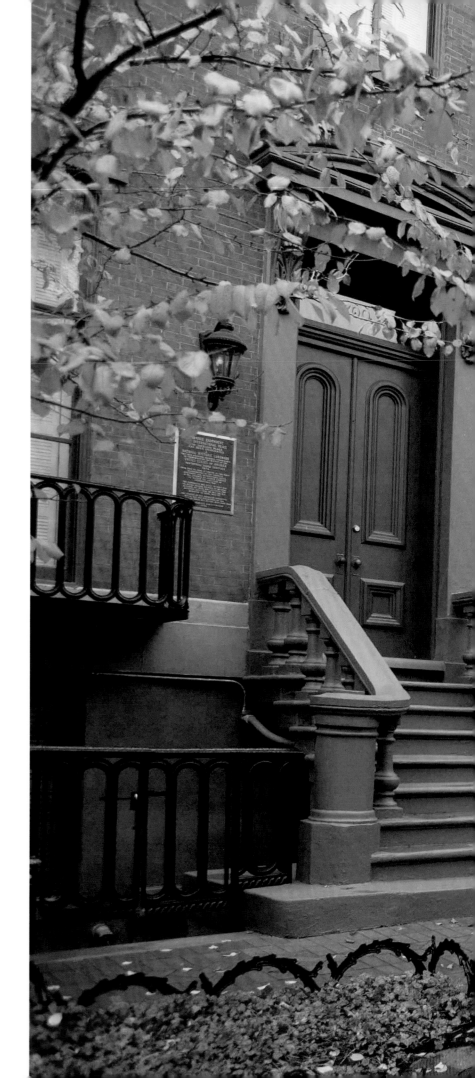

THE WRECKERS HAVEN'T STARTED YET,
AND UNTIL THEY DO,
THE SQUARE CAN BE SAVED.

FIRST LADY JACQUELINE BOUVIER KENNEDY

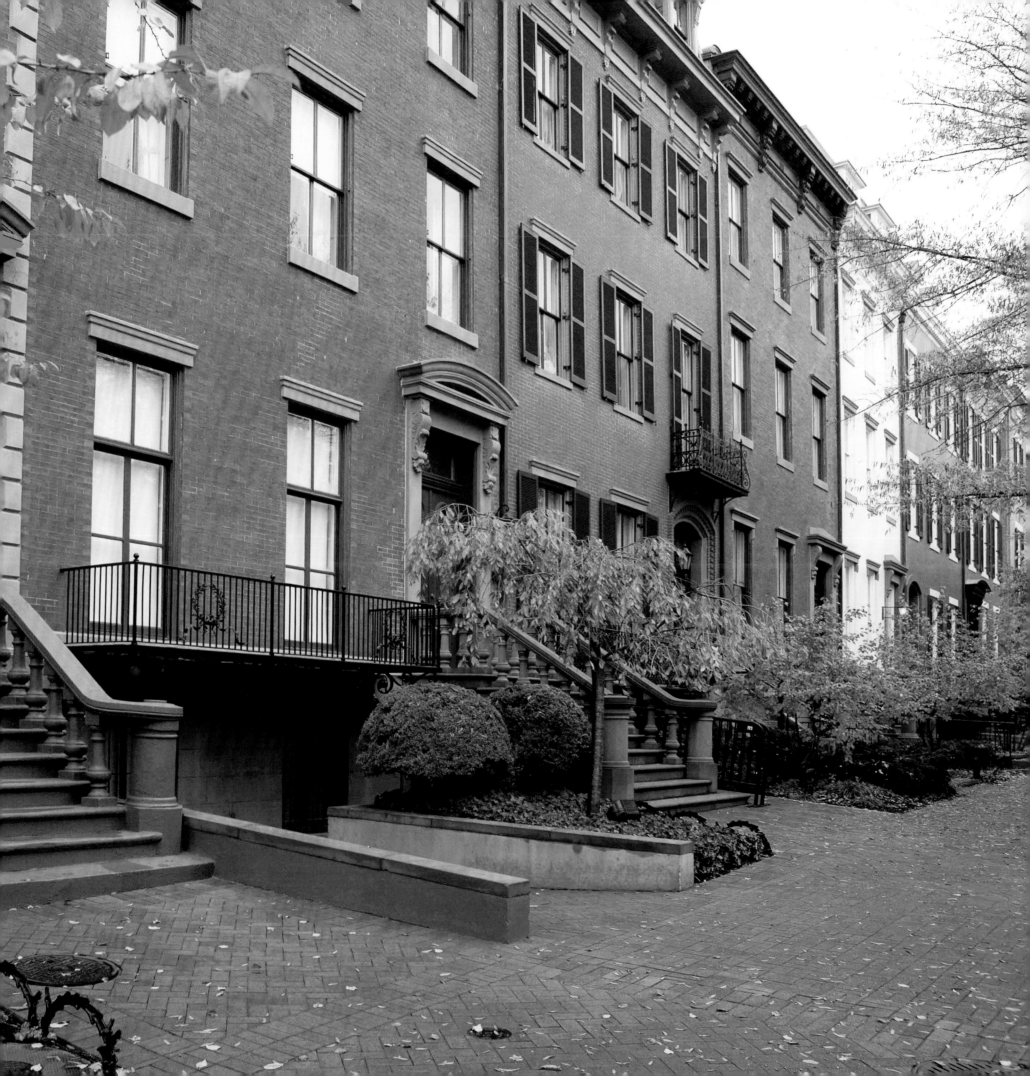

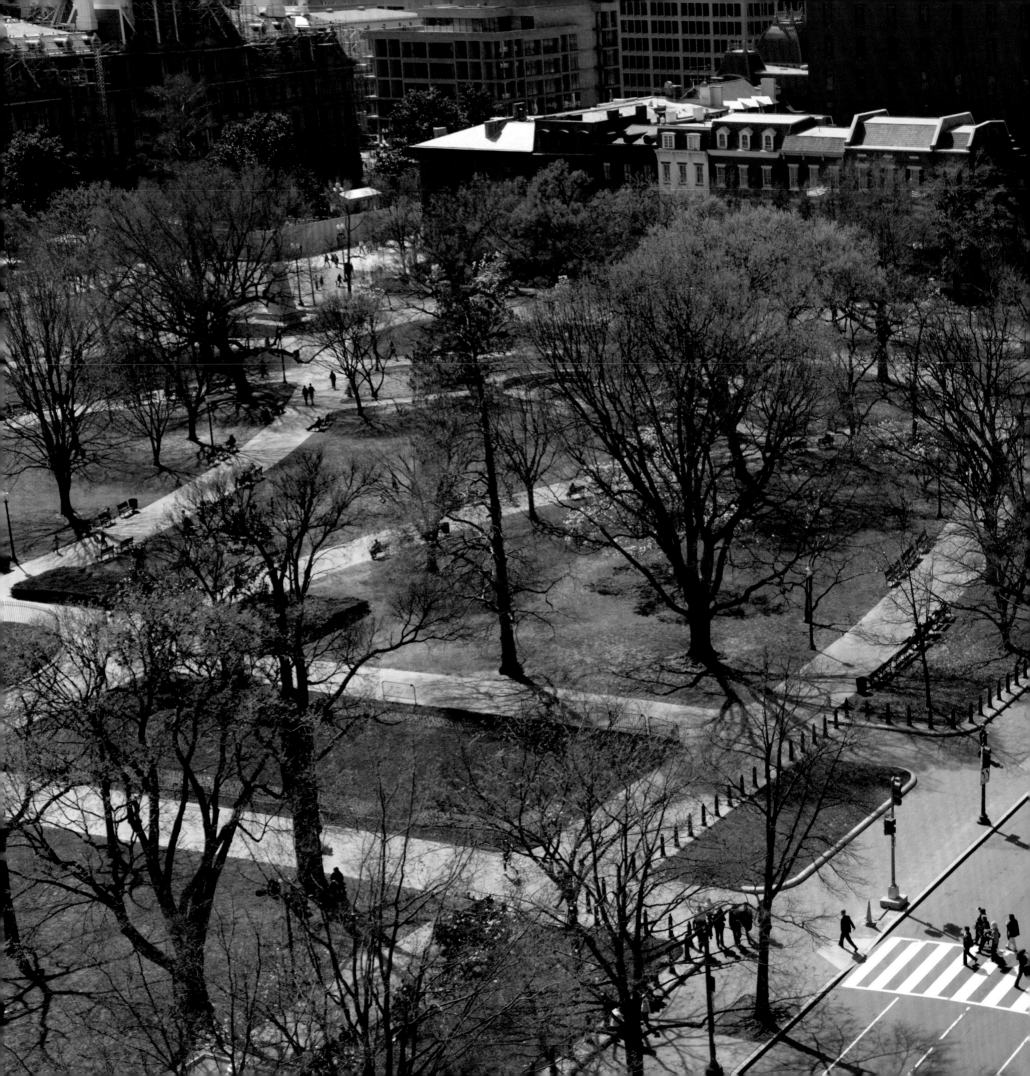

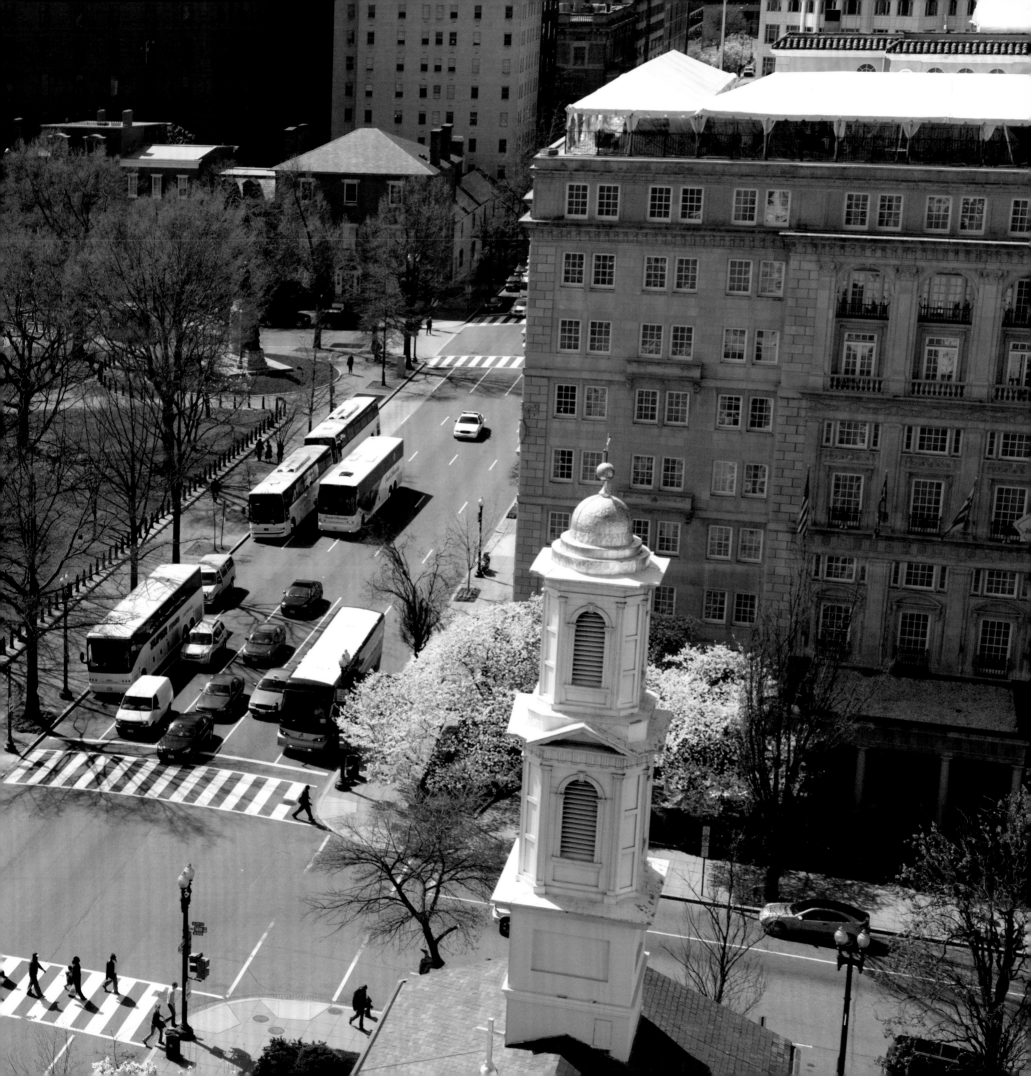

I BELIEVE THAT THE IMPORTANCE OF
LAFAYETTE SQUARE LIES IN THE FACT THAT
WE WERE NOT WILLING TO DESTROY OUR
CULTURAL AND HISTORIC HERITAGE
BUT THAT WE WERE WILLING TO FIND
MEANS OF PRESERVING IT WHILE STILL
MEETING THE REQUIREMENTS
OF GROWTH IN GOVERNMENT.

PRESIDENT JOHN F. KENNEDY

AN EPISCOPAL CHURCH OF GREAT CHARACTER

Washington's richest man, John Tayloe III, a planter from Virginia and local resident, saw the need for a church in the White House neighborhood. He called in the federally salaried architect B. Henry Latrobe, British-born, and paid him to design an Episcopal church in the latest style. There were two men in charge, Tayloe and Latrobe, and Tayloe deferred to Latrobe. Completed in 1816, the resulting building had great charm, even whimsy. Deeply moved by his architectural masterpiece, Latrobe sat at the organ and played proudly the dedicatory hymn of his own composition.

The church was in the British Plain Style, simply constructed in stucco and brick, with brick floors inside laid in sand, from which an architecturally dramatic neoclassical play of arches and vaulting were flooded with natural light from a shallow dome above.

From the start, St. John's, which was only one of many places of worship in the capital, was associated with the presidents at the other end of the square. A healthy, robust congregation carried it through two centuries. However, it seems that the Episcopal Church, in such disarray and abandonment at the close of the American Revolution, was still going through resuscitation when St. John's, in all its secular splendor, was built. Not many years after its opening, St. John's received all the signature church devices—a dome and a portico—and was architecturally sanctified. But the careful eye can still discern Latrobe's masterpiece, where worshippers had always claimed they felt closer to God.

Through time "The Church of the Presidents" has become the capital's most famous house of worship. By custom the presidents have walked across the street to attend services. Most have

felt a close kinship to the old church. A plaque denotes an obscure corner pew that Abraham Lincoln often slipped into to hear the sermon alone, just after services began. He would slip back out, unnoticed, just before services ended and walk back to the White House through Lafayette Park. President Franklin D. Roosevelt began the tradition of a pre-inauguration worship service in 1933 when he arranged for a private service to be held at St. John's Church before his swearing-in ceremony. The tradition has been continued by every president to the present day.

During the presidency of Chester Alan Arthur, St. John's Church engaged Lorin, a studio based in Chartres, France, to create stained glass windows for its new pictorial glazing program. A window depicting the Resurrection was created as a memorial to the president's late wife Ellen Herndon Arthur, who died too soon to become first lady of the land. At the request of President Arthur, the window was placed at the south transept of the church so that he could see it at night from the White House.

When the church was enlarged in the early 1820s during the Monroe administration, a 965-pound Revere Bell was purchased from the Boston company owned by Joseph W. Revere, son of the famous patriot Paul Revere. It was installed in the steeple at St. John's on November 30, 1822, and has the distinction of being the only Revere Bell in Washington, D.C., still in its original steeple. In continuing use since its installation, the bell calls the congregation together each week and the familiar hourly peels mark time for office workers in the surrounding blocks.

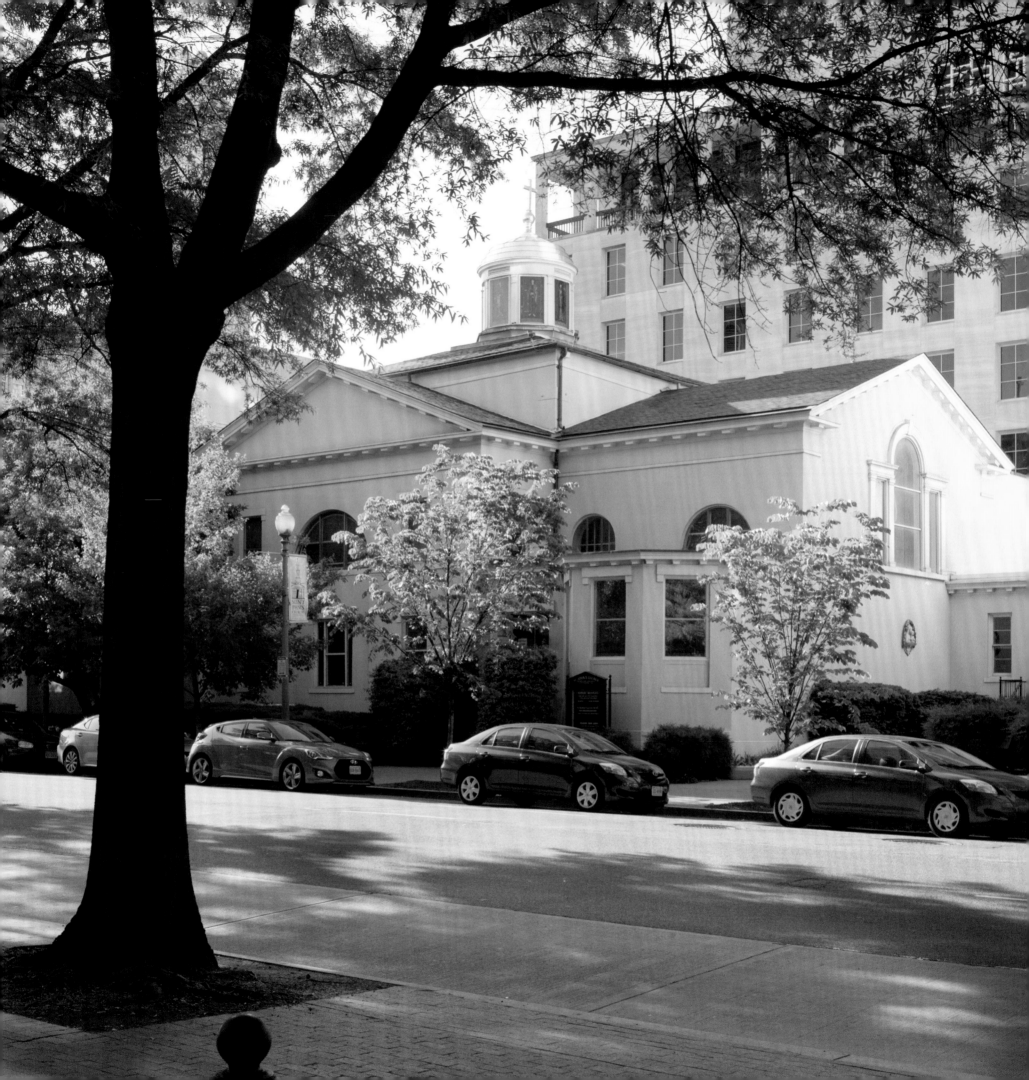

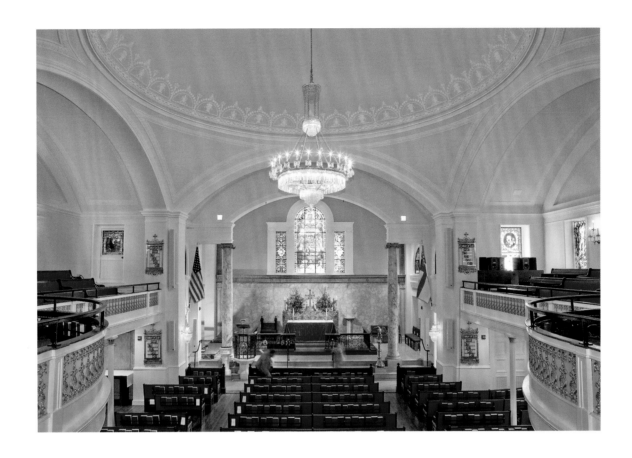

St. John's Church, which I have built is a pretty
thing, and has a celebrity beyond all bounds.
It has made people religious who
were never before at church.

B. Henry Latrobe

To the Glory of God
and in memory of Ellen Lewis Herndon Arthur:
entered into life January 19, 1880

dedication on stained glass window
given by President Chester A. Arthur in memory of his wife

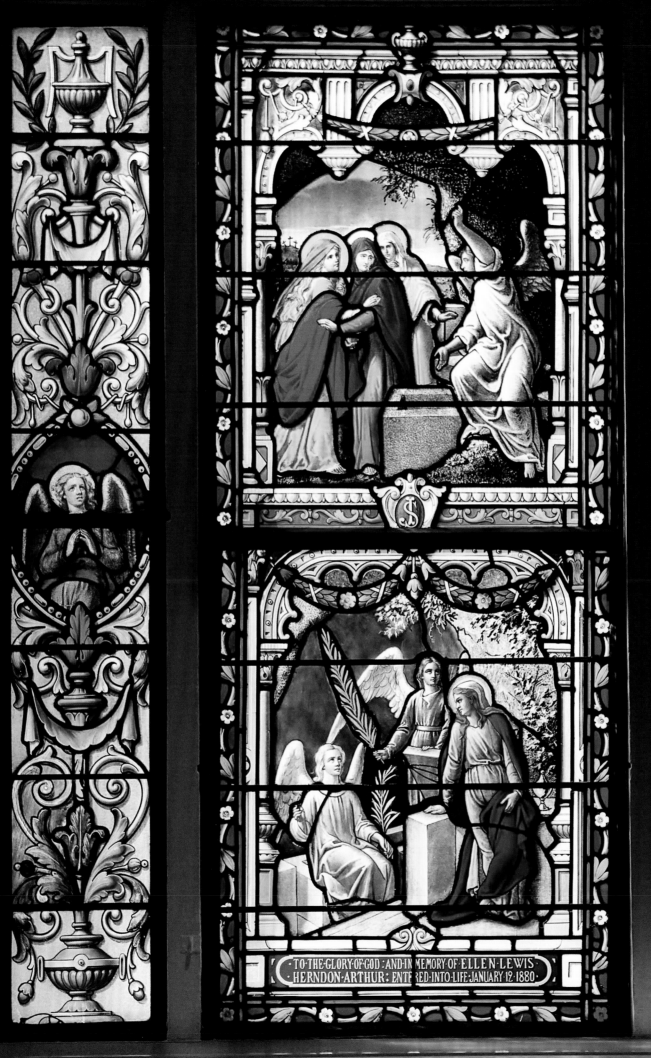

TO·THE·GLORY·OF·GOD·AND·IN·MEMORY·OF·ELLEN·LEWIS
HERNDON·ARTHUR·ENTERED·INTO·LIFE·JANUARY·12·1880

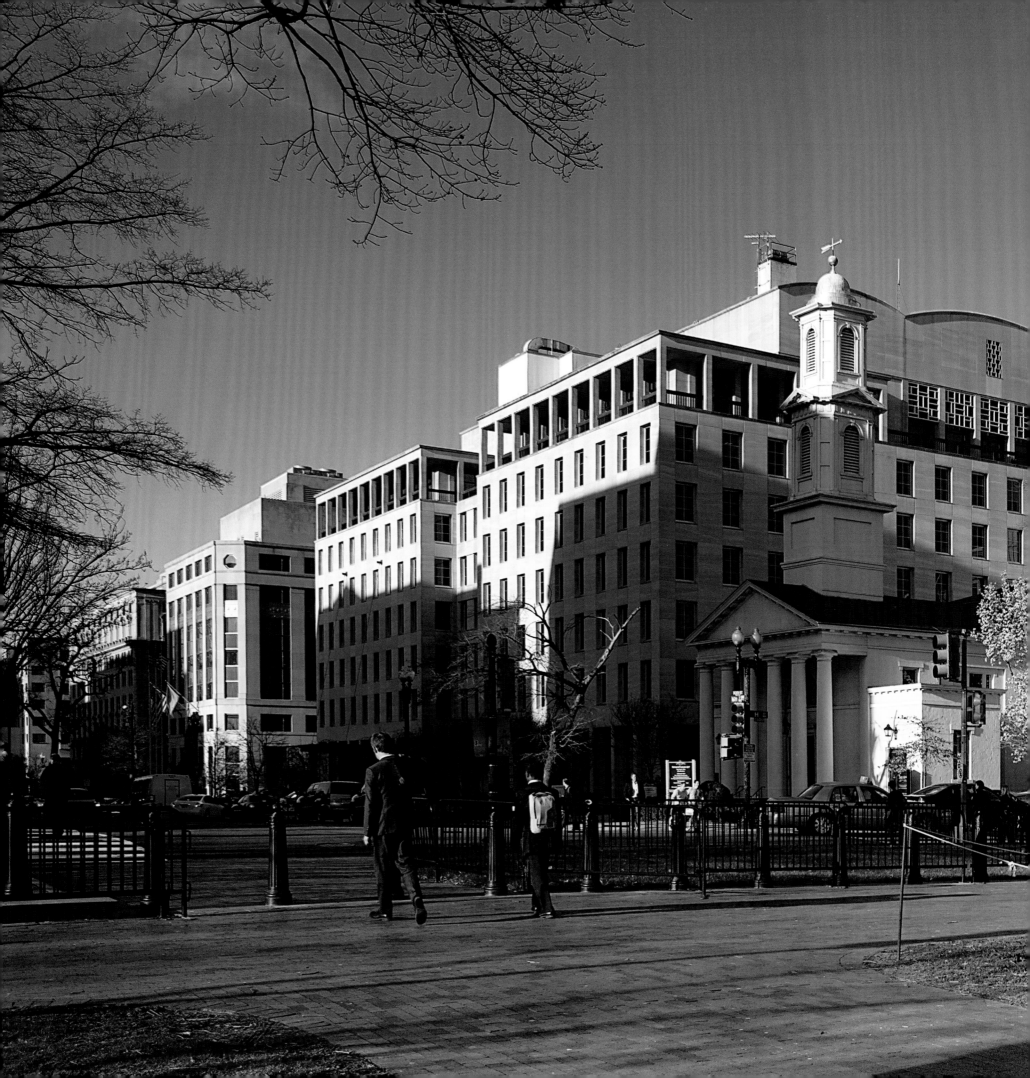

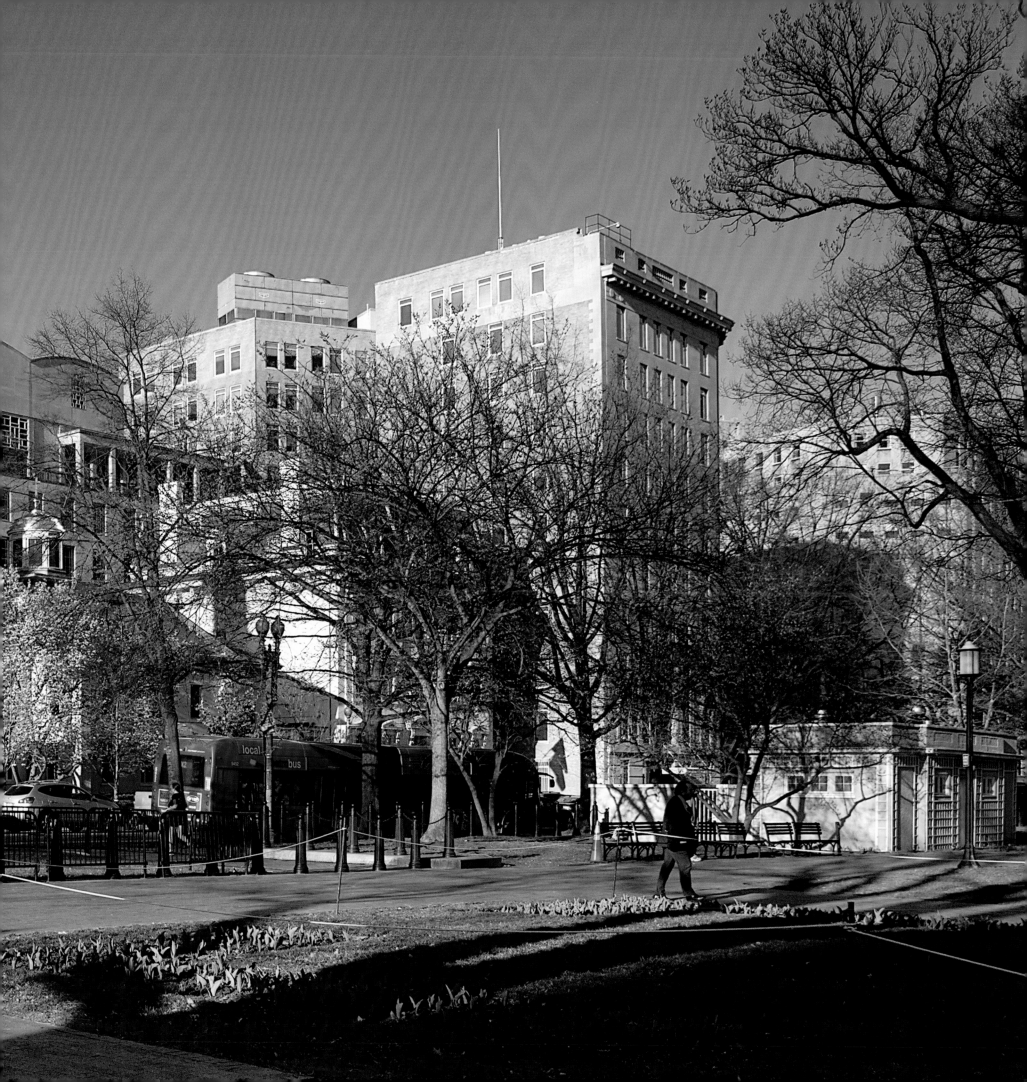

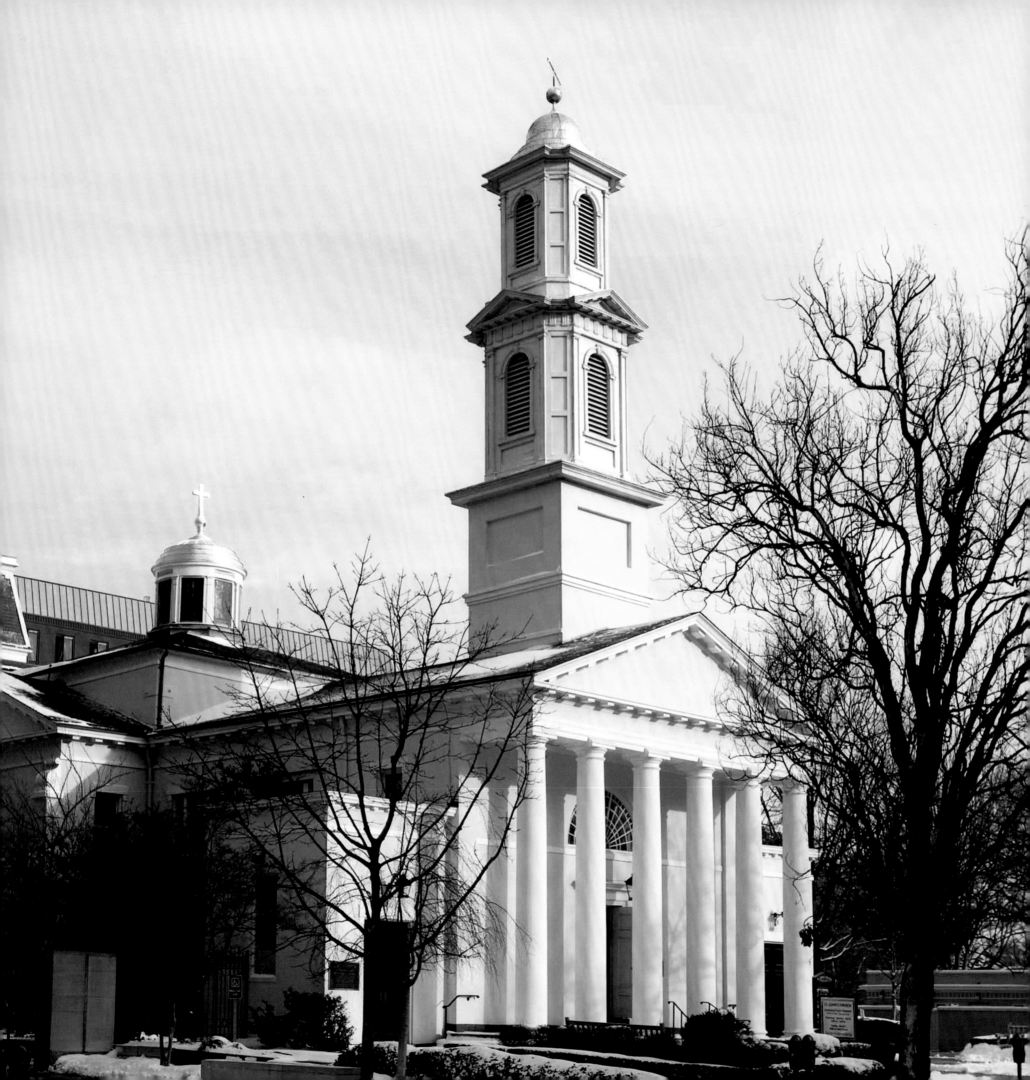

THE PROXIMITY OF ST. JOHN'S,
ITS HISTORIC ASSOCIATIONS,
WHICH HAVE GIVEN IT
THE NAME OF "THE CHURCH OF THE
PRESIDENTS," ARE ALL AMONG THE
CONSIDERATIONS WHICH MAKE ITS
VENERABLE FABRIC A FITTING PLACE FOR
THESE ANNUAL SERVICES.

PRESIDENT FRANKLIN D. ROOSEVELT

ONE TIME, I WENT TO CHURCH AND
SAW MY FRIEND SONNY MONTGOMERY.
I SAID, "SONNY, COME ON BACK AND WE'LL
HAVE SOME HAM AND EGGS FOR BREAKFAST."

PRESIDENT GEORGE H. W. BUSH

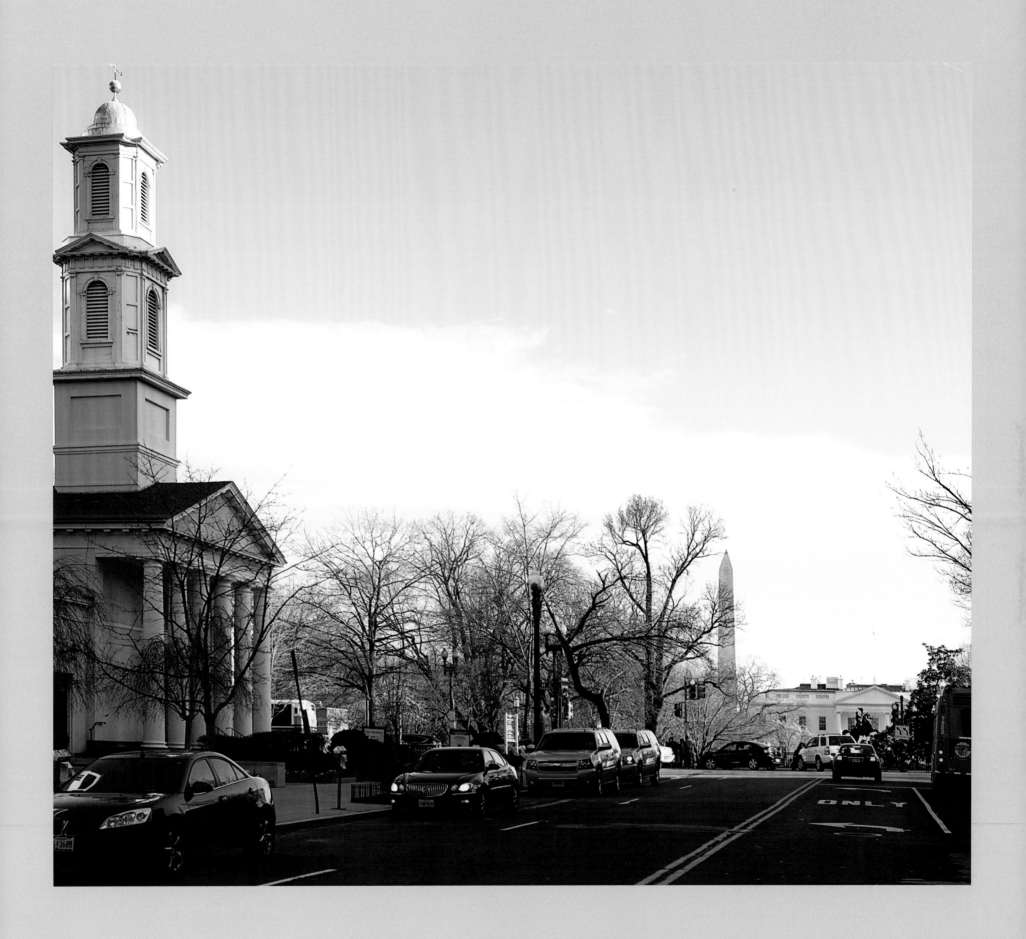

A HOUSE FIT FOR "IMPRESSIVE ENTERTAINMENTS"

There seems to have been another house standing on the square when St. John's was built. We know little of it, except that it was a burnt-out farmhouse, once of some importance, that had formerly been owned by the venerable Pearce family. The ruins of the house, the intact stables, slave quarters, and groves occupied land that ran the entire west side of Lafayette Square. The Pearce family sold it to the city commissioners to divide its lots, and it was purchased in its entirety from the city in 1817 by Commodore Stephen Decatur (in fact, Stephen Decatur Jr.). He commissioned from B. Henry Latrobe the first residence on Lafayette Square, and it still bears his name. The street Decatur House faces today is called Jackson Place, with H Street forming the corner.

Decatur was 38 and the nation's man of the hour. His sea exploits were many and legendary, from the capture of the HMS *Macedonian* in 1812, which thrilled an American public long angered by British interference with U.S. shipping. Before that, he had plunged with the U. S. Navy into the tangle of piracy and bribery centered in Tripoli. His success there attracted the admiration of British Lord Nelson, who called Decatur's rescue and burning of the captured American ship *Philadelphia* "the most bold and daring act of the age." Captain Decatur had waged hand-to-hand battle with pirates, rescued his men from death, and nearly always shown solid judgment in his strategies. Tall and handsome, rather Byronesque—if his portraits are accurate—Decatur held the respect and love of his men. In the American public's search for a hero for the years after George Washington, Decatur was at the top of the list. Almost certainly he eventually would have been elected president. But that honor would be awarded to Andrew Jackson, a decade after Decatur built his house and was gone from the scene.

Decatur was rich with spoils from his conquests at sea when he built his house, and had been advanced to the rank of commodore. His only known instruction to his architect Latrobe was to build him a house fit for "impressive entertainments." This Latrobe did, creating the big red-brick block that still stands today.

Decatur and his pretty wife Susan, toasts of Washington, moved fine furniture, silver, and porcelain to their house in 1818, and began to live there in princely style. He was stationed in Washington, an appointed naval commissioner with relatively little to do. Out of water, his impatience and sharp tongue led him into a duel with his former shipmate at sea, Commodore James Barron. Decatur was brought back from the dueling field in a carriage, mortally wounded, to die on March 22, 1820, age 41, in the room to the left of the front door. He did not want Susan to see him. Remaining in the hall outside his room, she sobbed, sunk to her knees, and banged on the door as he faded from life. He called his lawyer to bring his will and witnesses. Susan was to be his sole heir.

The young widow continued the pattern of living and entertaining that she had enjoyed with Decatur, but at last quit and moved to Georgetown. Not for some years did she sell Decatur House, but rented it to the come-and-go people of the city. Foreign ministers—the highest rank present in diplomacy as the United States had no ambassadors until 1893—politicians and elected officials hurried to rent her premises. Most of the property of the block she sold off as lots, leaving her house with its large corner lot and accompanying small side garden and service yard out back.

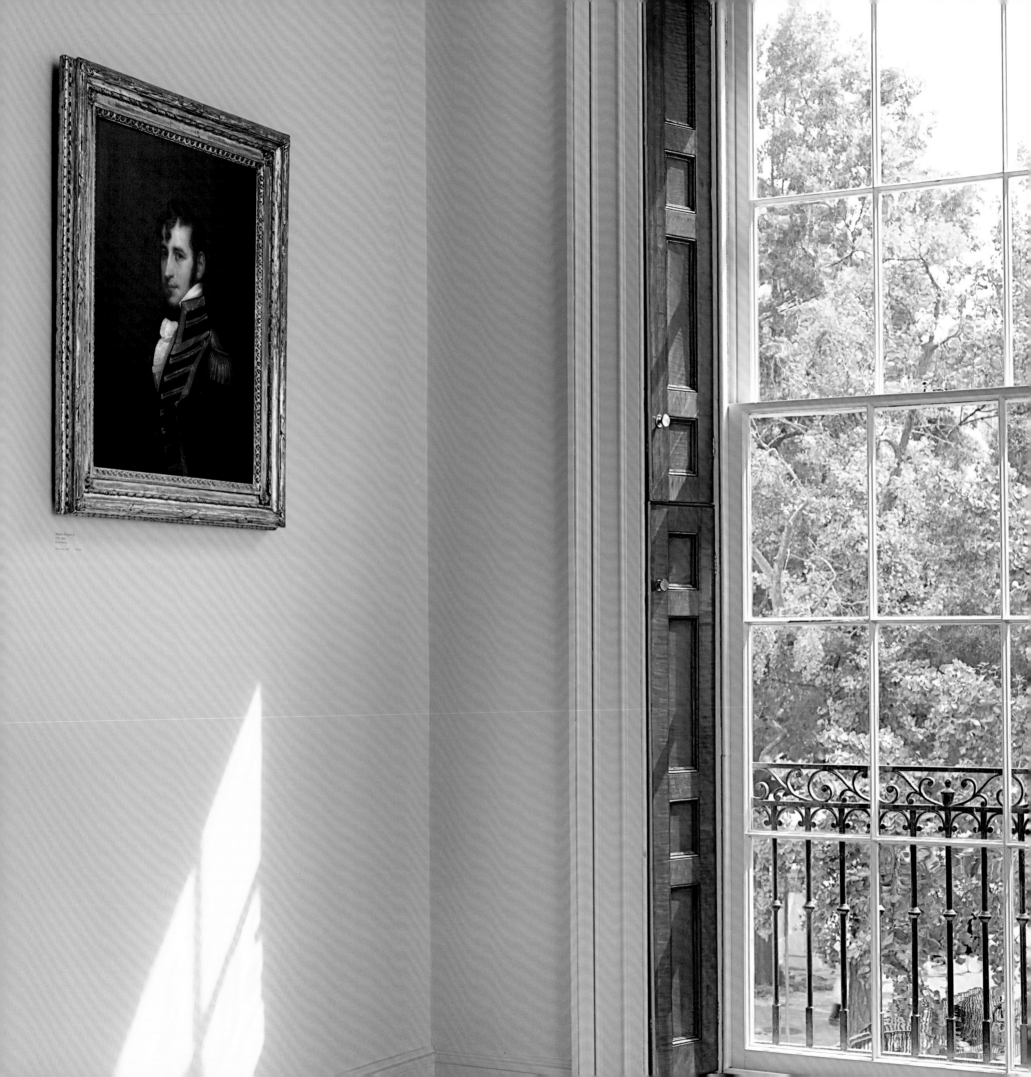

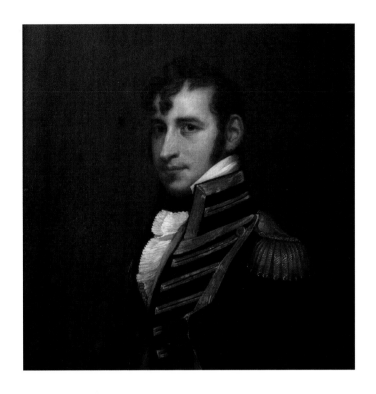

I transmit to Congress copies of a
letter to the Secretary of the Navy
from Captain Decatur, of the frigate
UNITED STATES, reporting his combat
and capture of the British frigate
MACEDONIAN. Too much praise
can not be bestowed on that officer
and his companions on board
for the consummate skill and
conspicuous valor by which this
trophy has been added to the
naval arms of the United States.

President James Madison
speaking about naval hero Stephen Decatur

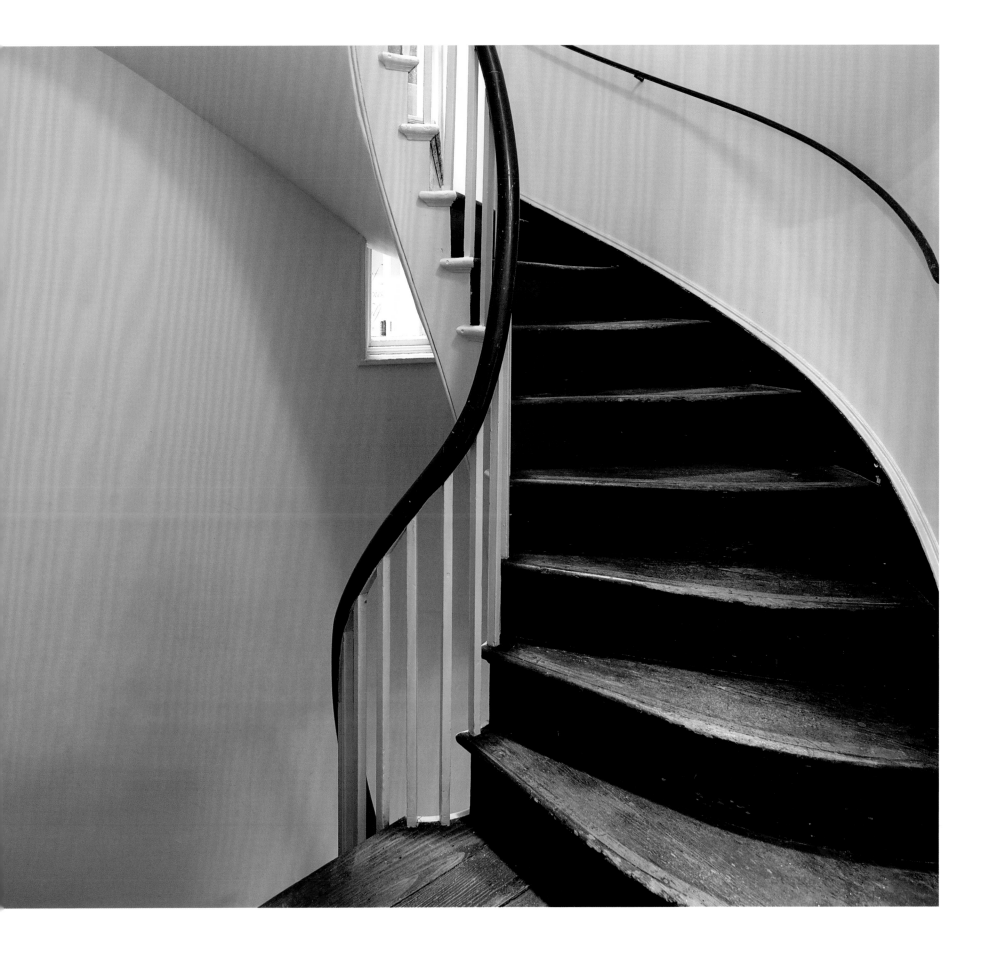

After the Civil War, the Decatur House was at last sold to General Edward Beale. A native of Washington, kin to the Pearce family that had once owned the Decatur House site, Beale was a navy man, adventurer, and entrepreneur. Called "Ned," he had been a young officer during the Mexican War, and in postwar times, disguised as a Mexican vaquero, he secretly carried samples of the new California gold discovery to Washington and spread them before President James K. Polk. The president made note of California gold in his State of the Union address and, with an almost electric response from the citizens, began the Gold Rush.

It happened that in 1848, when Ned Beale crossed Mexico in his nugget-bearing journey to the White House, he stopped off in Mexico City at the end of the American conquest there, met Ulysses S. Grant, then a quartermaster with General Winfield Scott's army. They developed a close friendship, so when Grant was elected president, Beale left his ranch and moved to Washington to enjoy the benefits of his friendship. Grant made him minister to Austria-Hungary. When Beale was at home in Washington, he and the president rode saddle or sulky nearly every day, racing fast on Pennsylvania Avenue to the Capitol and back. Then as today, when a presidential procession passes, one gets out of the way.

Addressed as General Beale, Ned Beale purchased Decatur House, which had accumulated further fame with distinguished rental occupants such as Vice President Martin Van Buren, Senator Judah P. Benjamin, and others. Like a good Victorian, Beale made alterations to the facade, using the sandstone called "Washington brownstone." Someone before him had added a long wing to the rear for kitchen and servants' quarters. Innovative houses like Latrobe's (and Frank Lloyd Wright's) are not for everyone, and Decatur House was remodeled early on with a backyard kitchen and workrooms replacing those Latrobe had put in the house. The house further received Ned's mark. He cov-

ered the ocher-painted floors of the two gala rooms upstairs with mahogany floor and had installed in the dining room floor a large parquet representation of the state seal of his beloved California; it remains today, precisely where he put it. He suspended giant glass chandeliers in his gala rooms, reflecting those put up in the East Room at the same time by President Grant.

Ned was often an overbearing parent who doted on his daughters Emily and Mary but was tough on his son Truxton. Grown up, Trux graduated from law school. He was bored in legal practice, so his father paved the way for his appointment as minister to Persia. Trux held other diplomatic posts and traveled extensively, especially in Asia. After the old general died in 1893, Trux, at 40, married the perfect wife, Harriet, daughter of James G. Blaine. Then suddenly, not long after the birth of their son, Trux filed for divorce and headed west. Adventures and misadventures were numerous, but Trux, recast in the cowboy mold, proved an excellent manager of the Tejon ranch. He married

Marie, a girl he met out there, but not before he shot a newspaper man for casting a shadow over her reputation. They sold the ranch in 1912 and moved back to Washington, stripping Decatur House of General Beale's Victorian improvements, "restoring" it. Both lived and died in Decatur House years later. Marie rose to being the premier of diplomatic socialites in Washington. Her lively open houses, held after the rather bland New Year's receptions at the White House, were talked about in every embassy in the world. In her will she bequeathed Decatur House, which she loved, to the nonprofit National Trust for Historic Preservation.

In 2010, the Trust yielded its stewardship to the White House Historical Association, which devoted the building to housing the David M. Rubenstein Center for White House History. Decatur House can be toured today, its vacant rooms and well-preserved architecture conveying in a curious way the melodramas of its past.

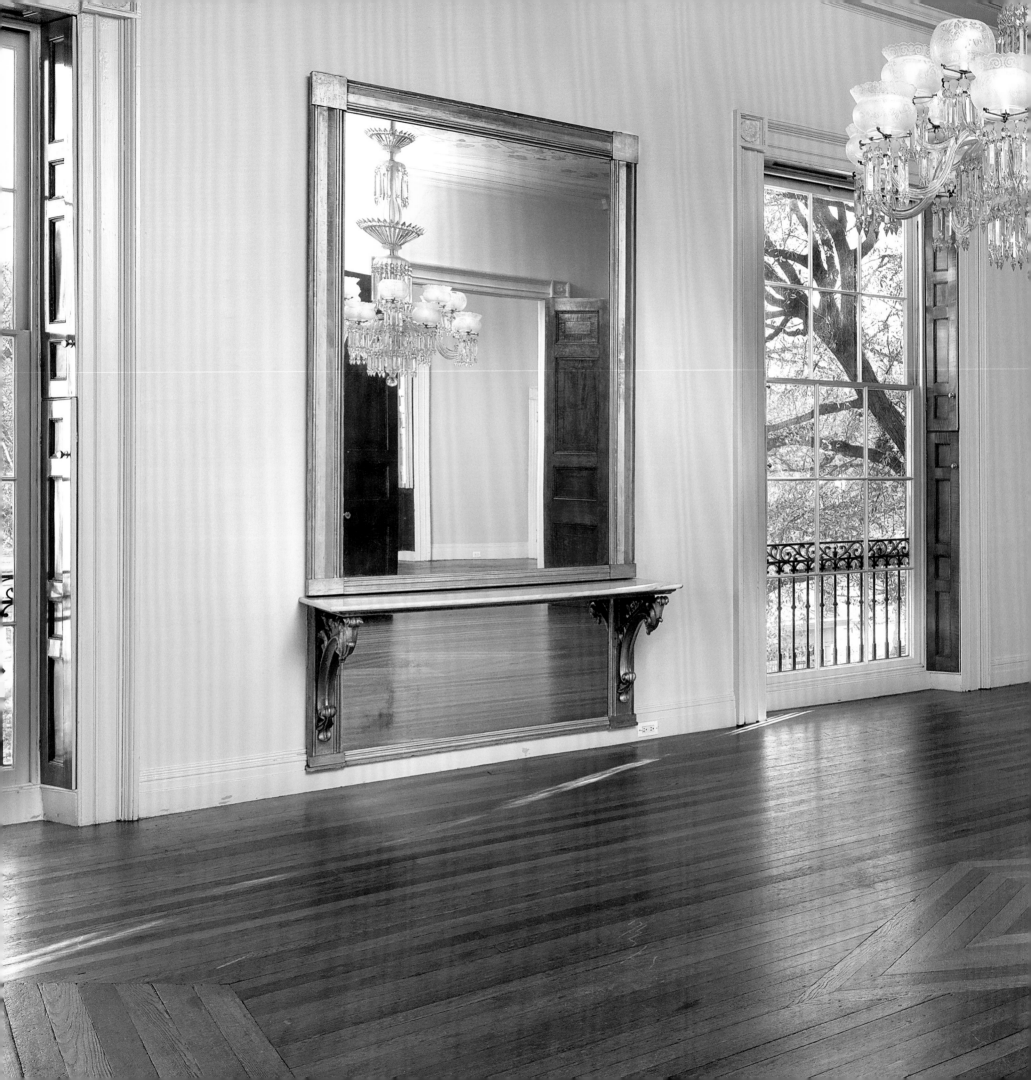

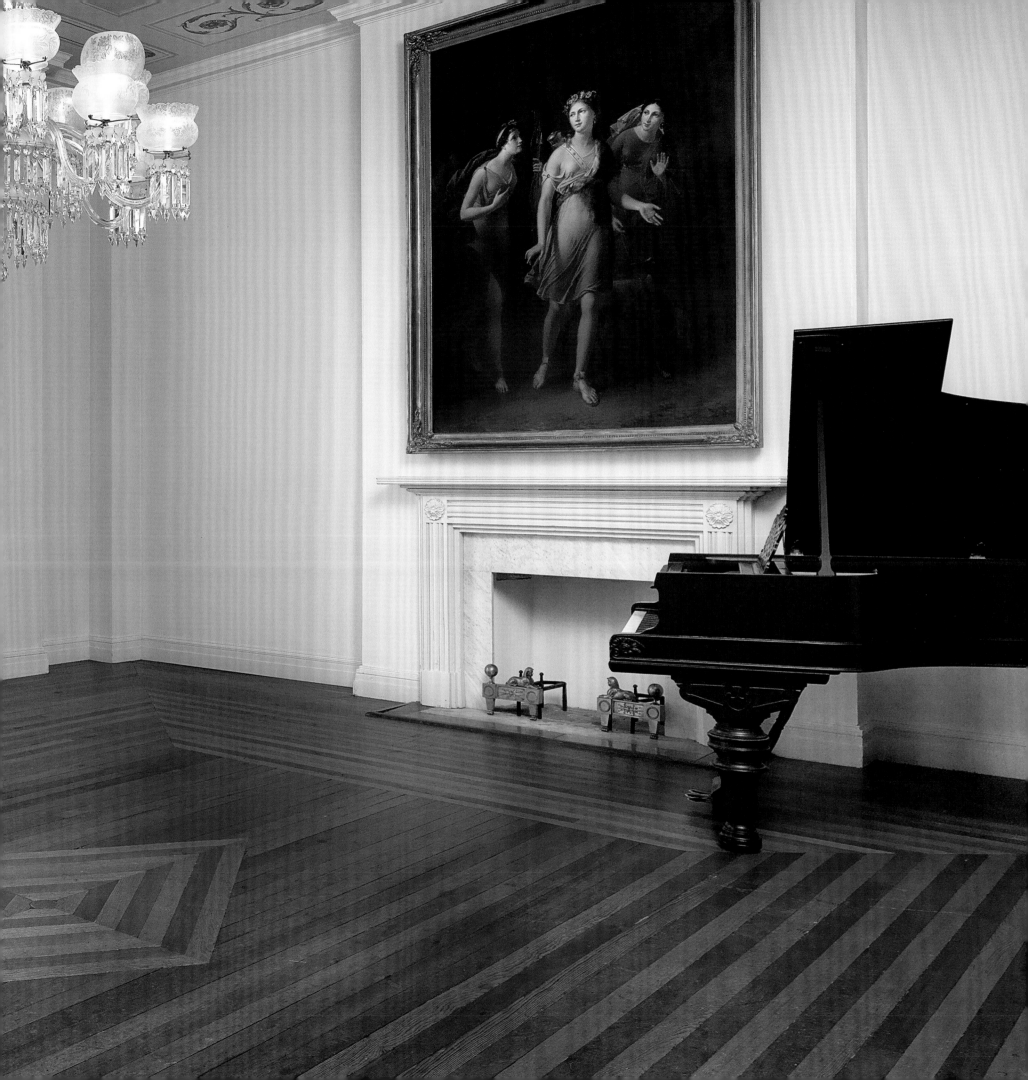

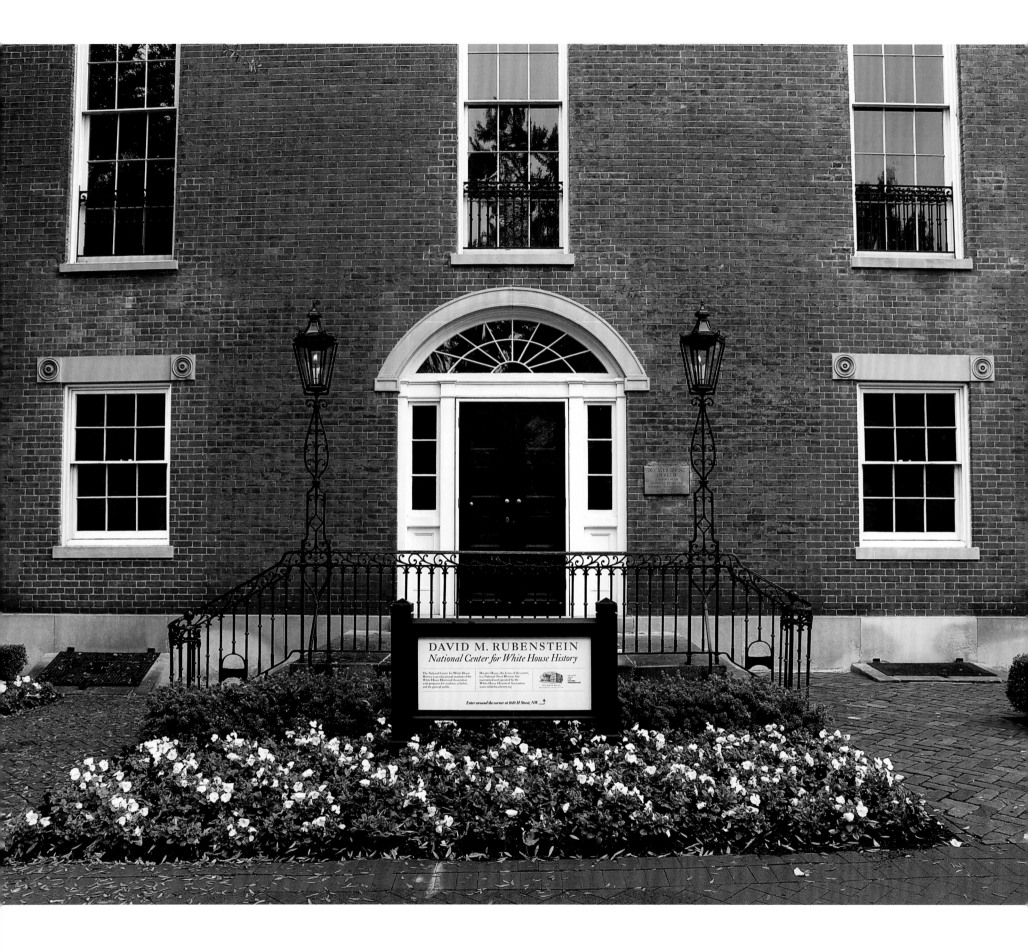

THE PRESERVATION OF HISTORIC SITES FOR
THE PUBLIC BENEFIT, TOGETHER WITH THEIR
PROPER INTERPRETATION, TENDS TO
ENHANCE THE RESPECT AND LOVE OF
THE CITIZEN FOR THE INSTITUTIONS
OF HIS COUNTRY, AS WELL AS STRENGTHEN
HIS RESOLUTION TO DEFEND UNSELFISHLY
THE HALLOWED TRADITIONS
AND HIGH IDEALS OF AMERICA.

PRESIDENT FRANKLIN D. ROOSEVELT

For nearly 200 years, as our country has grown and evolved, the Decatur House has grown and evolved right along with it. This house has hosted parties and social events with some of our nation's foremost leaders. . . . But from the back of the house, from a structure far less lavish, comes even more history. . . . I'm talking about the slaves who lived here at Decatur House . . . And so it is our responsibility as a nation to ensure that their stories are also told.

First Lady Michelle Obama

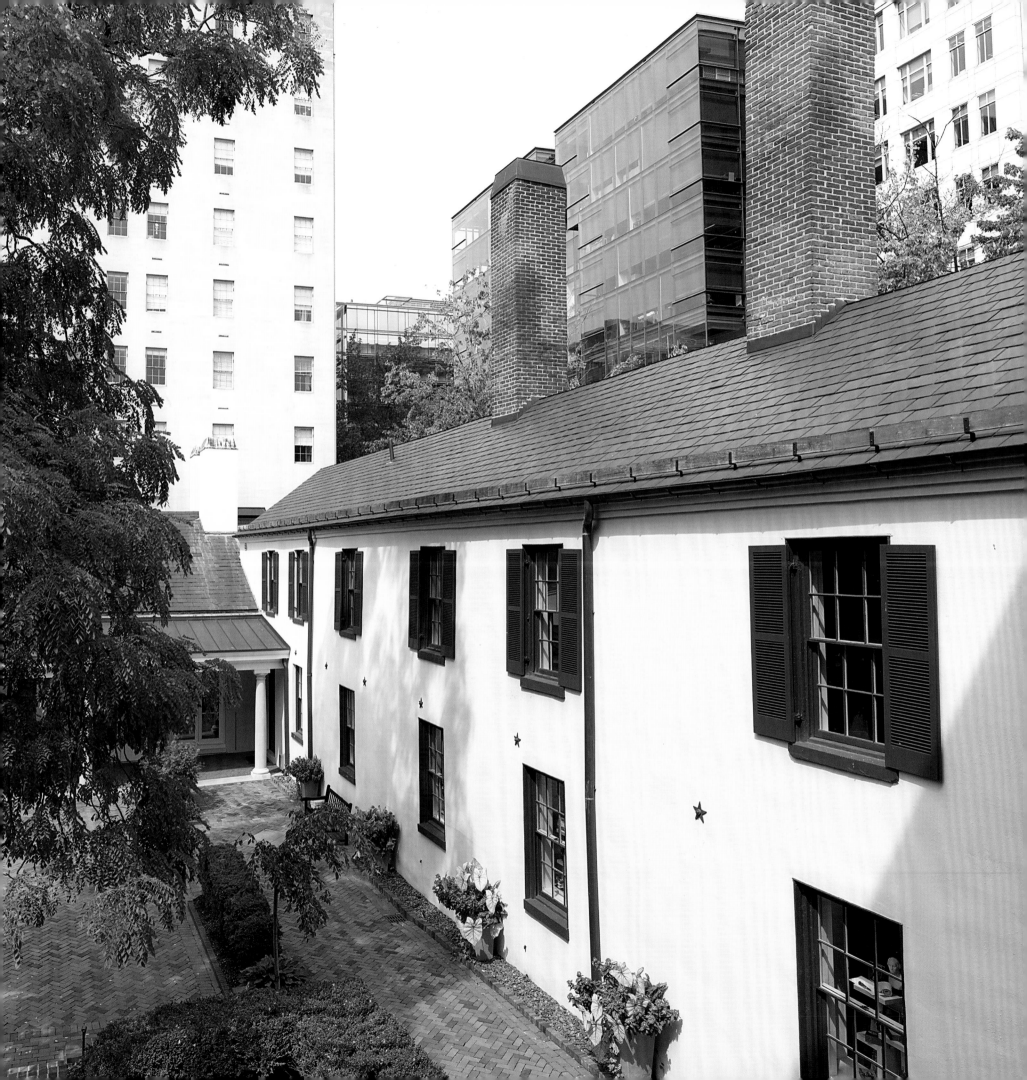

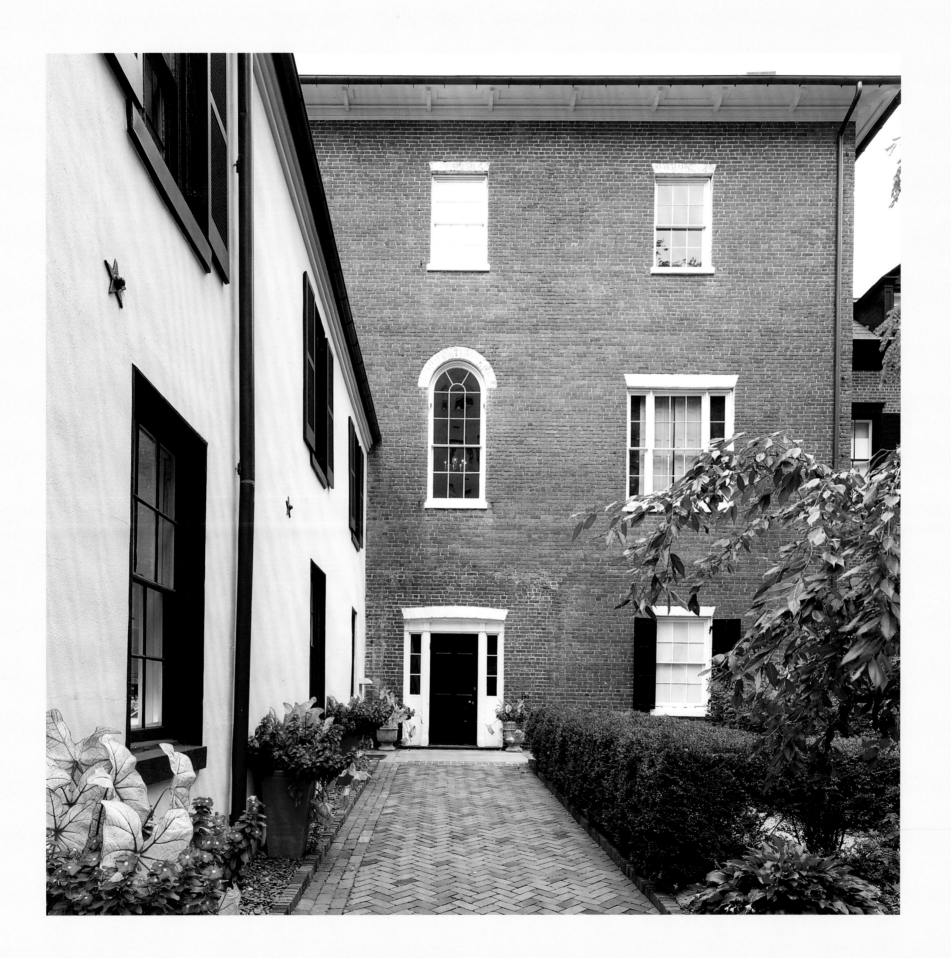

A TRADITIONAL WASHINGTON TOWN HOUSE OF THE BETTER SORT

Across Lafayette Square from Decatur House, on the corner of Madison Place and H Street, opposite St. John's, is the Dolley Madison House. It was once a traditional Washington town house of the better sort, built of brick, with long stairs up from the sidewalk to the front door. Years of use called for expansion and change; to cover the scars of additions, the walls were surfaced with smooth stucco, scored to resemble stone.

James Madison purchased the house from its builder, Richard Cutts, husband of Dolley Madison's sister Anna, and it remained in Mrs. Madison's estate for the rest of her life, rented out at first, but after 1845 it was her permanent home until her death there in 1849. Sold by her estate, it went through many owners, including Admiral Charles Wilkes, famed for his Pacific explorations, and General George McClellan, the Union commander. There were a few changes, such as the cast-iron grillwork on the park side and a handsome arched doorway around the side, toward St. John's.

Dolley Madison inherited the house from her husband in 1836. They had lived on their farm, Montpelier, in Orange County, Virginia, after his retirement in 1817. Madison was no farmer, although he espoused the agricultural ideal. His resources suffered from financial panics, and he died before the economic avalanche that came the year after his death. Dolley Madison was, nevertheless, left well fixed but came to rely upon her son by her first marriage, Payne Todd, a profligate young man who had some good qualities alas snuffed out by an addiction to gambling. He got into bad trouble with his losses, could not pay, was threatened with bodily harm, as the tradition goes, and ran to his mother for help. She could not refuse him. At last, as her life began to wind down, she returned to Washington in 1845 to the one remaining Madison property not entailed, the house on Lafayette Square. Here she lived out her last four years and from here, on her death, she was borne across the street to St. John's Church to lie in state before her funeral.

In his last years, Madison had seen dark financial clouds ahead

for the nation. He turned to his own papers and archives, which he had kept carefully over the years, as the way out of looming difficulties. He and Dolley spent many months organizing these documents, including the journals he had kept during the Constitutional Convention. Making such notes had been prohibited by the convention, but he broke the rules, and the statements and debates he set down in his journals, which everyone seemed to know about, interested lawmakers and statesmen for years. After his death the papers, filed in two large trunks, never left the Widow Madison's side. One night the house on Lafayette Square caught fire in the attic. All Dolley Madison could think about were those trunks. She herself struggled to carry them out and soon was helped by neighbors. The fire was put out, the papers saved, but the urgency the close call created for the preservation of the papers was acute. Henry Clay and Daniel Webster stepped forward and sent a bill through Congress to offer Mrs. Madison $25,000 for the lot. She accepted. It took Payne Todd little time to feast upon her prize, and Dolley

Madison was at last no better off. It might be added that the amount thus paid by Congress—nearly always generous in historical matters—was equal to the annual salary of the president of the United States.

Near to the Madison House was the Tayloe House, a home built by John Tayloe's son, Benjamin Ogle Tayloe, who lived there for all his adult life. A fine home with a remarkable collection of furniture from the estates of famous people, it was the center of Washington society for more than half a century. In 1886 the Madison and Tayloe Houses were acquired by the Cosmos Club, a private literary organization. In 1952, under pressure from the federal government, which had plans to redevelop the block, the Cosmos Club moved into the Townsend Mansion at 2121 Massachusetts Avenue, where it remains today. The United States Court of Claims then moved in. The court's need for more space in 1963 led to the building of the red-brick ten-story office annex inside the block behind the houses.

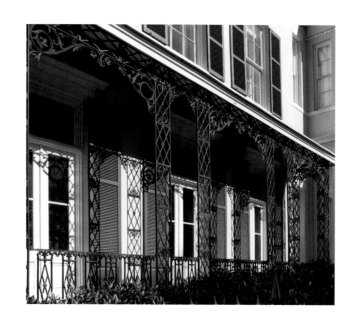

I HAVE ONLY TO SAY THAT MY HOUSE
& LOTS HERE ARE THE ONLY PROPERTY REAL, WHICH I
POSSESS IN THE CITY AND THEY ARE ENCUMBERED
TO THE AMOUNT OF 3000$.

FIRST LADY DOLLEY PAYNE MADISON

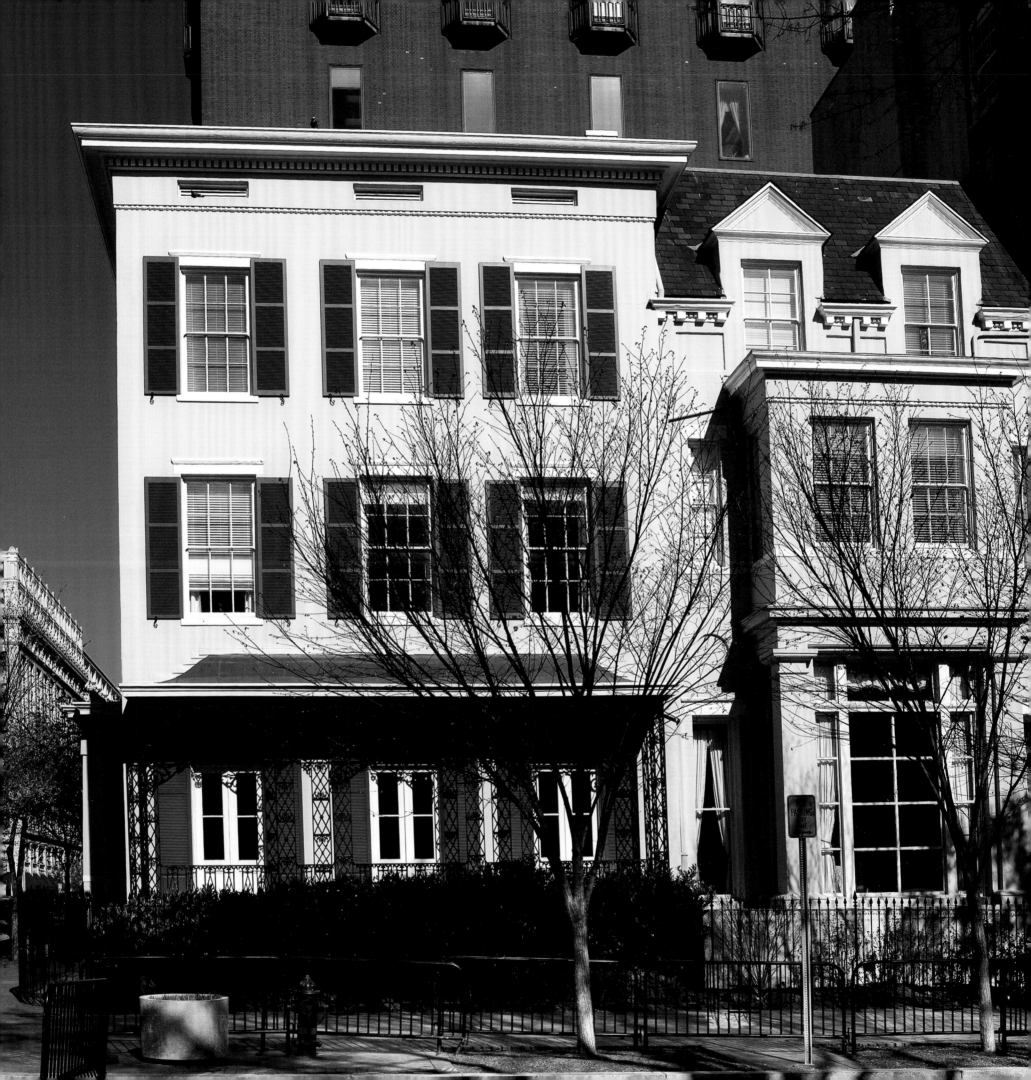

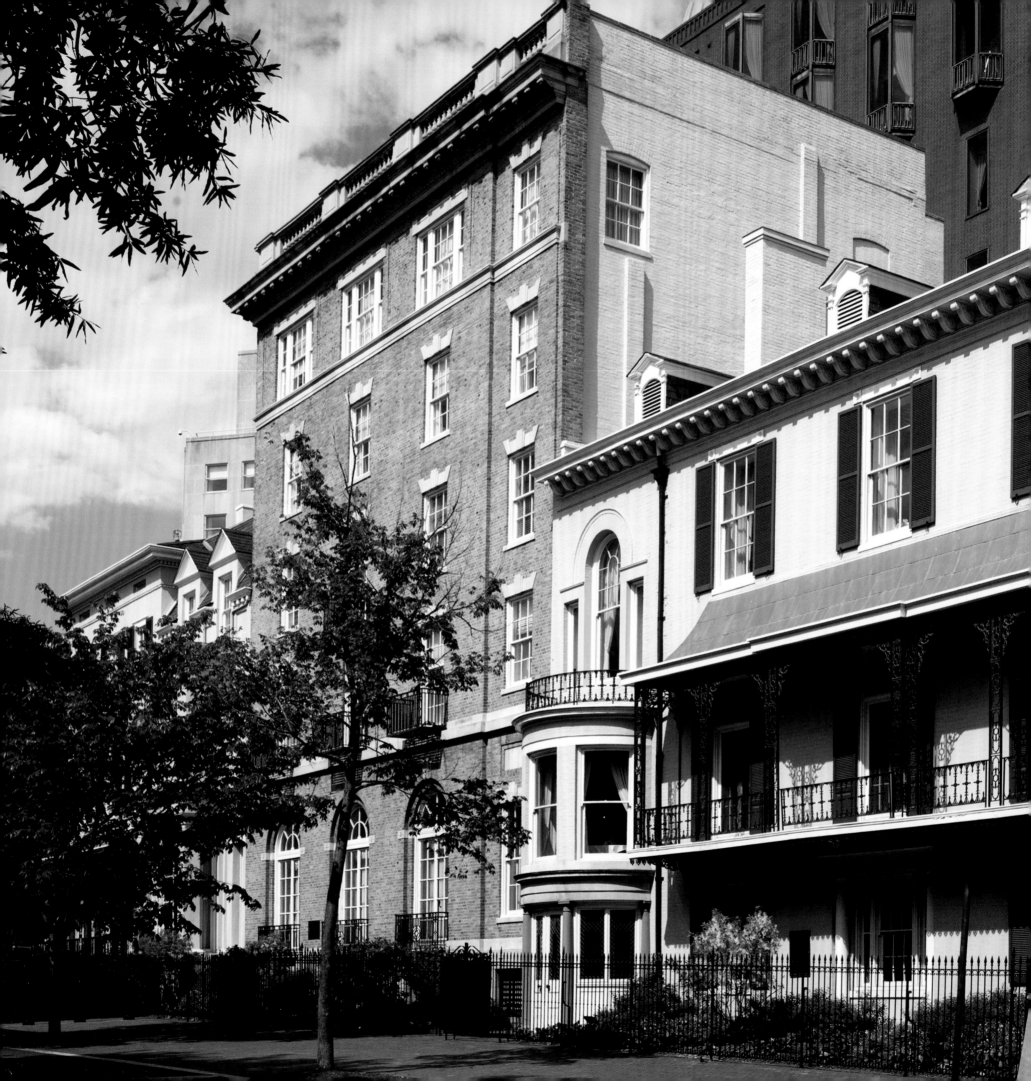

Hold your breath . . .
the Dolley Madison and
Tayloe houses will be saved!!!

First Lady Jacqueline Bouvier Kennedy

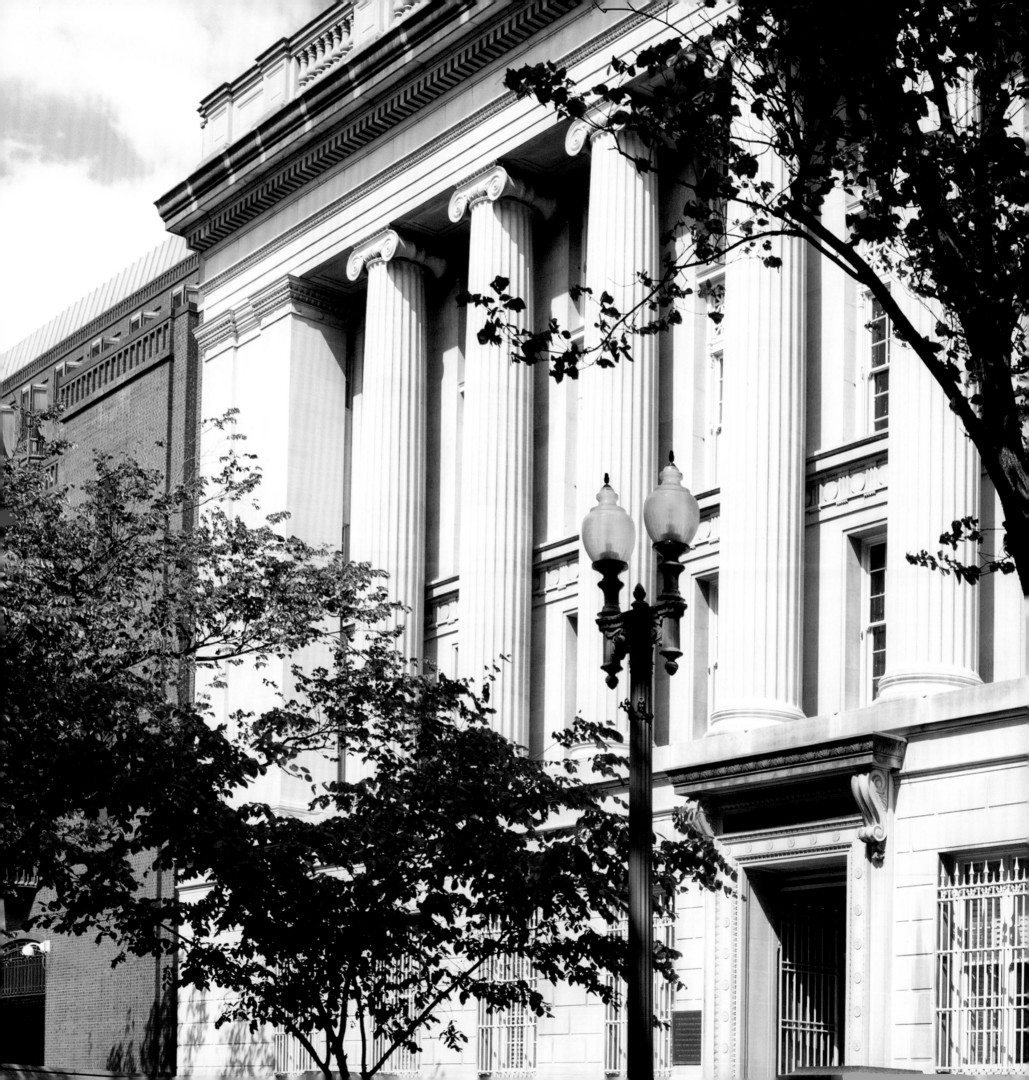

TIME TO MAKE WASHINGTON LOOK LIKE A WORLD CAPITAL

Within Lafayette Park itself stands a pair of urns, cast in bronze, that were made for the park to the specifications of the capital's first art patron, W. W. Corcoran. They are patterned on the famous Medici Vase Corcoran had known at the Uffizi Palace when in Florence on visits to the sculptors' studios, including that of Hiram Powers. The original is marble. Corcoran and friends wished to demonstrate the skill of Washington's Navy Foundry, among the finest in the world thanks to its development during the Civil War, and opted for bronze. The two urns were formed in clay from drawings, perhaps supplied by Powers or someone known to him, cast, and set up on high pedestals in the park. Smaller than the original, which is 5 feet tall, the height is achieved by the pedestals. Seldom noticed, the urns reflect a time in America when not only technology but also fine arts were becoming important. The bronze urns were a marriage of both.

As the nineteenth century neared its end, the park began to receive in succession, four magnificent sculpture groups, all established at the four corners of the park by the outbreak of World War I. They are part of an interesting change of attitude toward the capital city that began not so long after the Civil War and by the close of the century was full blown. The United States became a participating international power with the Spanish-American War, 1898, and it was clearly time to make Washington look like a world capital.

The subjects were four indispensable foreign officers who gave service in the American Revolution. All were European, celebrating their own countries as much as their personal contributions. The first was erected on the southeast corner of Lafayette Park, a tribute to Major General, the Marquis de Lafayette, the rich French noble who came to fight in the Revolution at his own expense, outfitting a ship and men. Unveiled in 1891 before great crowds of spectators, including several hundred Frenchmen and French officials, the sculptors were Jean Alexandre Falguière and Marius Antonin Mercié of Paris. President

Benjamin Harrison had hoped the statue would be presented two years before as a feature of his elaborate celebration of the 100th year of the Constitution. For art, he had to wait. It follows a pattern the other three were to honor, showing the principal figure, set up on a high granite pedestal, with secondary groups, here Comte de Grasse and Comte d'Estaing, both naval commanders who crossed the sea with the French forces. All four of the statuary groups feature these groups around the central column of the base, and all depict major associates of the main figure. This group seems also to have set the standard of detail for the other statues. Like much of the art of the day, re-creating the spirit of the past, the detail in the bronzes is fastidious, with coats, cravats, cloaks, firearms, boots, and swords rendered accurately from museum originals.

On the southwest corner, unveiled in 1902, stands the bronze statue of Lieutenant General Comte de Rochambeau, a French noble sent at the behest of Louis XVI to fight for the Americans in the Revolution. The sculptor was J. J. Fernand Hamar, who replicated the memorial near Rochambeau's chateau at Vendôme, France. On the northwest corner, directly across from Decatur House, Major General Wilhelm von Steuben's statue by Albert Jaegers, unveiled in 1910, represents the Prussian officer who joined the French at Valley Forge. Allegorical figures also in bronze surround the base, symbolizing his courage and ability as a military teacher. Throughout the United States, Von Steuben's representation in statuary and commemoration is second only to that of Washington.

Across from the Dolley Madison House, on the northeast corner, is the bronze of Brigadier General Tadeusz Kosciuszko, Polish-born and French-trained engineer. Kosciuszko captivated his men with his performance as commanding officer, and they idolized him. The statue, by Antoni Popiel, was unveiled in 1910. Secondary figures along the central base are allegories of the general's bravery and humanity in battle.

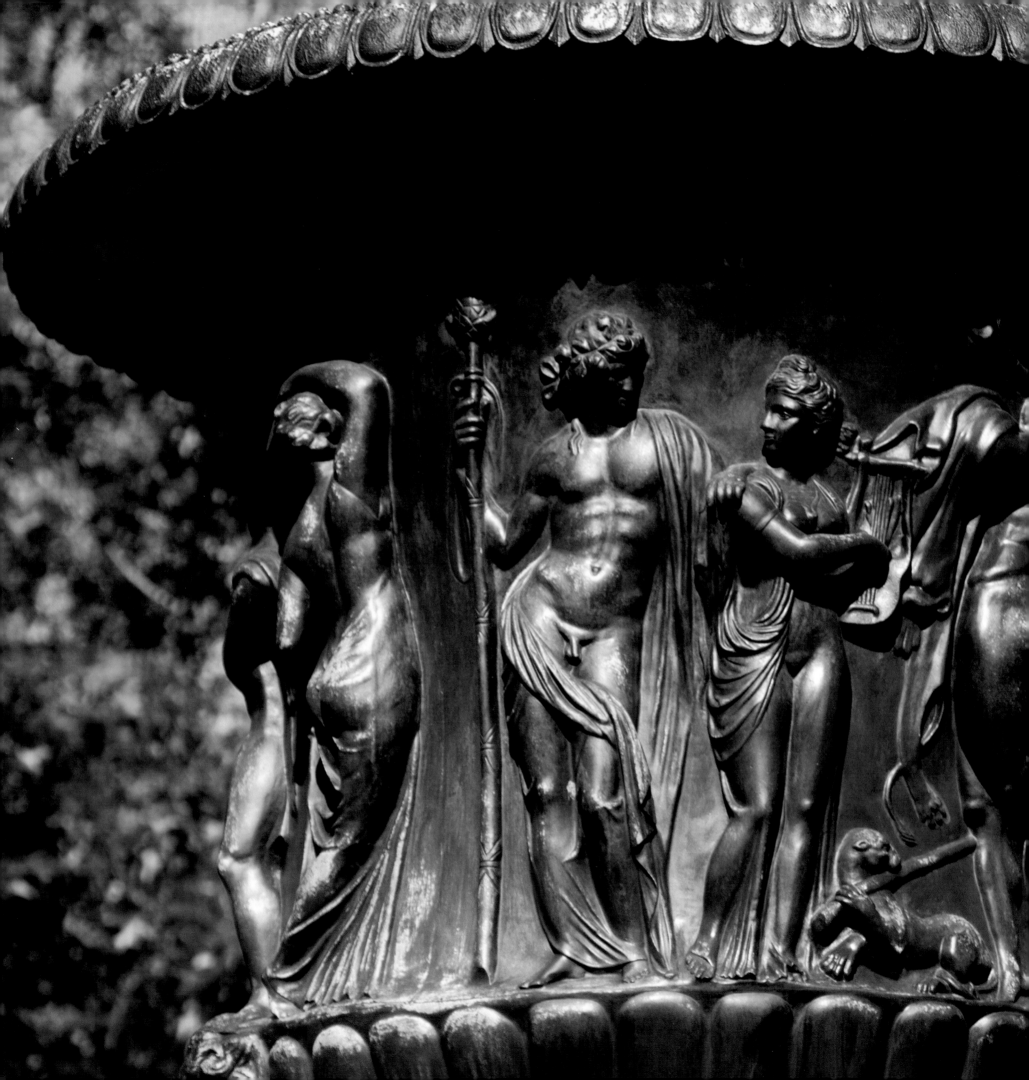

THE HUMAN NEED TO CREATE AND
ENJOY ART IS AS PROFOUND AS THE
URGE TO SPEAK. IN FACT, IT'S
THROUGH OUR ART THAT WE BEST
UNDERSTAND OURSELVES AND CAN
BE UNDERSTOOD BY THOSE WHO
COME AFTER US.

PRESIDENT RONALD REAGAN

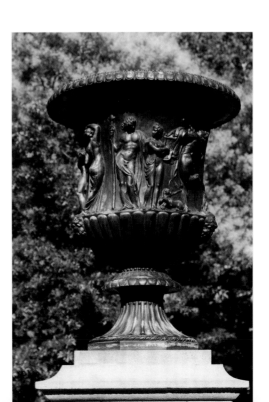

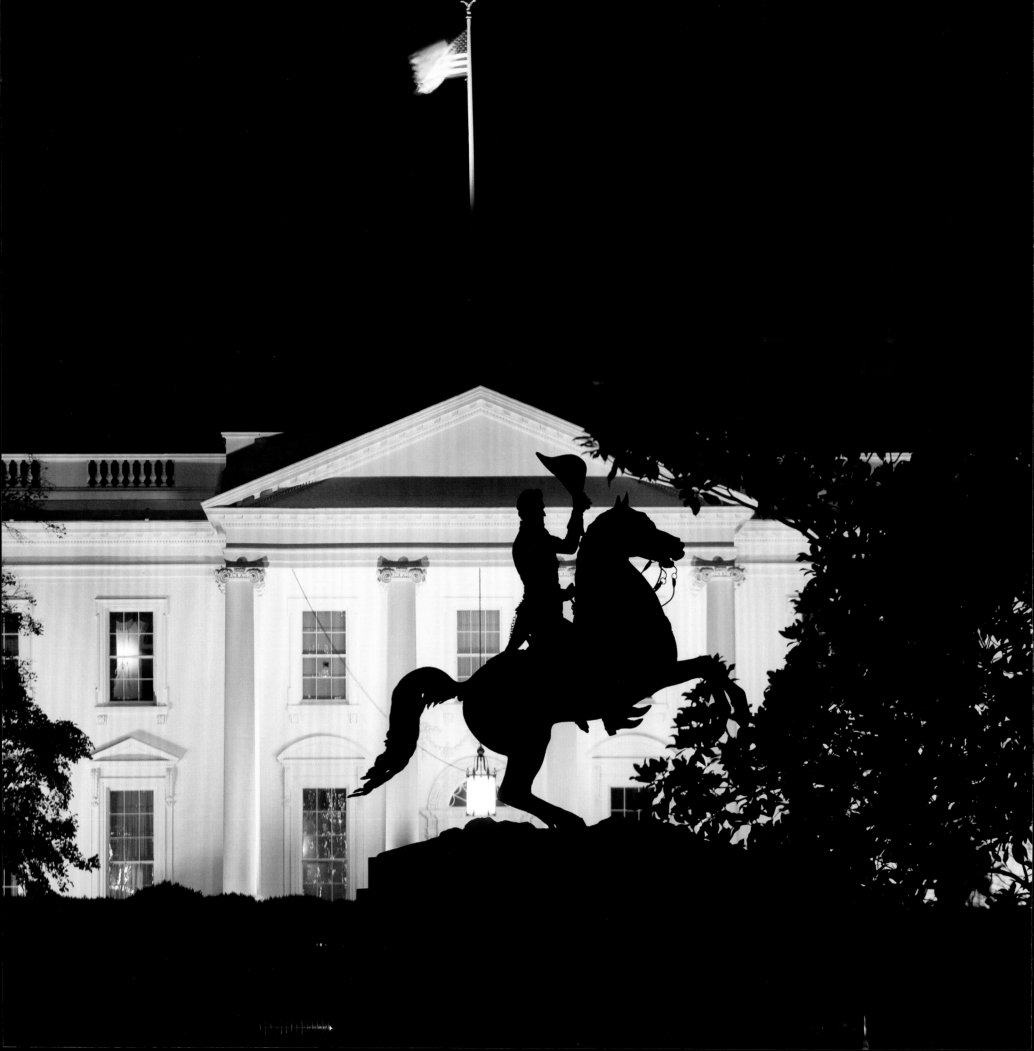

The night is falling and the spirit of other days, too, broods over the scene. Andrew Jackson looks down upon us from his prancing steed: . . .

. . . AND THE FOUR CORNERS OF THE SQUARE
. . . ARE GUARDED BY THE FIGURES OF
INTREPID LEADERS IN THE REVOLUTIONARY
WAR—VON STEUBEN, THE GERMAN;
KOSCIUSZKO, THE POLE; AND
LAFAYETTE AND ROCHAMBEAU FROM THE
SHORES OF FRANCE. . . . OUR GUARDIANS
OUT OF THE PAST AND FROM FAR SHORES
ARE, I SUPPOSE, AS DIVERSE IN BLOOD
AND ORIGIN AS ARE THE UNCOUNTED
MILLIONS THROUGHOUT THE LAND TO
WHOM THESE WORDS GO OUT TONIGHT.

PRESIDENT FRANKLIN D. ROOSEVELT
CHRISTMAS GREETING TO THE NATION

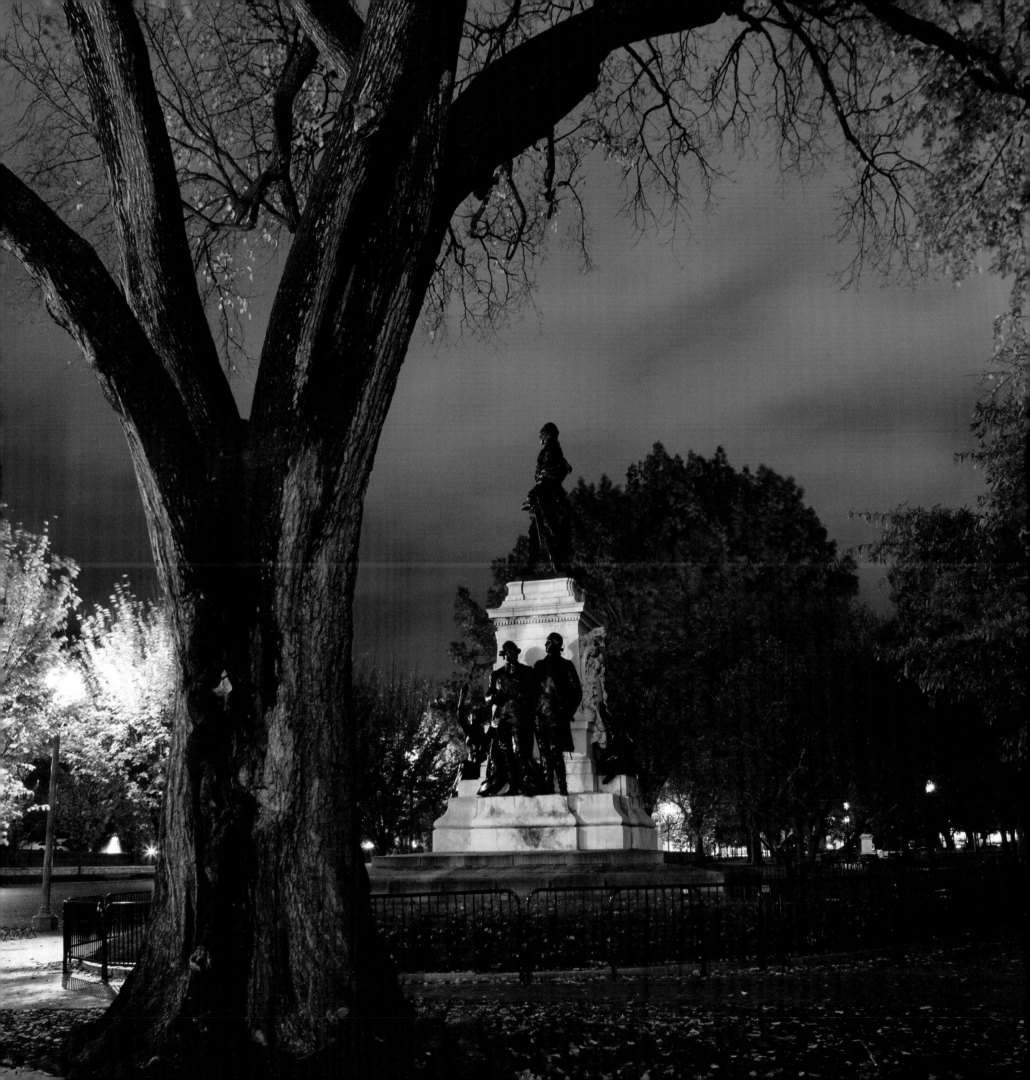

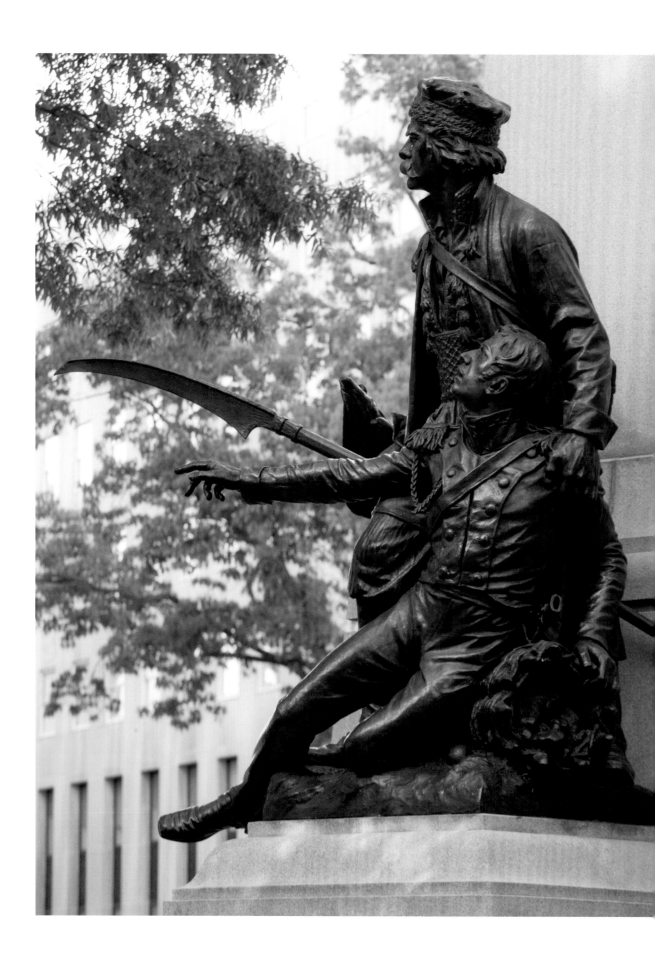

HERE MAY THE YOUTH OF
THIS EXTENSIVE COUNTRY
FOREVER LOOK UP WITHOUT
DISAPPOINTMENT, NOT
ONLY TO THE MONUMENTS
AND MEMORIALS OF THE
DEAD, BUT TO THE EXAMPLES
OF THE LIVING.

PRESIDENT JOHN ADAMS

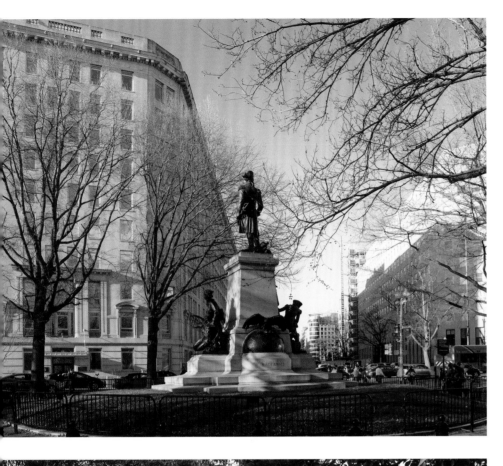

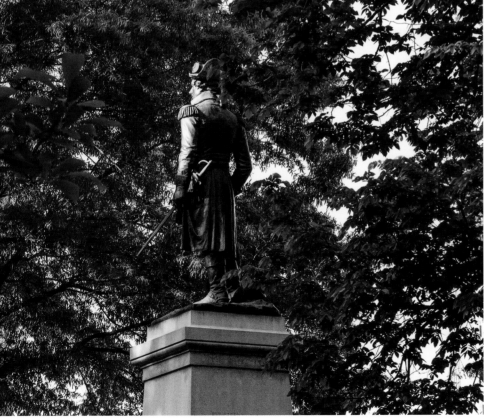

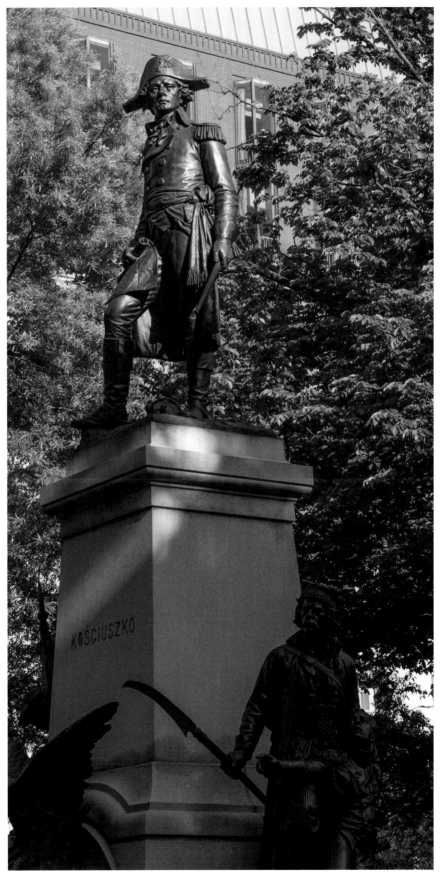

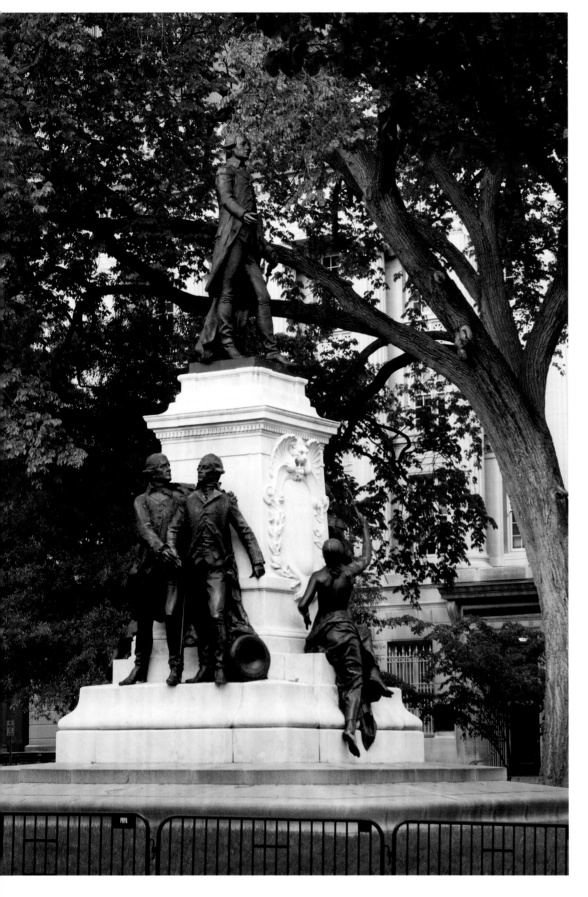

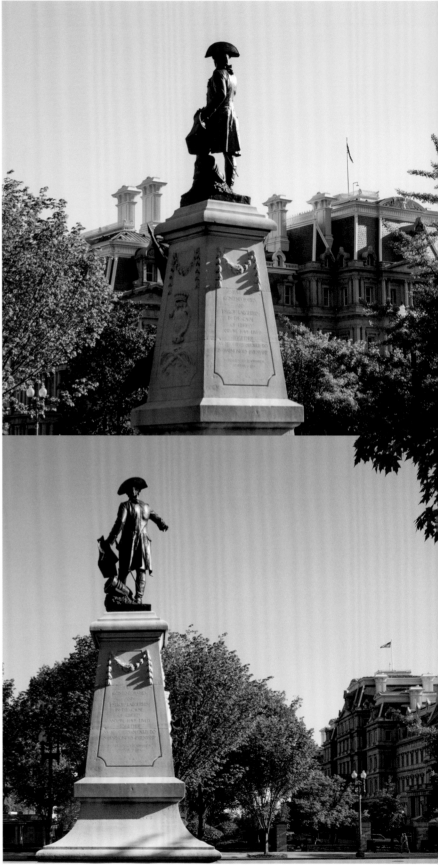

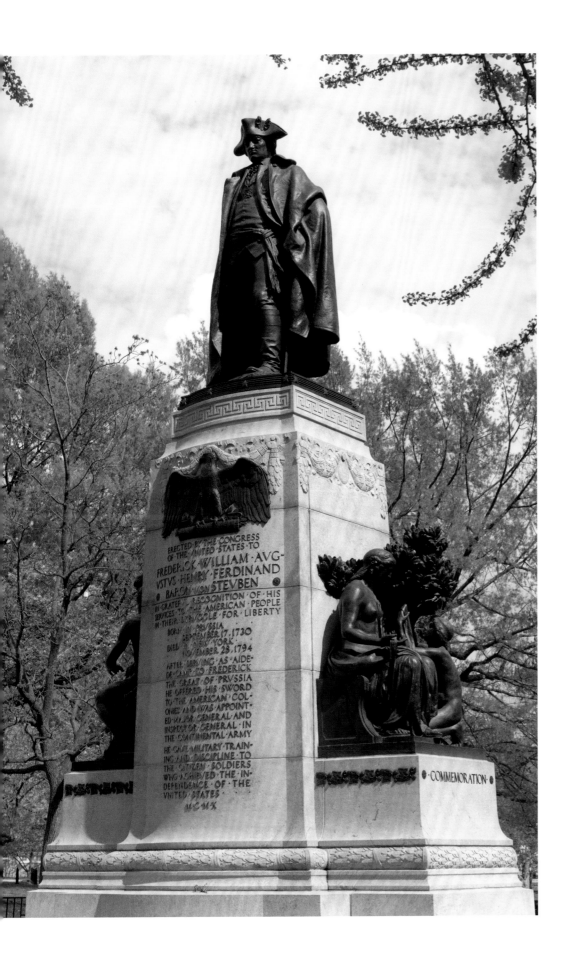

We never call a man "noble" who serves only himself; and if you will look about through all the nations of the world upon the statues that men have erected—upon the inscribed tablets where they have wished to keep alive the memory of the citizens whom they desire most to honor—you will find that almost without exception they have erected the statue to those who had a splendid surplus of energy and devotion to spend upon their fellow-men. Nobility exists in America without patent.

President Woodrow Wilson

TO SUIT THE COMFORTS AND NEEDS OF FOREIGN GUESTS OF STATE

Francis Preston Blair's house still stands. He had been, in modern terminology, Andrew Jackson's publicist and was largely responsible for the Jackson statue in the park. His son Montgomery was in Lincoln's cabinet. They were a rip-roaring, if very private family who lived here and on their Maryland farm Silver Spring.

The house, built in 1824 and acquired by Preston Blair in 1837, met none of the misfortunes of the other survivors in the White House neighborhood, but came down to one last family member, sentimentalist Gist Blair, and his shrewd nephew Percy Blair, who politicked its survival through President Franklin D. Roosevelt's well-known love for old houses.

In 1942 it became a sort of White House overflow, a house for special guests of the president. Preserved under the auspices of the Department of State, Protocol Office, it serves its dual purpose, to be beautiful and to provide whatever it takes to suit the comforts and needs of important foreign guests of state. It is the only building that could be called "residential" still serving that purpose in the White House neighborhood.

Over time Blair House, still containing its furnishings and memorabilia, has been expanded to incorporate the Lee House on its right and, to the left a large, Victorian House, which occupies the corner of the block, diagonally facing the White House. It is an original house, as is the 1850s house adjacent, facing the square, also now a part of the complex.

Blair House, from its location, has witnessed the passage of American history from President John Quincy Adams's administration to the present. A random sampling of great Americans

who have known it well, in addition to the distinguished Blairs, are Generals Sherman, Grant, Scott, Frémont, Robert E. Lee, and George C. Marshall; Presidents Jackson, Van Buren, Harrison, Tyler, Taylor, Lincoln, Theodore and Franklin Roosevelt, Truman (who actually lived there nearly four years), Eisenhower, Kennedy, and Clinton. The traditions of Blair House continue, thanks to basic government maintenance and generous private funding.

The remainder of houses on both sides of the square date from the 1970s and 1980s, reproductions from old photographs of what was there before government buildings and private institutions took over. The tales make a rich, sometimes scandalous tapestry. It was on this side of the square that the most notorious crime of passion in 1850s Washington took place. New York Congressman Dan Sickles got wind of an affair his young wife Teresa was having in an empty nearby house with randy Philip Barton Key, son of Francis Scott Key, author of "The Star Spangled Banner." Enraged, Sickles shot and killed Key on the sidewalk. Tried for murder, he was acquitted and went on to become General Sickles of the Union Army, lost his right leg in the Battle of Gettysburg, and became American minister to Spain, where his affair with the queen was no secret.

I SHOULD SO SOON HAVE TO PLEAD WITH YOU ABOUT
THE PRESERVATION OF MY OWN HOME, THE "BLAIR HOUSE."

GIST BLAIR
WRITING TO PRESIDENT FRANKLIN D. ROOSEVELT

I RECOMMEND THAT FUNDS BE SOUGHT FOR THIS ACQUISITION SO
THE BLAIR HOUSE MAY BE PRESERVED AS A HISTORICAL AND
CULTURAL LANDMARK IN THE NATIONAL CAPITAL. . . .
BLAIR HOUSE IS ONE OF THE FEW SURVIVING HISTORIC HOUSES
IN THE CITY HAVING A DISTINGUISHED ASSOCIATION OF MORE
THAN A CENTURY WITH THE POLITICAL AND
SOCIAL LIFE OF THE NATIONAL CAPITAL.

U.S. SECRETARY OF THE INTERIOR HAROLD L. ICKES

I AM, THEREFORE, INCLINED TO APPROVE
THE PURCHASE OF THE BLAIR HOUSE.

PRESIDENT FRANKLIN D. ROOSEVELT

THANK YOU FOR YOUR
KINDNESS AND HOSPITALITY
TO OUR FRIENDS AND
FAMILY. WE WILL BE
FOREVER GRATEFUL.

FIRST LADY MICHELLE OBAMA

YOUR HOSPITALITY IS
IN THE STYLE OF ABRAHAM,
WHO WAS THE GREATEST
HOST IN HISTORY.

SHIMON PERES
PRIME MINISTER OF ISRAEL

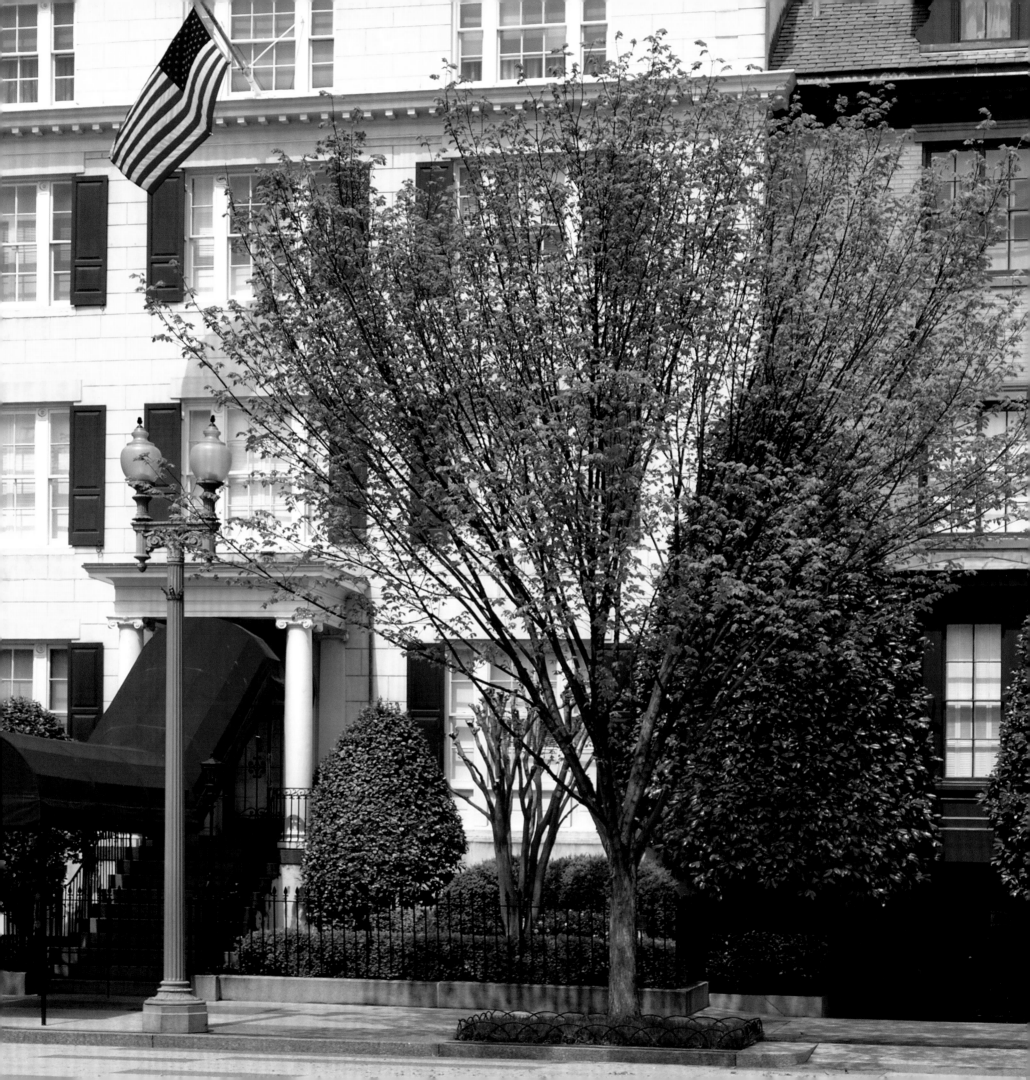

BEAUX-ARTS MANIA AT CONNECTICUT AND H

The elegantly colonnaded U. S. Chamber of Commerce Building, designed by Cass Gilbert, is a later representation of the Beaux-Arts mania that first captivated Americans in the Chicago World's Fair of 1893. It stands today as one of three built parts of an unrealized scheme for rebuilding all of Lafayette Square in the Beaux-Arts neoclassical mode.

To complete reference to this spot at the north end of the square is to mention three houses that no longer stand, the W. W. Corcoran House, which stood at the corner of Connecticut Avenue and H Streets, diagonally across the intersection from the Decatur House; and the John Hay and Henry Adams Houses on the next corner directly across from St. John's and diagonally from the Dolley Madison House.

W. W. Corcoran is considered Washington's first millionaire. He made his money selling Mexican War bonds to banks in Britain and in a banking partnership with George W. Riggs. A local merchant and entrepreneur before that, Corcoran in 1854 commissioned James Renwick Jr. to expand an existing house on Lafayette Square into a mansion of great size. Renwick had designed the Smithsonian Castle and other buildings in Washington. The Corcoran commission was a plum with a client of taste and a fat budget. The finished house was of Washington brownstone without, and within, a gaslit Aladdin's lamp of fantastic decor and luxury that survives today only in photographs. Corcoran, a southern sympathizer, moved to Paris when the Civil War started, renting his mansion to the French minister, who, with some difficulty, kept the wartime government out. Corcoran returned to a changed America and had to face some scorn. One tour book published just after the Civil War referred to his house

as a display place for "upholstery." He was still called, nevertheless, "The Prince of Entertainers" and was very charitable. A widower since 1840, he mourned the loss of his wife for the balance of his life. The only one of his three children to survive to adulthood was Louise. She was constantly with him, married to a bright, debonair lawyer and member of Congress from New Orleans, George Eustis. Her death after their return from Paris devastated the father. Eustis followed her in death five years later. Their daughter and two sons remained with Corcoran, however, until his death in 1888, living for the most part in Washington. The house was demolished in 1922.

Corcoran's house contained in its bones the previous brick house that had belonged to Daniel Webster, gift of New York and Boston admirers in 1841. It was in this house that Webster, secretary of state under presidents William Henry Harrison and John Tyler, sat at his huge bulky desk and negotiated with Alexander Baring, first Baron Ashburton of the British Foreign Service, the 1842 Webster-Ashburton Treaty that fixed the Maine and Minnesota borders with Canada, as well as the 49th parallel to the Rocky Mountains. The treaty called for the end of slavery on the high seas (the United States had already abolished the slave trade from outside its boundaries in 1808). When destruction of the Daniel Webster House took place in 1922 as part of the building of the Chamber of Commerce, workmen found stored away in the attic the huge mahogany desk upon which Webster and Ashburton had signed their treaty. The U.S. Chamber of Commerce kept it for display in the new building, where it remains today.

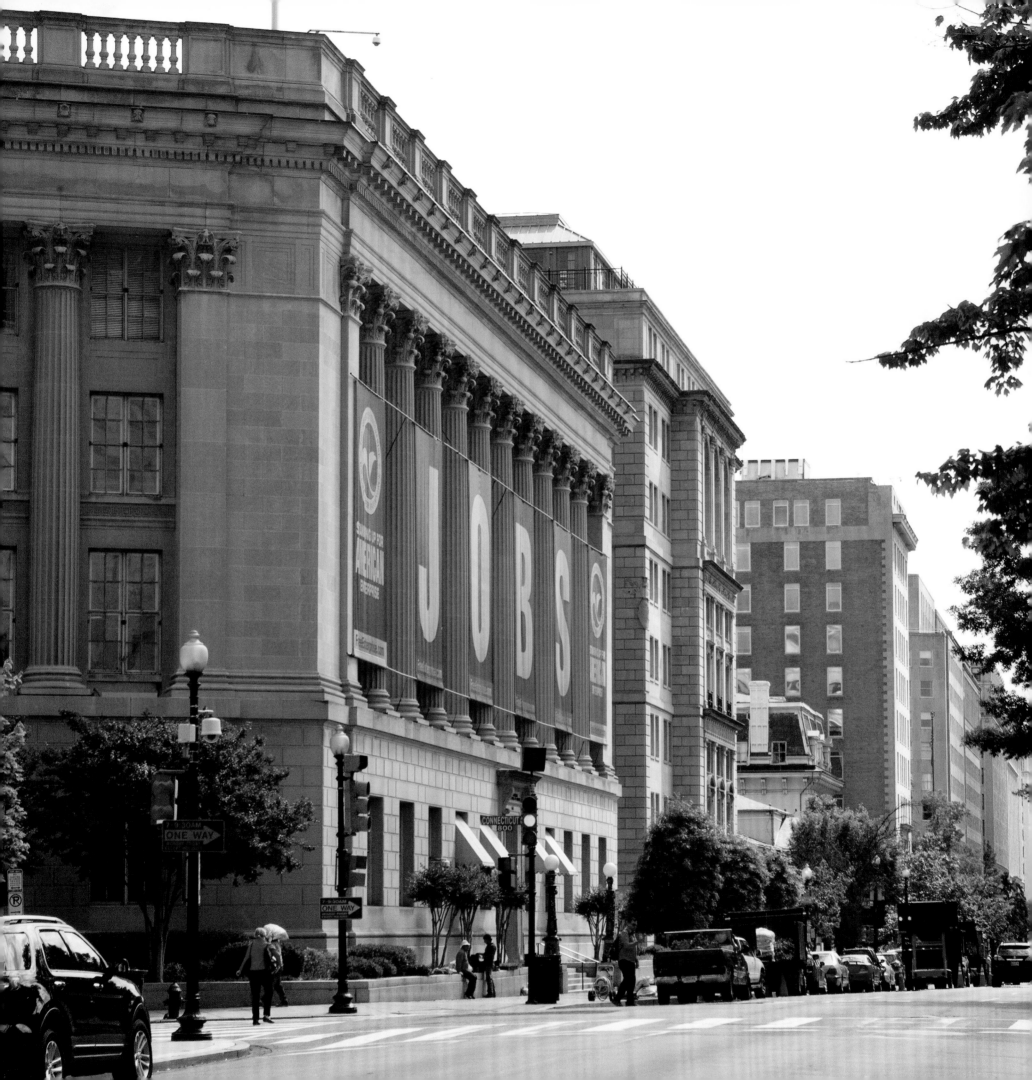

It is good to be here today at the
Chamber of Commerce. I'm here in the
interest of being more neighborly.
I strolled over from across the
street, and look, maybe if we had
brought over a fruitcake when
I first moved in, we would have
gotten off to a better start.
But I'm going to make up for it.

President Barack Obama

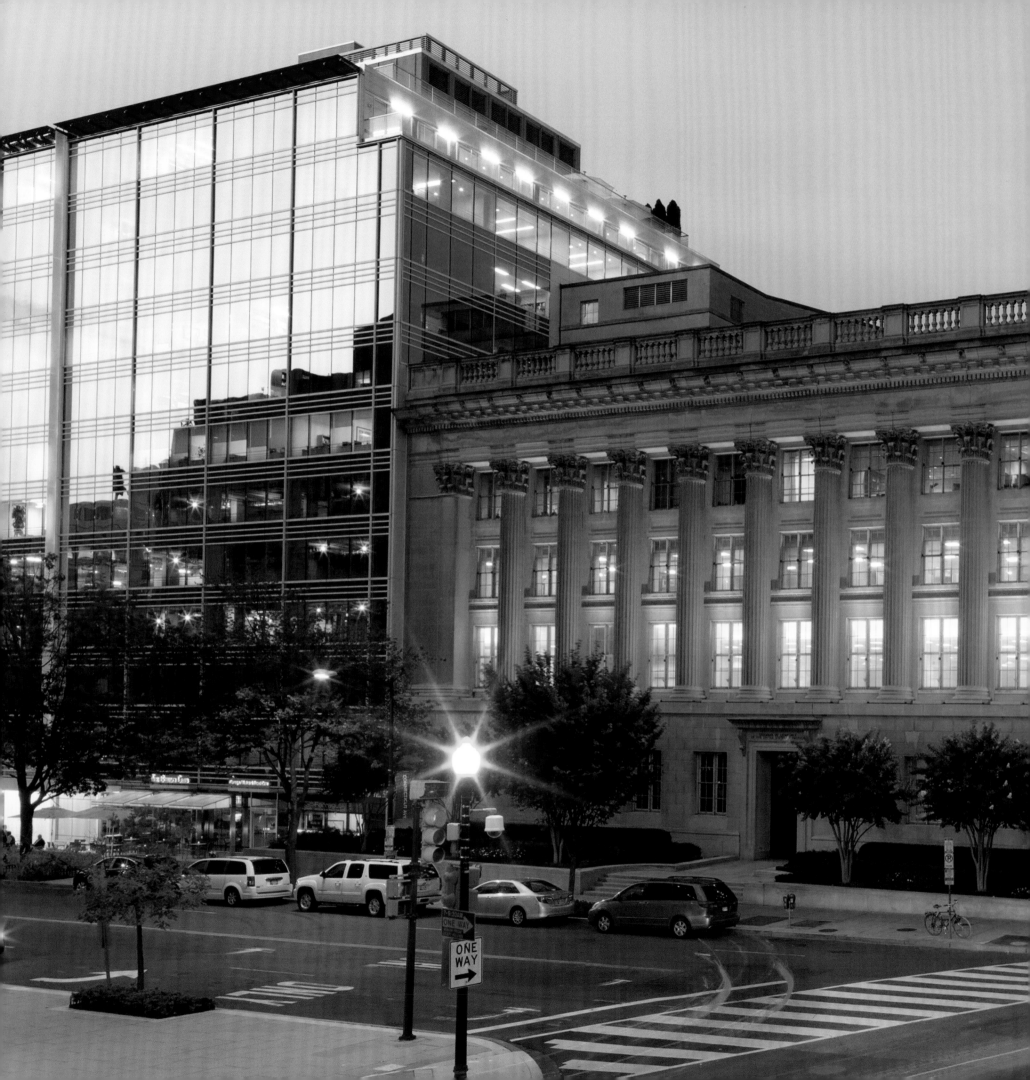

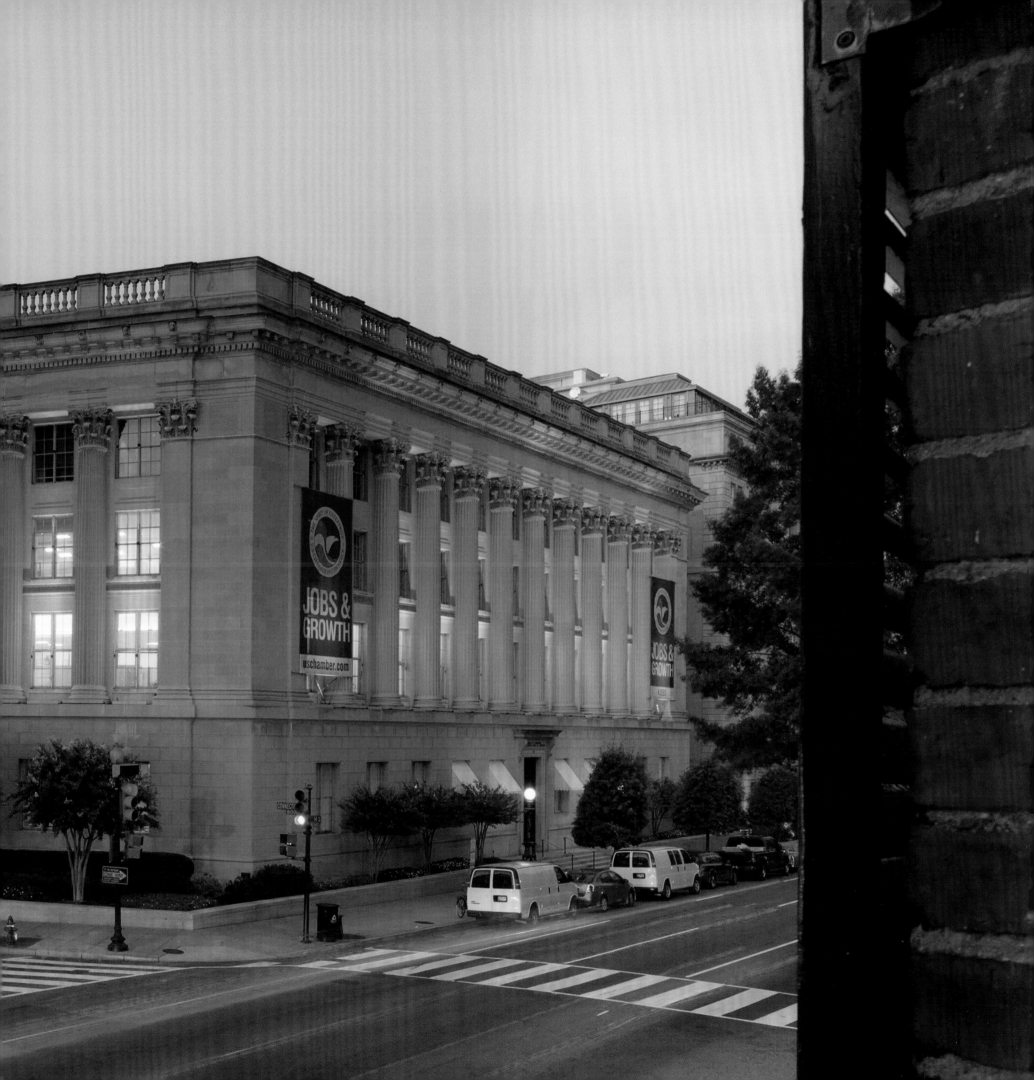

OVER TODAY'S WHITE HOUSE NEIGHBORHOOD REIGN THE HAY-ADAMS AND THE MAYFLOWER

At the east end of the 1500 block of H Street was once a double house called the Hay-Adams after the owners, Henry Adams, the historian, and John Hay, the diplomat.

Adams, soon to be a widower, and Hay, with a big family, engaged Henry Hobson Richardson of Massachusetts to build such a house, where the two households would live in close proximity in a sort of compound, although both houses were entirely separate. Richardson had been a student of Adams at Harvard. At the peak of his career, Richardson's public buildings and houses greatly pleased those who wished to build the unique and different. What he built for his two clients was called "Romanesque" in architectural circles. To most people it looked like a castle, tall and gloomy. The interiors were very dramatic, with beautiful management of natural light framed in dark wood. Hay pointed out the colorful and rare marbles of his fireplaces, while Adams said little of his interior and stuffed it with books and mementos of his world travels. Richardson scolded Adams that any shortcomings in his house were the result of his tight-fistedness, not that of the architect.

The Hay-Adams houses can only be remembered in photographs. Some parts were salvaged and used in two new suburban houses by architects who admired Richardson. It is believed that some of the handsome public rooms in the Hay-Adams Hotel on the site came from the Hay House, perhaps the rich paneling in the old dining room. The wrecking ball came in 1927, after the house was sold by Hay's daughter, who owned both houses.

Over today's White House neighborhood reign the Hay-Adams and the Mayflower Hotels. The Hay-Adams rose on the former

residential site in the late 1920s. It remains intimate, even cozy, as an elegant place to dine or stay. Weddings are held on the roof, overlooking the White House. Both President George W. Bush and President Barack Obama have especially liked the Hay-Adams dining room. For those working in the neighborhood, lunch in the cellar grill, Off the Record, with its political cartoons, is a special treat.

Down Sixteenth Street the Mayflower is a much larger and slightly older hotel. The Hay and Adams houses still stood as the ground was prepared for the eleven-story Hotel Walker. Even as costs rose, the Walker Hotel Company increased the size and quality. When the Walker Company jumped to safety from a financial tightrope, the hotel was completed by C. C. Mitchell & Co., after being sold unfinished, on February 18, 1925. It boasted 440 guest rooms, each with bath, the largest banquet rooms in Washington, and large public areas at street level.

The very open and luxurious splendor of the Mayflower is wholly different from the repose of the Hay-Adams. President Harry Truman called it "Washington's second best address." President Richard Nixon loved the grill all his days in Washington and once, after making a surprise appearance among protesters on the Mall, felt refreshed enough to stray from his Secret Service escort to enjoy there a ham and cheese sandwich, remembering privacy and old times. He had entertained often at the Mayflower as vice president, pinch-hitting for an ailing President Dwight Eisenhower.

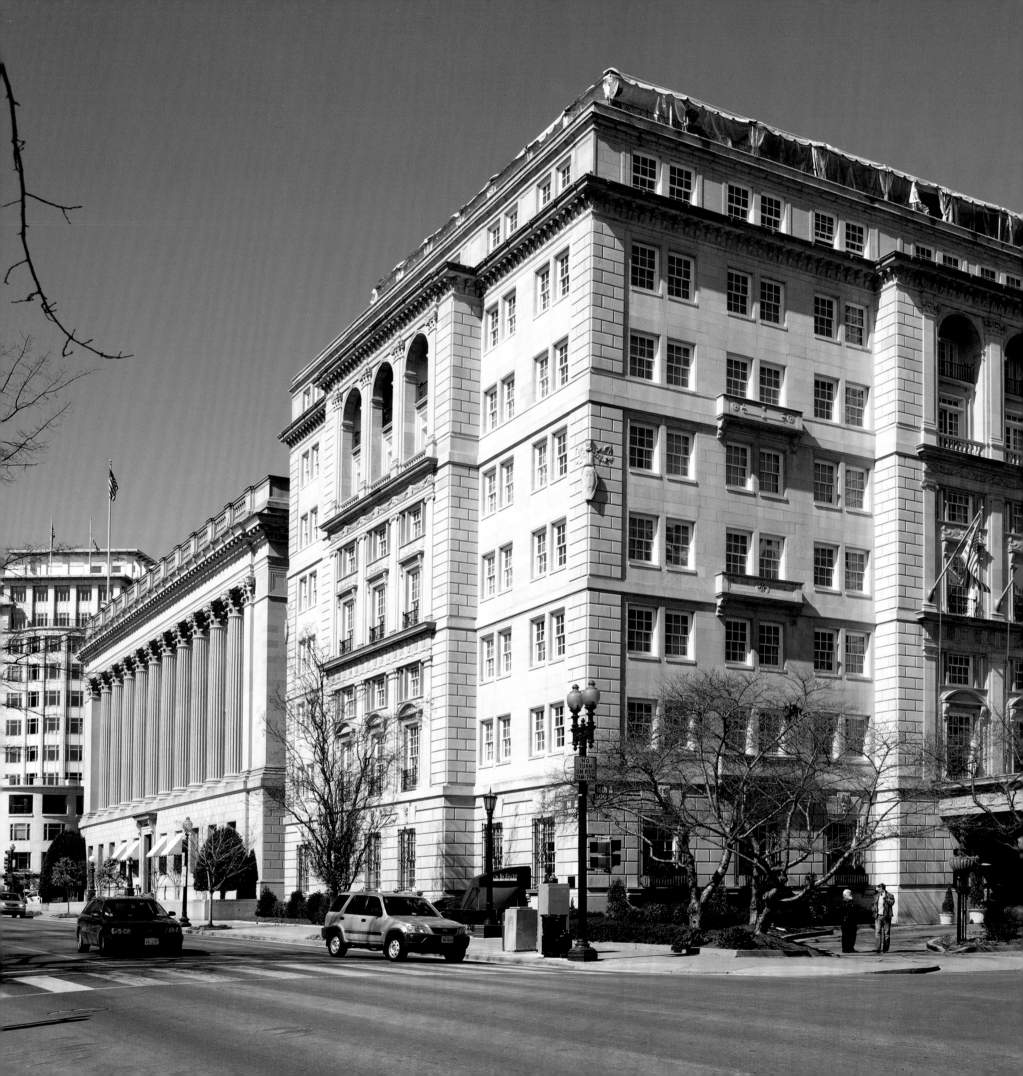

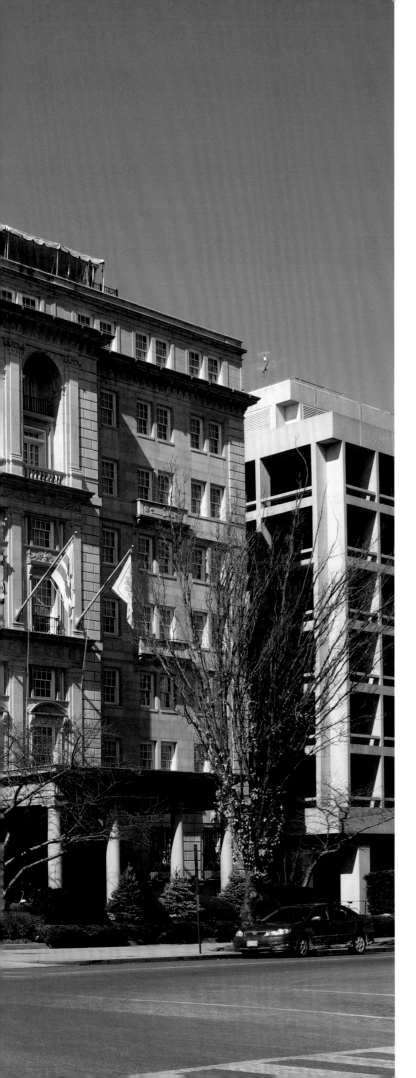

Then Ronnie and I walked across Lafayette Park to the Hay-Adams Hotel for a quiet lunch. The Secret Service was with us, of course, but by now we were used to them. People seemed startled when we entered the dining room, and then, spontaneously, everybody stood and applauded. It was such a nice gesture, and it made us feel so welcome. Little did I realize that this was the last time in all of our Washington years that Ronnie and I would just walk out the door and down the street like ordinary people. The enormous change in our lives had yet to sink in.

First Lady Nancy Reagan

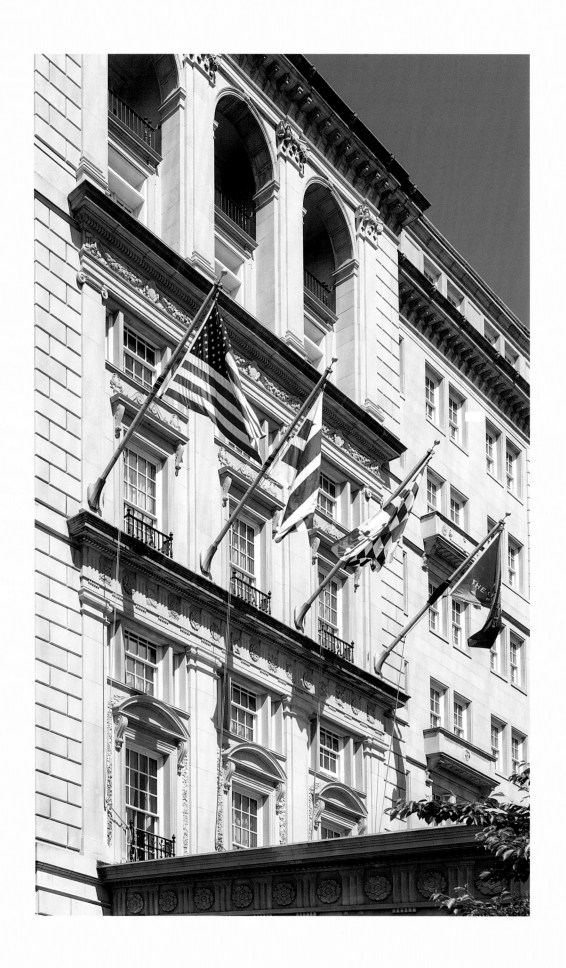

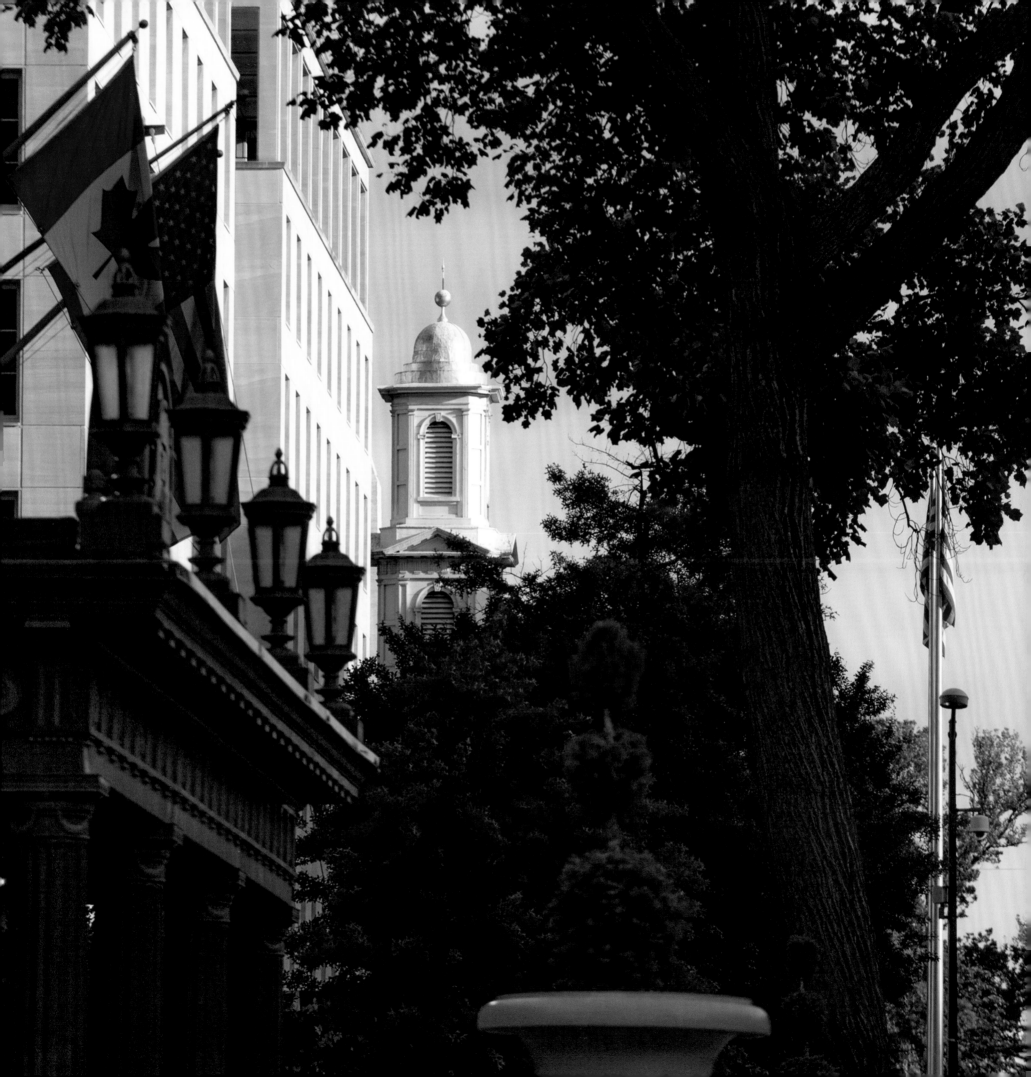

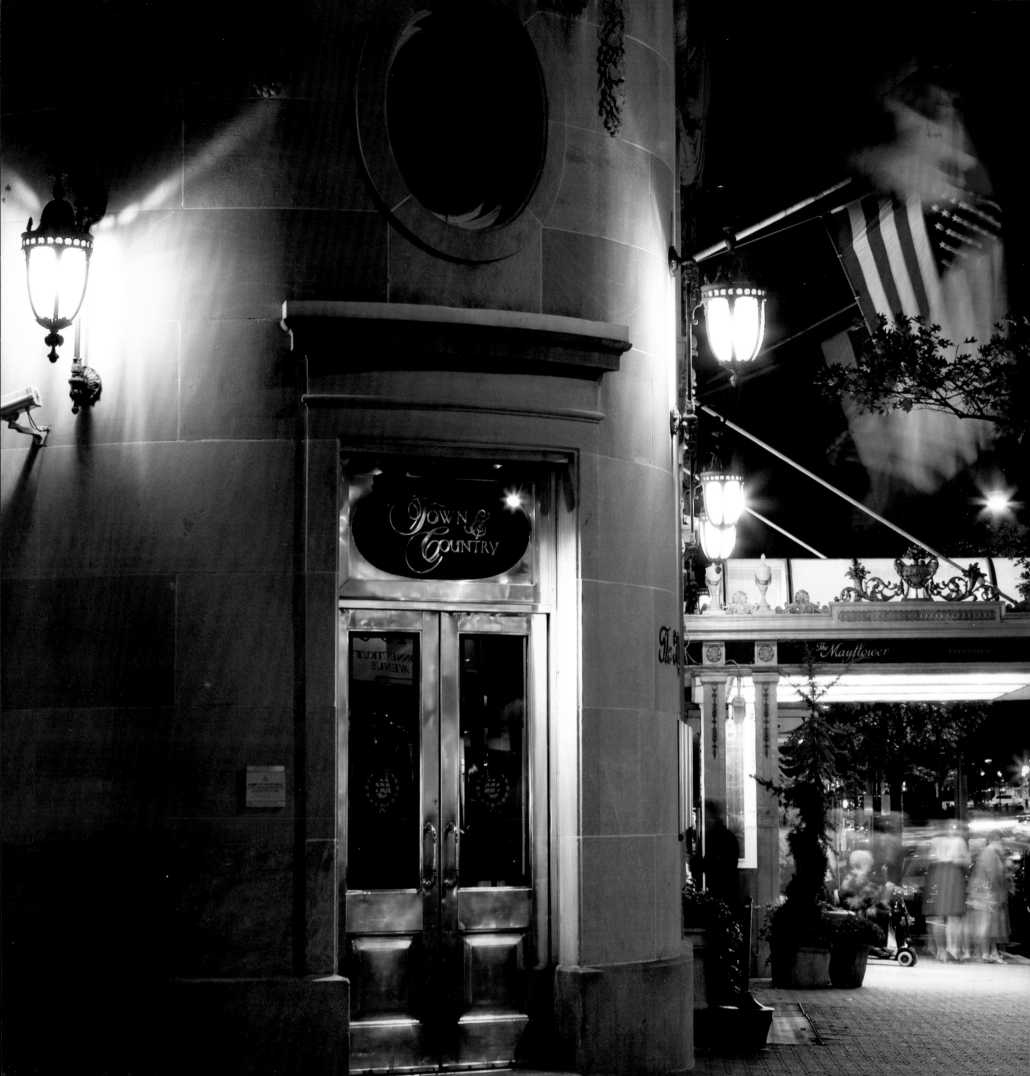

WASHINGTON'S SECOND BEST ADDRESS.

PRESIDENT HARRY S. TRUMAN
SPEAKING OF THE MAYFLOWER HOTEL

PARKS GREAT AND SMALL PROVIDE AIR AND LIGHT

A block away from Lafayette Square, Farragut Square commemorates Admiral David Farragut, the Civil War "first admiral" who, among his daring feats along the Gulf of Mexico, captured Confederate New Orleans in 1862, thus opening the mouth of the Mississippi and its lower regions to Union ships. The assault was planned on the dining room table at Blair House. General Ulysses S. Grant's victory at Vicksburg a year later completed the job, opening the entire river as it severed the South. The Farragut bronze was created by the Washington sculptor Lavinia (Vinnie) Ream Hoxie, who knew the admiral well. A resolute Farragut surveys a tranquil, tree-shaded square, today surrounded by buildings of the twentieth century, most of them solid masonry, some walls of glass.

Notable among the sites of the square are the Metro station Farragut West, and the Army and Navy Club, a high-rise bearing architectural reference to the early twentieth-century modernism of the W Hotel, a few blocks away. It was built more than thirty years after the Farragut statue was unveiled by President and Mrs. James Garfield on April 25, 1881, three months before his assassination.

Pierre Charles L'Enfant, under President George Washington's eye, planned a capital city ideal for living, as such open space parks such as Farragut Square and McPherson Square demonstrate. With L'Enfant, Washington imagined a great urban center, both the political and the economic capital of the land. As Washington himself desired, in the abstract, an American capital

on the scale of Paris, L'Enfant put the idea to paper with the dichotomy of Washington in mind—capital and city. Once on the scene, L'Enfant quickly fell in love with the Potomac landscape. He sketched and made notes—hills and plains contrasted sharply and inspired dramatic planning. In simplest terms, L'Enfant overlaid the city with a network of diagonal avenues that joined at circles or squares—looking rather in plan like Tinker Toys. These great avenues led from public and official centers to others. The junctures were parks great and small to provide air and light. Spaces between the avenues were filled with grids for residential and commercial use.

Thus Washington was to be a city of neighborhoods, the two different "worlds" of government and private life articulated in one plan. Washington today can be said to have twenty-six neighborhoods, including that surrounding the White House.

Happenstance led to the latter. Lafayette Square was not part of the great scheme of parks. As designed, the space we know as Lafayette Square and its park were filled by three grand ceremonial avenues—Connecticut Avenue, Sixteenth Street, and New York Avenue. These would have come from the north and converged in a great court before the "palace" that became the White House. This feature of the plan never materialized. Litigation and modification left the area bereft of avenues, a vacant 7 or 8 acres awaiting Lafayette Square yet to come.

In those days the grounds of the White House were open to the public and we played there too, as well as in the various little parks with which Washington is dotted. The squares and circles such as Lafayette Square, Dupont Circle, McPherson Square, Farragut Square, Franklin Square, and Washington Circle, each had its individual charm and character.

Alice Roosevelt Longworth
daughter of President Theodore Roosevelt

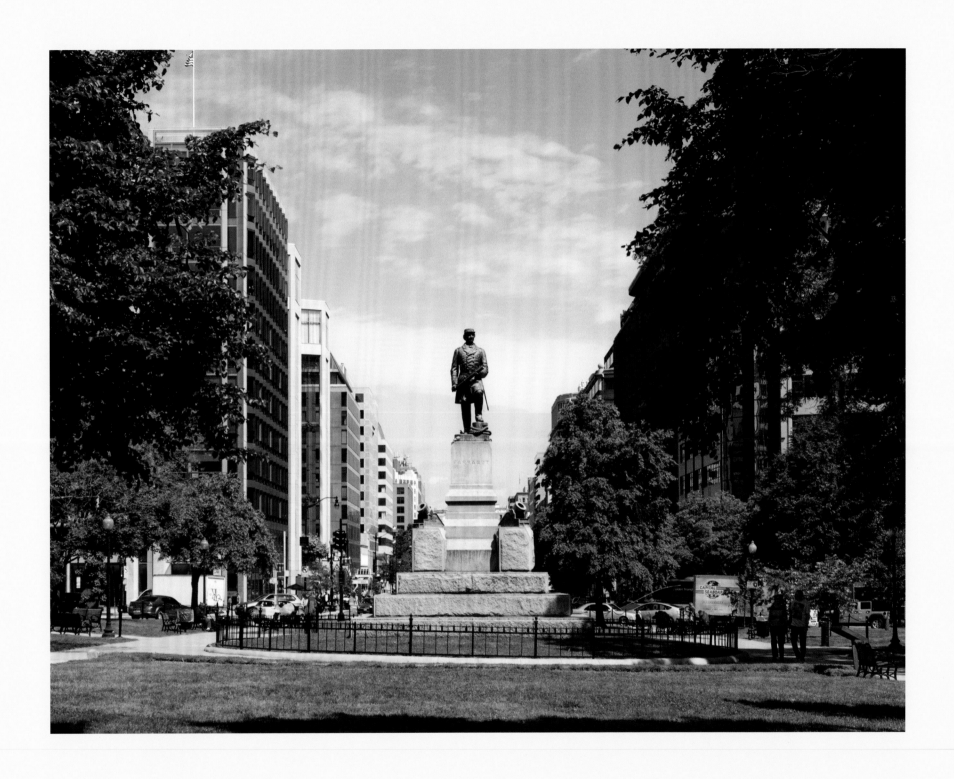

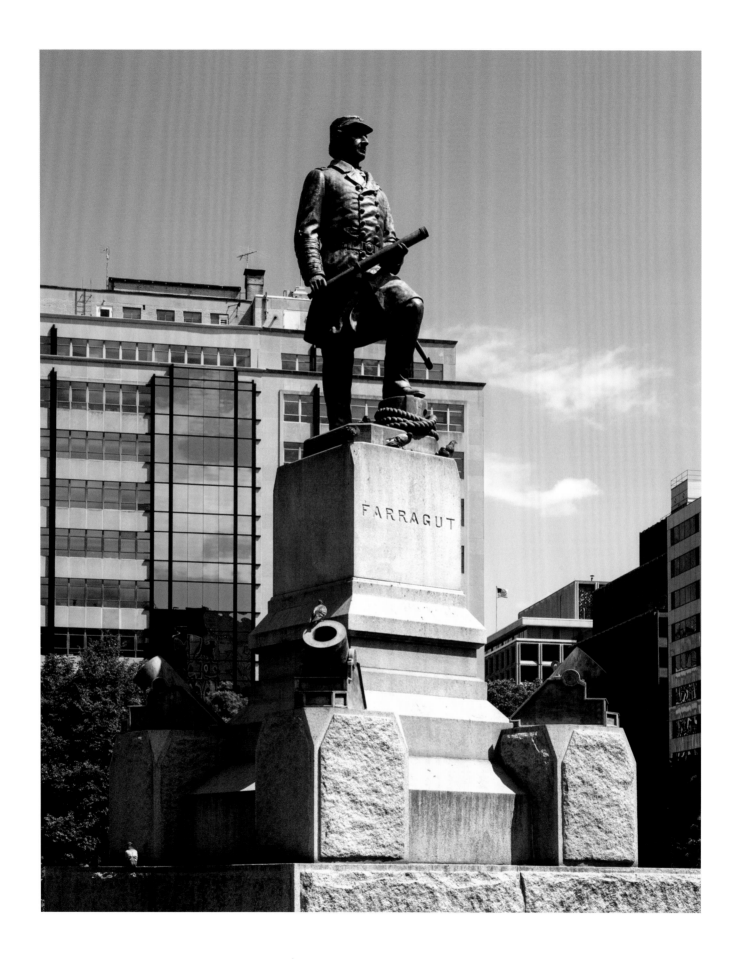

As the years pass on these squares and public places will be rendered more and more populous, more and more eloquent by the presence of dead heroes of other days. . . . These heroes come by the ministry and mystery of art to take their places and stand as permanent guardians of our nation's glory. Today we come to hail this hero . . . to take his place as an honored compatriot and perpetual guardian of his Nation's glory. In the name of the Nation I accept this noble statue, and his country will guard it as he guarded his country.

President James A. Garfield
address at the unveiling of the Admiral
Farragut statue in Farragut Square

In the old days, I'm told, the Army and Navy Club often invited their neighbor, the President, to all their parties. I've also heard that Benjamin Harrison and Grover Cleveland walked over for a toddy or two. Oh, for the good old days. If I'd known that the club was this beautiful, Nancy and I would have stopped by long ago, and we would even walk, if the Secret Service would let us.

President Ronald Reagan

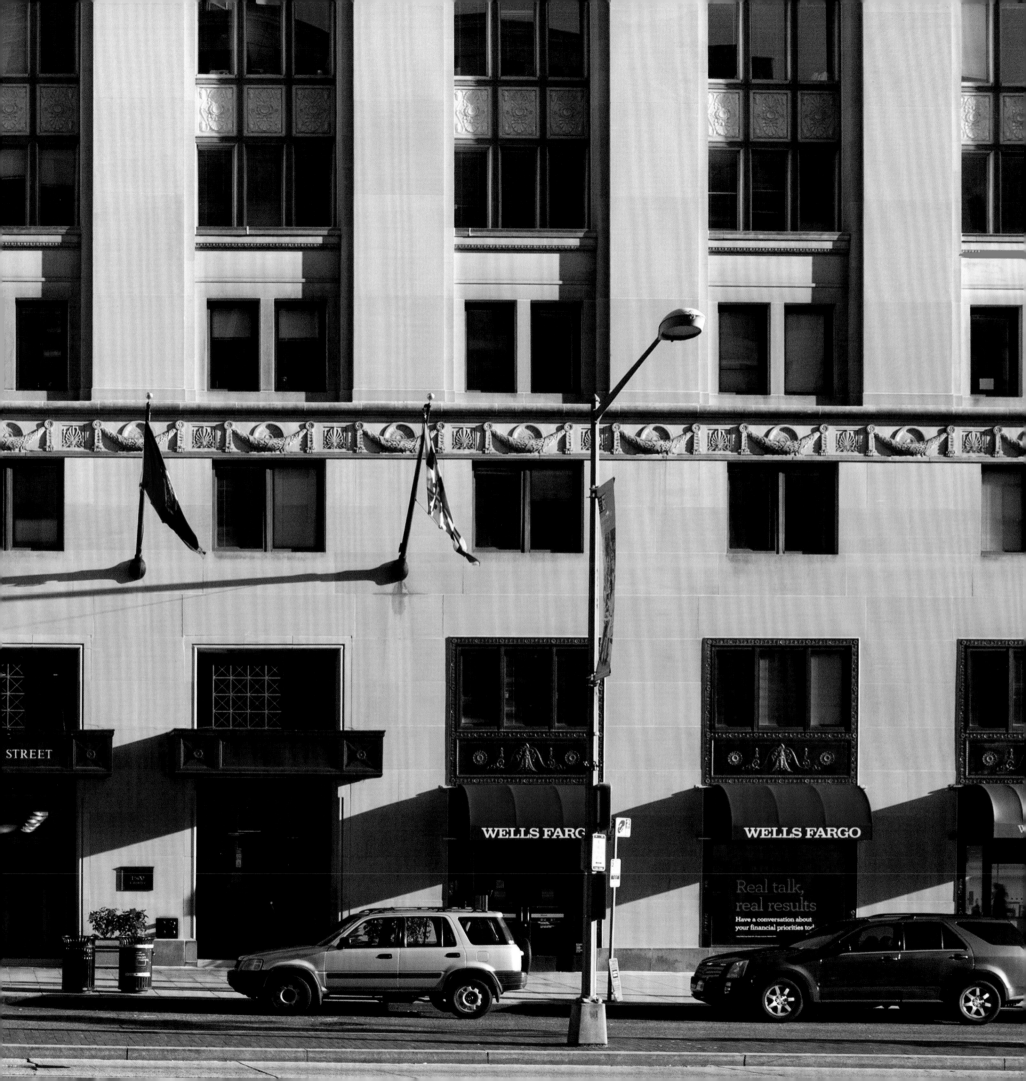

Well-kept streets and parks, fine
public buildings, and private
construction of a pleasing
design, all developed with a
thought to a harmonious whole,
are considered essential to
a modern community . . .
limitations placed on the height
and character of buildings in
recent years have brought about
the development of a distinctive
type of American business
architecture. It has been much
admired and praised by visitors
from abroad.

President Calvin Coolidge

WHAT OF THE GRAND AVENUES THAT WERE TO CONVERGE AT THE WHITE HOUSE?

The seemingly perfect situation of Lafayette Square in the midst of the White House neighborhood masks the complexity of its creation. Pierre Charles L'Enfant did not include this park in his plan. But it does have reference to his plan. It has been noted that the L'Enfant Plan of 1792 showed three principal avenues—relating to the ceremonial aspect of the city—approaching the President's House from the north. On the opposite side of the President's House, Pennsylvania Avenue approached from the southeast, making a direct ceremonial connection from the mansion to the Capitol.

The plan President George Washington endorsed was for a capital in the European sense, one that would be the financial and cultural center of the country, as well as the political headquarters. He wanted a capital the world would respect and under-

stand. The road to the goal has not been direct, but the goal itself has remained sound. Politics, a displeased entrepreneur, and money intervened.

Washington's "palace" was reduced to a "house"; the resulting building was so much smaller than the spot L'Enfant had specified that the house had to be shifted to achieve a proportionate and important placement. Washington himself drove the stakes locating the house where it is. The grounds of the White House were invaded again by Washington in locating the government's office buildings within them relatively near the White House. This was a political necessity that did not necessarily please the president, but he dutifully drove the stakes at the sites to locate the two buildings. Those buildings flanking the White House today, Treasury on the east and the Eisenhower Executive Office

Building on the west, preserve the original locations of the executive offices and are only the third on the sites.

President Washington himself watched over every other detail thereafter, even though he knew that he would never live in the President's House. He even placed the house where it is, facing the north-south axis of the new city, but this threw the structure out of the uninterrupted vista from the Capitol, although it preserved the triple avenue front. However, a Georgetown merchant, Sam Davidson, insisted he already owned the ground through which the avenues were to pass. Controversy over ownership of the land delayed any activity toward situating the avenues. By the time the government purchased the land again in 1818, President James Monroe designated it as a park; six years later, when General Lafayette began his triumphal visit to America (at the expense of Congress), Monroe honored him by naming the park "Lafayette Square."

What of the grand avenues that were to converge at the White House? Two were reduced to insignificance, while Sixteenth Street, between them, rather held its own because it followed the north-south axis of the city plan. In fact, if you followed the line of that axis, you would cross Lafayette Park, cross Pennsylvania Avenue, enter the White House through the North Door, cross the Entrance Hall and go through the Blue Room out to the Mall, where your path would intersect with the east-west axis that runs from the Capitol, where it bisects the Rotunda.

THE AVENUES ARE MADE TO
CONVERGE TO THE ENDS OF A
BUILDING OF SUPPOSED EXTENT.

PRESIDENT THOMAS JEFFERSON

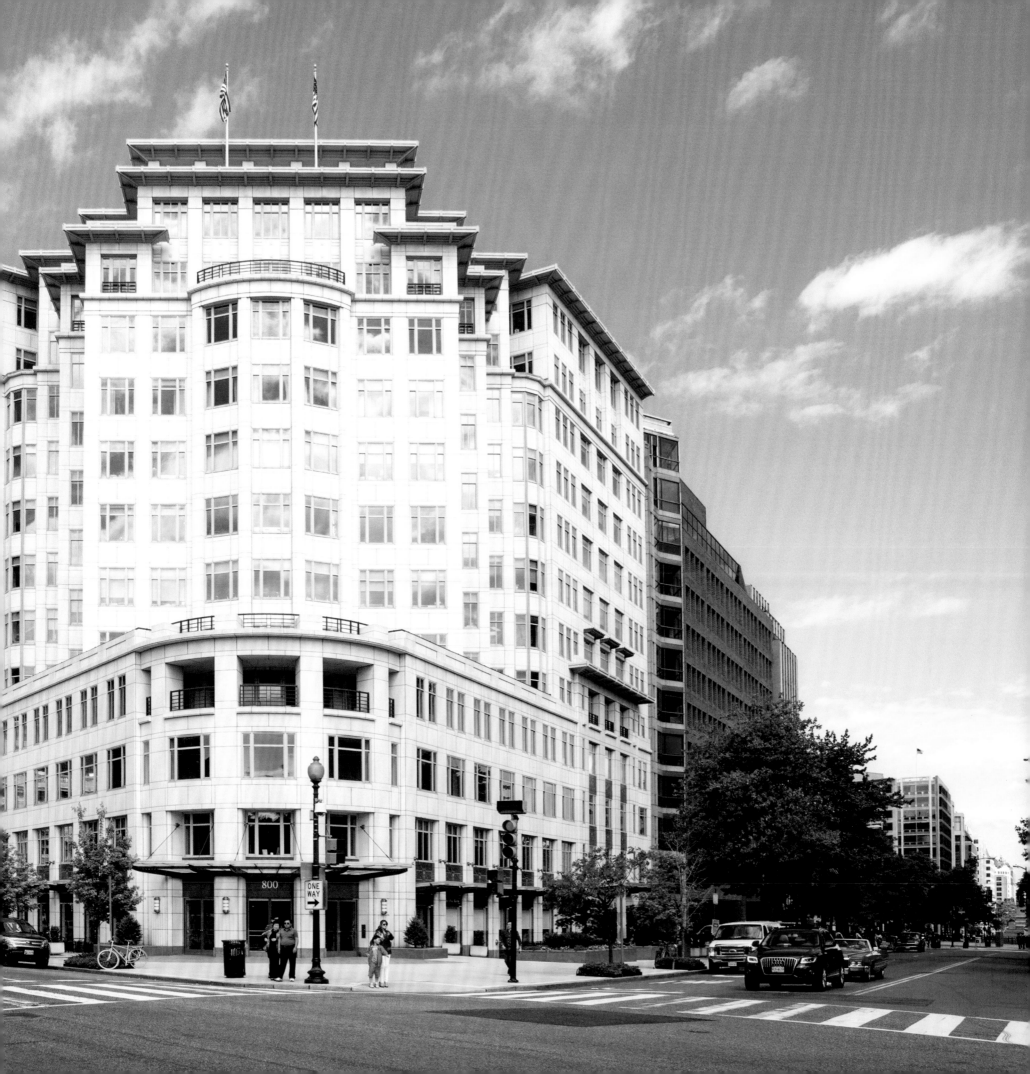

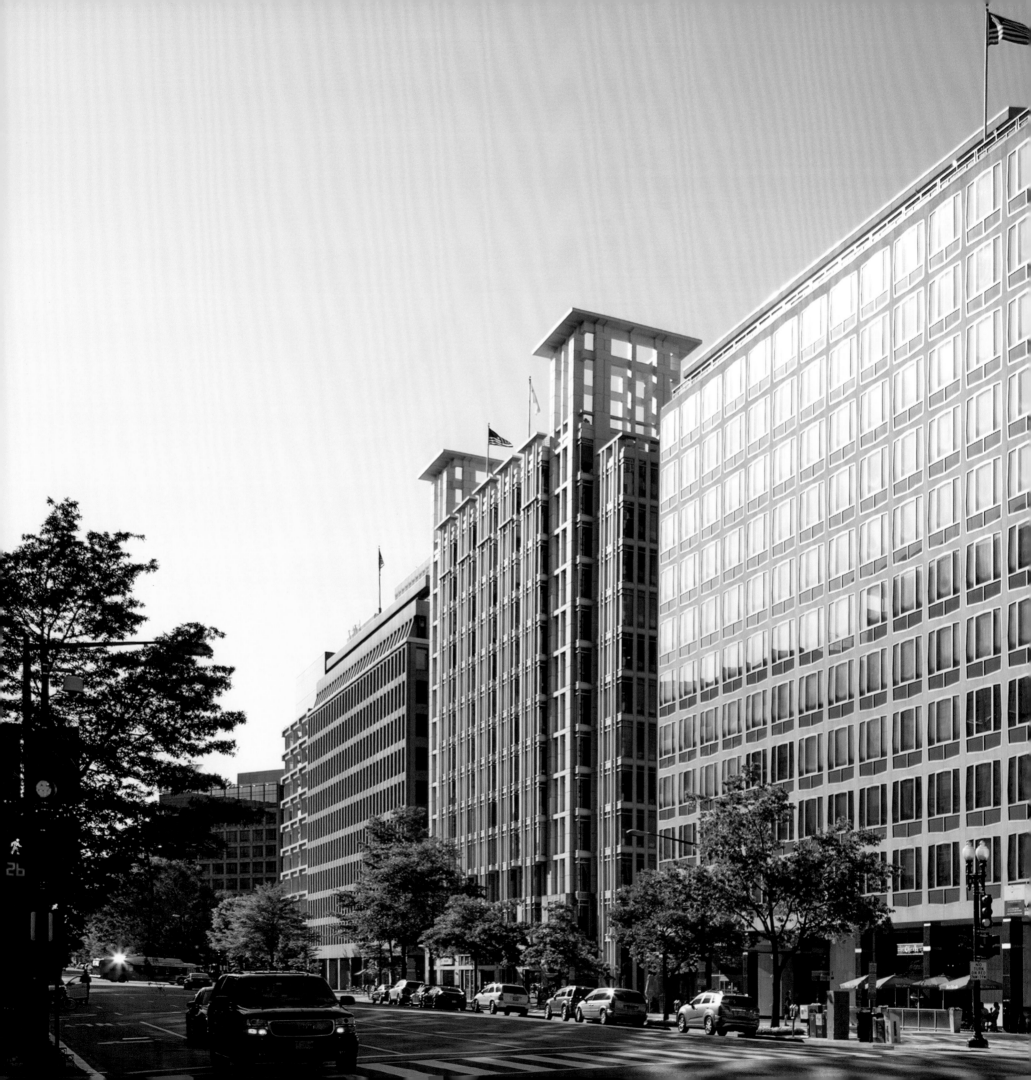

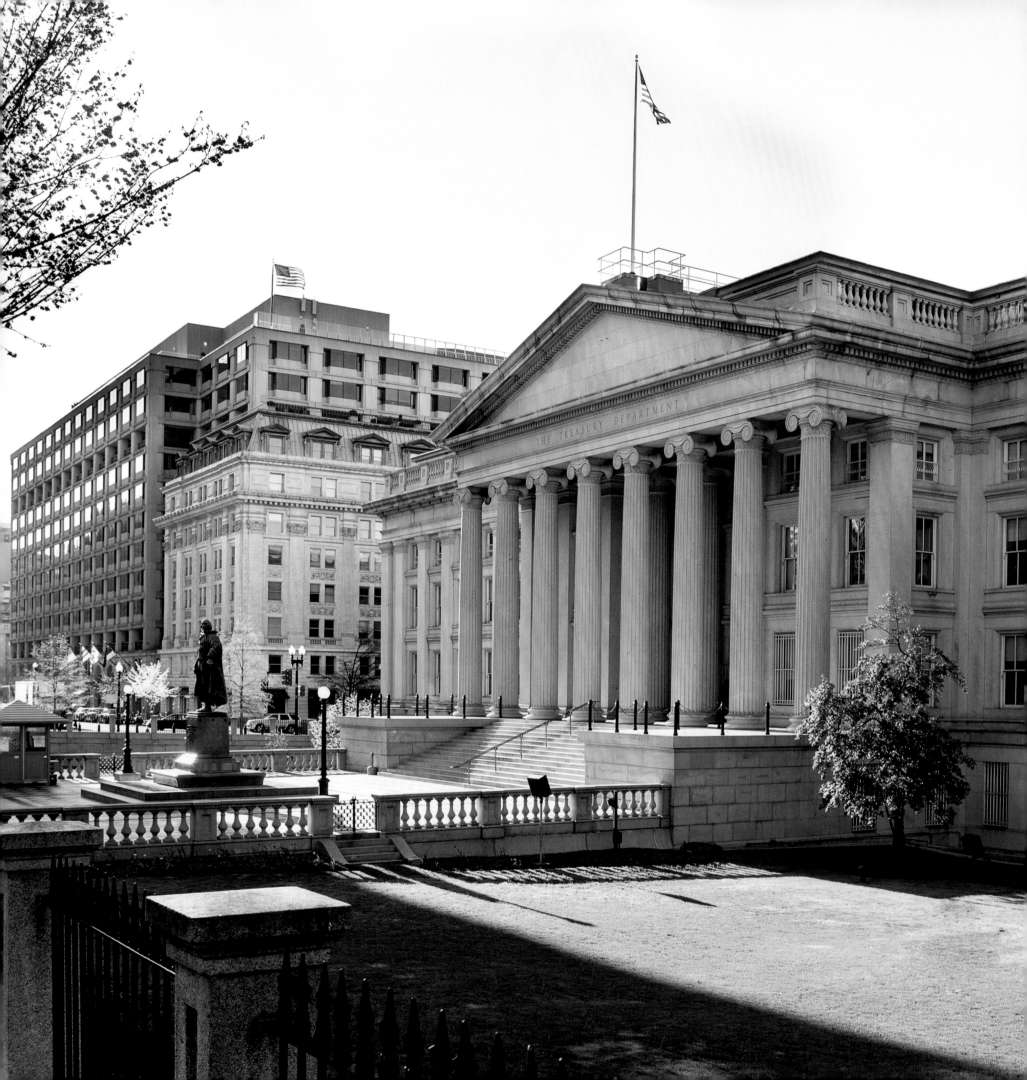

THE NEIGHBORHOOD TO THE EAST

PENNSYLVANIA AVENUE: CONVENIENCE FIRST, A STRAIGHT SHOT TERMINATED

Security at the White House is made nearly as invisible as possible, although it is very extensive. The grounds are graded on the sides to give seclusion to the south side, leaving a clearing in between that is not only stunning to see from the end of the grounds but provides privacy within. The north side is an open yard of lawn and trees from which one gains the closest view of the house. Since 1818 it has been protected by an iron fence. Guard houses flank the gates. As security's role has become greater at the White House, ever more creative "natural" means of secluding it have appeared, to facilitate presidential safety. The most visible of these efforts was the closing of Pennsylvania Avenue to cars. Reluctantly approved by President Bill Clinton in 1995, the dreaded alteration, which impacted the neighborhood, proved a boon to enjoyment of the area as a pedestrian and bicycle way. Soon the streets around Lafayette Square were closed as well. Today the old neighborhood is about as pleasant a place as one can find in the capital to have lunch or a stroll.

Just east of the White House on Pennsylvania Avenue, well within the president's neighborhood, two Treasury buildings flank the street. That on the south is the venerable United States Treasury Building designed and built in the 1830s by the public architect Robert Mills, to replace the 1818 brick structure that the British had burned. The architect also designed the Washington Monument. With Treasury, almost unquestionably he was influenced by the contemporary German architect Karl Friedrich Schinkel, whose heroic colonnades and monumental massing of "Grecian" style public buildings in Berlin are very evident in the building.

The structure was added to three times. Just before the Civil War it was extended to the south. Just after the Civil War it was extended to the north, bringing it up to Pennsylvania Avenue. The sunken terrace between the portico and the avenue absorbs the change in grade. While the Ionic portico of this addition appears that it could date from the 1840s, it was made to be compatible

with the earlier building that extends behind it. Compared with the modern facades of the State, War and Navy Building on the west of the White House, it became quickly out of style for its time, if magnificently so.

Here, on the day before Woodrow Wilson was inaugurated, several thousand women marched down Pennsylvania Avenue in a giant suffrage parade, led by Inez Milholland, a glamour figure of the time, dressed in a very filmy gown and mounted on a silver-white horse. Their destination was the Treasury portico, where a vast audience awaited the various tableaux they were to perform. To the horror of most spectators they arrived beaten and bruised, their clothes ripped, victims of angry men who jumped out from the sidewalks. Nevertheless the women's spirits prevailed, and the carefully staged performance symbolizing the vote for women went on as planned. Neither President-elect Wilson nor the women of his family attended. The outgoing president's wife, Helen Herron Taft, and her daughter were there,

strong believers in the cause, as was William Howard Taft himself.

The White House neighborhood on the east presents a confusing episode of street planning. Had a king decreed Pennsylvania Avenue, it would have—as L'Enfant planned—gone arrow-straight from the White House to the Capitol. But democracies have only elected temporary kings who must be practical men and, of course, committees. In resituating the White House in 1792, to better place the smaller building, Pennsylvania Avenue's straight shot was terminated. Soon public buildings were built on the avenue's path near the White House. Convenience first, then by permanent plan, about 1824, the avenue was connected to Fifteenth Street to pass before the White House. The resulting "dog leg" arrangement linked Pennsylvania Avenue to the main front of the White House, where it became part of the White House neighborhood.

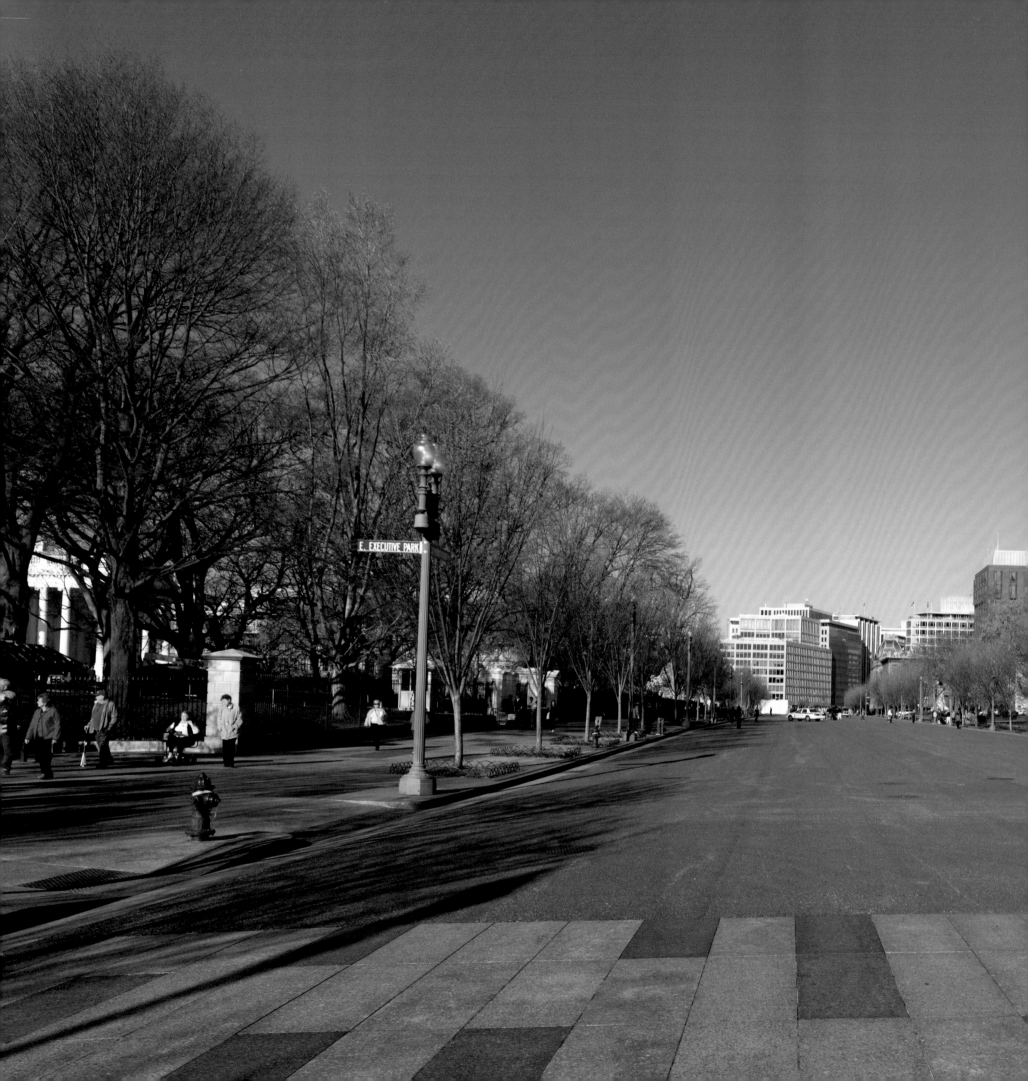

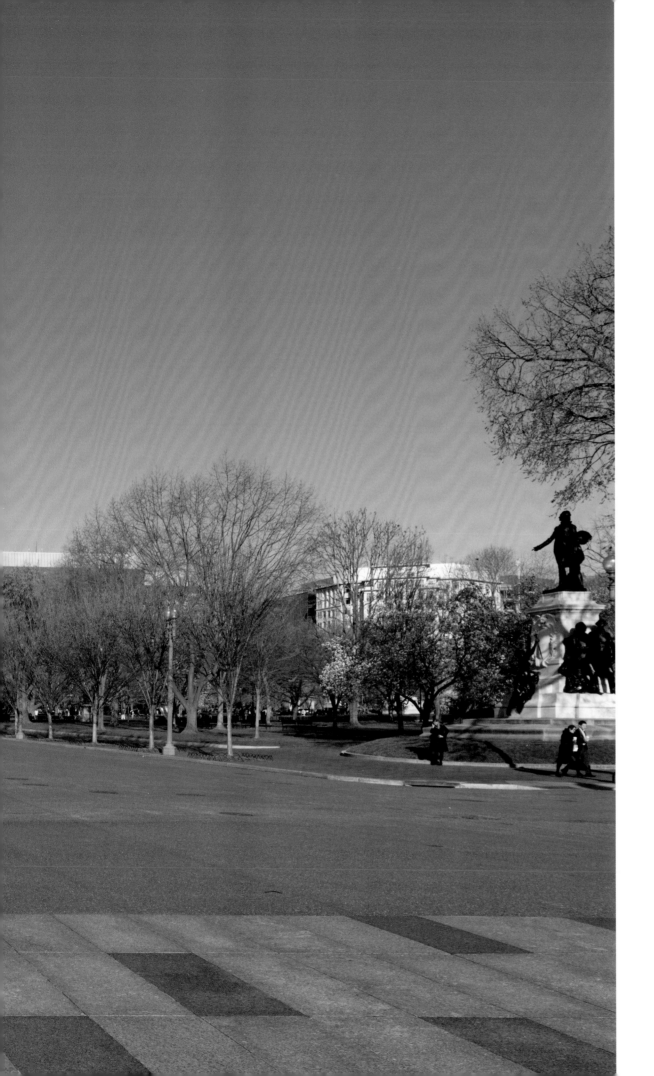

THIS THOROUGHFARE HAS
ALWAYS BEEN A CONNECTER—
CONNECTING THE WHITE
HOUSE, AND THE CAPITOL,
AND THE THREE BRANCHES OF
GOVERNMENT—AND A NEW
PENNSYLVANIA AVENUE WILL
AGAIN CONNECT VISITORS
WITH THIS GLORIOUS CITY
WITH THE PEOPLE'S HOUSE AND
WITH AMERICAN HERITAGE.

FIRST LADY LAURA BUSH
SPEAKING AT THE CEREMONY TO
REOPEN PENNSYLVANIA AVENUE, 2004

I LEFT THE WHITE HOUSE ABOUT 20
MINUTES OF 7 AND GOT BACK ABOUT A
QUARTER AFTER. I WENT UP 17TH TO RHODE
ISLAND, OVER TO 15TH STREET AND BACK TO
THE WHITE HOUSE. JUST ABOUT 2 MILES.

PRESIDENT HARRY S. TRUMAN

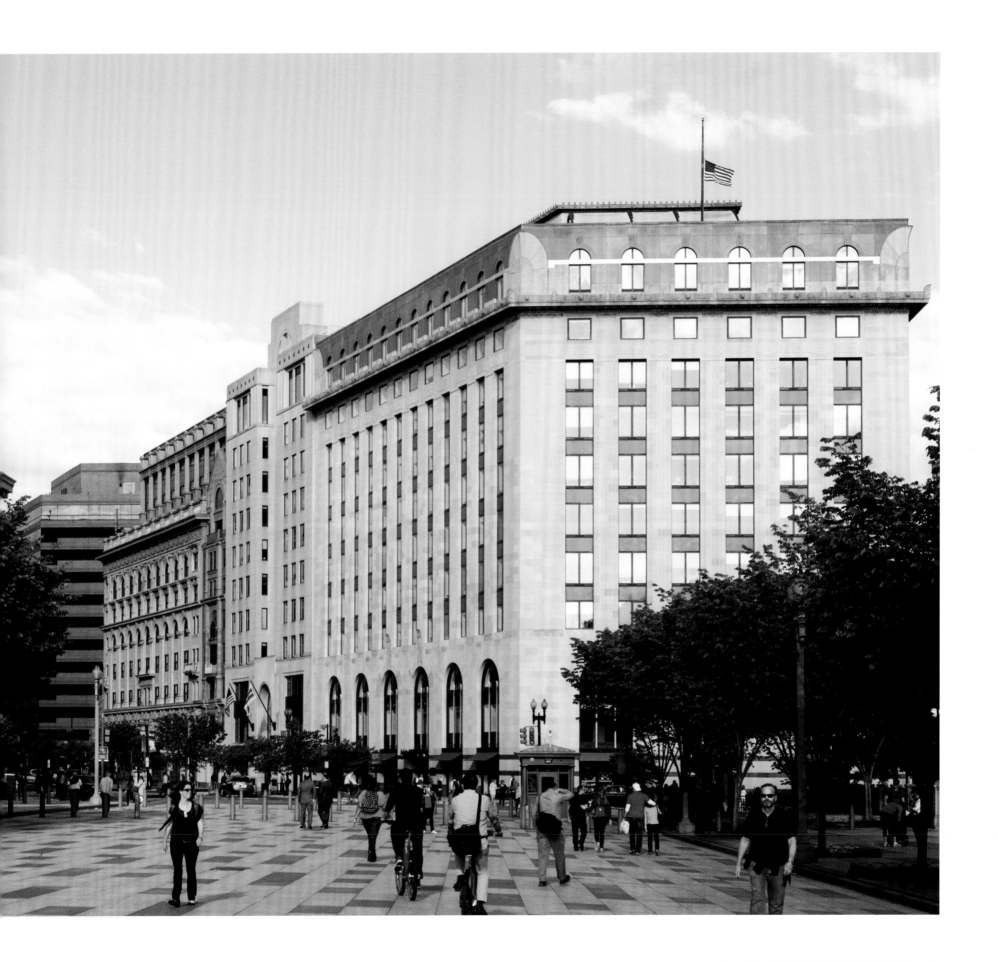

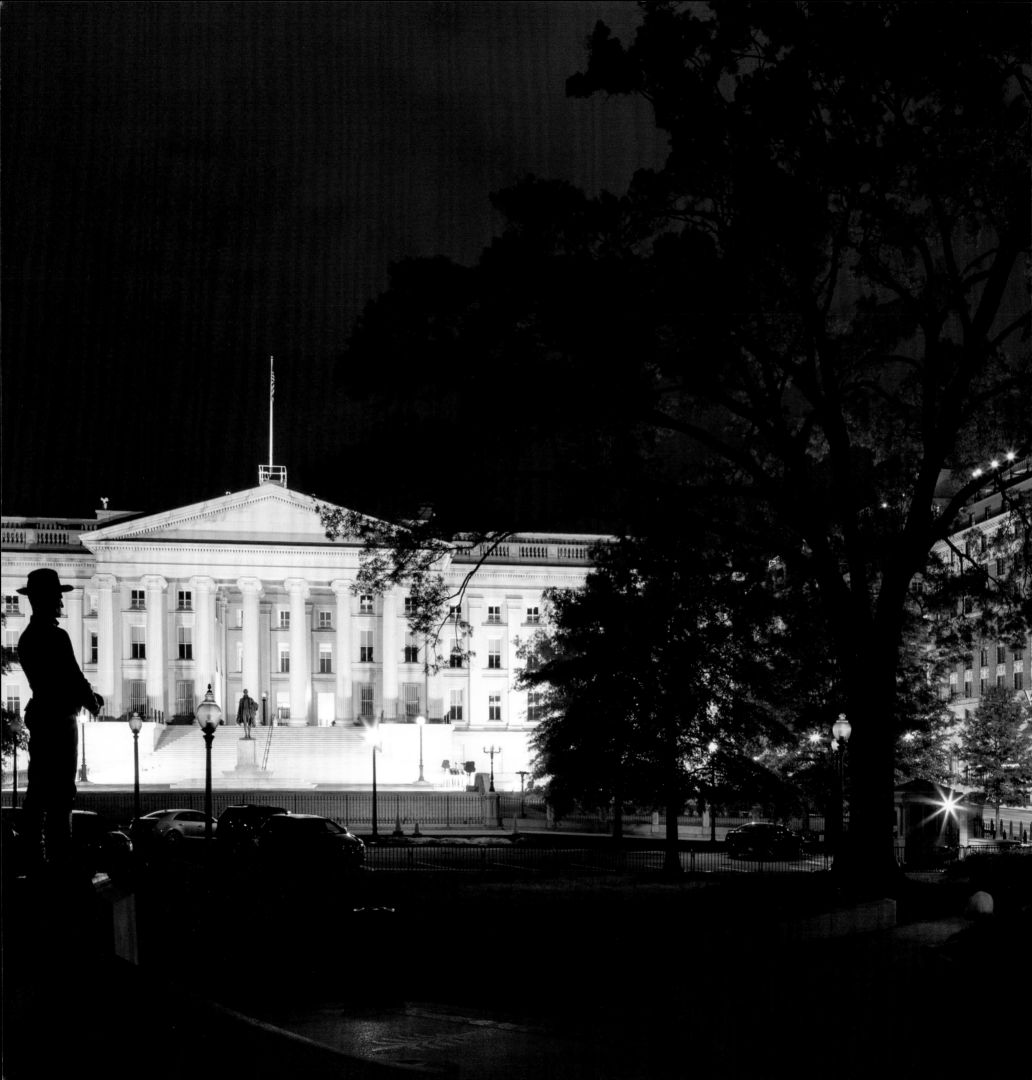

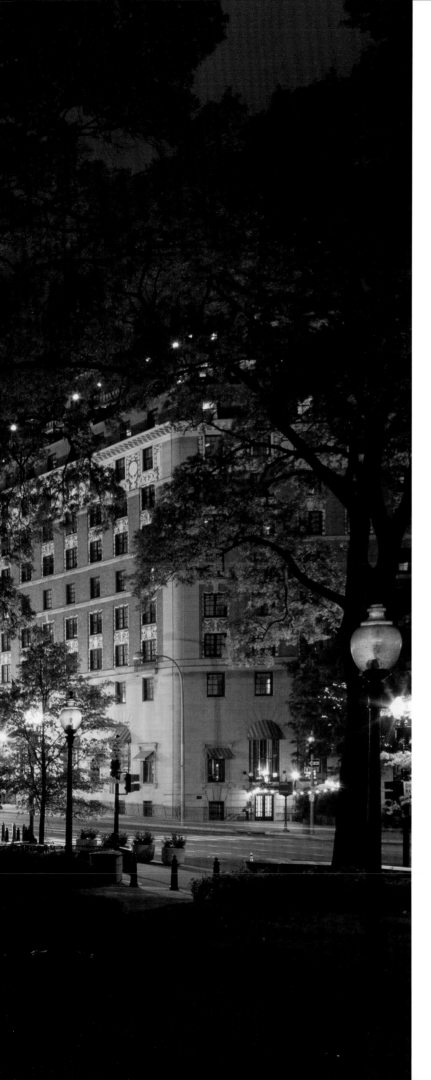

We all know the Treasury is
one of the original four Departments
established by the First Congress.
And what isn't as well-known is that
in its long history Treasury has been
in some ways the birthplace of the
Federal bureaucracy.

President George H. W. Bush

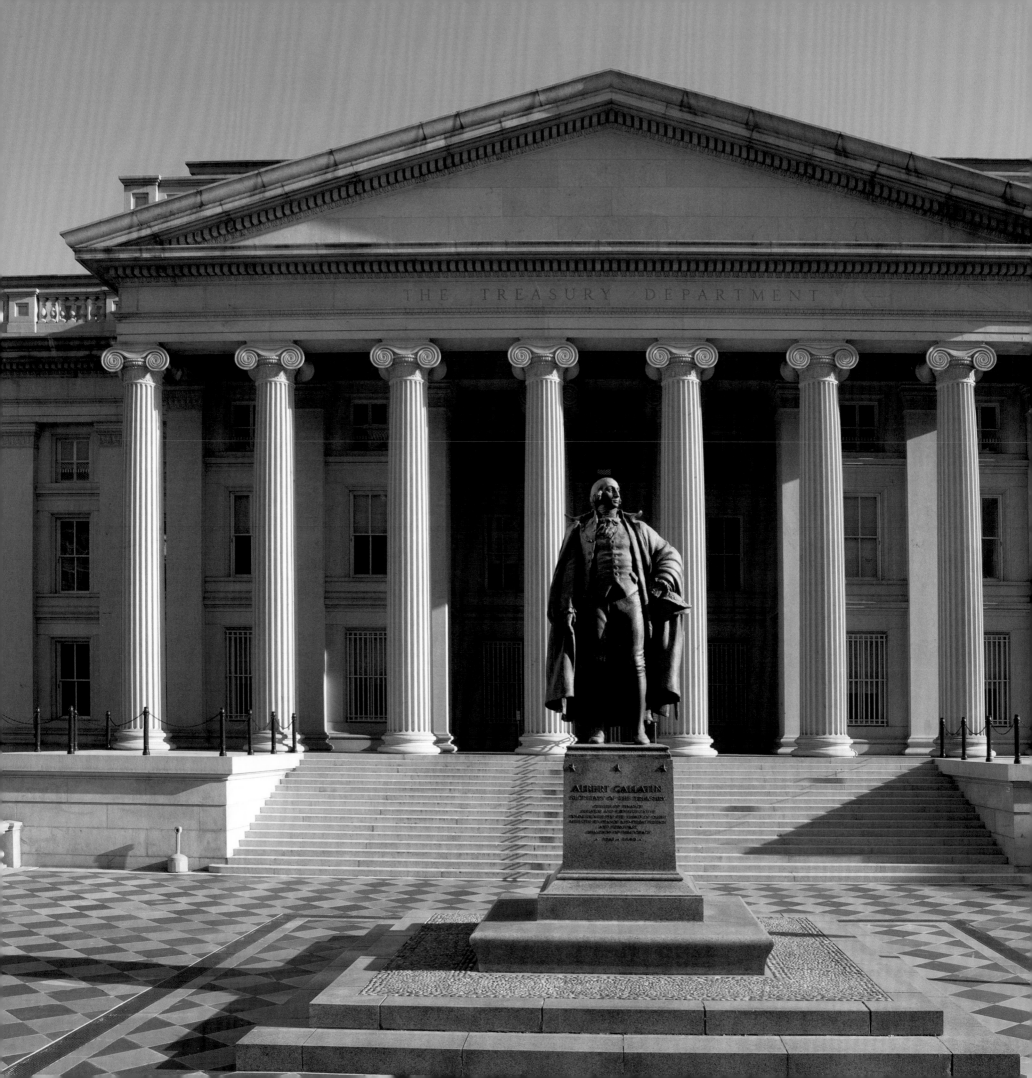

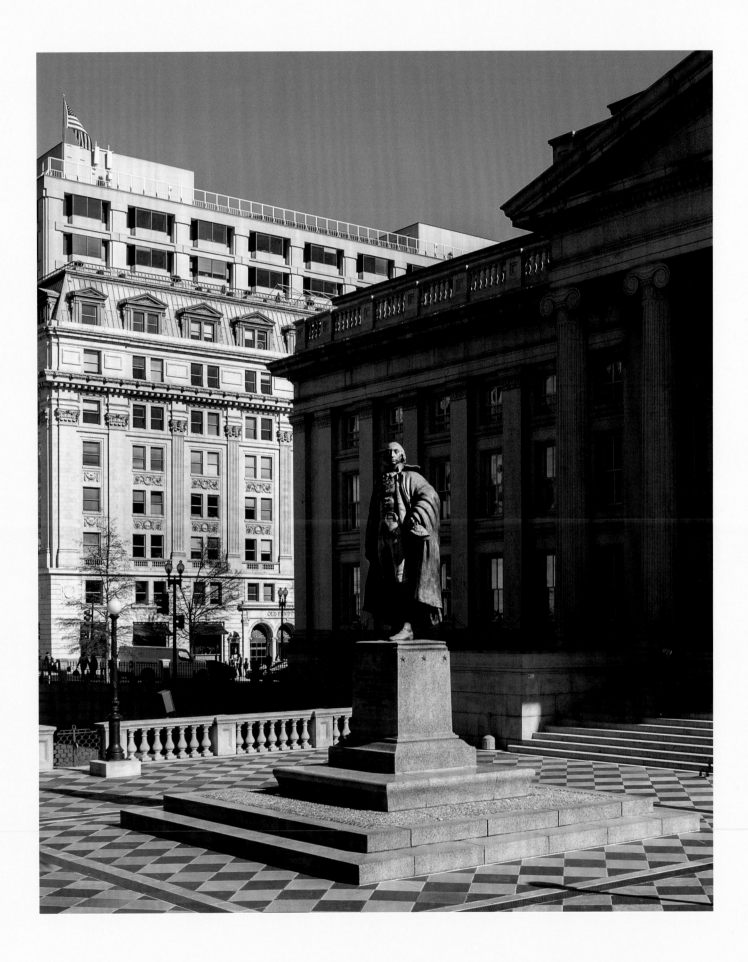

I TRANSMIT A REPORT MADE TO ME BY THE ARCHITECT OF THE PUBLIC BUILDINGS . . . EXHIBITING A PLAN OF THE TREASURY BUILDING NOW IN PROCESS OF ERECTION, SHOWING ITS LOCATION IN REFERENCE TO THE ADJACENT STREETS AND PUBLIC SQUARE ON WHICH IT IS LOCATED, ITS ELEVATION, THE NUMBER AND SIZE OF THE ROOMS IT WILL AFFORD SUITABLE FOR OFFICE BUSINESS AND THE NUMBER AND SIZE OF THOSE SUITABLE ONLY FOR THE DEPOSIT OF RECORDS.

PRESIDENT MARTIN VAN BUREN

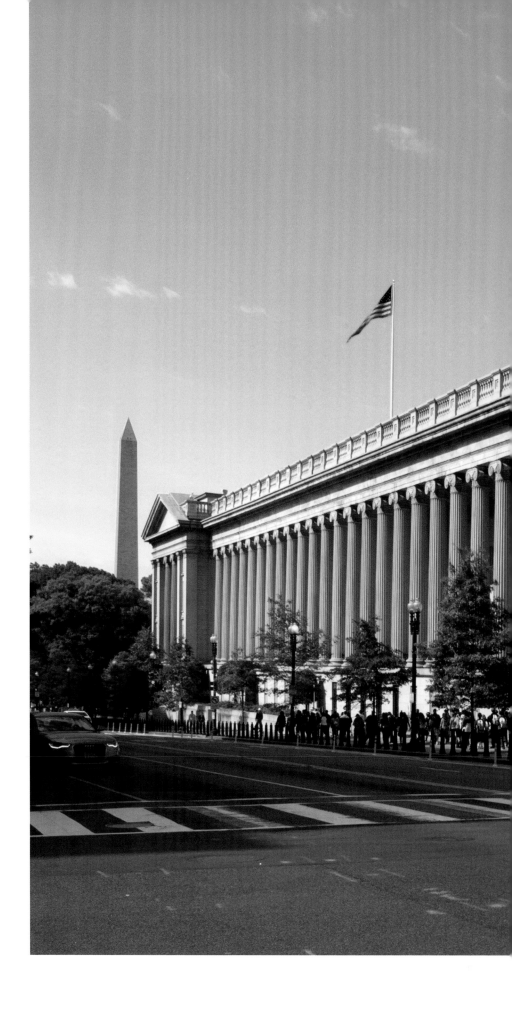

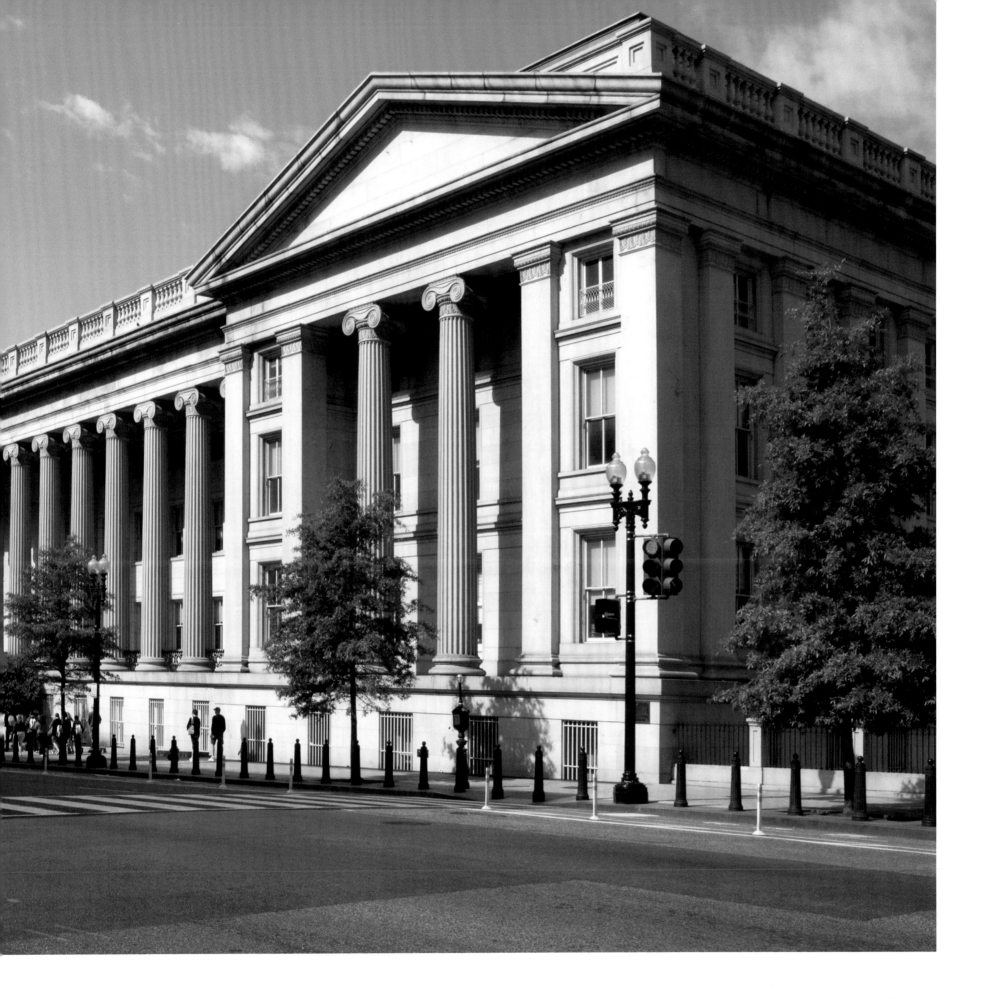

THE WHITE HOUSE NEIGHBORHOOD ALWAYS HAD ITS BANKING HOUSES

While Congress holds the purse strings, a president stays close to the purse, as does commerce. The White House neighborhood thus always had its banking houses, many in close proximity to the Treasury. Two bank buildings are located appropriately across Pennsylvania Avenue from Treasury. They no longer serve their builders. Riggs Bank, built in 1902, is the middle structure between the west corner Treasury Annex and the American Security and Trust Building of 1904 that wraps around the east corner. Both represent distinguished Washington business families. George W. Riggs was partner to W. W. Corcoran in the original bank, while the American Security and Trust Company Building began as an investment of Alexander Graham Bell's family. Neither institution has survived by name since the late twentieth century. They are both very fine buildings, honoring the great Treasury's north facade across the street. Their designs,

however, are not Greek Revival like the Treasury, but in the Beaux-Arts mode popularized in the main exhibition buildings of the Chicago World's Fair of 1893. The Beaux-Arts refers to a manner of teaching architecture in the famous French École des Beaux-Arts in which the student is immersed in the monuments of the past, measures them, knows them in person, and uses what he learns to create a *modern* architecture, history flavored, but never copied directly.

Riggs Bank, appearing to be one-story, greeted the visitor with a thundering ground-floor banking room, a monumental marble and bronze interior only more splendid than the same sort aspired to at the time by banks all over the United States. The American Security Building, which follows Riggs's lead in design, also appeared externally to be one tall story, massive in granite construction over steel frame and orderly in its neoclassical de-

tailing. Around the corner an Ionic colonnade, reflecting the Treasury's colonnade in the next block south, rises from ground level and overshadows Fifteenth Street. The interior is a very richly finished office building, walled in a wide variety of marbles, with trim in brass, bronze, and mahogany. Together Riggs Bank and the American Security Building, which appear to be one, effectively balance the massive Treasury they face across the avenue, without imitating it.

The National Savings and Trust Company, across the street from the American Security Building (now SunTrust) could not be more different in its architecture. Of course it is earlier, 1888, a romantic, even amusing pile in earth-colored red brick. It noses up to the corner of New York Avenue and Fifteenth Street like a ship, its lofty clock tower, with oriel windows, a fanciful bow. For all the larger and more magnificent banking houses and public buildings nearby, the National Savings and Trust Company Building stands out as the anchor of that part of the White House neighborhood, a curious—indeed delightful—Victorian intruder among the surrounding neoclassical buildings.

The Ohio architect Cass Gilbert, who moved to New York about 1900 and became one of the greatest practitioners of the Beaux-Arts in American architecture, built the Treasury Annex. Most of Gilbert's buildings, and certainly those in the White House neighborhood, took the neoclassical route to interpreting the principles of the French Beaux-Arts, borrowing from the Renaissance primarily. He could have selected Gothic or Elizabethan as his base and have been just as securely "Beaux-Arts."

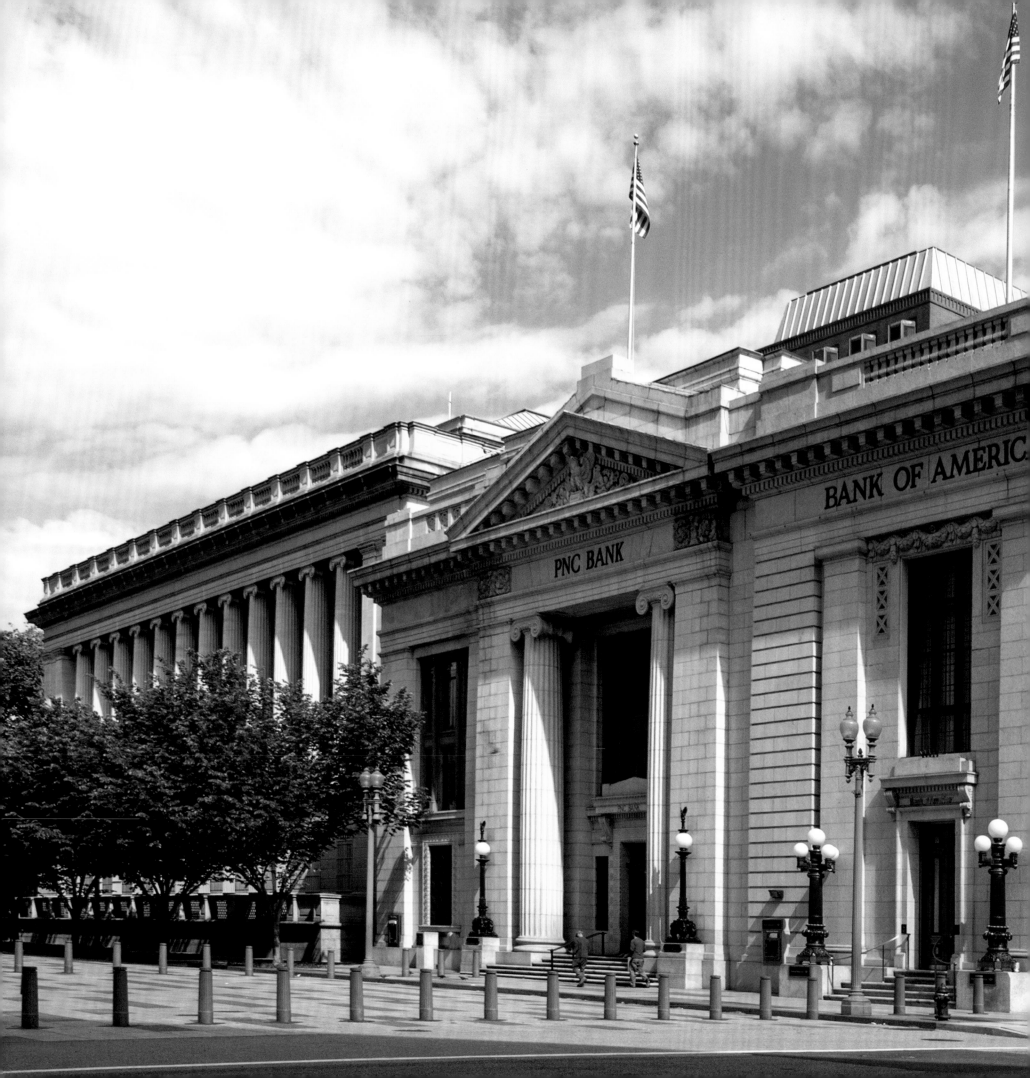

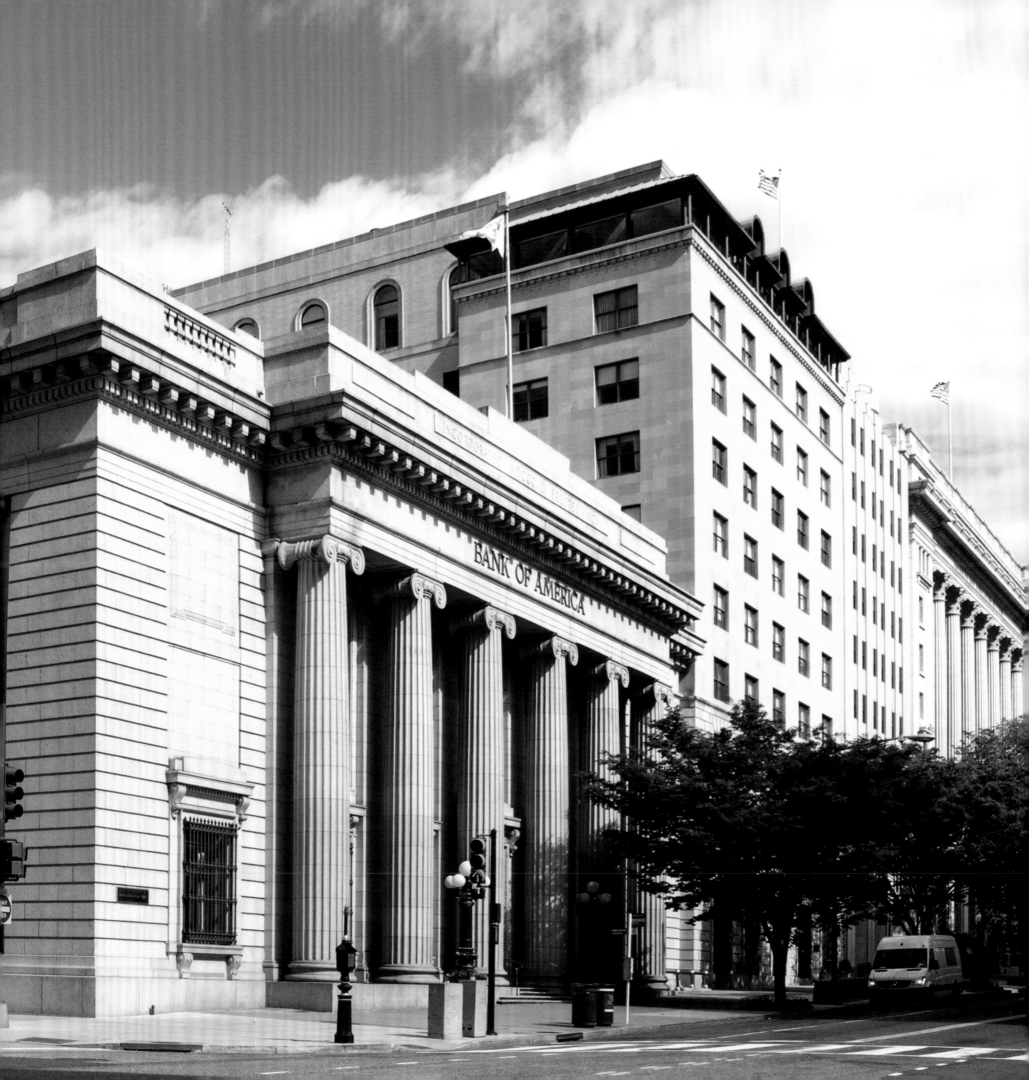

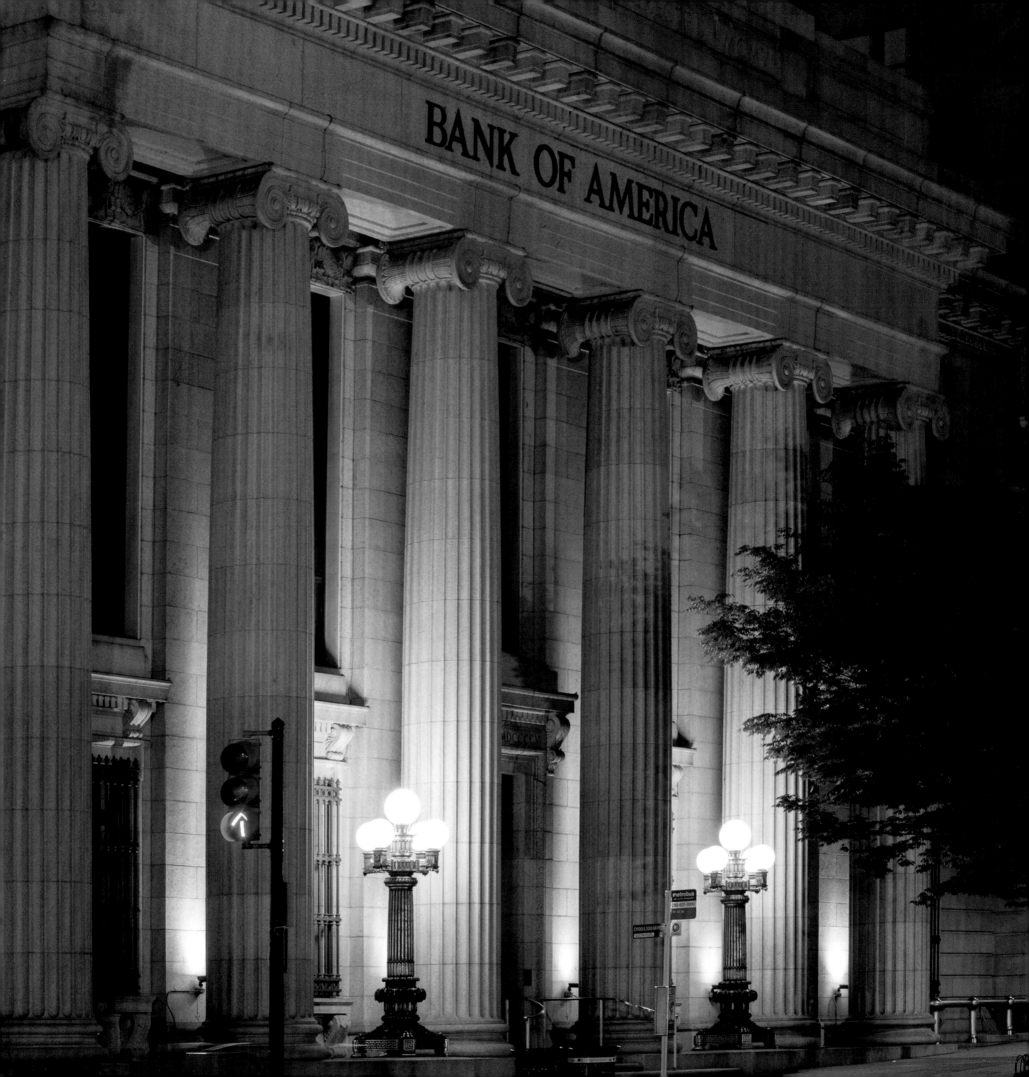

THE RIGHT TO BORROW AND COIN MONEY AND
TO FIX ITS VALUE AND THAT OF
FOREIGN COIN ARE IMPORTANT TO
THE ESTABLISHMENT OF A NATIONAL
GOVERNMENT.

PRESIDENT JAMES MONROE
SPECIAL MESSAGE TO THE HOUSE OF REPRESENTATIVES

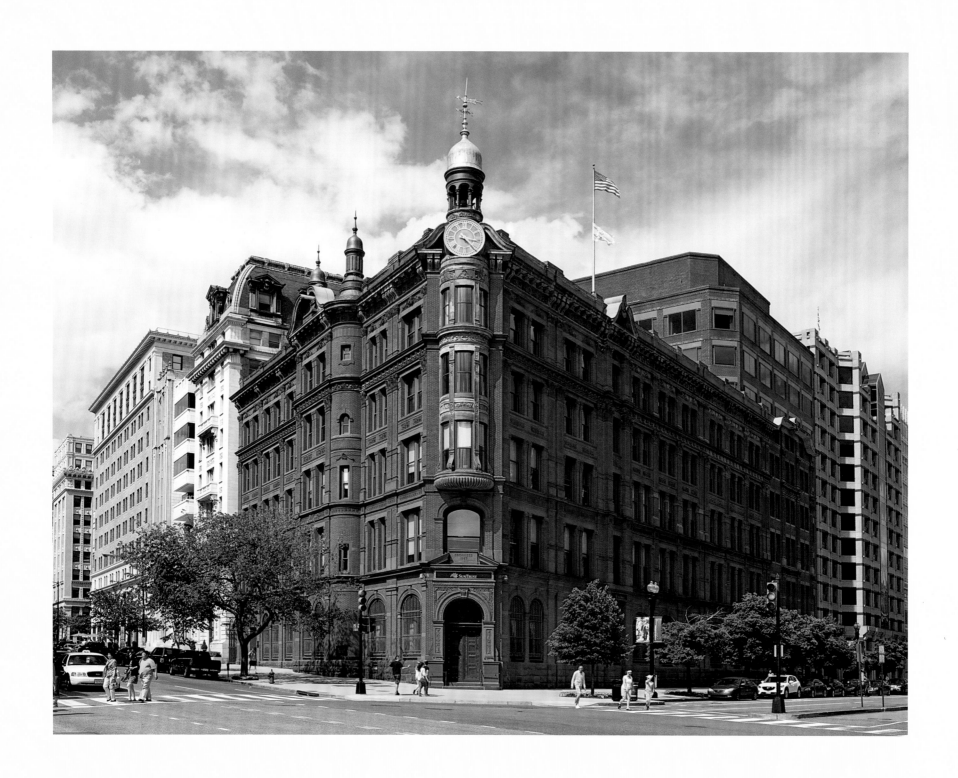

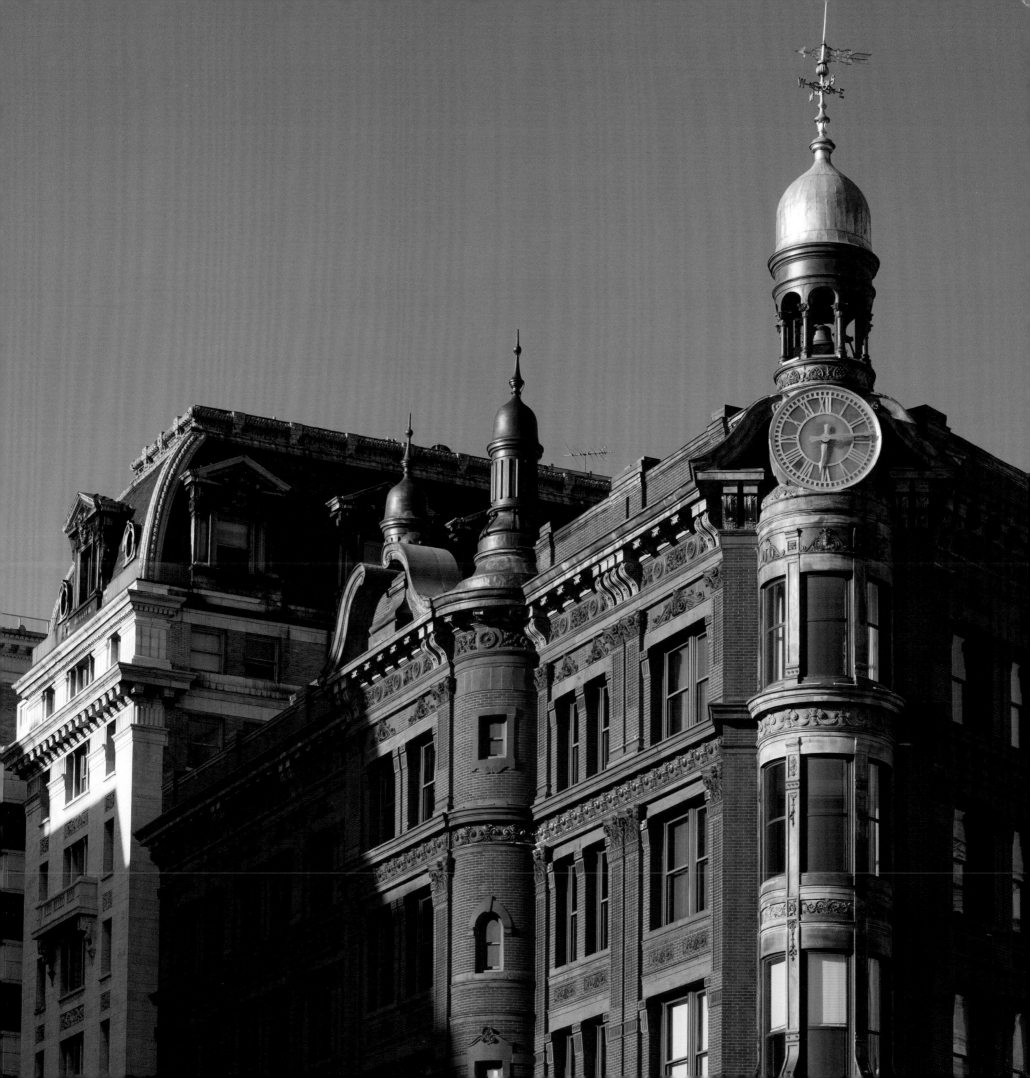

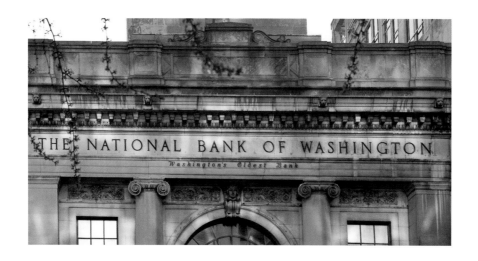

I AM NOT INSENSIBLE OF THE GREAT DIFFICULTY
THAT EXISTS IN DRAWING A PROPER PLAN
FOR THE SAFE-KEEPING AND DISBURSEMENT
OF THE PUBLIC REVENUES, AND I KNOW
THE IMPORTANCE WHICH HAS BEEN ATTACHED
BY MEN OF GREAT ABILITIES AND PATRIOTISM
TO THE DIVORCE, AS IT IS CALLED, OF THE
TREASURY FROM THE BANKING INSTITUTIONS.

PRESIDENT WILLIAM HENRY HARRISON

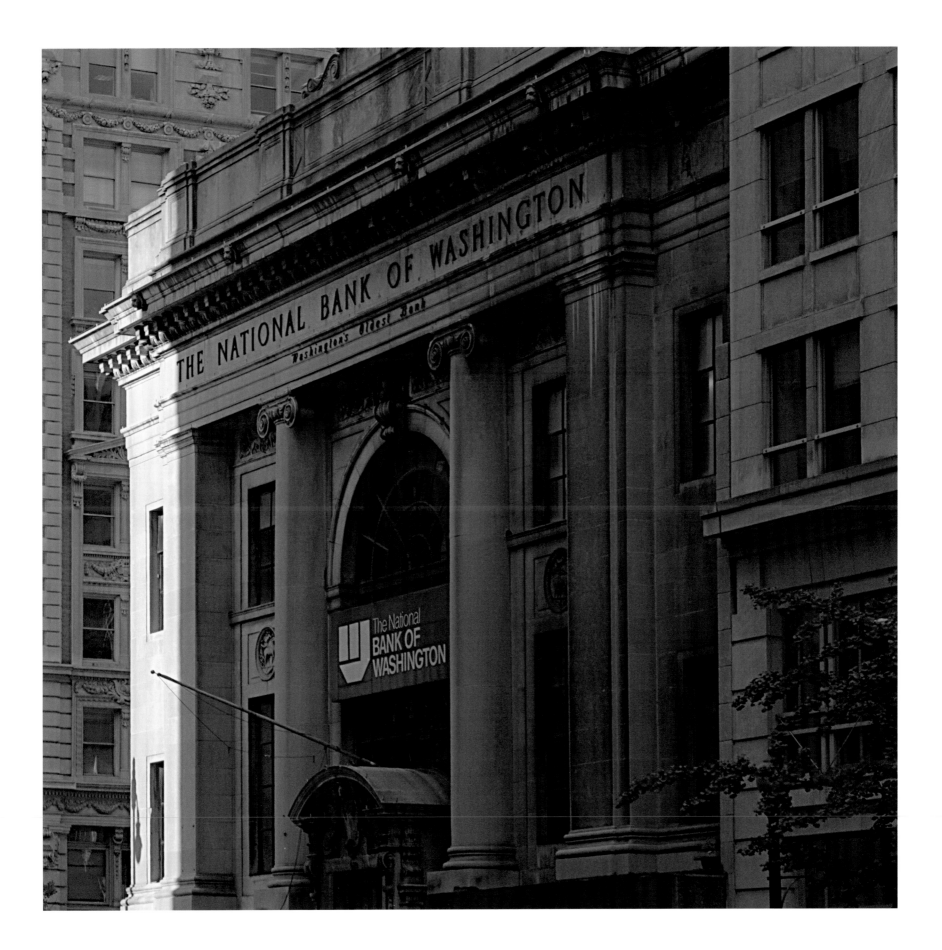

ARCHITECTURE RICH IN EMBELLISHMENT

Architecture in the White House neighborhood is sometimes rich in embellishment. The earliest is the 14-foot carved swag, a garland of flowers, fruit, and griffins, above the North Door of the White House. Probably the finest example of architectural carving in eighteenth-century America, the sandstone swag, carved by a Scottish mason, survived the burning of the house in 1814 and casts a symbolic power over nearly every building in the neighborhood. The familiar image of the White House, a distant view with porticoes, does not include details of the stone carving, and it is often missed even by those who visit. The modern glass towers that seem to hover at the neighborhood's edges, in their naked simplicity of mirror surfaces, seem foils to that earlier creation.

Commercial buildings in the neighborhood along Fifteenth Street are usually exceptionally ambitious in carved details, setting off smooth marble on granite walls. These are essentially office buildings in which external grandeur—the garlands, cherubs, and extra detailing—may extend into the ground-floor hall, but the rest behind the facade is simple, functional office space, be it a building of 1900 or 2000.

Ornament varies. Predominant are reflections or even clear examples from ancient times in Doric, Corinthian, Ionic, and Tuscan columns. Greek key borders are familiar in the Beaux-Arts–inspired structures, both private and public—eagles, acanthus leaves, animals, urns, and drapery. The disapproval of John Adams and

James Monroe of "nudities" in domestic ornament casts not a shadow.

In contrast, B. Henry Latrobe introduced at St. John's Church and Decatur House the fashionable British Plain Style, which found ornament in its own shapes and forms. Decatur House is a near cube of red brick, probably washed in a lime wash tinted a deep red to give uniformity to the walls; the unadorned walls on Jackson Place and in streets are ornamental by their carefully proportional openings—windows and a fan-transom front door announcing the entrance—and by a necklace of a roof overhang following a simple vernacular pattern of exposed "rafters," suggesting farmhouses in France and Italy. The more subtle ornamentation of the 1880s is likewise seen in color and form, with carving often rich but restrained, suggesting sometimes Turkish tradition or Romanesque, in polished granite, heavy stone arches, towers, and iron-studded doorways. By the 1870s, even the simplicity of Latrobe's Decatur House displeased General Edward Beale, who lived there then, and he added heavy stone hoods over the windows and likewise framed the front door. Restoration work in the 1940s removed these additions, exposing the original detailing of Decatur House, which we see today.

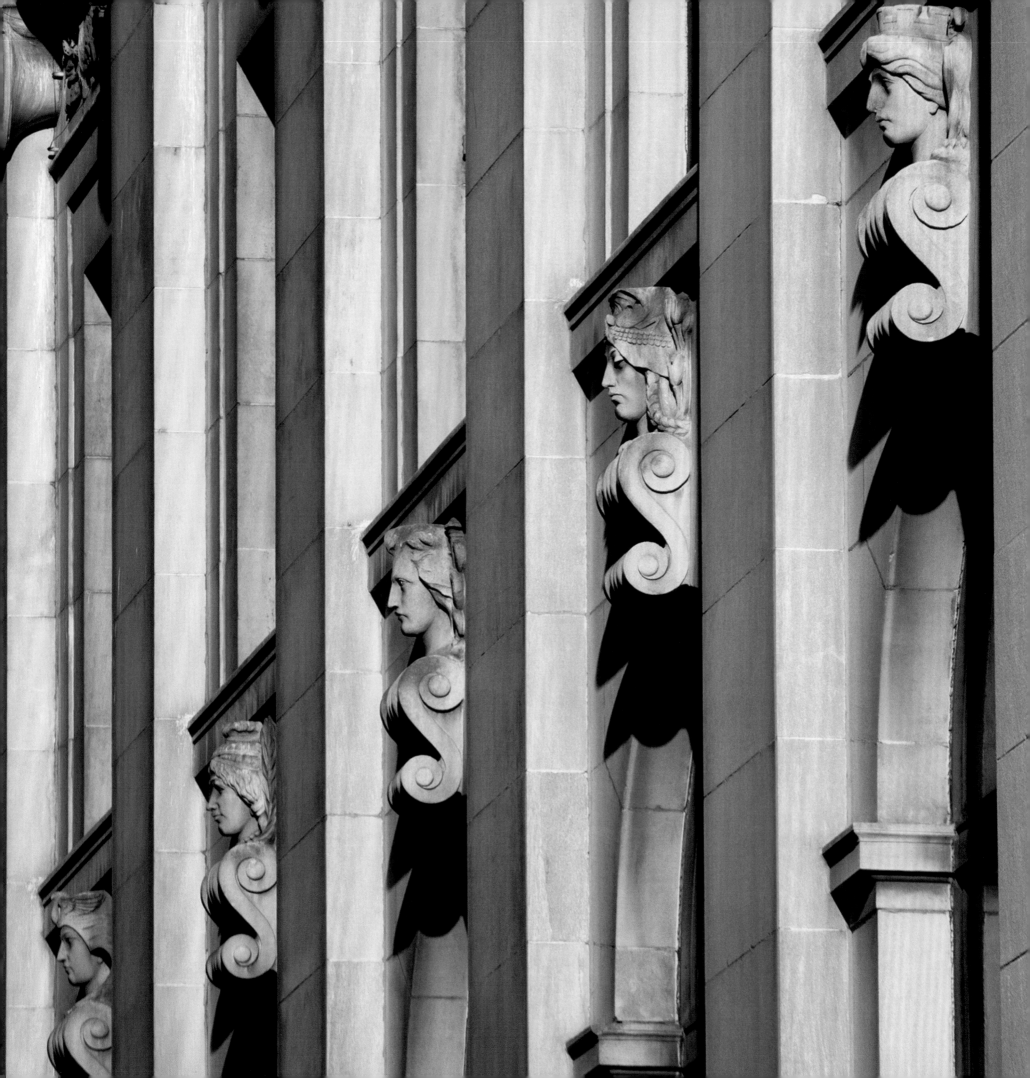

Today we honor the living symbol of
our democracy, the American bald
eagle. It was, in fact, on July 4th, 1776,
the very day the Declaration of
Independence was signed, that our
Founders first considered the ques-
tion of a fitting emblem for our
Nation. . . . Finally, six years later, the
Continental Congress approved a
design for the Great Seal of the United
States, a proud bald eagle, wings
stretched wide, an olive branch in one
claw, 13 arrows in the other,
"A free spirit," said Thomas Jefferson,
"high-soaring and courageous."

President William Jefferson Clinton
on the removal of the American Bald Eagle
from the Endangered Species List

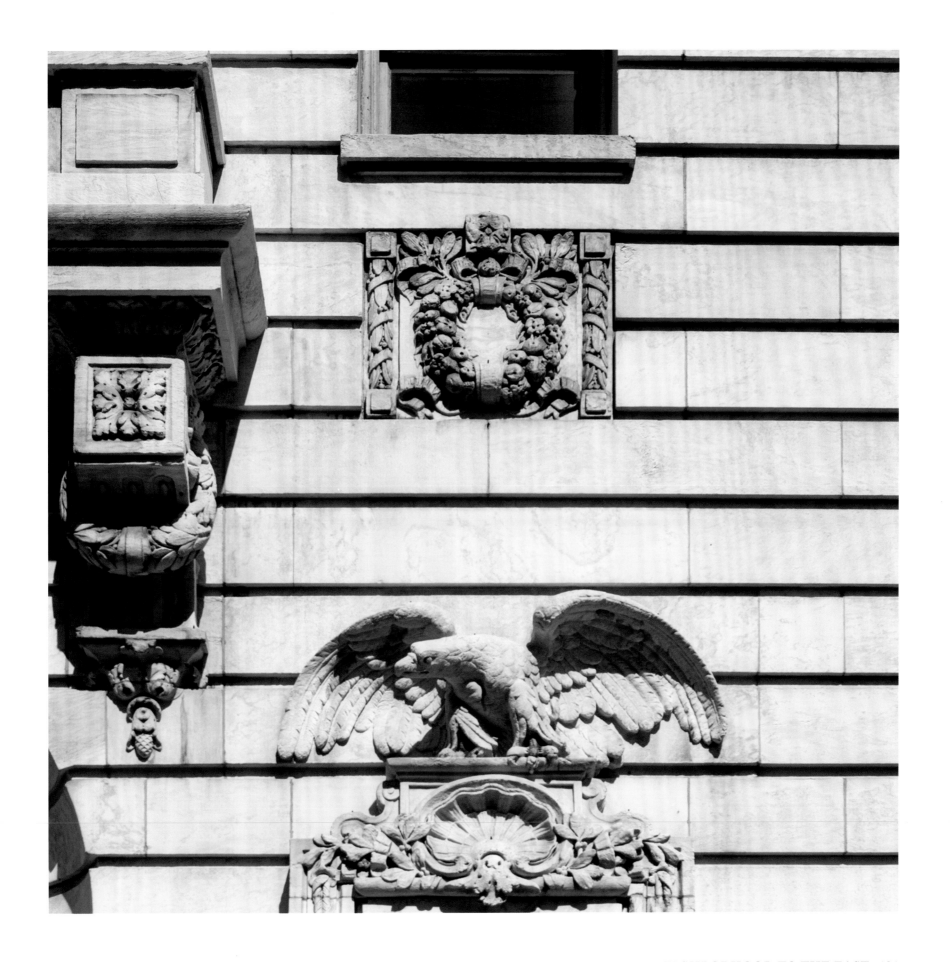

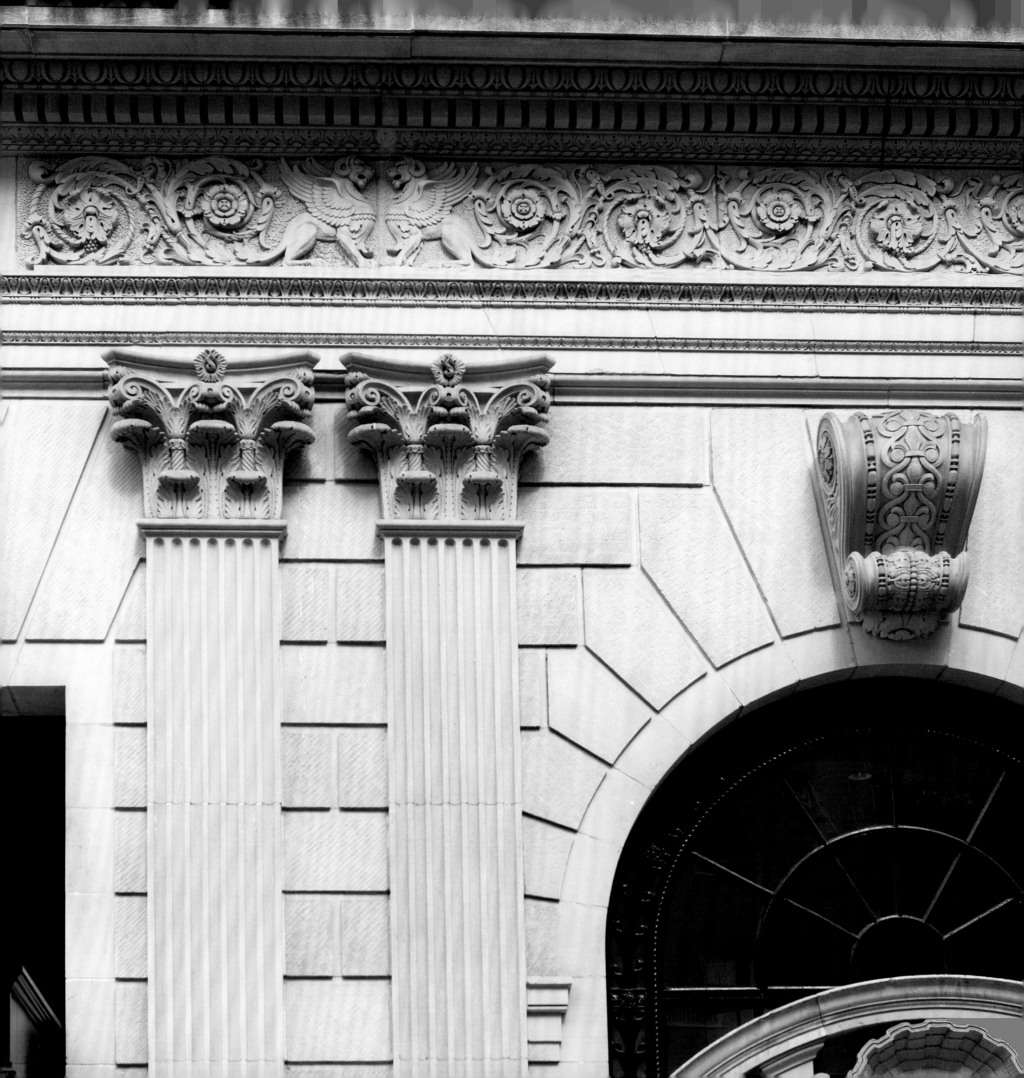

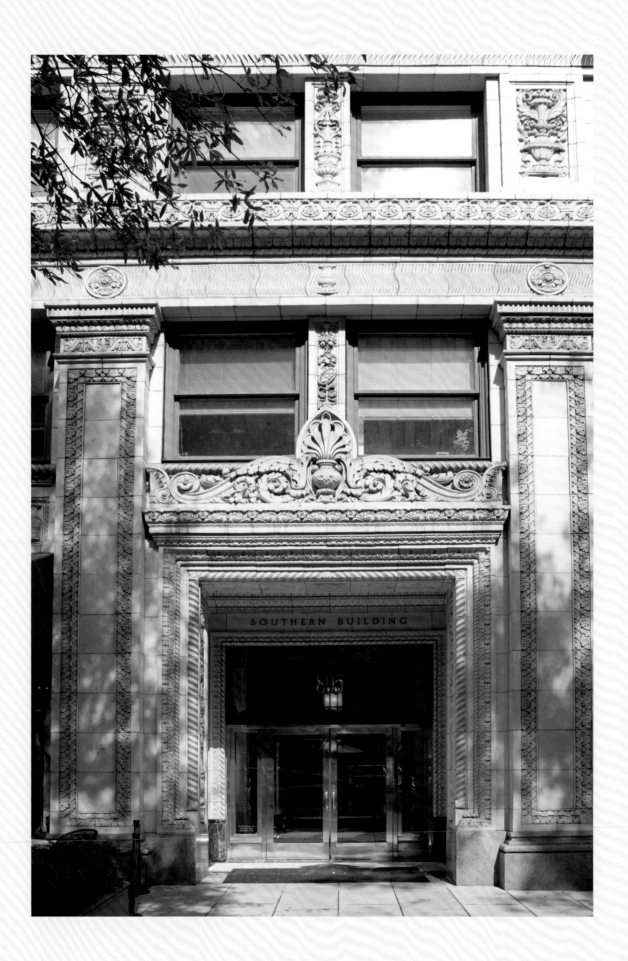

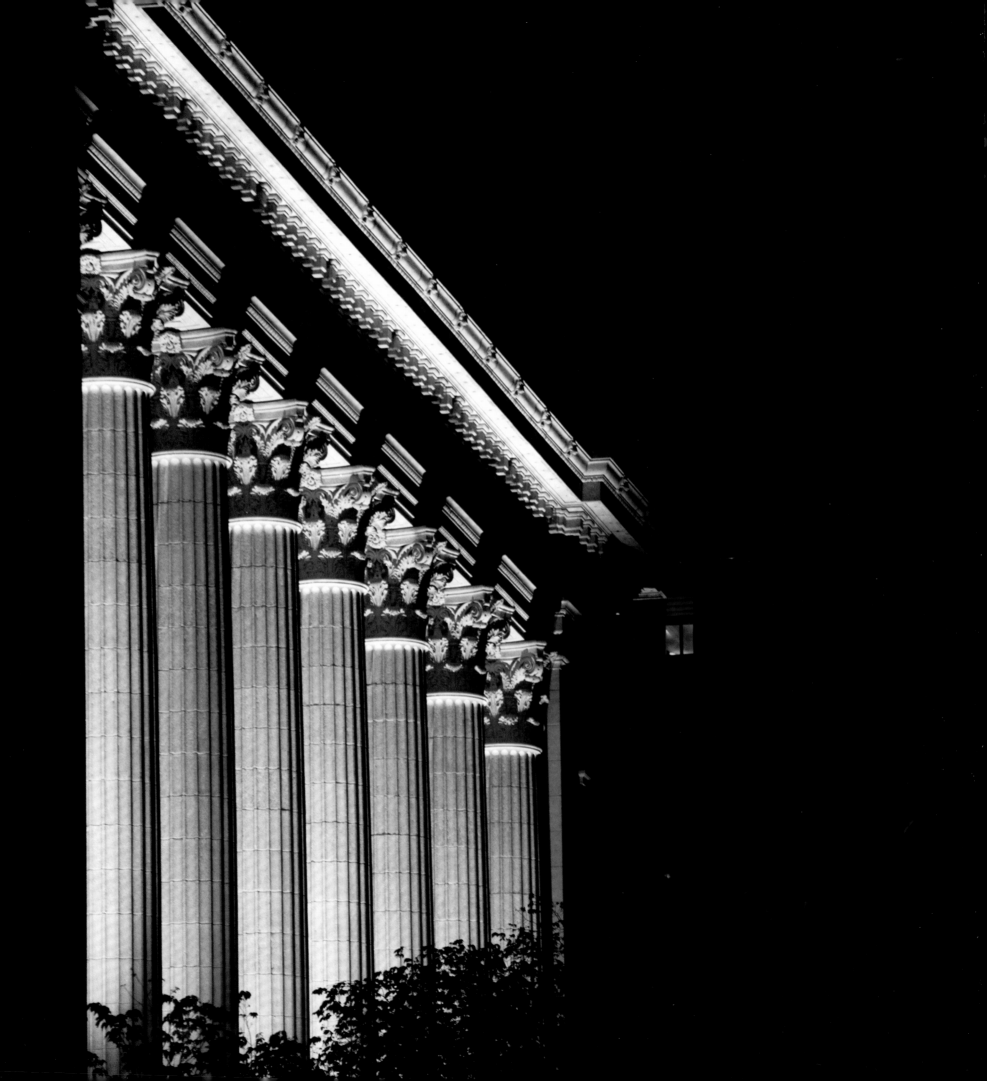

IF OUR COUNTRY WISHES TO COMPETE
WITH OTHERS, LET IT NOT BE IN THE
SUPPORT OF ARMAMENTS BUT IN THE
MAKING OF A BEAUTIFUL CAPITAL CITY.
LET IT EXPRESS THE SOUL OF AMERICA.

PRESIDENT CALVIN COOLIDGE

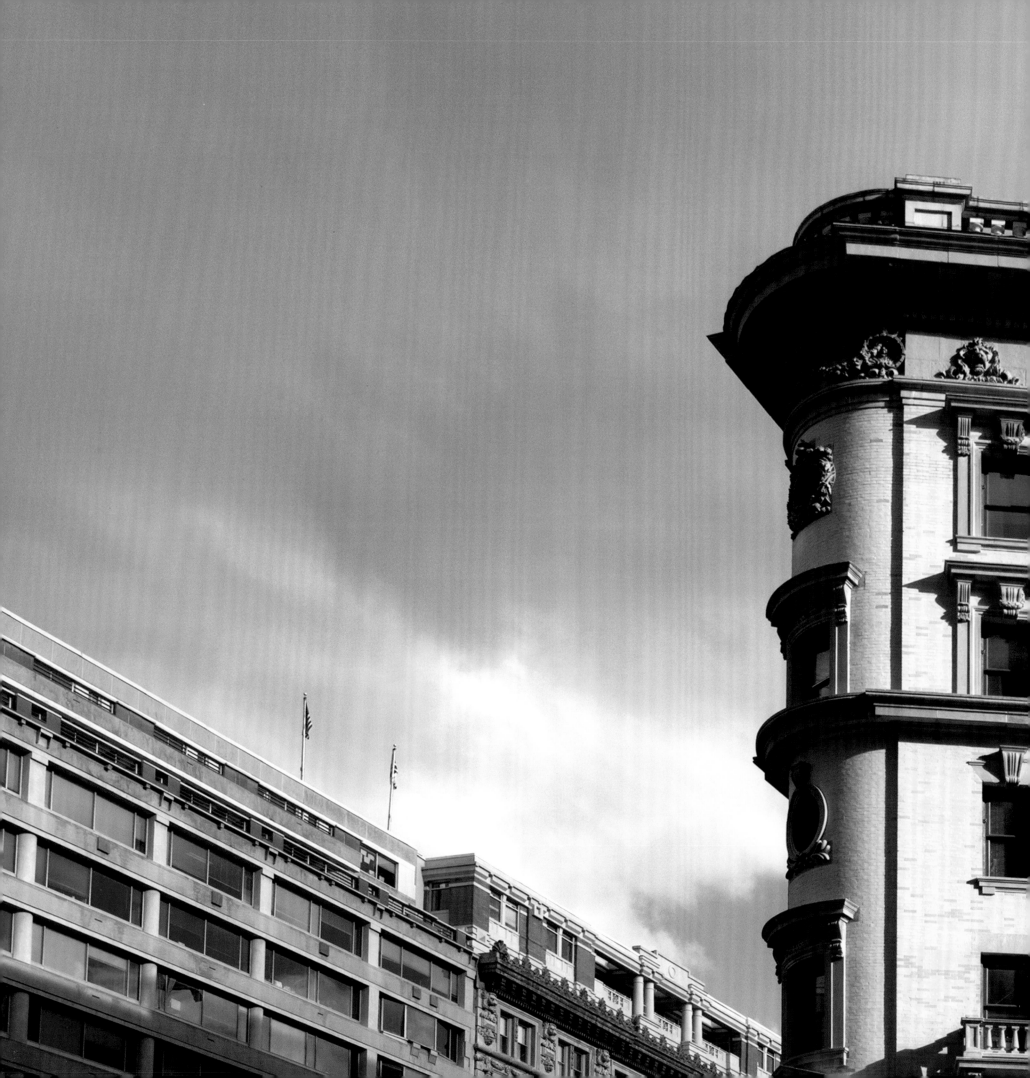

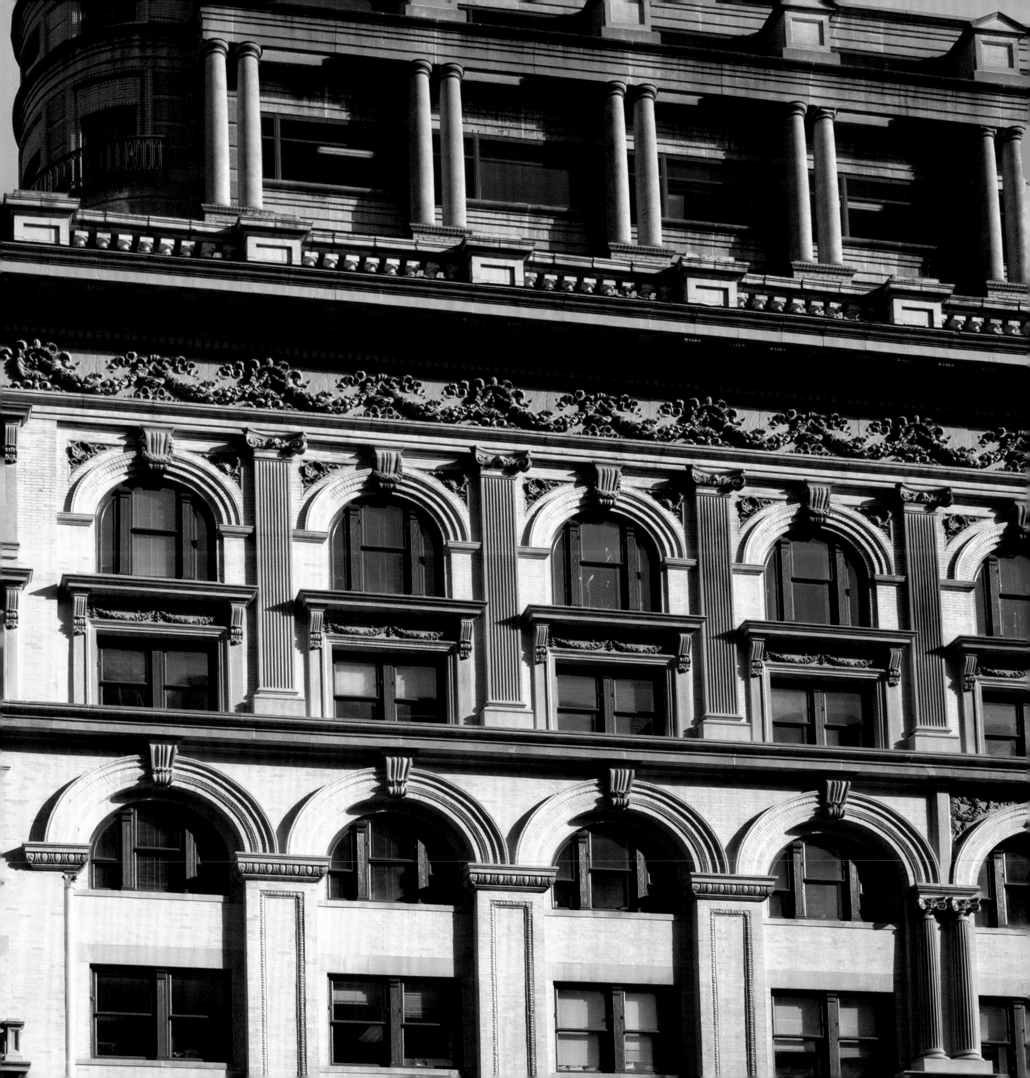

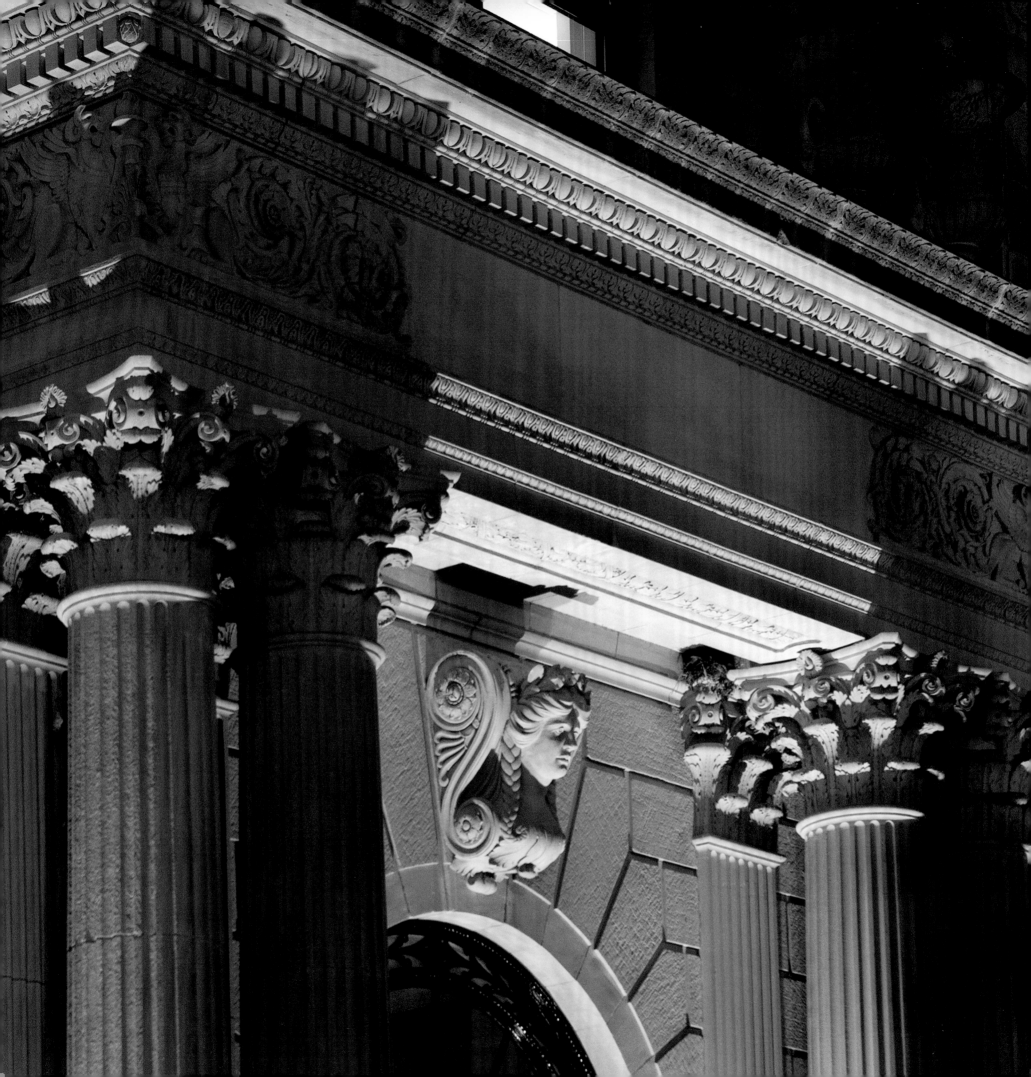

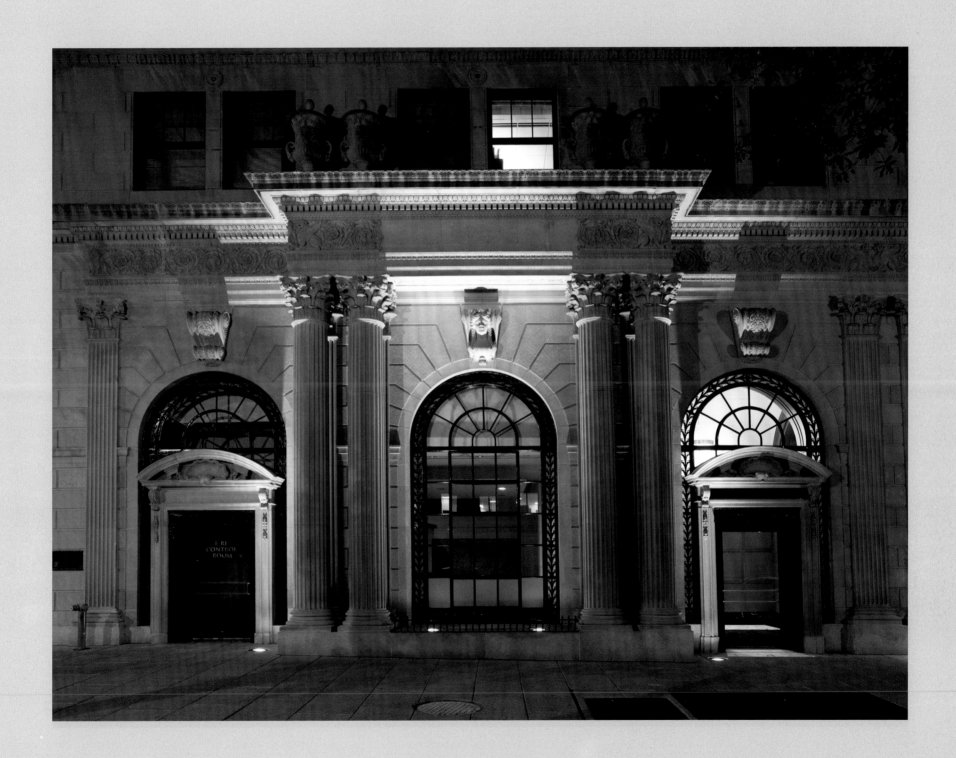

A SALOON FOR ALL SEASONS: OLD EBBITT GRILL

The Old Ebbitt Grill is a century-old Washington tradition and certainly the most elegant saloon-restaurant in town. Founded in 1856 and originally located somewhere in Chinatown, the Old Ebbitt Grill was purchased by William E. Ebbitt and became Washington's first known saloon. As an innkeeper, Ebbitt also used the building as a boardinghouse, and prominent guests such as Presidents Andrew Johnson, Ulysses S. Grant, Grover Cleveland, Theodore Roosevelt, and Warren Harding visited the premises. The location of the Old Ebbitt Grill changed several times over its years of operation. In the early twentieth century it occupied a building on Fourteenth and F Streets, now the National Press Club Building, and 1427 F Street. In 1970, the Old Ebbitt Grill was auctioned off to Stuart Davidson and John Laytham, owners of Clyde's Restaurant Group, and finally in 1983 the popular saloon moved to its current location at

675 Fifteenth Street. In its previous incarnation, before 1980, its mildly Tudoresque barroom interior was cramped and dark, if cozy and filled with celebration of the press and politics, heavy cigarette smoke, great bar food, and generous drinks. In 1984, the old building went with clearing part of the block for the present buildings. National outrage accompanied the loss of historic eighteenth-century Rhodes Tavern on the northeast corner of F and Fifteenth Streets, which was demolished in that same clearing.

When the wrecking ball took down the historic Rhodes Tavern, it was the oldest surviving building in downtown Washington. Built in 1799 by Bennett Fenwick, the building was sold to William Rhodes in 1801, who operated it as a tavern and inn until 1805. Throughout its rich history Rhodes Tavern housed

important political events and institutions. The City Commissioners, who supervised building the city in the 1790s, and not least the White House and Capitol, had met at Rhodes Tavern. The first city council election took place there in 1802, and in 1814 it became the Bank of the Metropolis, and in 1836 the Corcoran and Riggs Bank, and it served as the National Press Club from 1909 to 1914. By 1978, the block was ripe for redevelopment, and preservation organizations such as Don't Tear It Down (now the D.C. Preservation League) and Citizens Committee to Save Rhodes Tavern were formed to thwart the endeavor. The building was largely intact. All that was really gone from the original was the character of the street-floor interior, which had served every imaginably destructive purpose over time; upstairs, second floor and finished attic were intact, recognized and praised by historical architects. Nevertheless, demolition of the tavern, approved by the city against public opinion, was carried out. In June 1984, Rhodes Tavern fell very quickly before the bulldozer, and its loss is regretted. All the then-existing buildings of the west side of the block are gone, replaced by an impressive group of white marble structures that honor Washington's Beaux-Arts tradition.

Bypassing sour grapes, one can readily say that the Old Ebbitt Grill, relocated around the corner to Fifteenth Street, and next door to where Rhodes Tavern stood, is a worthy memorial. Lots of bricks and mortar are gone, but great food and drink remain. The new marble facade seems to belong to the neighborhood, and the interior's design is by no means prudish.

It's not every day you find a restaurant
that can boast a bar that's served
Grant, Cleveland, McKinley, Roosevelt,
and other presidents.

Nation's Restaurant News, 1970

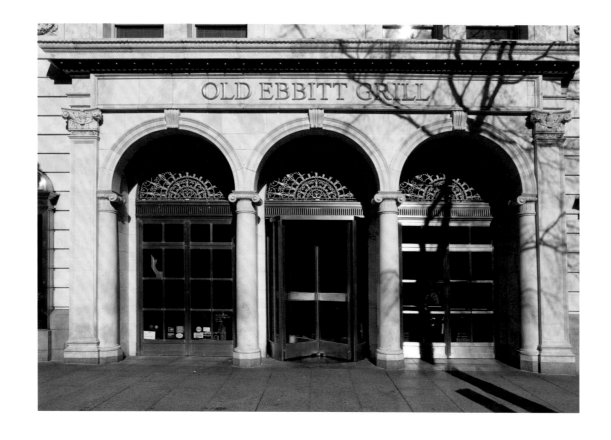

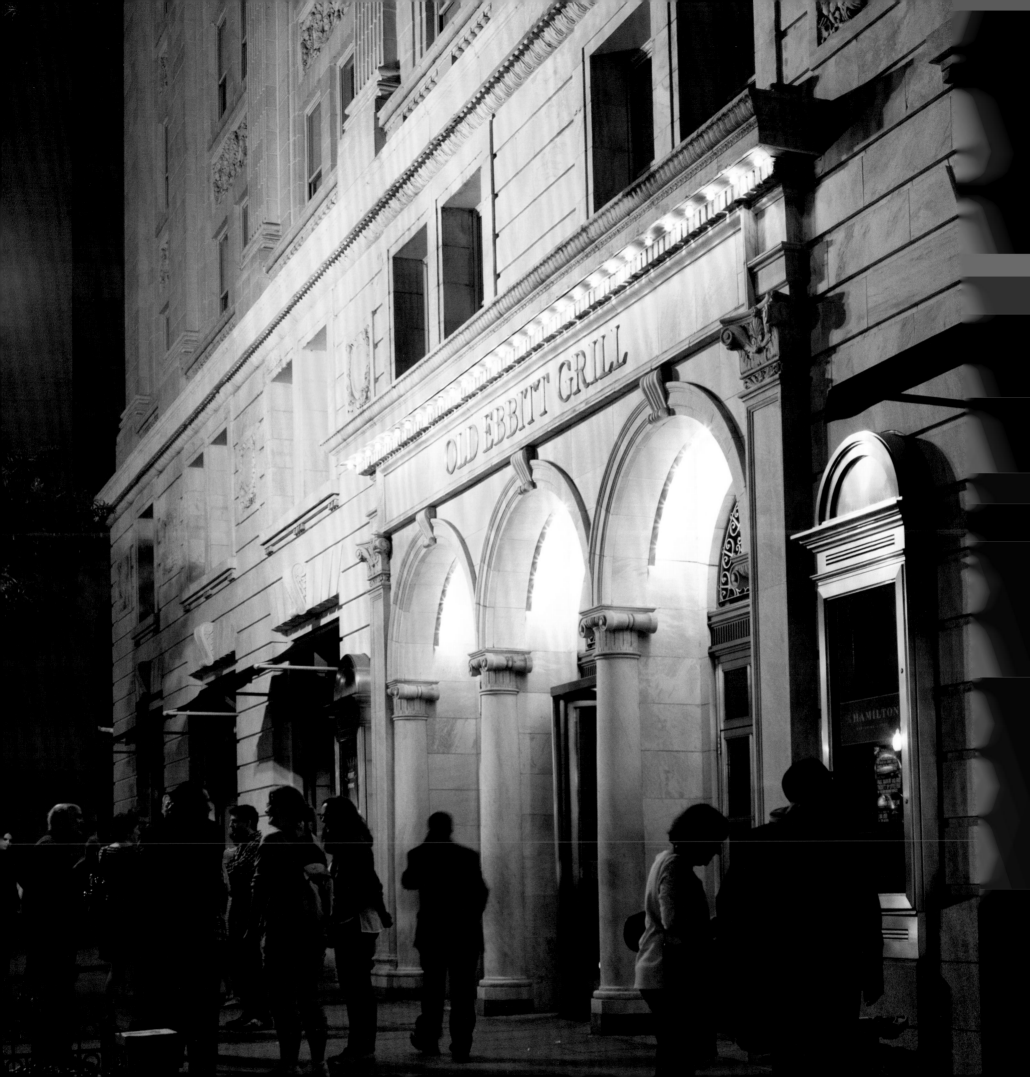

SPLENDID LOBBIES WERE AGAIN FILLED WITH GUESTS

The Willard Hotel is slightly outside the White House neighborhood, but no account of Washington hotels near the White House could ever omit it. Several hotels have stood on the site since 1818, the Willard presence dating to 1847. The present monumental late Second Empire Willard was opened in 1901, its architecture clearly acknowledging that of the fading grand dame, the Arlington Hotel. Some of the most famous people in America have stayed at the Willard during its long history. Abraham Lincoln would top the list, when he declined many private invitations and moved to the Willard for more room and public access, not to mention convenience for Allan Pinkerton's astute protection services.

Others scratched their pens on the Willard's register: Emily Dickinson, Walt Whitman, the numerous Japanese embassy of 1860, and Clara Barton. Calvin Coolidge lived at the Willard while Warren G. Harding's vice president. Many presidents checked in before their inaugurations and move to the White House.

Time saw the Willard decline. In the early 1970s it was an abandoned building. Developer Oliver T. Carr rescued it, and apart from the verbal cuffs he received for demolishing nearby equally historic buildings, notably the eighteenth-century Rhodes Tavern, his hotel emerged in triumph, the restored Willard, the oldest hostelry in Washington, restored not only in bricks and mortar but restored to life. Its splendid lobbies were again filled with guests. The famous Peacock Alley resumed its lush palm-lined way as an exotic place in which to see and be seen for a cup of tea or to receive a secret letter. The exterior itself for so long gloomy and neglected, was alive again with playful additions to accommodate the new spaces needed in a modern grand hotel.

Another hotel operated continuously is the Hotel Washington (now the W Hotel), adjacent to the Willard on the edge of the White House neighborhood. Opened during World War I in 1918, this highly decorative structure makes a sharp contrast to the Greek Revival Treasury Building across the street. It was designed by the New York–based architects Carrère & Hastings, who, though better known for classical architecture, did have a predilection for French style, which is quite evident in the "French modern" and other European touches. Carrère & Hastings also built the more traditionally neoclassical or "Beaux-Arts" Senate and House Office Buildings.

These hotels stand at the northwestern end of Pennsylvania Avenue. No place can be more symbolic of the "New Washington" that began with President John F. Kennedy's brief administration. The area was run down and bland looking, rather seeming a set for a movie about an abandoned city. Through it all, the decline, which had begun around World War II, the Hotel Washington had stood its ground, owned and maintained by the Moody Foundation in Texas. The Willard was a relic with a population of pigeons; the Occidental restaurant next door was closed. Like a bouquet of flowers, the area in the 1970s seemed to pop up in color, and the Willard returned to life, the Occidental resurrected as a great seafood restaurant, and a combined support of private development and governmental participation wholly polished away the smell and look of ruin.

One can interpret the rebirth of this area as emblematic of the renaissance of the inner city, creating the sort of quasi commercial-governmental "downtown" common to capital cities the world over.

THE GREAT SIGHT OF AMERICA
AT SUCH A TIME AS THE PRESENT
IS THE CROWD AT WILLARD'S HOTEL. . . .
THEY REPRESENT NOT ONLY THE
WEALTH OF THE NATION BUT,
EMPHATICALLY, ITS BUSINESS ENTERPRISE.

NATIONAL REPUBLICAN, 1867

W<small>ILLARD</small>'<small>S</small> H<small>OTEL COULD MORE JUSTLY</small>
<small>BE CALLED THE CENTER OF</small> W<small>ASHINGTON</small>
<small>AND THE NATION THAN EITHER THE</small>
C<small>APITOL OR THE</small> W<small>HITE</small> H<small>OUSE OR</small>
<small>THE</small> S<small>TATE</small> D<small>EPARTMENT.</small>

N<small>ATHANIEL</small> H<small>AWTHORNE</small>, 1861

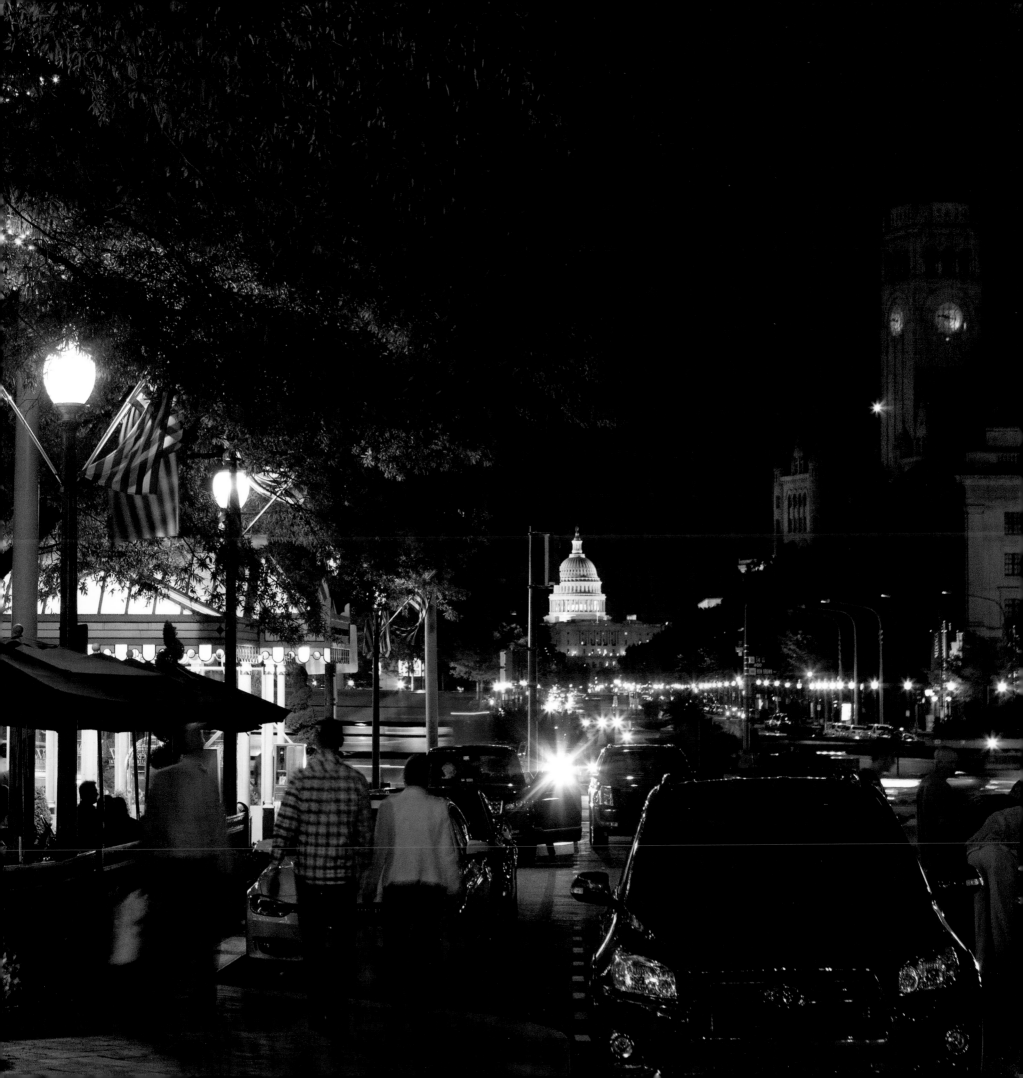

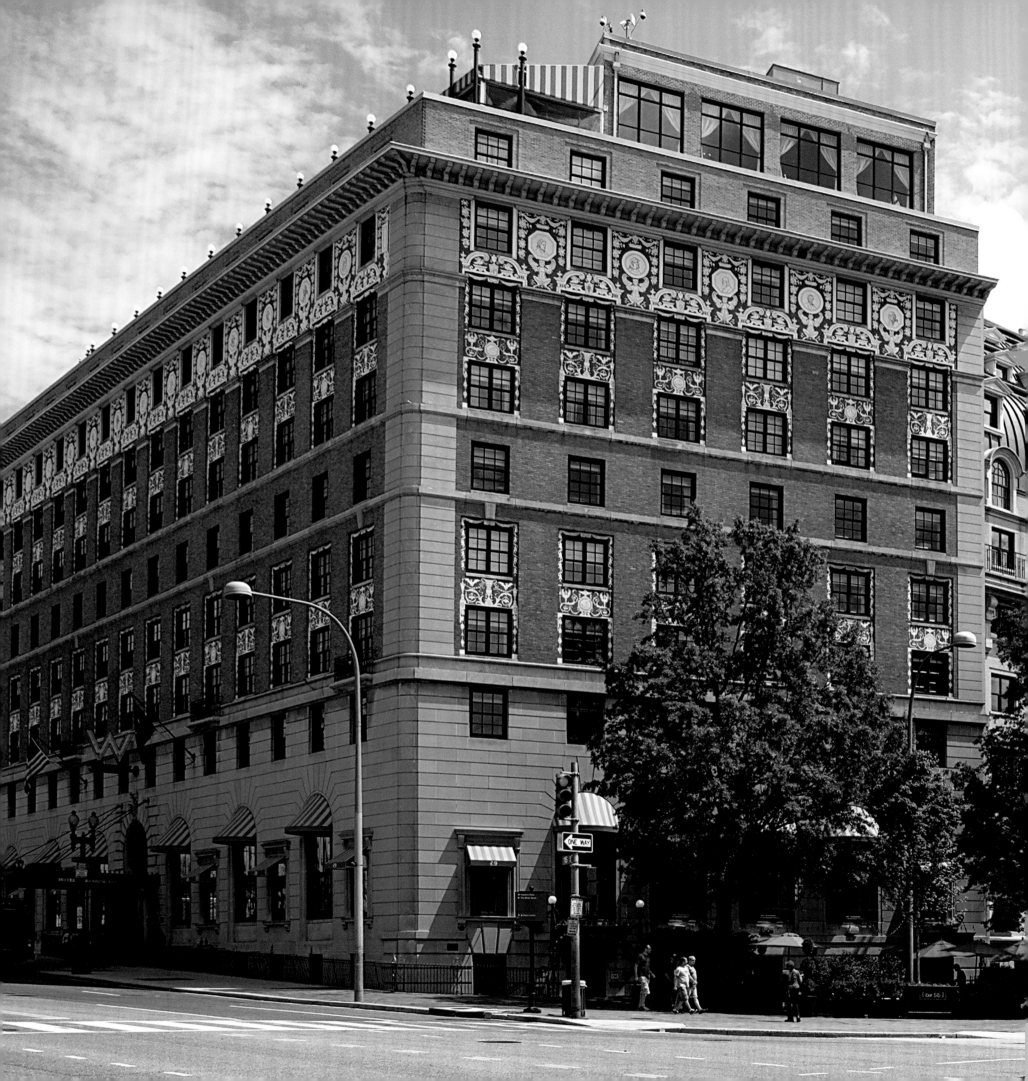

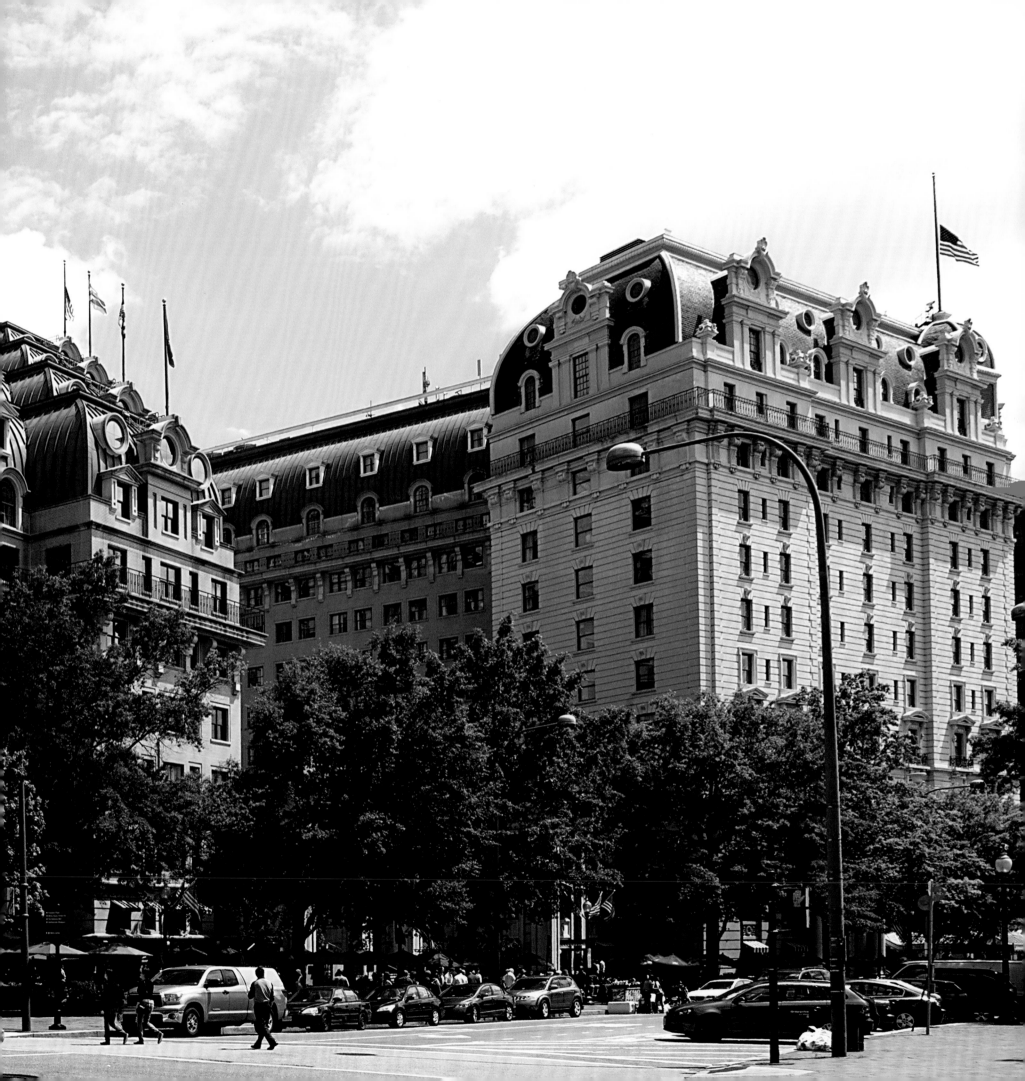

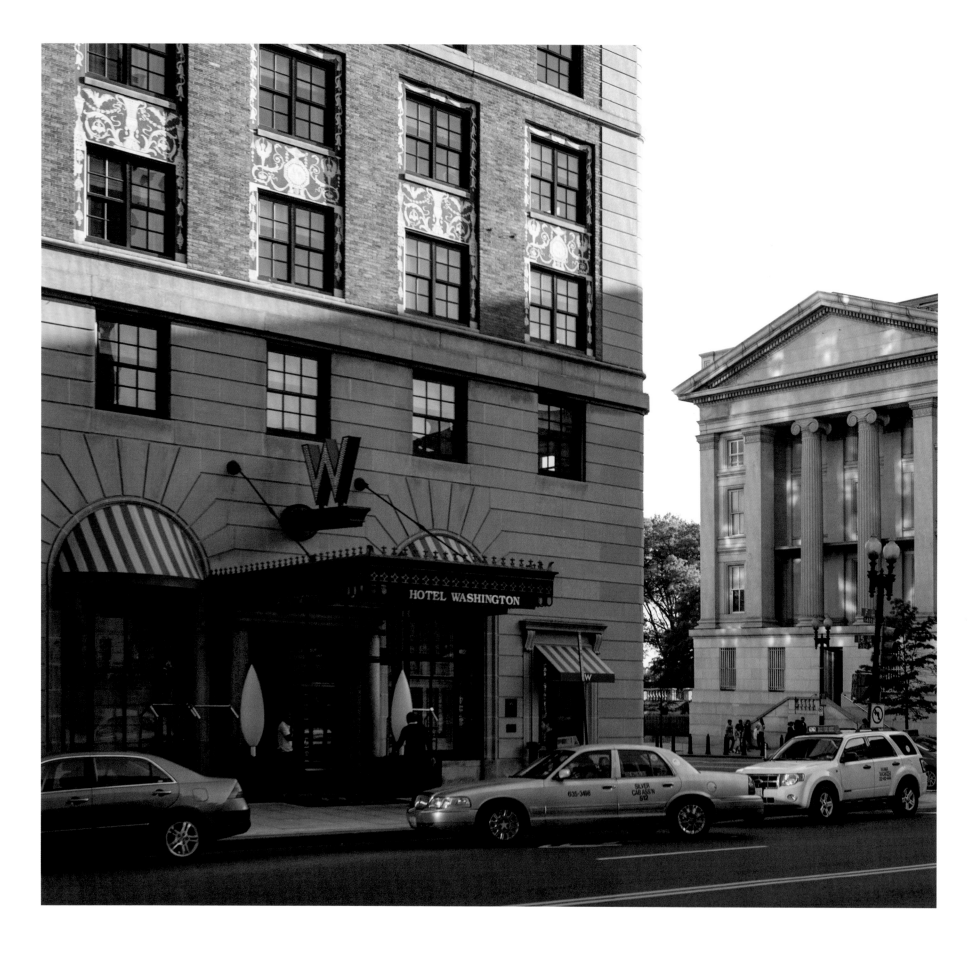

Good morning, and welcome to the Rose Garden. In a moment you can come up and welcome our guest of honor, Stars the turkey. He looks pretty friendly. He actually looks well rested. You'd be well rested, too, if you had your own room in Hotel Washington here in Washington, D.C.

President George W. Bush
Remarks at the 2003
Thanksgiving Turkey Pardoning Ceremony

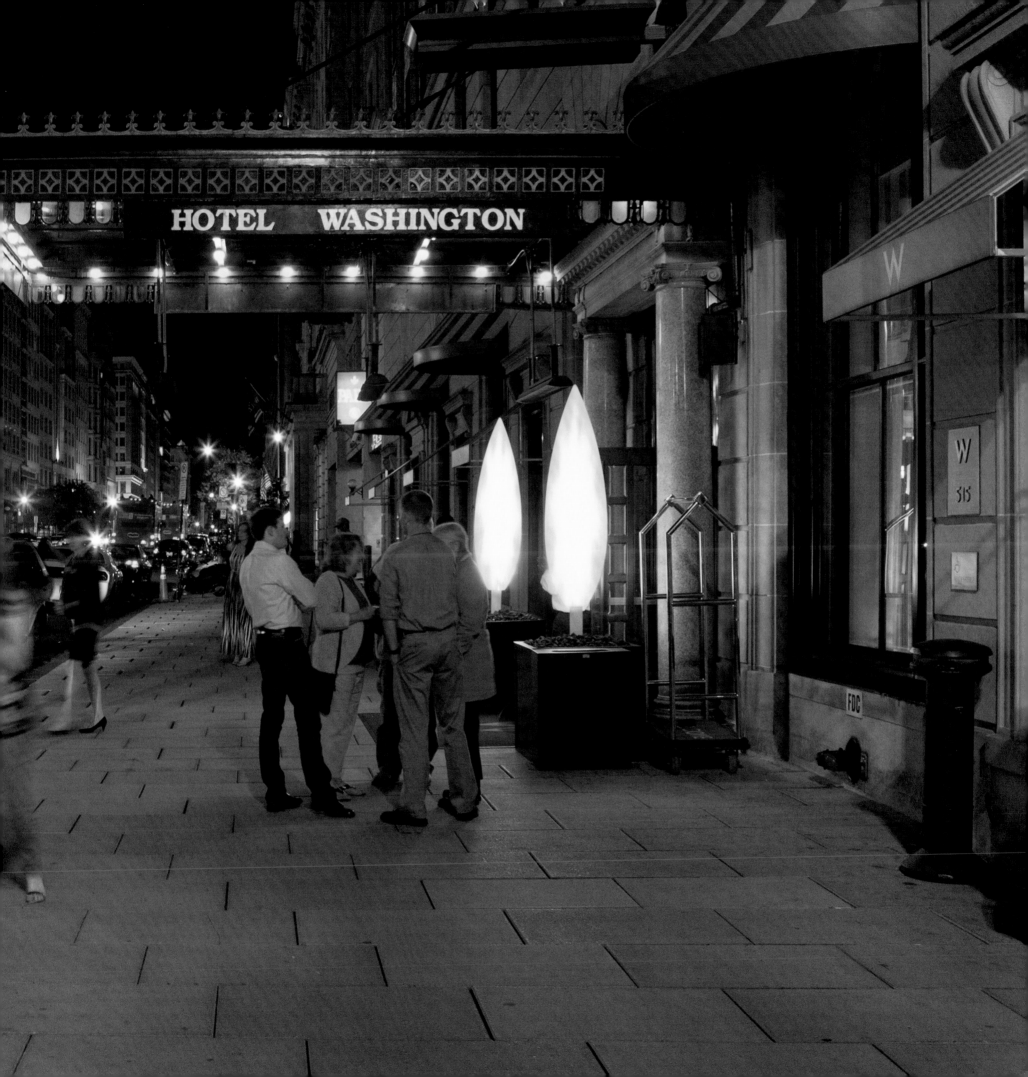

THE WHITE HOUSE NEIGHBORHOOD HAS NEVER LACKED FOR PRIVATE OFFICES

Once entirely residential, the blocks surrounding the White House today contain far more business rentals than residents. Neighborhood buildings not directly associated with the government house thousands of professional and nonprofit associations and societies, lawyers, and commercial ventures. Until the 1970s, when Washington began to "take off" in an urban way, the neighborhood streets were dark and seemed abandoned. They now teem with activity as the workers—goverment and private—enjoy restaurants and shops, the tranquil parks, and the satisfaction of being so near the executive center of the federal government.

Entrepreneurs and services swarm to capitals, and from its beginning around 1800, Washington had been no exception. The White House neighborhood has never lacked for private offices,

law firms in particular, with reason to be near Congress, lobbying or representing clients. Today Washington has a greater concentration of lawyers than any other city in the United States, and unemployment among them is almost nonexistent. The eyes of lawyers constantly view the White House from tall buildings on Pennsylvania Avenue, and their offices occupy leased spaces on Fifteenth Street, and Connecticut and New York Avenues.

Creating sufficent work space for public employees has always been a challenge and duty for federal administrators. When an individual department requests new office space, the job is turned over to the General Services Administration. In addition to its most visible work of maintenance and construction, GSA has taken a strong interest in the preservation of the huge inventory of historic buildings owned by the government.

Congress always keeps an eye on public building. An especially fine building in the past usually developed under the watchful eye of a member of Congress, who kept the budget together and saw to its enlargement if necessary. Today the government is very aware of building to accommodate modern design ideas, and restoring the old. It is hard to conceive of the great numbers of people who must be housed under one department. The president, for example, has his West Wing office building at the White House, accommodating his most intimate staff members. This flows wave-like from the wing into other buildings nearby, accommodating a presidential staff of more than three thousand in the White House neighborhood alone.

GSA puts out most of the architectural work to competition and actual construction in contracts to builders who have won by bidding. An entire department manages the bidding process, and it is long and arduous. What we would call Contemporary or Modern design is in the forefront, for it is able to more suitably shelter more workers than can historical period designs, made for a smaller world.

A surprising number of office buildings occupied by government workers are privately owned and leased by the government. The GSA polices this. The contract for the building goes by bid to a real estate developer. Under strict restrictions this party builds the new building with the knowledge that if all goes well, it will have instant occupation and income from the lease. For all the political pitfalls that might seem to accompany this arrangement, it has saved the government vast resources.

As Secretary of the Treasury, however, Hamilton's vision well comprehended the necessities of Federal Government activity in support of commerce and industry. Of the bureaus which are now included in the Department of Commerce, those of Patents, Census, Lighthouses, and Navigation were established by him in the Treasury.

President Herbert Hoover

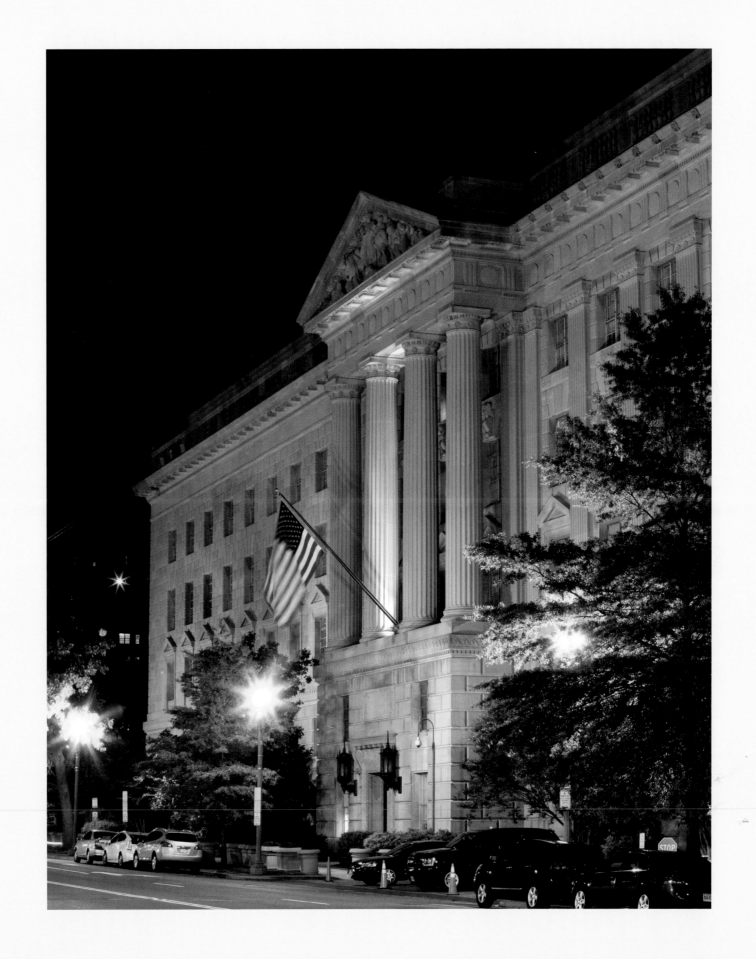

THE SUPERB BUILDING WHICH YOU WILL
DEDICATE TOMORROW WILL VISUALIZE
TO THE EYES OF THE PEOPLE THE MAJESTY
OF THE LAW UPON WHICH OUR PEACEFUL
NATION IS SECURELY ROUNDED AND
WHOSE RIGHTS AND LIBERTIES THE LAW
PROTECTS. . . . THIS BUILDING WILL
MAKE MORE CONVENIENT YOUR LABORS
OF CARRYING ON THIS GREAT
TRADITION . . . SO LONG AS OUR
FORM OF GOVERNMENT SHALL LAST,
THIS BUILDING WILL STAND AS A SHINING
MONUMENT TO THE CHARACTER OF
A GREAT PEOPLE WHO WISELY PUT THEIR
TRUST IN LIBERTY UNDER LAW.

PRESIDENT HERBERT HOOVER
ADDRESS TO THE AMERICAN BAR ASSOCIATION

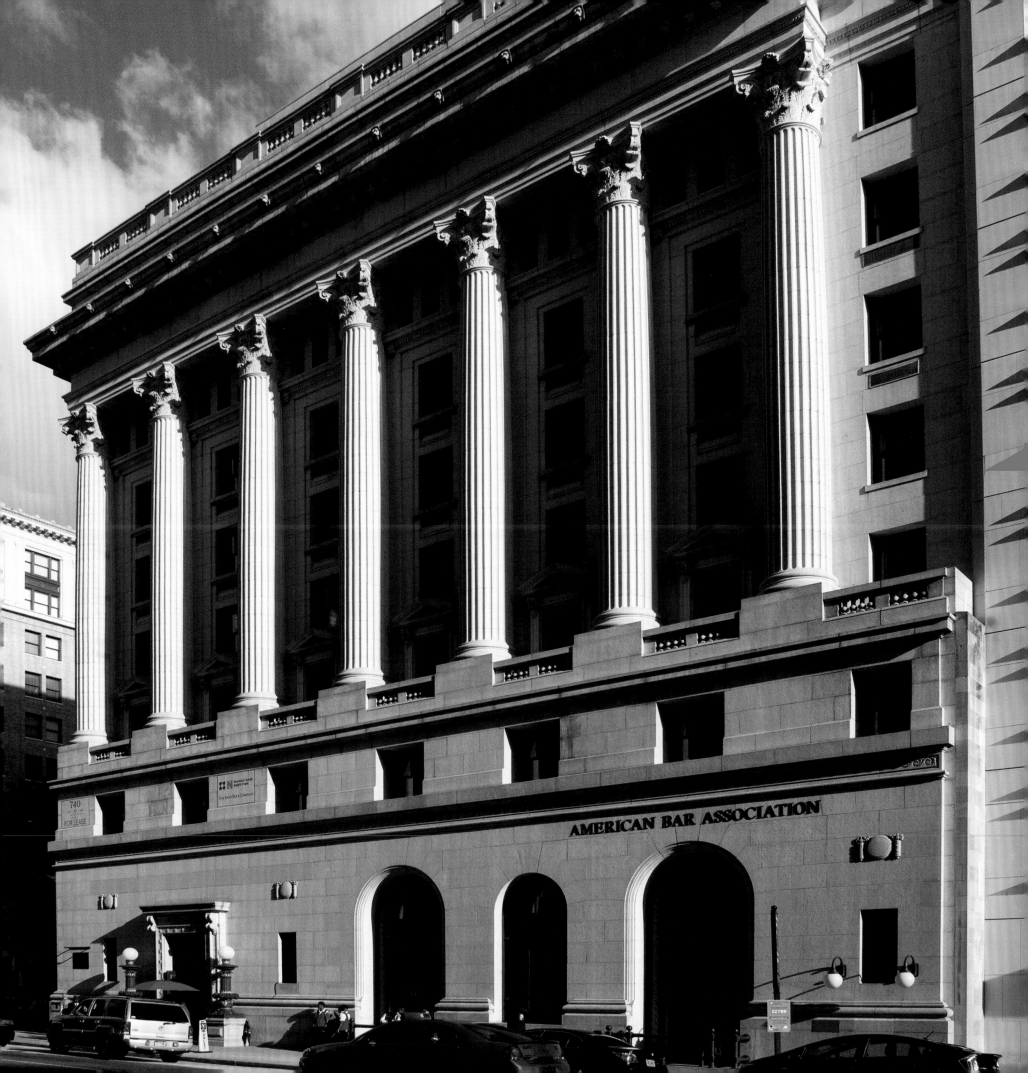

THE WASHINGTON BUILDING

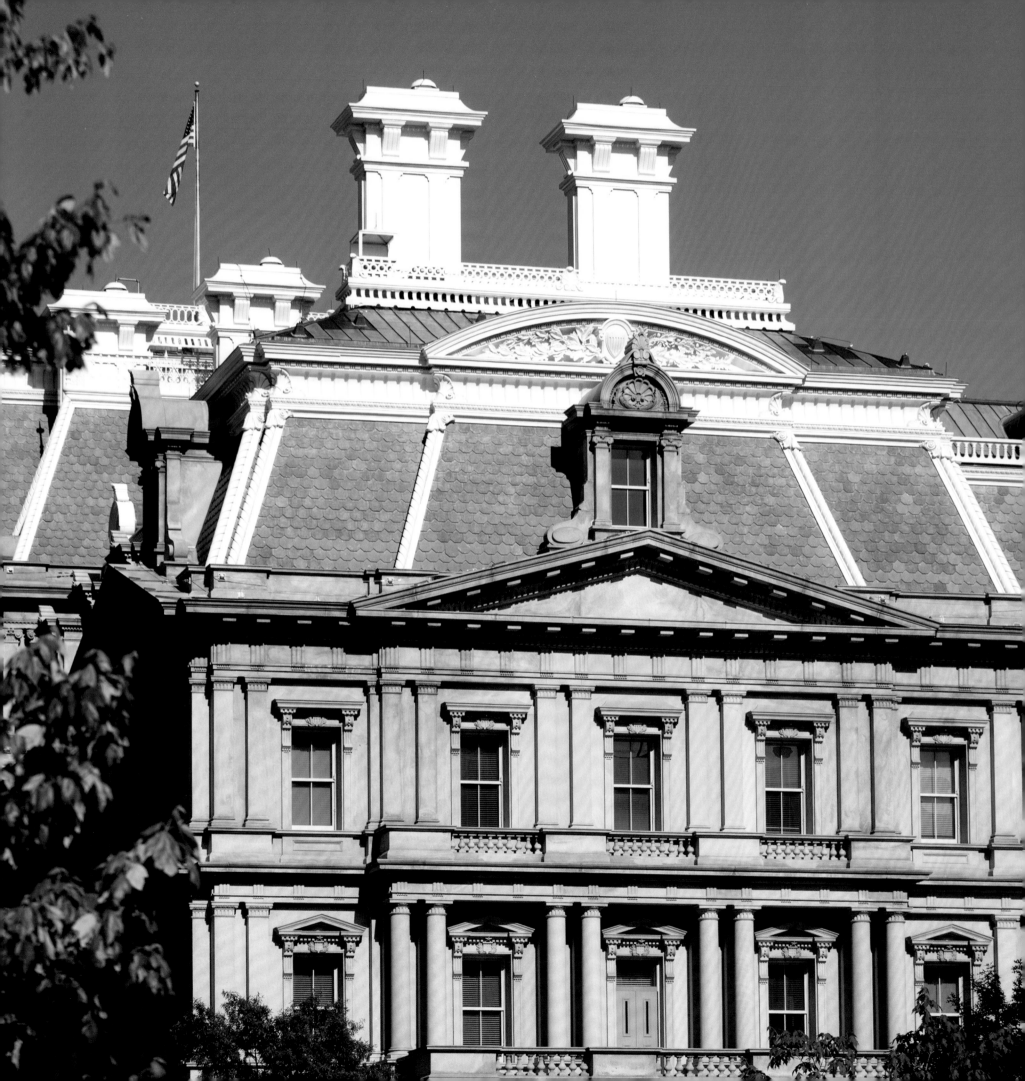

THE NEIGHBORHOOD TO THE WEST

A PREMIER EXAMPLE OF SECOND EMPIRE ARCHITECTURE

The old State, War and Navy Building is on the west side of the White House, directly across Pennsylvania Avenue from Blair House. It was built between the years 1871 and 1888 of the finest granite construction, and it was occupied before it was completed. Certainly the premier example of Second Empire architecture adapted to American use, it replaced two earlier offices on the site. It was approved and managed by Supervising Architect of the Treasury Alfred B. Mullett in the French Second Empire style of architecture that was current in the Paris of Napoleon III, expressing the economic revival Louis Napoleon brought to the French people, and it incorporated many traditional motifs of historic French architecture. It primarily echoes the New Louvre.

The State, War and Navy building is an astonishing architectural pile, expressing in florid terms the high noon of the Victorian era. It cost more than $10 million, rose five highly embellished stories from ground level, and remains a magnificent creation.

Its French roofs, its American porches, whip-like grand stairs, and the unifying color of the pale gray granite are carried through in theme inside the building where vast marble-floored passages pierce rows of large, high ceilinged offices and an occasional formal and very grand room, as the State Reception Room, the Library, and the Indian Treaty Room. Spectacular curving stairs of marble connect the floors. The finish and detail of the interior are superb, thanks to Mullett and his able assistant Count Richard von Ezdorf, and later Thomas Lincoln Casey of the Army Corps of Engineers. No more magnificent building was ever built in Washington, although the French Second Empire style was so odd as to bring the building down in history as a splendid curiosity.

"War and Navy" is now known as the Eisenhower Building for

his love of it and the part he played in rescuing it from almost certain demolition thanks to panic that resulted from a fire. Since then special attention has been paid to the building in extensive improvement, as well as a model program of historical "archaeology" into what the original decor was like. The result, ongoing, has been a restoration of the interiors in an amazing resurrection of sumptuous gilding, decorative stenciling, and fine woodwork and ironwork. Schemes of original furnishings, including fringed armchairs and brass spittoons, had to yield for the most part to functional office furniture, yet original bookcases and conference tables have been restored and carry the theme of the original architecture.

The ceremonial office of the vice president is located here, a high Victorian cousin to the Oval Office. War and Navy is an easier workplace than the West Wing. Its rooms are large, airy, and secure, boasting very thick walls and tall windows. No place in Washington, after the building's completion, has provided so spacious an environment for the ongoing fury of tasks that surround those privileged to serve the president for four or eight years. As vice presidents, Lyndon B. Johnson and Richard M. Nixon enjoyed the convenience of War and Navy, and as presidents, they maintained their offices there as well. Johnson's office suite overlooked Seventeenth Street and offered a sunset; Nixon's looked down on the North Lawn of the White House.

More executive offices are in a red high-rise, known as the New Executive Office Building, in the middle of the block across the street. Federal courts and offices are similarly housed on the east side of Lafayette Square.

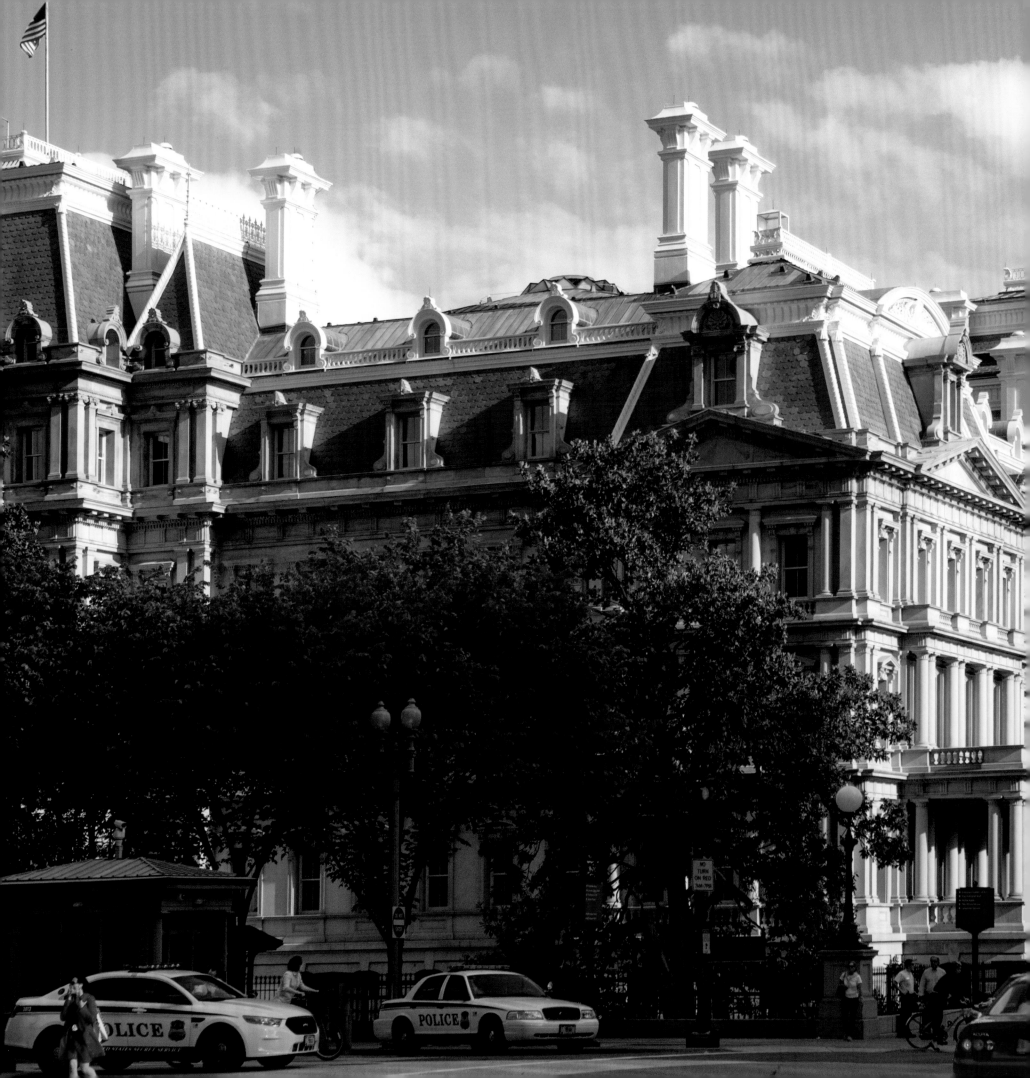

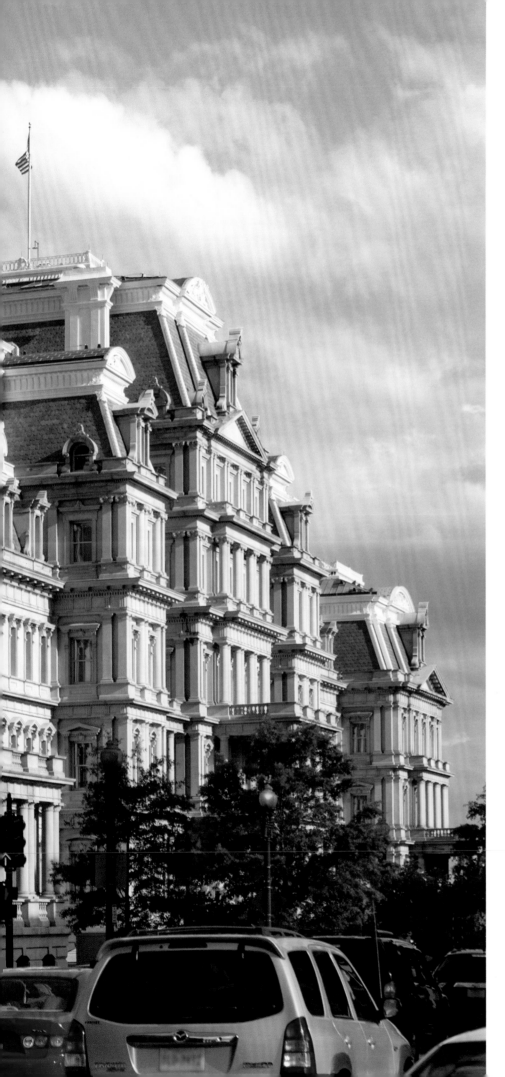

And standing outside this building
on a spring morning 73 years ago,
you might have seen Dwight
Eisenhower pull up in a 1927 Buick
and walk up the stairs to his office.

President George W. Bush
remarks at the dedication ceremony
to rename the Dwight D. Eisenhower
Executive Office Building

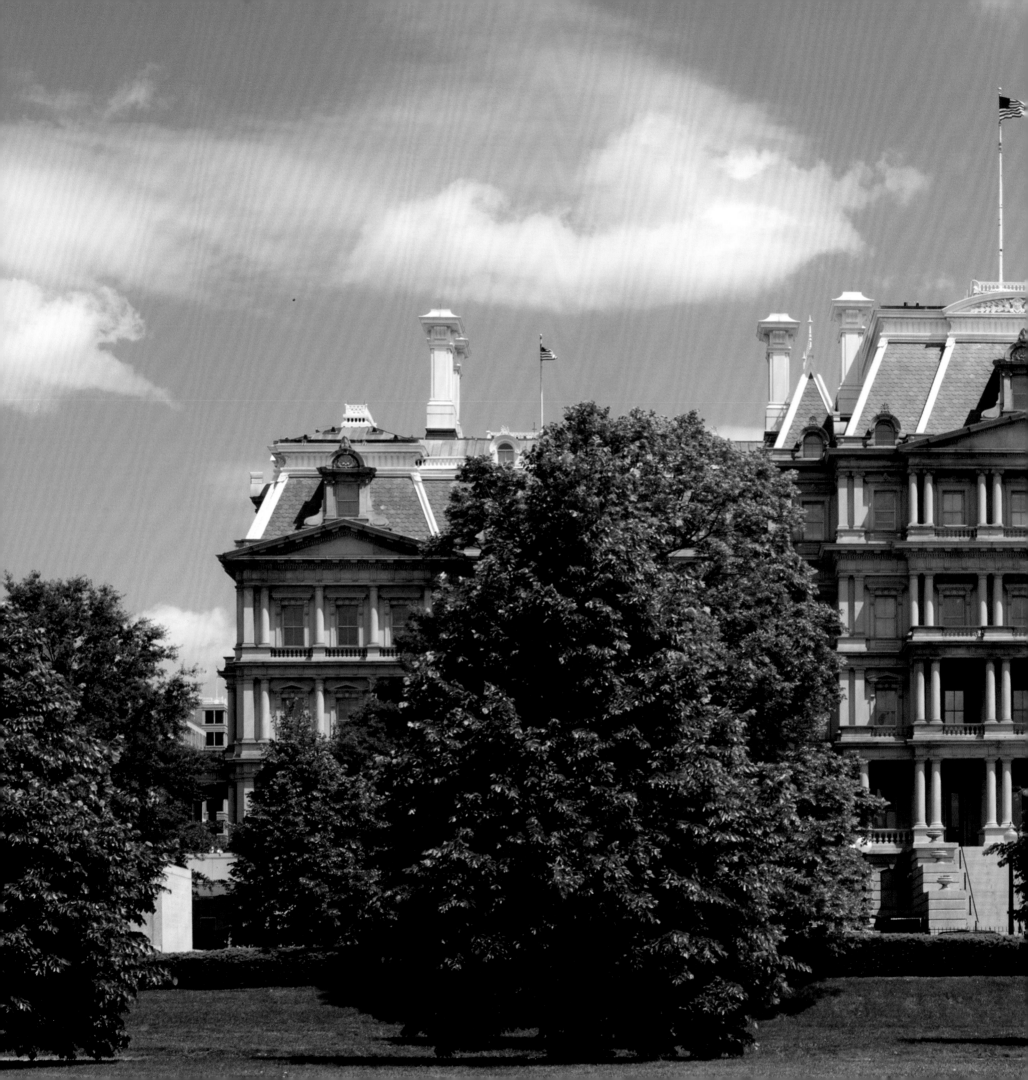

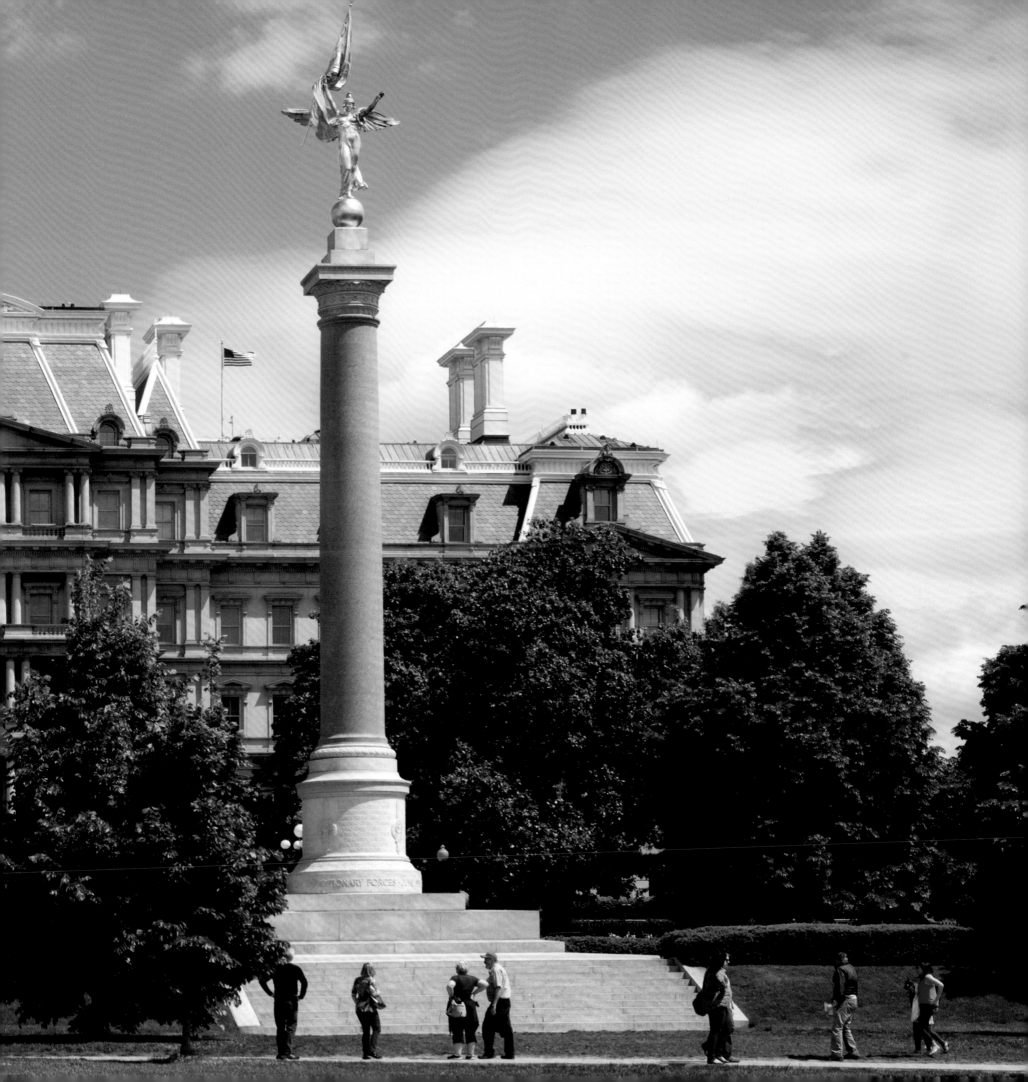

In my White House years I did far more work at night than in the mornings. . . . I never went to bed before midnight, however, and sometimes far beyond midnight. Those were long days. . . . I took naps in the White House too when I could, but I never went back to the residence for them as some did. I just went over to the EOB. I always took naps right there on the couch.

President Richard M. Nixon

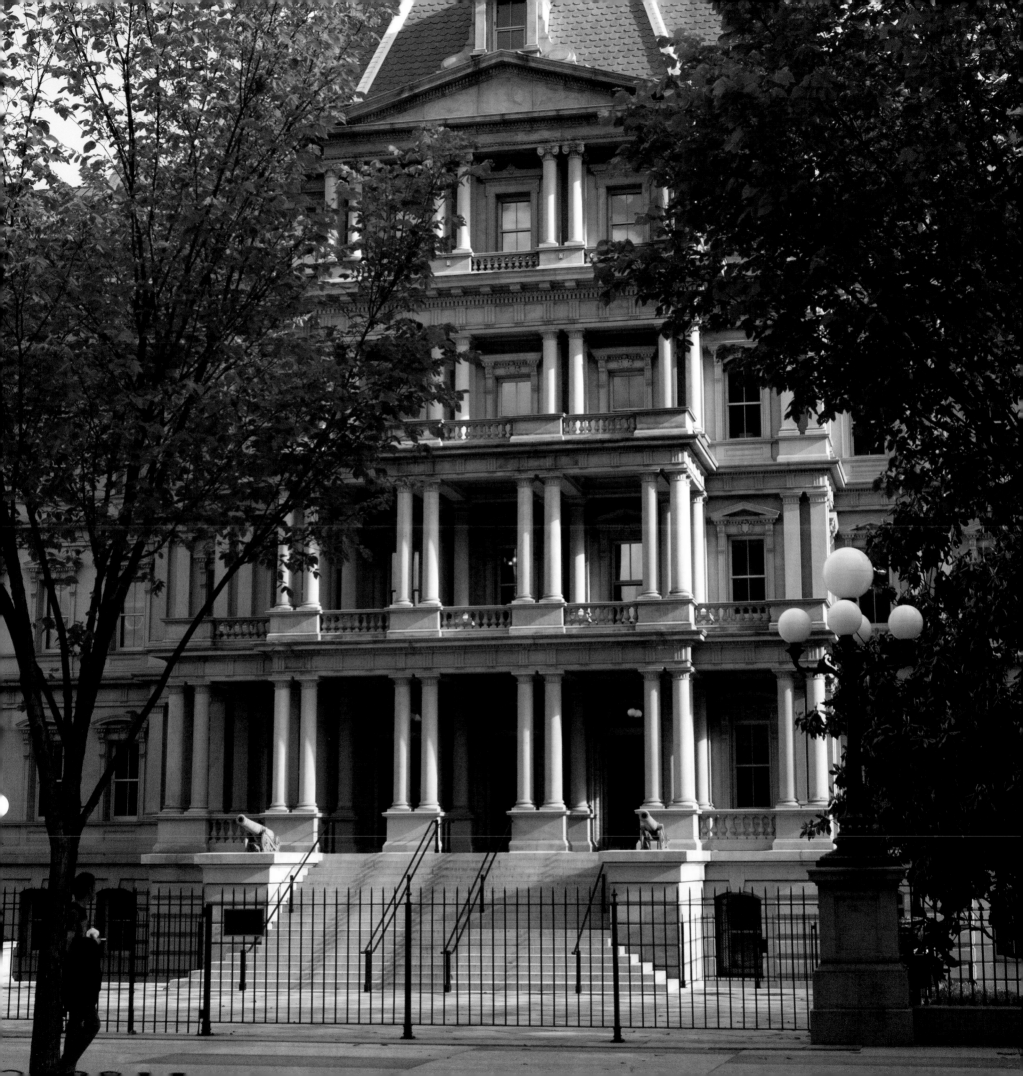

A WHITE MARBLE ROW

The white marble Red Cross Building, completed in 1917, the year the United States entered World War I, was built to commemorate the service of women in America's wars. It rather resembles a house, set well back on a carpet of lawn, a lofty Corinthian portico its central feature. There is a softness to it that contrasts to the other public buildings of the White House neighborhood. Historical murals inside provide a gallery for the public. Most of the building contains offices for the headquarters of the organization.

Memorial Continental Hall, national headquarters of the Daughters of the American Revolution, next of the great buildings going south on Seventeenth Street, was built in 1905 and expanded in the later 1920s. Built of white marble, the design was ordered to be "colonial," which by its time was fairly generic for any building with columns. The design might be said to have many sources, not least certain echoes of the White House. Within the building is a large exhibition of period American

rooms, displaying American antiques. The genealogical library is an admired source for researchers. Much of Alex Haley's *Roots* was researched here. The complex includes Constitution Hall, a much-used theater and concert hall. Realizing its strong interest in history, the DAR is also a highly political organization of women, established in Washington in 1890, with First Lady Caroline Harrison as the organization's first president general.

Last and most notable architecturally of the monumental row of buildings on Seventeenth Street was what is called today the Organization of American States Building. When it was built in 1910, it was the Pan-American Union, representing an attempt to promote cooperation among the nations of South America and the United States in commercial matters and judicial issues.

It is a building of remarkable beauty, in full Beaux-Arts form suggesting a villa. The Beaux-Arts was extremely important in late nineteenth- and early twentieth-century Latin America, so

its use was a happy melding that still enlivens the spirit of the building. The structure is one story, its tall, arcaded mass sheathed in white marble. It was extolled as a villa, a great gate, but it also reminds one of a large orangery, like those seen in palaces in Europe. A screen of highly decorative bronzework fills the three great arches of the facade, which gives into a patio of tropical plants, trees, and birds. This conservatory is one of Washington's most surprising moments in public architecture. On a snowy day one is transported to a tropical paradise, fragrant and warm. Throughout the public parts of the main floor, murals and some statuary are the special feature, most painted by American artists. They are all symbolic murals representing the pre-Columbian peoples of the Americas and the heroes of the national period, including Simón Bolívar and George Washington. Industry and manufacture are symbolized in accurate representations of life and terrain in the different nations.

Where the OAS stands was one of Washington's most magnificent houses, the Van Ness House, built for a rich, landholding client by B. Henry Latrobe about 1813–16. An elegant mansion, it had gate lodges and interiors decorated with neoclassical bas-reliefs of dancing maidens. When it was demolished in 1908 it had suffered many years as a saloon and clubhouse for a racetrack. The stable remains on the rear of the property, along with later buildings associated with the work of the Pan-American Union.

The monumental Corcoran Gallery of Art (the new Corcoran School of the Arts and Design) predates the Beaux-Arts movement in Washington, D.C. Architects have held it in high regard since its last stone was mortared in suggestion of a bigger-than-life late-Roman public structure. It is placed in the row of white buildings as superbly as a fine stone in a bracelet. The Corcoran story is told more fully on page 275.

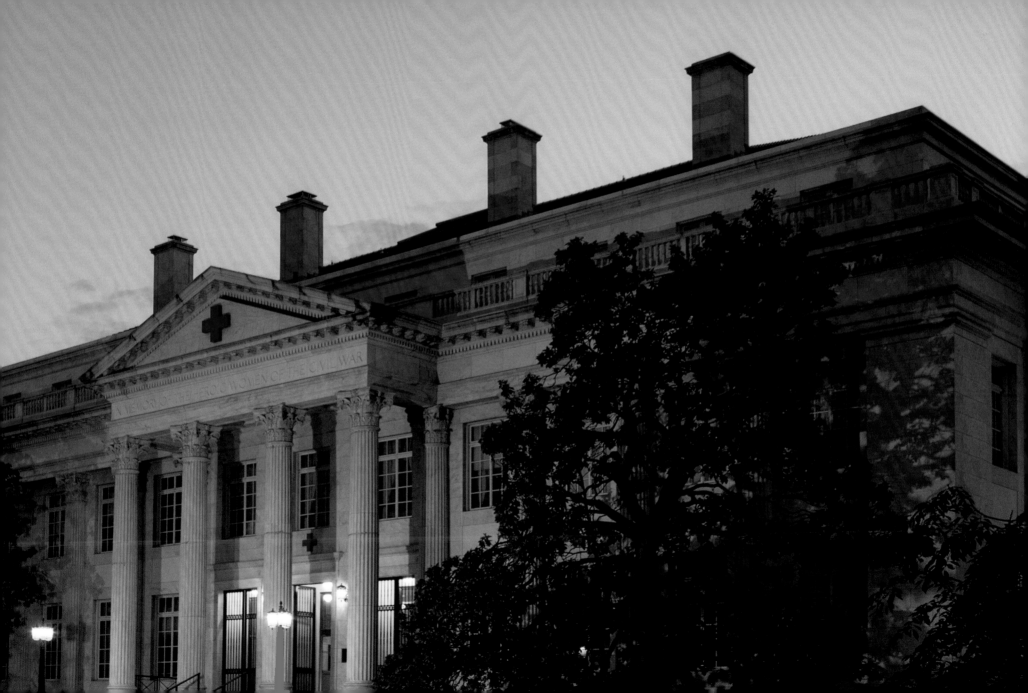

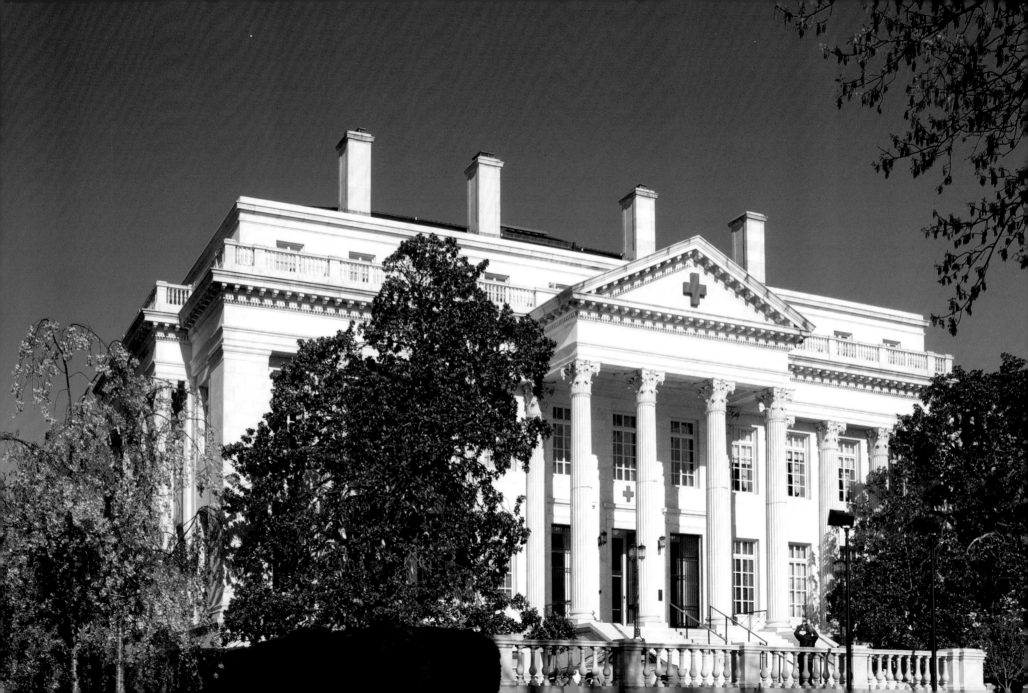

IT IS NOT AN ORGANIZATION HAVING A TEMPORARY
OR AN EPHEMERAL EXISTENCE DUE TO ONE GREAT
NATIONAL OR WORLD AFFLICTION, BUT IT IS A
PERMANENT INSTITUTION AVAILABLE FOR NATIONAL
AND WORLD EXIGENCIES, AS A FIRE DEPARTMENT OR
A POLICE DEPARTMENT IN A LARGE COMMUNITY, OR
AN ARMY AND A NAVY IN NATIONAL EMERGENCY . . .
BECAUSE OF THE NATIONAL SIGNIFICANCE, BOTH
HISTORICAL AND PRESENT, OF THIS STRUCTURE, IT IS
MOST FITTING THAT THE CORNERSTONE SHOULD BE
LAID BY THE PRESIDENT OF THE UNITED STATES.

PRESIDENT WILLIAM HOWARD TAFT
SPEAKING AT THE CORNERSTONE LAYING OF
THE AMERICAN RED CROSS NATIONAL HEADQUARTERS

ONE OF THE MOST DISTINGUISHED
PATRIOTIC ORDERS OF OUR NATION IN
CHERISHING THE MEMORY OF THE PEOPLE
AND THE RECORD OF THE EVENTS OF THE
GREAT STRUGGLE WHICH RESULTED IN
AMERICAN INDEPENDENCE. . . .
TRULY, A POWERFUL FORCE FOR GOOD
IN OUR COUNTRY.

PRESIDENT CALVIN COOLIDGE

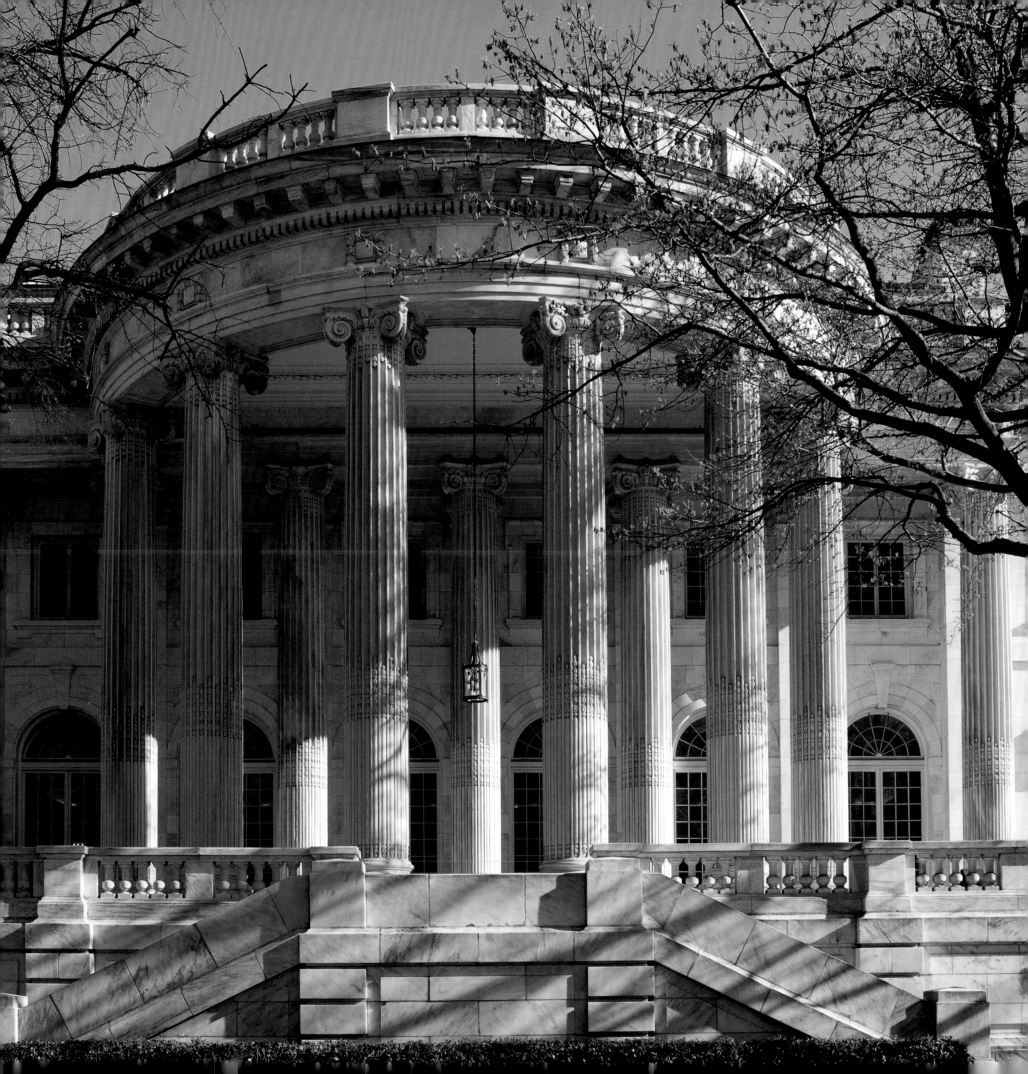

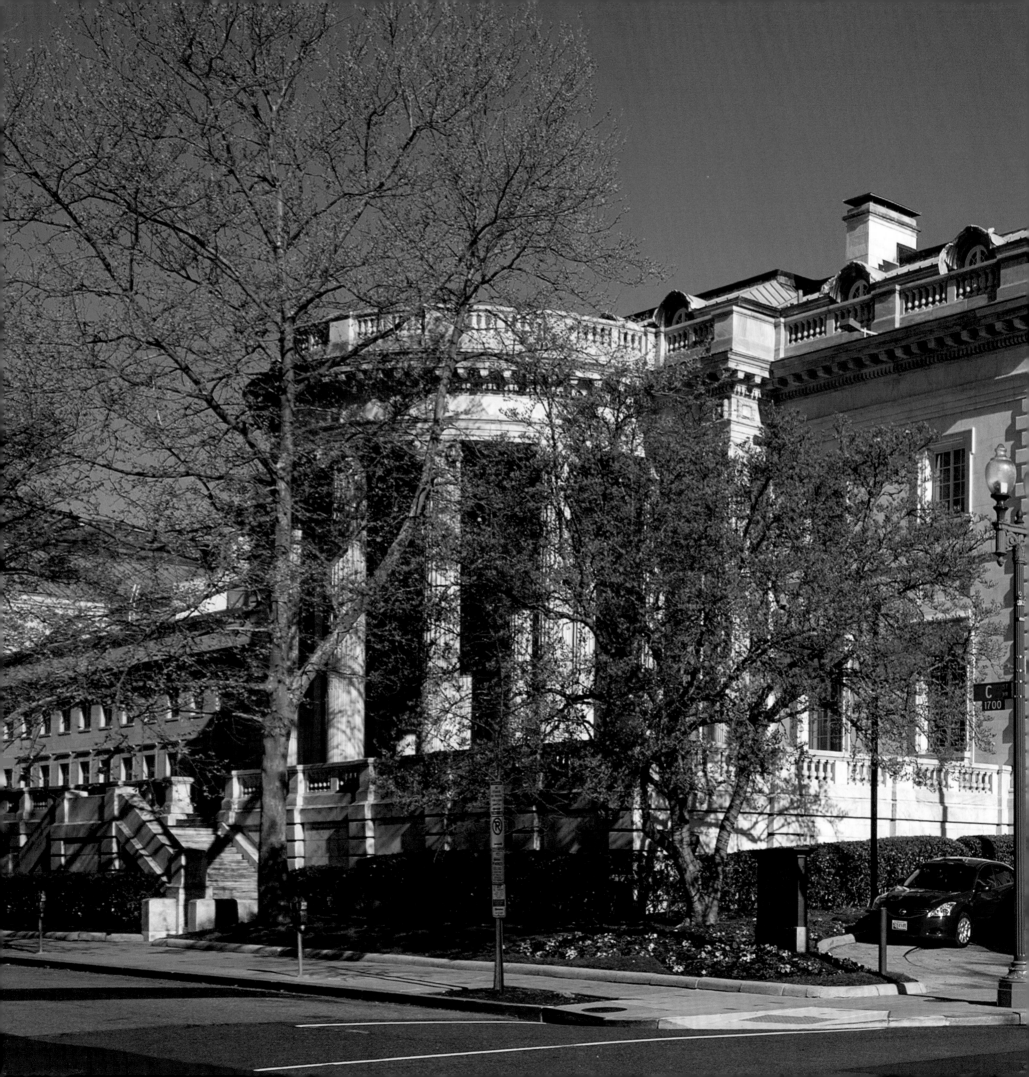

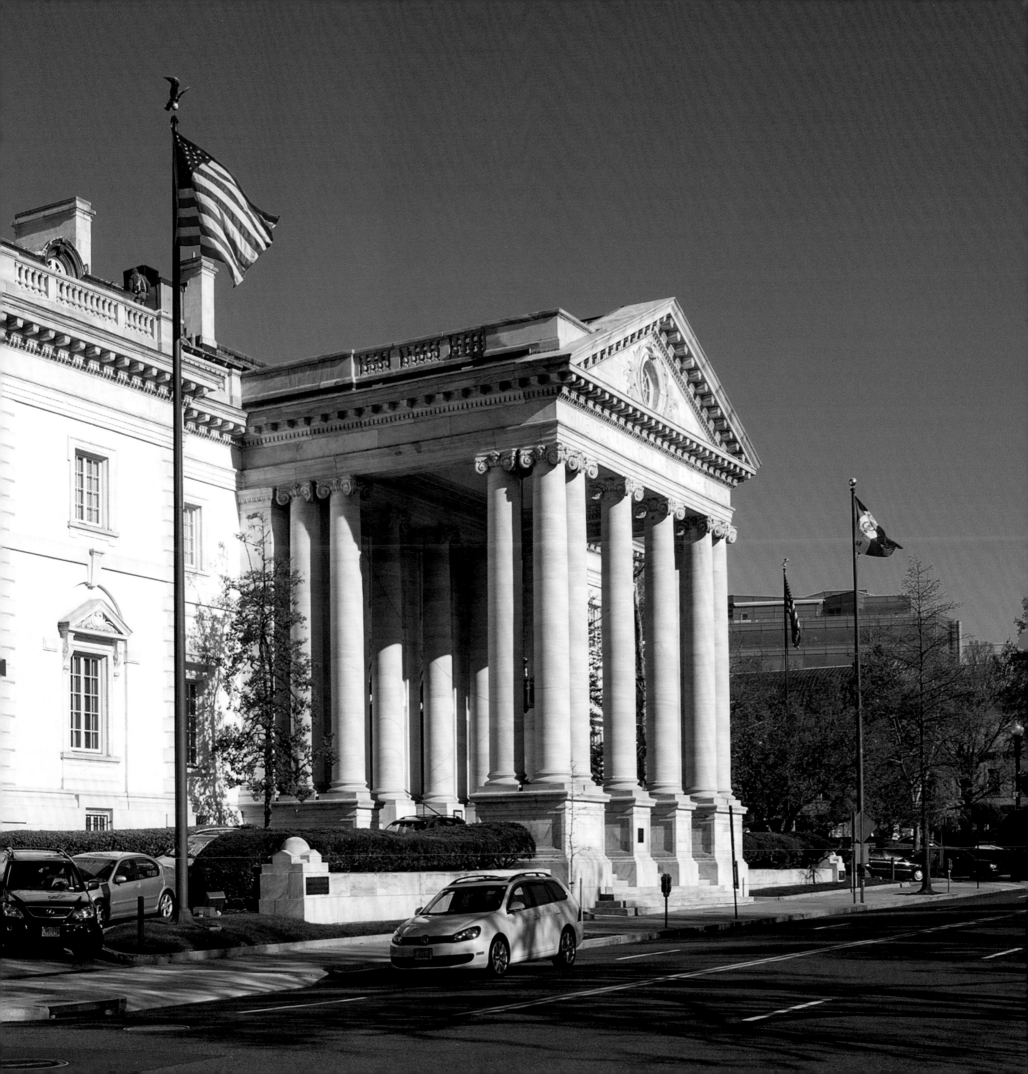

THE ORGANIZATION OF AMERICAN STATES
REPRESENTS A GREAT DREAM OF
THOSE WHO BELIEVE THAT THE PEOPLE
OF THIS HEMISPHERE MUST BE
BOUND MORE CLOSELY TOGETHER.

PRESIDENT JOHN F. KENNEDY

William Thornton, MD, the original architect of the United States Capitol, designed and built for the Virginia planter Colonel John Tayloe III, in 1800, a curious house known through time as The Octagon, named for its strange shape. Because it never left the family from its building until its acquisition by the American Institute of Architects in the early twentieth century, The Octagon has never suffered the ravages of neglect. In the parlors the original cast stone mantelpieces show off their dancing figures; ceilings retain their fine composition casting plaster and mortar; in the round entrance hall the marble pavers survive, as do, miraculously, the two iron stoves, which with coal fires warmed the drafty room.

The Octagon is the only structure of early Washington that playfully recognized L'Enfant's odd plan for the city. It faces the corner intersection, not the street. The plan of the house resembles a fan opened up. Like nearly all houses in which an oddity like the shape of The Octagon is incorporated, traditional living customs had to be twisted around. It is anything but a convenient house, as the Madisons learned when it was rented as their "White House" after the British burned them out. The placement of the rooms, spreading from a round entrance hall, is unusual and confining. The principal stairs are gracious enough, leading up to the round drawing room and rooms flanked by cramped halls, better called "landings." The rooms are few but ample. Still the house does not conform to the way people lived at the time and was considered strange. Nothing else like it was built in Washington. The Monroe House (today's Arts Club of Washington), a few blocks away, worked better for living, and President James Monroe and his family stayed there until the rebuilt White House was ready for their return.

Yet the wealthy Tayloes applied everything to their house to make it beautiful and convenient. The drawing room and dining room, constituting most of the first floor, were elegant, the sideboard set in an alcove, the woodwork neoclassical, the man-

tels of British Coade stone with classical nymphs and flowers cast on them. Mirrors, satin curtains, and the latest styles of furniture and Wilton carpeting were second only to the furnishings designed by B. Henry Latrobe for the Blue Room at the White House, gone to British torches. The "English" basement (half out of the ground with an areaway) was floored in brick pavers. The large fireplace accommodated an iron range or cookstove, fire safe and versatile, a water heater, and every culinary convenience for Tayloe's slaves to use in the preparation of his winter dinner parties. Bells in the rooms, connected by a system of wires to the basement, provided a communications system through the house.

The Octagon had survived the British invasion as the home of the French minister, which thus put it on "foreign soil." When the war was over, before the peace was signed, the Madisons took over the house. President Madison was there when the peace treaty came from England with every signature but his.

The treaty was signed by him in the upstairs round parlor, giving it the lasting distinction of being the place where the War of 1812 officially ended. By the time the ink dried, America was already a new, self-conscious nation, stirring to move west.

The Octagon was a family residence for many years after the government left it. Ultimately by the 1880s the family had no use for it but held on. Renters made apartments in the rooms, doing very little damage until the beginning of the twentieth century, when the family sold it to the American Institute of Architects, through the urging of its secretary, Glenn Brown, a Washington architect and great promoter of the Beaux-Arts development of the city into a world-class capital.

Today the AIA Foundation remains in The Octagon, while the AIA occupies the large headquarters it built on land behind the mansion, boomerang shaped, to cradle and enhance the historic house.

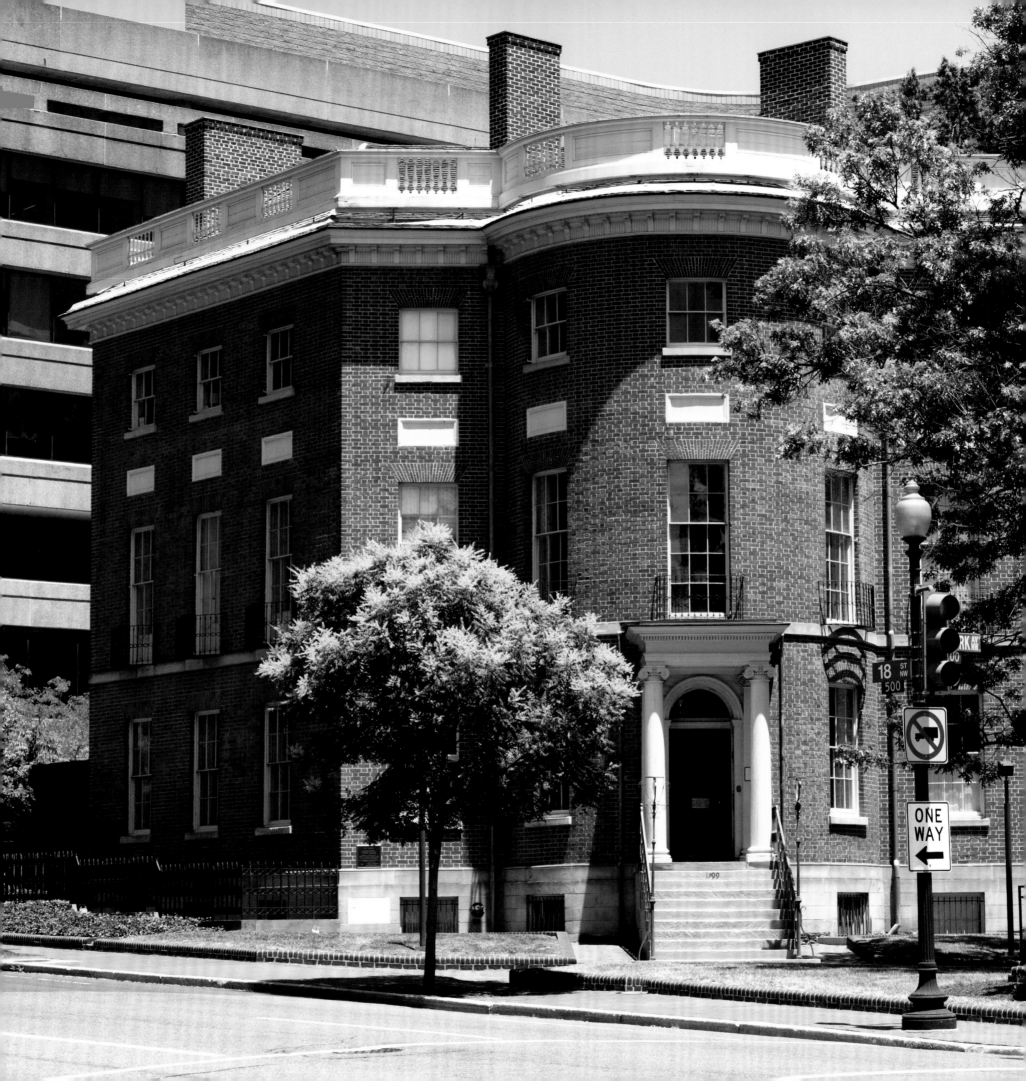

MR. J. TAYLOE OF [VIRGINIA]
HAS CONTRACTED TO BUILD
A HOUSE IN THE CITY
NEAR THE PRESIDENT'S
SQUARE OF $13,000 VALUE.

WILLIAM THORNTON
ARCHITECT OF THE OCTAGON

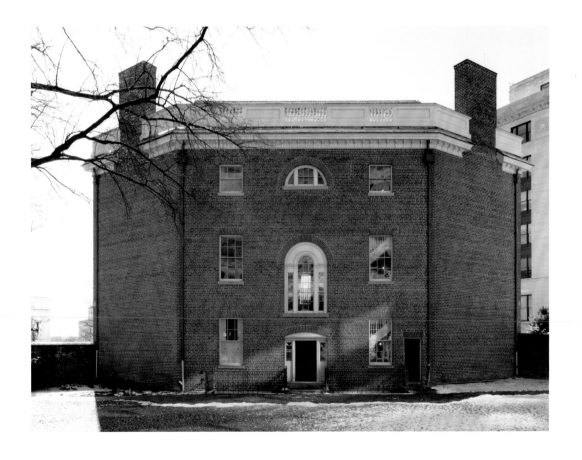

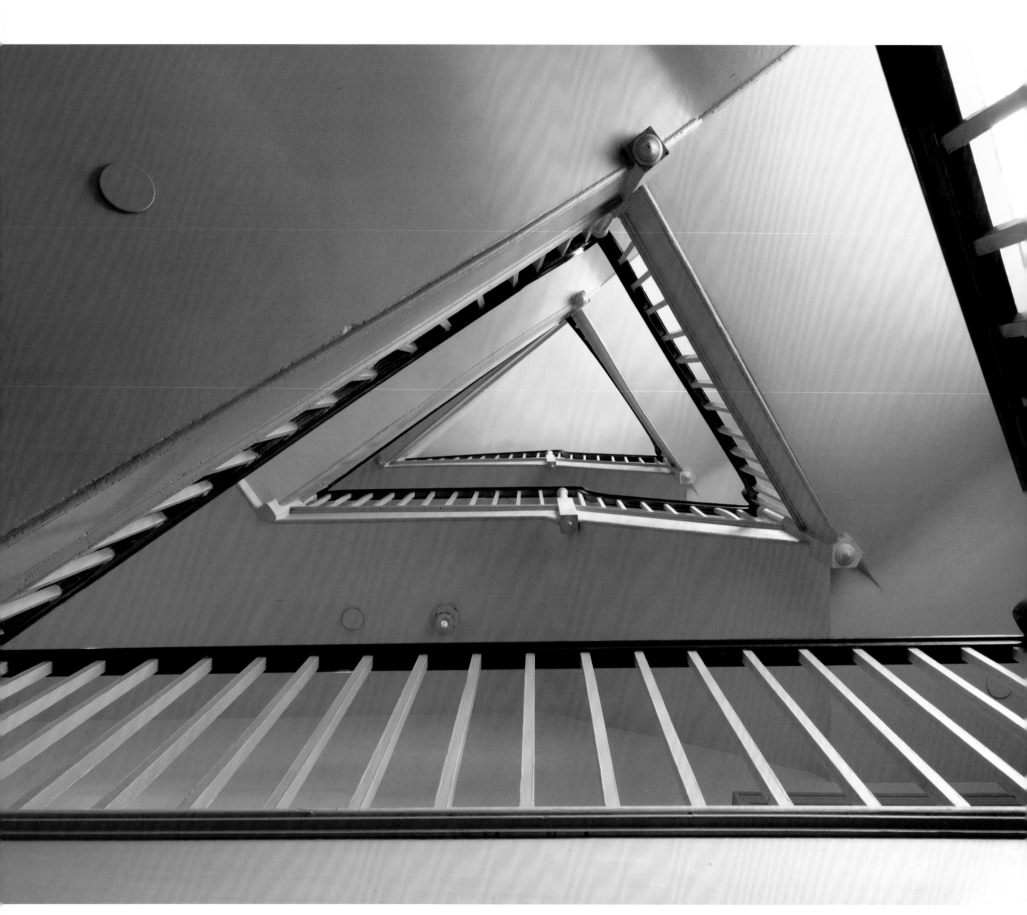

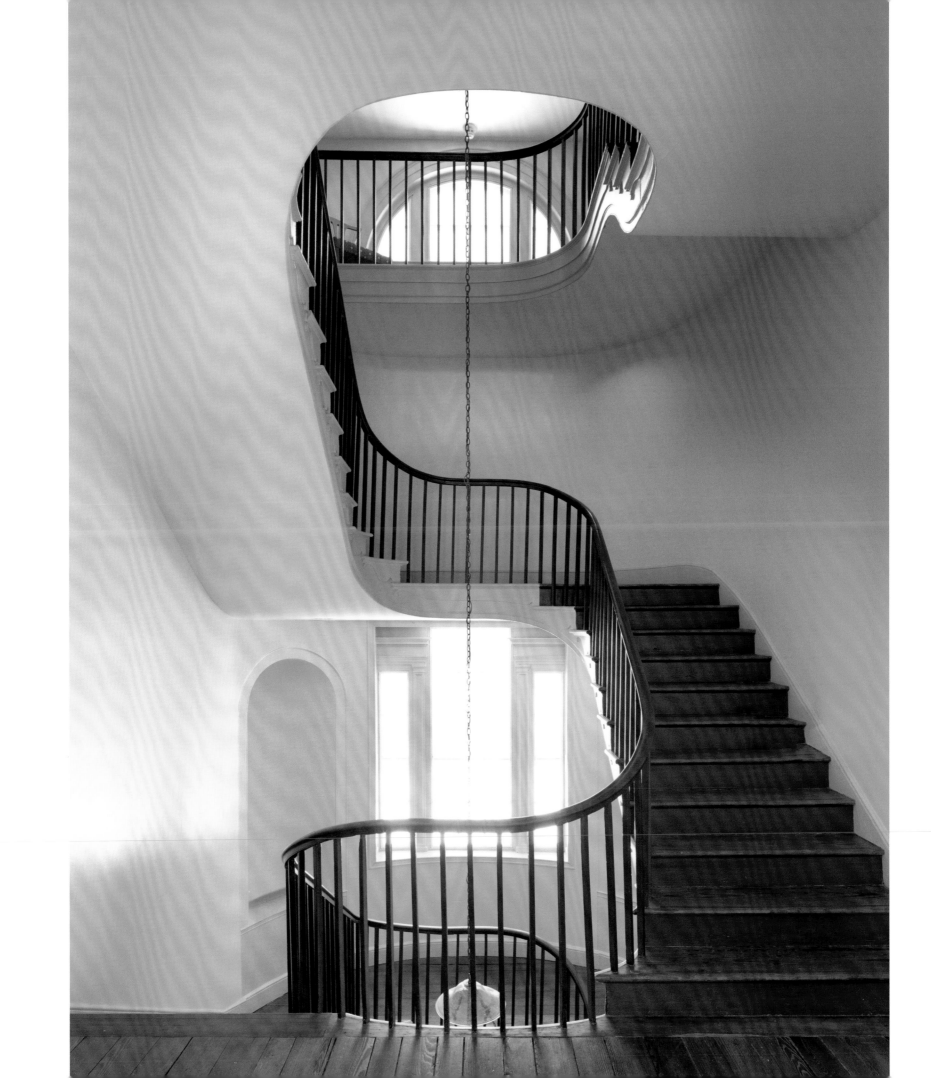

THE MONROE HOUSE STANDS ON ITS OWN IN THE PURITY OF ITS FEDERAL ARCHITECTURE

At 2017 I Street NW is a fine old row house of brick, with Aquia stone trim, that today houses the century-old Arts Club of Washington. Photographer Frances Benjamin Johnston stayed here at the turn of the twentieth century, as does Bruce White today. As a building it is more typical of Washington houses than The Octagon or Decatur House. Completed about 1808 or 1810, its brick walls, laid in Flemish bond, attest the skill of Washington builders, and Washington had quite a substantial building community, attracted by federal construction projects. The stone lintels likewise show the skill of Washington builders, but as easily could have been carved elsewhere and shipped to the capital. The side hall plan, the large room across the entire second-floor front, and the arrangement of other interiors are typical of the time. The kitchen was "out back" on convenient level with the house. It will be remembered that Decatur House, originally with a kitchen in the body of the house, was appended to have such a kitchen as this, in a separate back wing, for love of comfort and convenience.

James Monroe occupied this house as secretary of state and, until the rebuilding of the White House was complete, as president. His first inaugural ball was held here, the guests dancing in the drawing room that stretched across the second-floor front of the house. By his second inauguration the Monroes were living in the White House.

The Monroes were a glamorous couple who entertained a lot. Diplomatic residence in France influenced their tastes. They ate French food, spoke only French at home, and adopted French customs of receiving guests. For some, this would have attracted mockery. But James Monroe, tall and manly, a veteran of the

American Revolution, was considered a younger son by the Founding Fathers, and the American people shared this admiration. The Monroes would go on to the White House and apply their French ideas to making probably the most elegant White House in history.

Shoulder to shoulder with larger and more recent buildings, the Monroe House stands on its own in the purity of its Federal architecture. The relative simplicity of the facade, the fine brickwork, and the precise placement of broad windows surmounted by keystone jack arches of stone and stone-built courses were seen in other Washington houses, as preserved in documentary photographs at the Library of Congress, but alas, nearly all are gone today.

The Arts Club of Washington is what might be called a working professional club, with a membership made up of artists of painting and sculpture, photographers, writers, musicians, and scholars of all these endeavors. The club is generous with the Monroe House, opening it to the public at certain times. Under strict conditions it is available to rent for private parties, notably weddings. While the historic house is important to Washington, the life of the club itself is embodied in the use of the old house. There is no effort to create a museum of James Monroe, but a great effort to preserve the building. Nothing is "period" spiffy about the house. In total one might describe the overall impression as mellow, similar to the character long use and affection give an old family home.

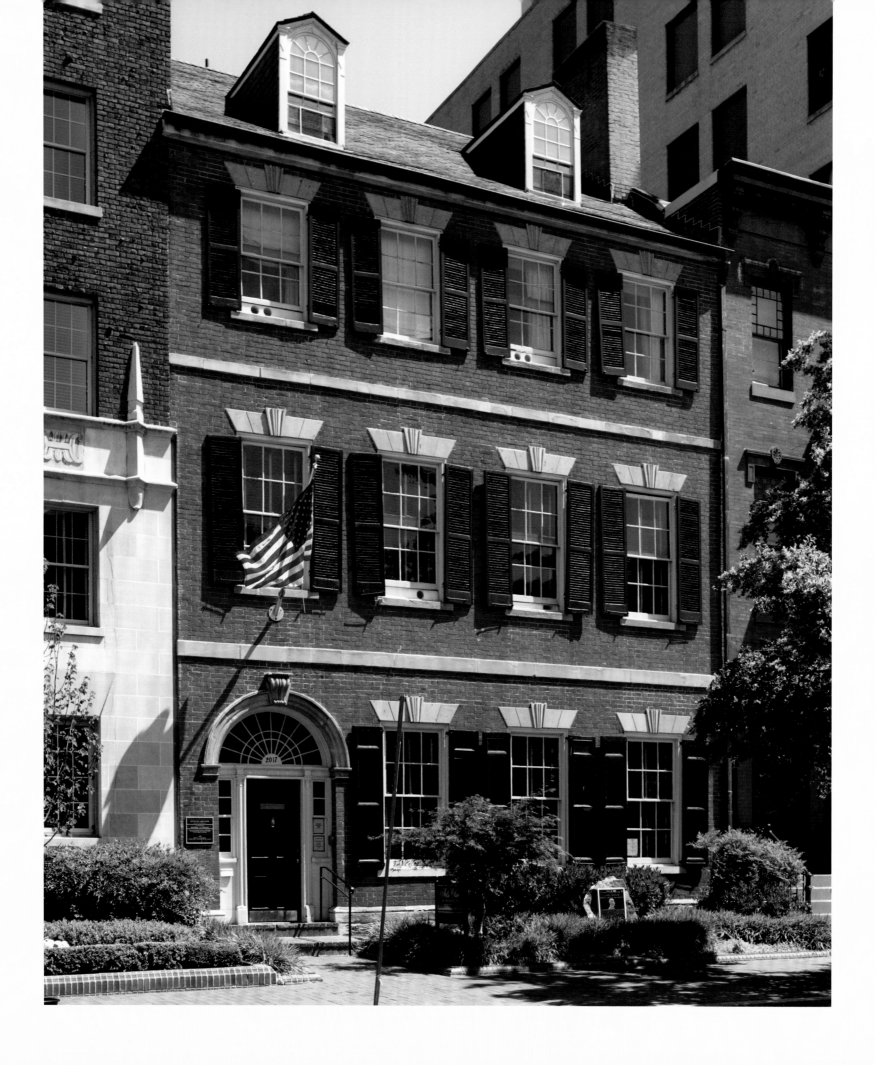

An unexpected change has taken place in my situation since I had last the pleasure to see you. An invitation from the President to enter into the department of State will take me to Washington. Having accepted the office, I set out tomorrow in the stage to commence its duties.

Secretary of State James Monroe

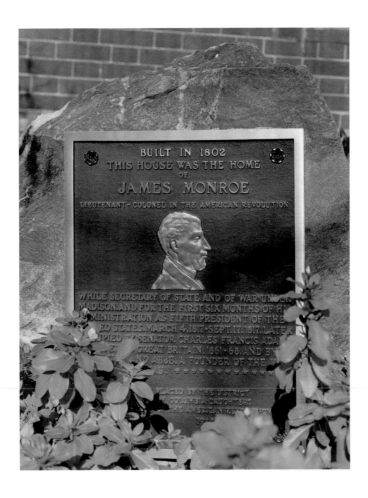

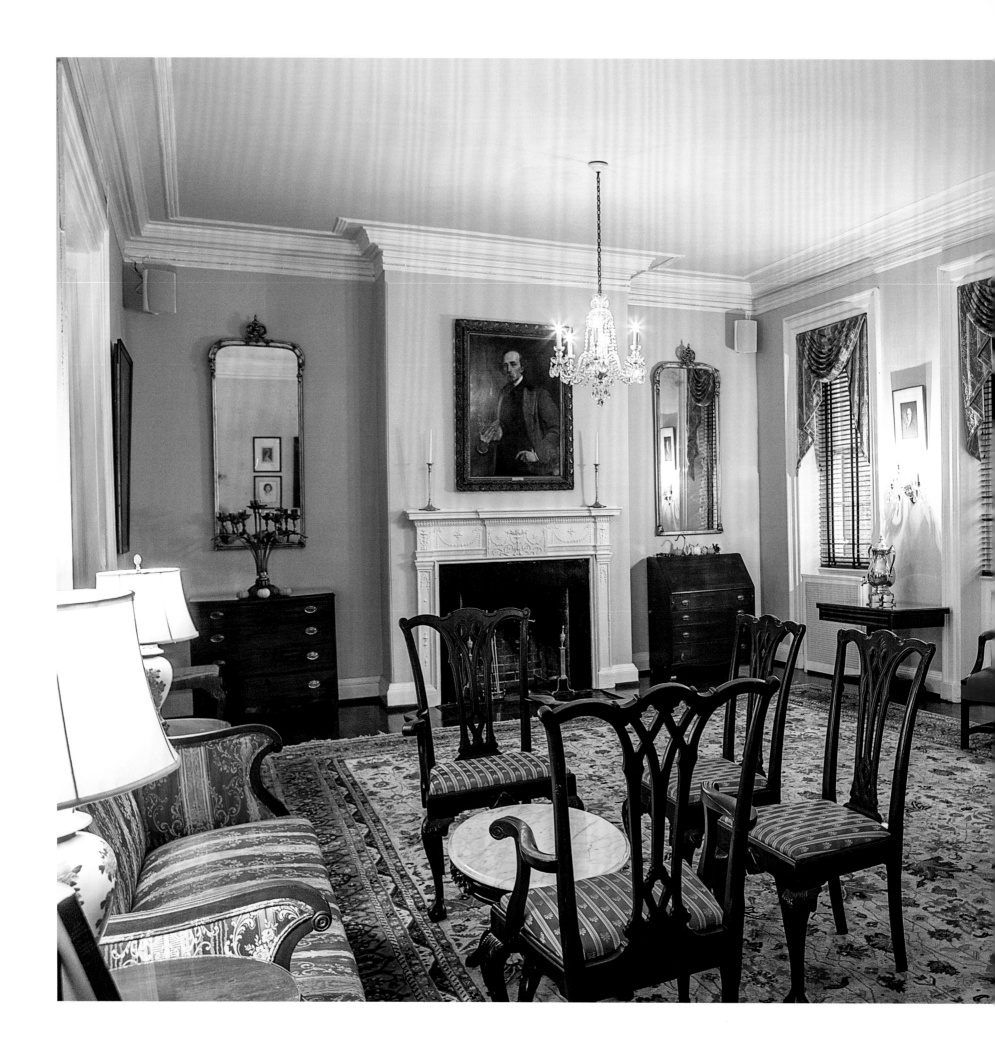

Secretary of State James Monroe and his wife Elizabeth came to live here in 1811, and tastefully furnished their home with objects acquired in Paris where Monroe served as America's minister. Following the burning of the White House during the War of 1812, the residence became the city's social hub. Dolley Madison was a frequent guest. In March 1817, it would gain greater luster when James Monroe was inaugurated as the nation's fifth chief executive. During the first six months of the new administration, the president and his wife continued to make this their home until the White House was fully restored in September of that year. The first of Monroe's Inaugural Balls was held in the spacious second-floor parlor.

Arts Club of Washington website

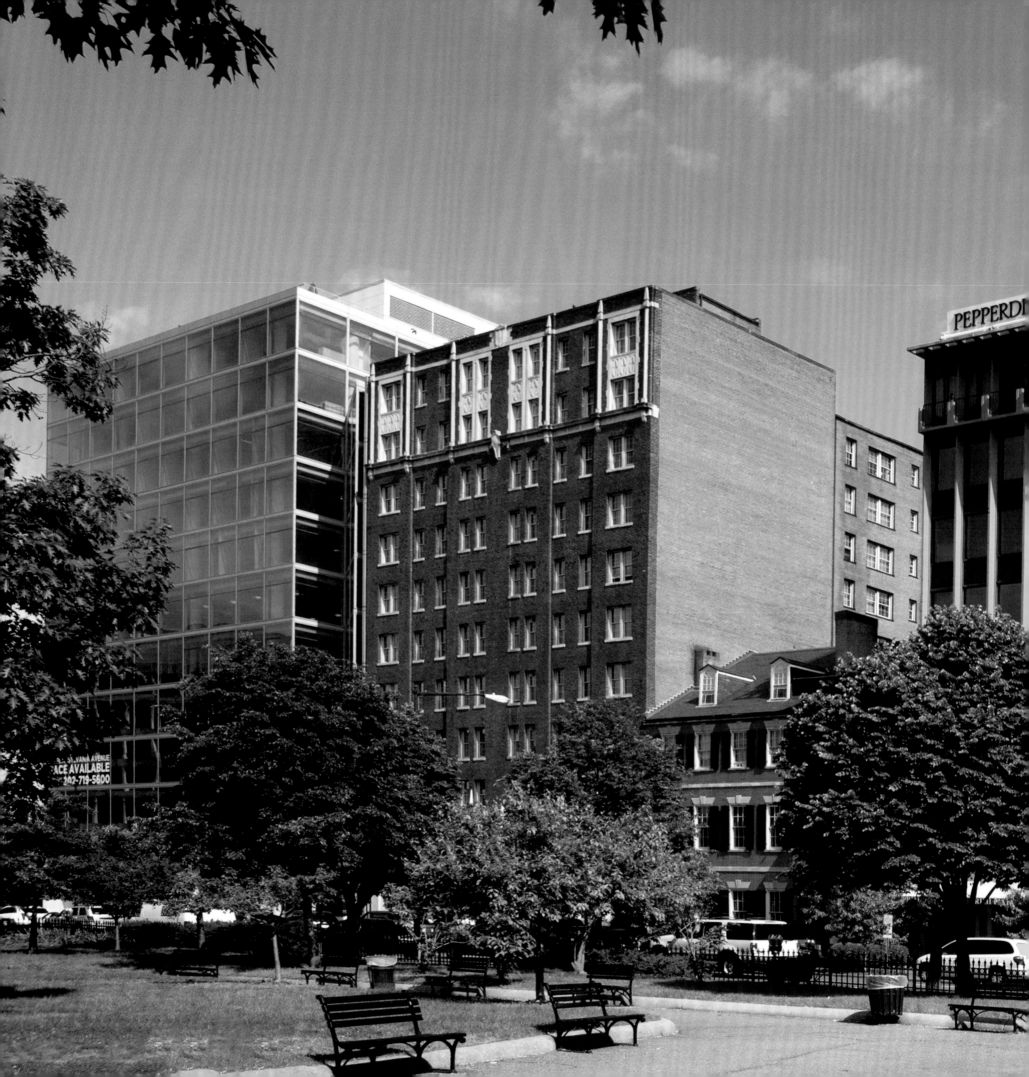

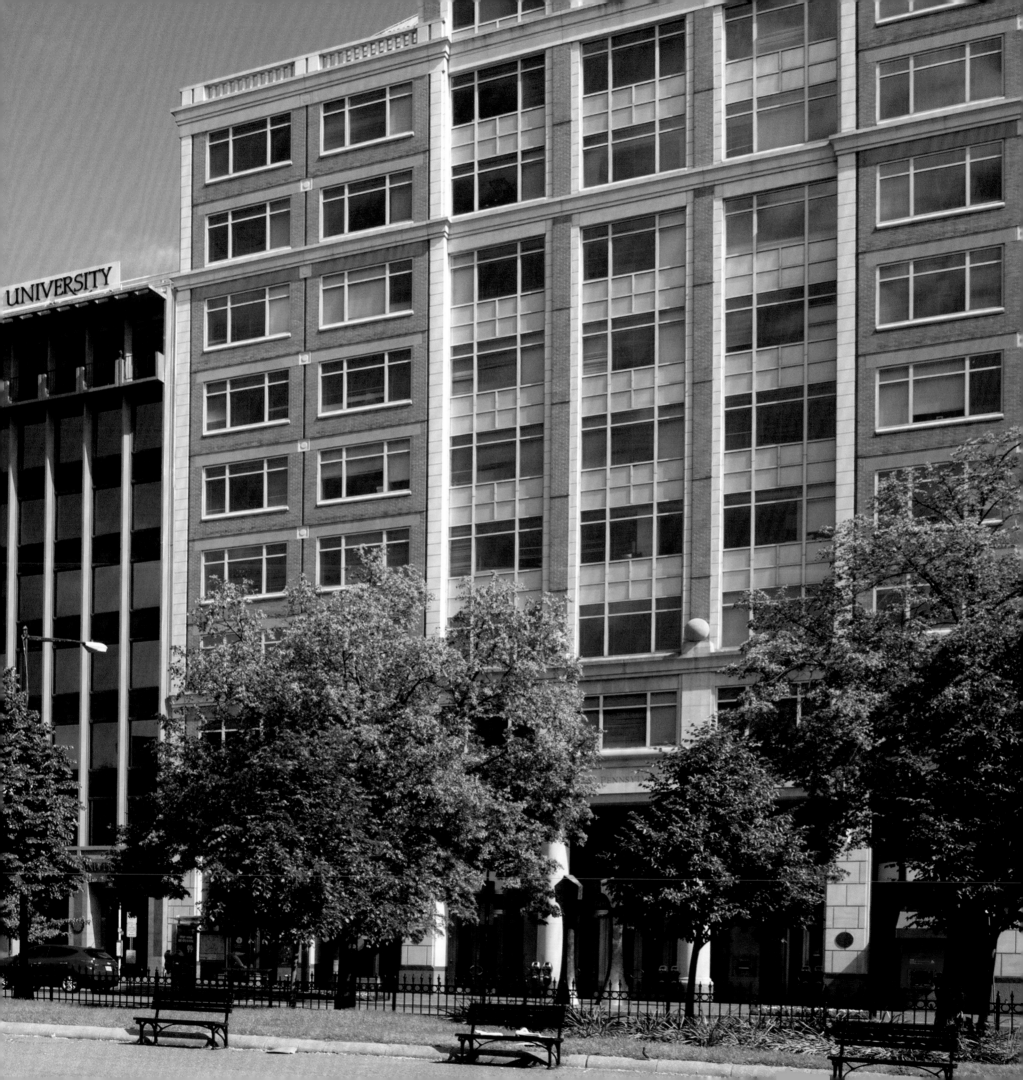

WASHINGTON'S OLD BRICK HOUSES

The row of old brick nineteenth-century town houses along the 2000 block of I Street, known as "Red Lion Row," was once near the site of the city's Western Market established in 1803. Many of the residents of the block were merchants and kept shops in their homes. In 1982 George Washington University underwent renovation of the rundown row houses, with a plan to preserve its historic character. Renamed "The Shops at 2000 Penn," thirteen historic row houses along I Street between Nineteenth and Twentieth Streets became nothing but a historic show for the shopping center built behind them. During construction, the buildings were joined together in the back and an eight-story office building was built behind them. Only the facades of the historic nineteenth-century row houses remain.

As for once-private houses remaining in the White House neighborhood, two classic Washington row houses still stand on Pennsylvania Avenue, in use by the Embassy of the Republic of Mexico. For the space needed, the houses were too small, but the Commission of Fine Arts would not allow them to be removed from the streetscape. The compromise was to demolish all but the facades, restore those, and build the embassy behind them. Mexico sent one the earliest ambassadors to the Washington diplomatic corps and has always maintained a notable embassy, even back in the days when the embassies and legations (except for Britain) were stuffed into relatively small rental houses. In this preservation-adaptation on Pennsylvania Avenue, Mexico keeps its crown for having one of the most unusual embassies in Washington.

The Bacon House is nearby, just off Seventeenth Street, and quite central to the White House neighborhood. It is an old house where in the early years of the republic Chief Justice John Marshall, resident of Richmond, made his Washington home while the Supreme Court was in session. Robert Bacon served major diplomatic posts and was secretary of state in the last month of Theodore Roosevelt's presidency. Bacon and his wife

Martha were naturally prominent in Washington for his various positions, his closeness to Congress, and his power behind the scenes even after the departure of the Republicans in 1913.

After Bacon's passing, an irascible Martha Bacon remained a leader in Washington society, but in the half century of her widowhood her most ardent interest was in historic preservation in the capital. Any effort to demolish a historic building in Washington met with her very vocal challenges. Upon her passing, the Bacon House was willed to be preserved with an endowment and passed to the nonprofit club, Diplomatic and Consular Officers, Retired. DACOR restored the building, changing very little. Looking inside very much as it did with the Bacons, the house is used for DACOR purposes and is one of the most popular venues in Washington to rent for social and political entertainment.

The Bacon House was of course exceptional, if typical of Washington in some ways in its original 1820s form. The vast majority of such houses in Washington followed the same pattern. The classic Washington row house of the 1820s might be level with the street or a short flight of steps up, basement about half out of the ground, with the main floor atop the front steps. Inside was a narrow stair hall with two rooms on one side, sometimes equipped with double doors so they could be thrown into one. Beyond the relating narrow hall a door opened into a small back hall with a steep backstair into an "L" wing, which contained service rooms up and down and an everyday dining room. Uses of rooms were various. In an estate inventory, for example, one might find a "back parlor" or "dining room" in the front block of the house, while in the wing a "work space" or "common dining room" or a "servants' room." Upstairs a drawing room extended entirely across the front, with a small room behind. On up to a third floor the same arrangement prevailed, and a single long room in the attic. The basement might be a dark cellar or other usable space but a kitchen, not usually.

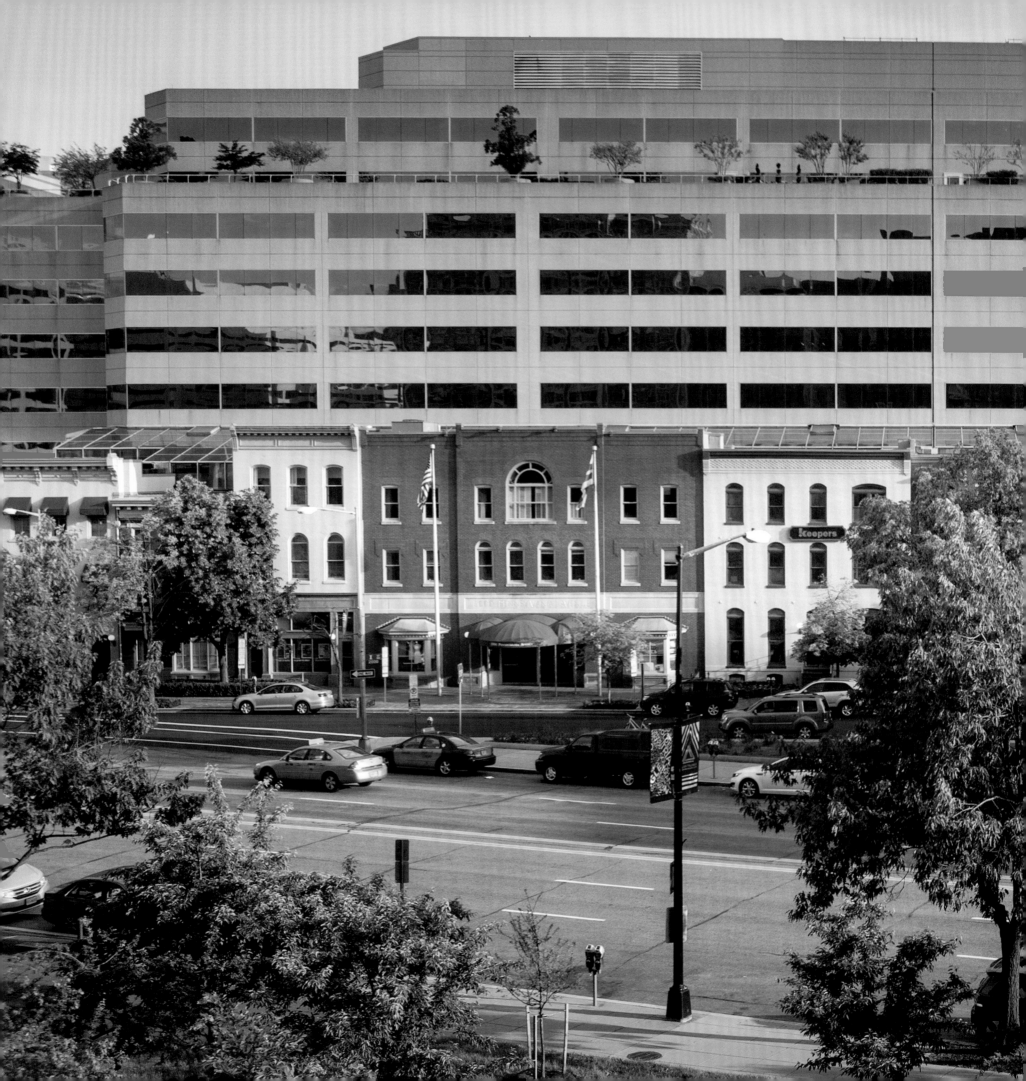

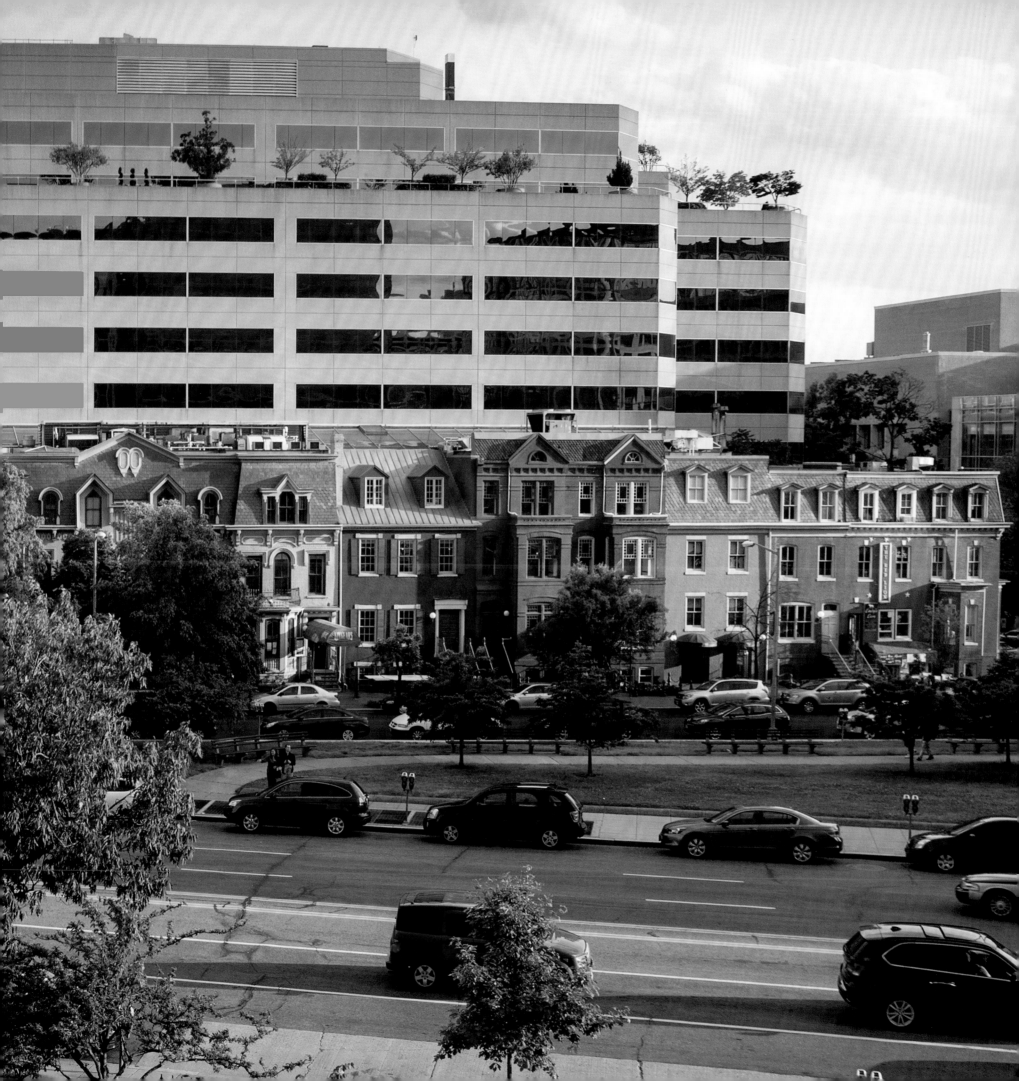

THE VERY CHARACTER OF THE STREETS HAS
CHANGED. THE SMALL, RED BRICK HOUSES
. . . ARE BEING EVERYWHERE REPLACED.

FIRST LADY HELEN HERRON TAFT

FOR REGULATING THE MATERIALS AND
MANNER OF BUILDINGS AND IMPROVEMENTS
ON THE LOTS IN THE CITY OF WASHINGTON,
IT IS PROVIDED THAT THE OUTER AND PARTY
WALLS OF ALL HOUSES IN THE SAID CITY
SHALL BE BUILT OF BRICK OR STONE.

PRESIDENT THOMAS JEFFERSON

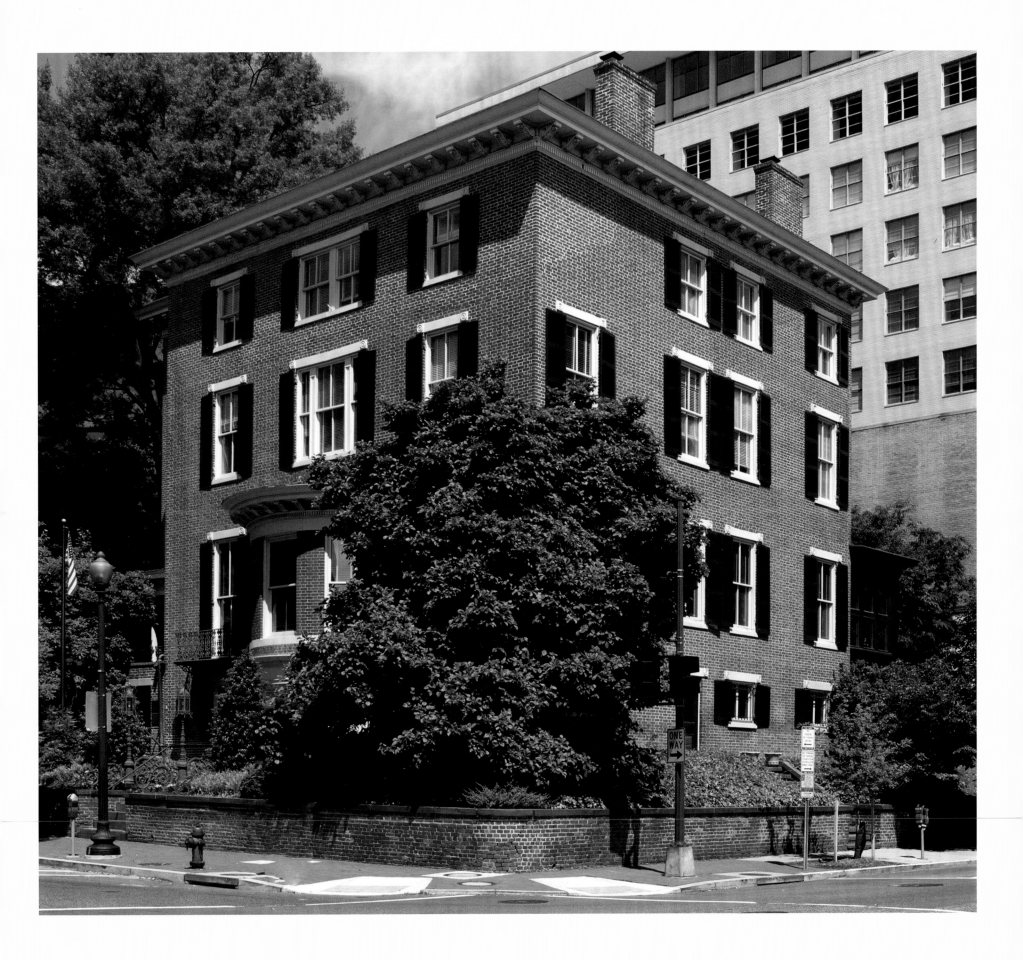

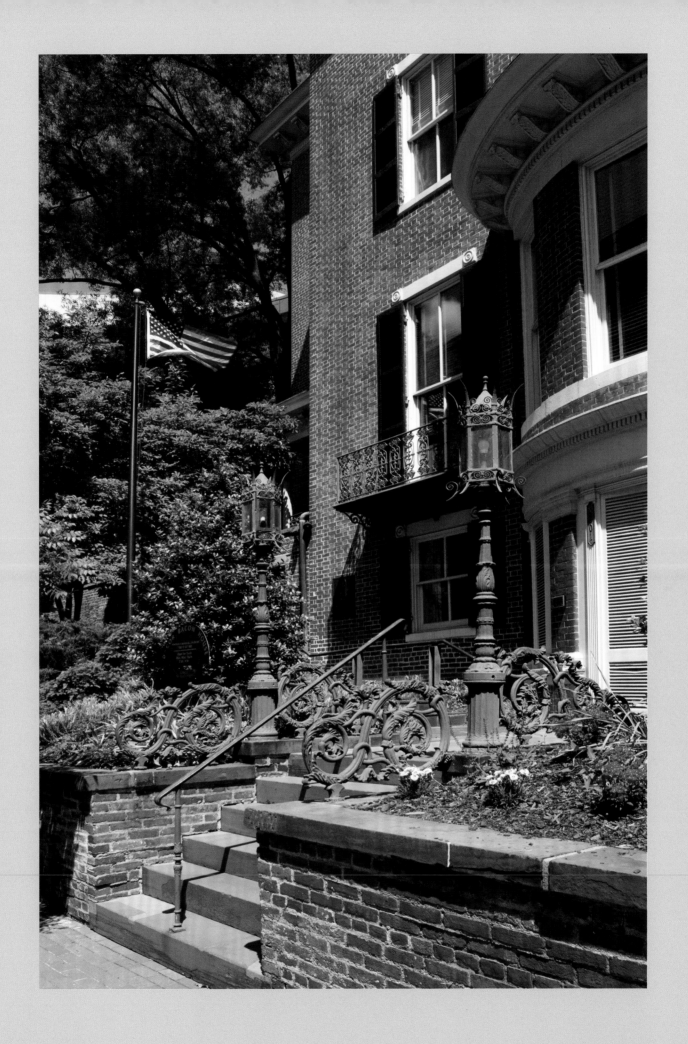

THE EXCLUSIVE CLUBS PROCEED

Several notable private clubs share the White House neighborhood. The Army and Navy Club on Farragut Square is one of two, this, the town club, and another Army and Navy, a country club in Arlington County, Virginia, across the river.

Until the 1950s the Cosmos Club was part of the neighborhood, but it moved on out Massachusetts Avenue in 1952. It had been founded in 1878.

The Metropolitan Club, at the corner of Seventeenth and H Streets, was founded in 1863, during the Civil War, and almost every famous Union general was a member. After the war, the club built a large headquarters that provided hotel arrangements for members, dining rooms, a library, and every other amenity

for a man away from home. Membership has tended to businessmen and prominent citizens of the city, as well as political leaders, notably top staff in the West Wing. In 1907 the headquarters burned down and was replaced by the present handsome building, modern for its time, built of glazed Roman brick and limestone, neoclassical in a sense, yet anticipating the Arts and Crafts movement to come, then in its infancy. The interior is reserved. A large entrance hall frames the grand staircase, which is lighted by large stained glass windows, providing the only theatrical feature of the house. Dining and meeting rooms above are formal, boasting high ceilings. Various uses of marble and the marble-like plaster scagliola mix with oak paneling and painted beams devised to resemble oak. Portraits of Union officers stationed in

Washington during the Civil War hang throughout the rooms.

In a modest town house very typical of nineteenth-century Washington is the Alibi Club. Founded in 1884, the club moved into this row house two years later and has occupied it since. Modeled on the smaller gentlemen's eating clubs in the major cities and in Europe, the Alibi is a very private organization dedicated to the interaction and friendship among its members. The membership is limited to fifty, never exceeds that, and while it is in no sense a "secret society," the names are not published. Inside it might be described as being like an old family house, a little tatty from use, but welcoming. In the hall of the Alibi Club is a plaque documenting the club's history that reads, "Together they sought relief from the vicissitudes of domestic life and the rigors of business . . . in the pursuit of happiness in comfortable surroundings among convivial friends."

Private clubs in Washington, like private clubs everywhere, have had their restrictive qualifications for membership challenged. Both the Cosmos Club, now a long way from the neighborhood, and the Metropolitan Club now admit women. Racial and ethnic restrictions went long beyond that. Theodore Roosevelt may have planned the Spanish-American campaign at the Metropolitan, and the National Geographic was envisioned at the Cosmos. All the great generals were members of the Army and Navy Club. And so, with modifications that are barely perceptible, the exclusive clubs proceed.

The Metropolitan Club is one of the most exclusive clubs in the world, and at the same the time one of the most democratic.

St. Louis Republic, 1903

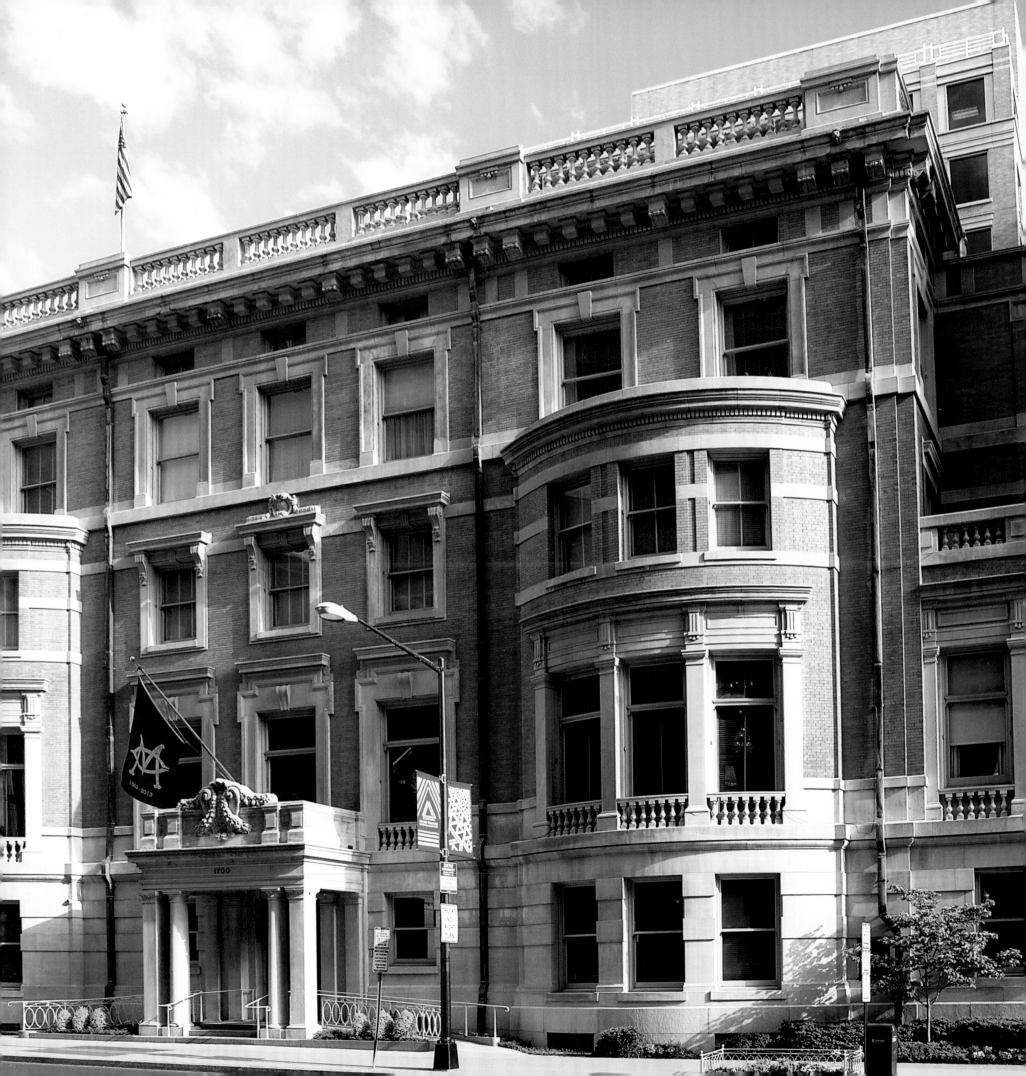

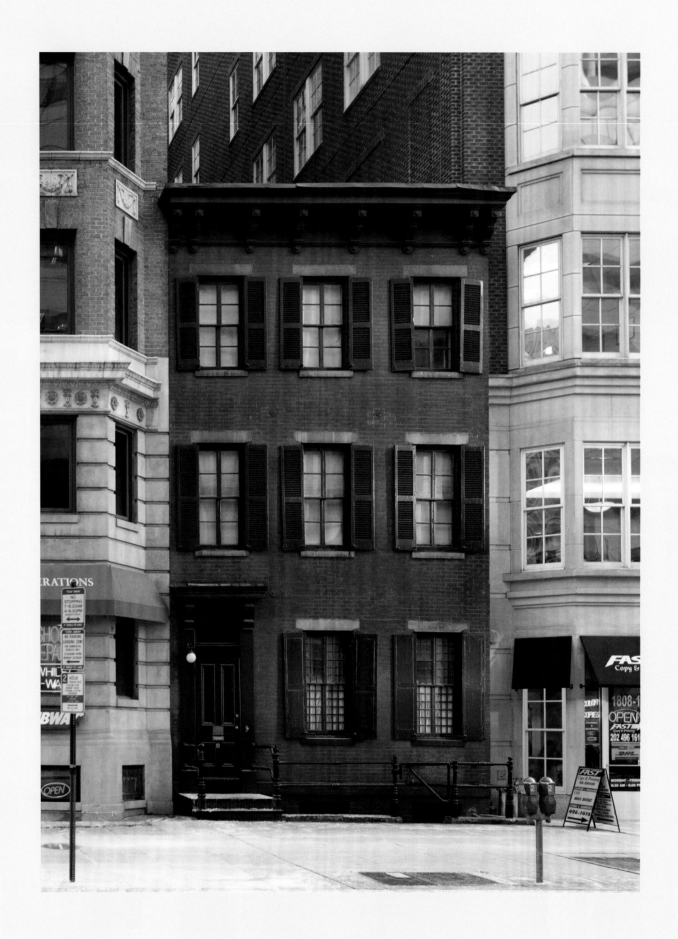

Together they sought relief from the vicissitudes of domestic life and the rigors of business . . . in the pursuit of happiness in comfortable surroundings among convivial friends.

Alibi Club History

It looks as though it is furnished with everything the Smithsonian ever rejected.

S. Dillon Ripley
Secretary of the Smithsonian Institution

THE CITY OF MUSEUMS THAT IS THE WHITE HOUSE NEIGHBORHOOD

Unless one considers the neighborhood itself an outdoor museum, four museums are found in the city of museums that is the White House neighborhood. Immediately west of Blair House and next door to it (or in fact next to the Lee House, to which the Blair complex is attached) is the Renwick Gallery, which was once the Corcoran Gallery built by James Renwick Jr. immediately before the Civil War to house W. W. Corcoran's ever-growing art collection and as an art school to make use of the collection. The building was not completed when Corcoran left for France. In his absence the federal government confiscated portions of the building for offices. Upon Corcoran's return the gallery was completed and open to the public. It was Washington's first museum after the Smithsonian, Patent Office, and

Medical Museum, and much celebrated at the time. The great feature of the collection was nineteenth-century art as espoused by Corcoran. Many fine paintings and pieces of sculpture were bought by Corcoran from southern families on hard times after the Civil War. The Corcoran Gallery of Art relocated to a new building on Seventeenth Street in 1897, and for many years the Renwick building housed the U.S. Court of Claims. In 1965 the building was transfered to the Smithsonian as a crafts center and museum, which it remains today, now as a branch of the Smithsonian American Art Museum.

The Corcoran Gallery of Art on Seventeenth Street, another white marble building in the row, honors neoclassical design in the Roman mode. Yet it fits into Washington's predominant

public architecture like a piece to a puzzle. The dramatic interior is entered through long stairs, continuing the white marble, to two splendid bright courts with basilican colonnades belting four sides of each. In 2014 the Corcoran Gallery was closed. Its famous art school was acquired by The George Washington University, and the collection was placed under stewardship of the National Gallery of Art.

The White House is in a sense a museum. It has been open to the public since the spring of 1801 when President Thomas Jefferson, inspired by the availability of tours in the stately homes he had visited in Europe, opened his "state home" to public inspection free of charge. Visitors wandered through the unfinished East Room and perhaps peeked at his breakfast room and parlor, then departed. The Treasury and other departmental buildings were also available for viewing on a very informal basis, especially after the nineteenth-century creation of the Cash Room at the Treasury and the State Reception Room at the State, War and Navy Building. White House security in recent years has necessarily reduced the availability to tourists, yet as much effort as can be made opens the doors. Through one's congressman or senator permission may be gained to tour the State Rooms of the White House. Pressure is eased by a fine White House Visitor Center in the 1920s Department of Commerce Building across Pennsylvania Avenue from the Willard Hotel.

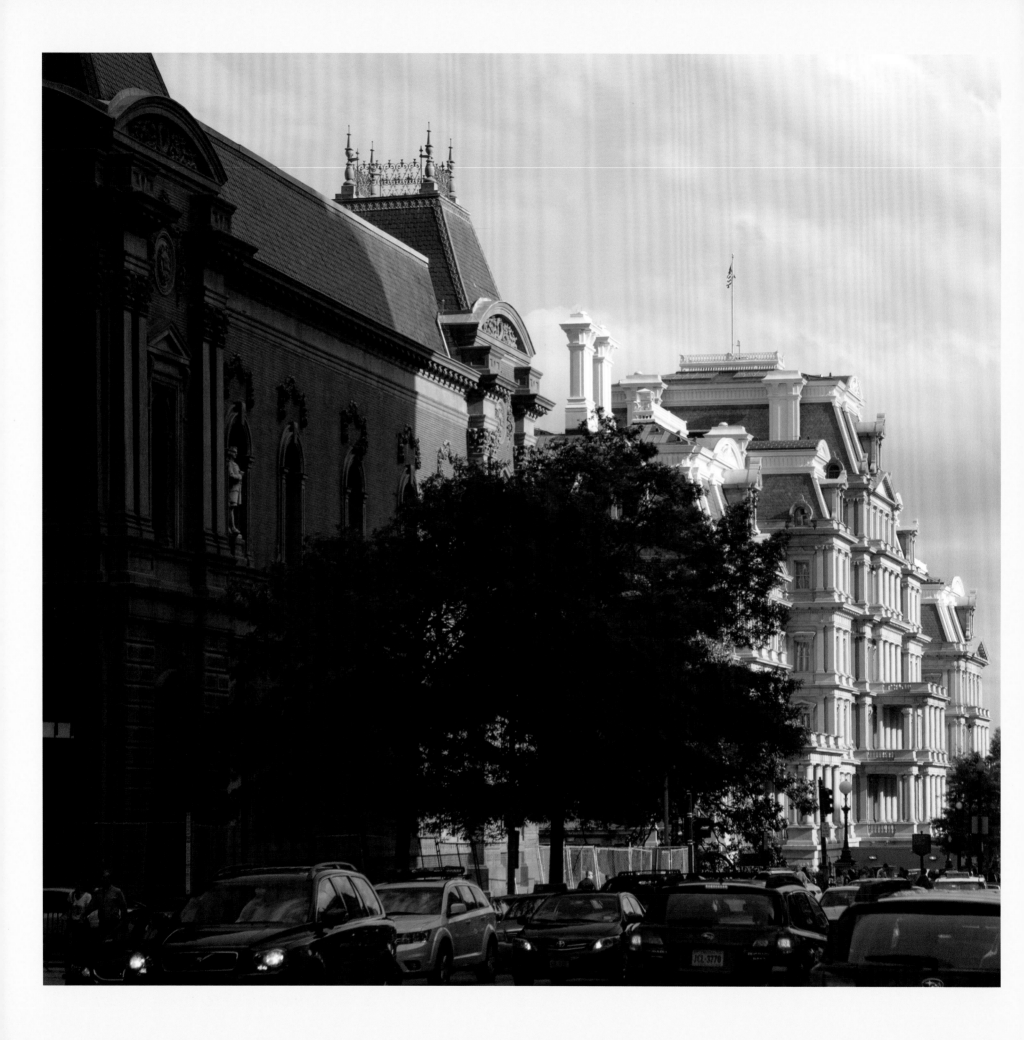

DEAR DR. RIPLEY: I AM ENTHUSIASTIC ABOUT
YOUR SUGGESTION THAT THE SMITHSONIAN
INSTITUTION TAKE OVER THE OLD U.S. COURT OF
CLAIMS BUILDING AND ESTABLISH IT AS A GALLERY OF
ARTS, CRAFTS AND DESIGN. NO MORE APPROPRIATE
PURPOSE FOR THE BUILDING COULD BE PROPOSED.

PRESIDENT LYNDON B. JOHNSON
REPLYING TO DILLON RIPLEY'S SUGGESTION THAT THE
RENWICK BUILDING BE RESTORED TO USE AS AN ART GALLERY

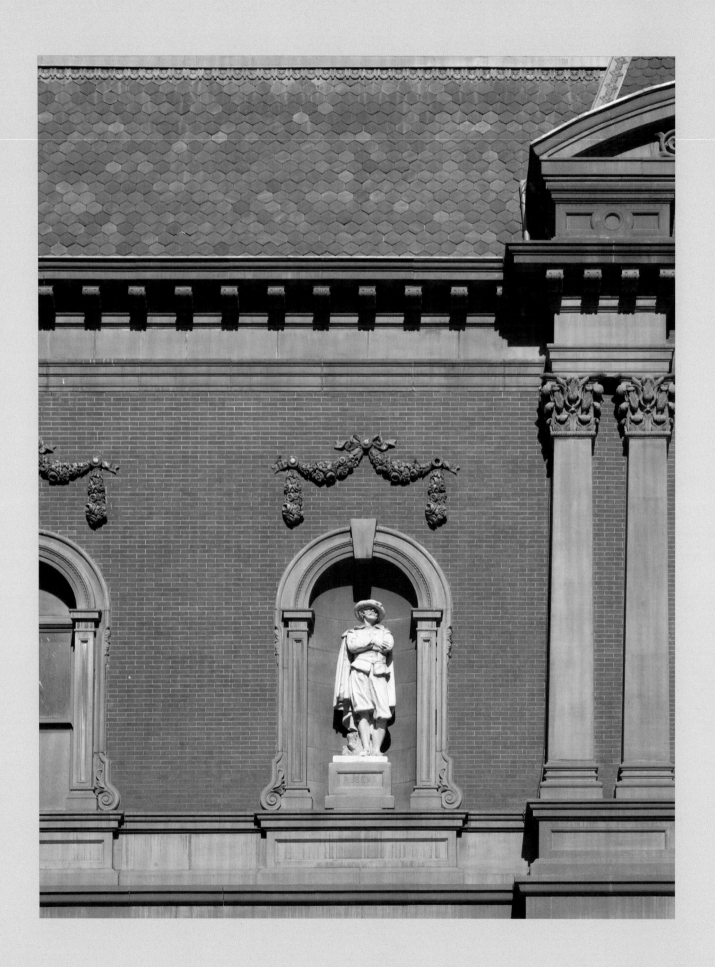

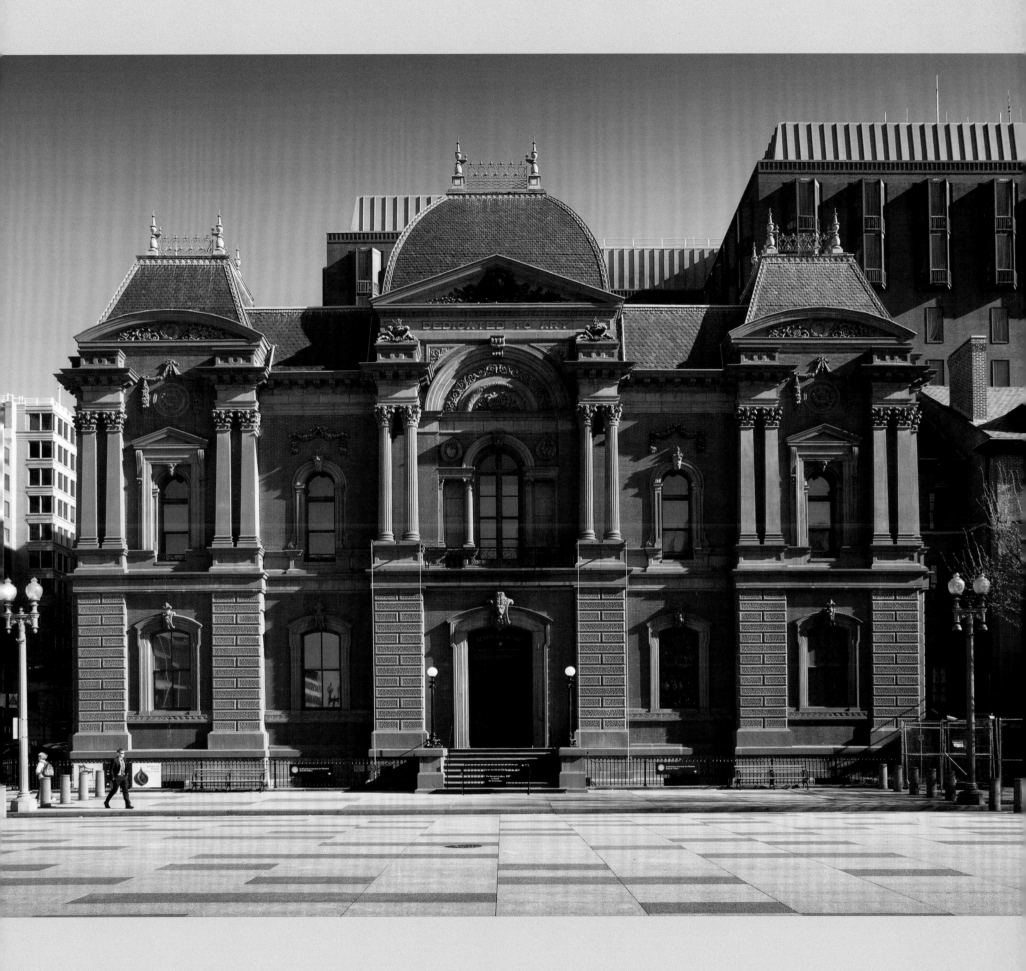

The best designed building in Washington.

Frank Lloyd Wright

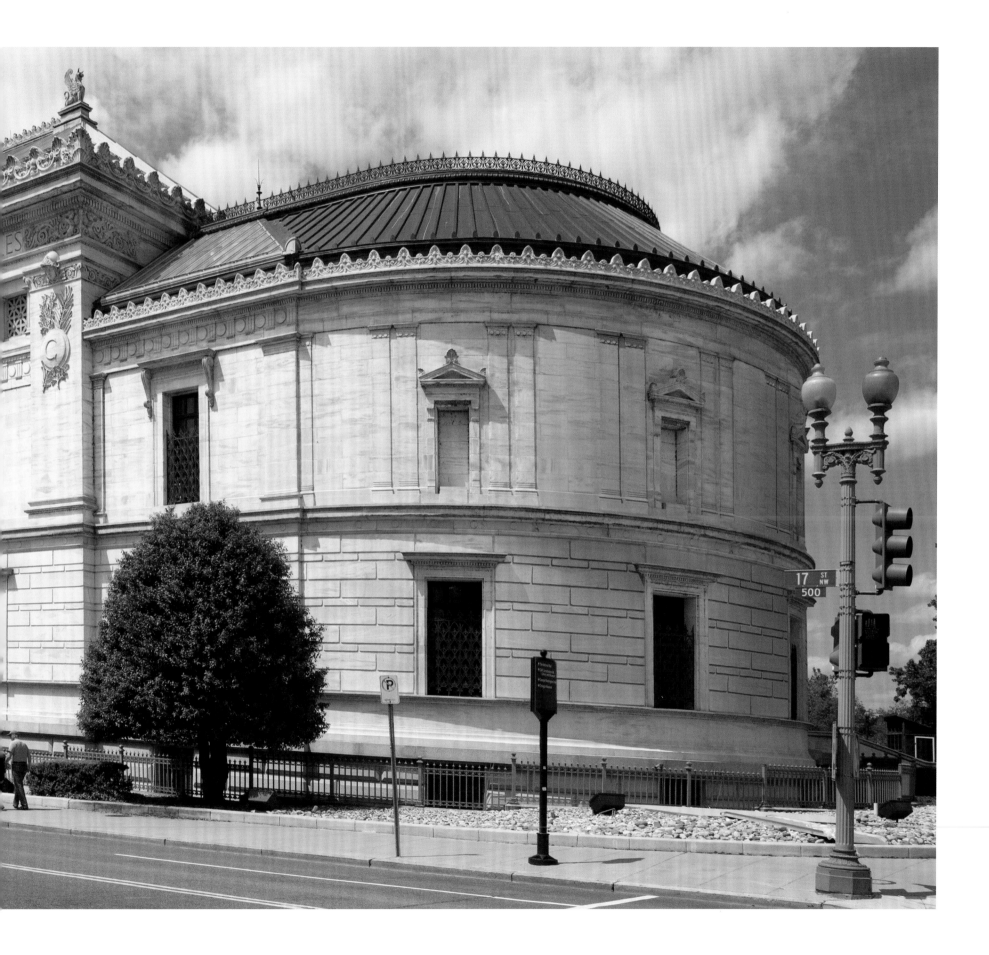

TWENTY-FIRST-CENTURY NEIGHBORS

The costs and, in some respects the appeal, of modern urban architecture began to appear in the White House neighborhood soon after World War II. Office space is so desirable in the area and the building costs so high that many efforts to increase size are interrupted in current modes. Of course they are cheaper modes as well, as developers want to take advantage of available office space for as little money as they can. Adaptations to existing buildings are few but often cleverly conceived and serve the neighborhood well. The Army and Navy Club, for example, extended its early building several stories upward, protecting the dignity of the earlier building extant. Although some glass facades appear as in-fill on lots, the trend today is the upward addition. Washington's historic height restrictions have suffered repeated challenges, but they stay firm thanks largely to the Commission of Fine Arts and its friendly relations with Congress. Near the White House the ever-changing rules of security are sacrosanct and shape all new architectural designs as well as requiring frequent alterations to existing structures.

The glass buildings are big in volume but sometimes seem transparent. They look temporary and sometimes cheap. Often, however, they represent the best compromise between a hoggish filling of a space and a visually lightened load. They are unlikely to outlive the older masonry structures. And that may be the theme of the day, to preserve the old for its charm and historical reflections, and for construction shortcomings, replace the new and consider it temporary. That flexibility is probably not a bad idea.

Meanwhile life goes on in the White House neighborhood. It has a tranquil appeal, the park with its tall trees and green canopy,

the leaky fountains, Andrew Jackson on his horse, the protesters who vent their opinions within the regulations specified by the National Park Service, all friendly and even a little homey, American style. The great White House, presidential icon to the world, continues to loom on its rise of ground, the landscaped lushness beyond the iron fence ever planned and tailored by experts, whose clever plantings make the building seem to fill the site more appealingly. George Washington's reduction of the size of the house, but not the location, was always a problem with the proportions of the White House in its setting.

The limousines of the past are fewer, passing in and out of the president's gate, replaced largely by highly polished black SUVs adapted to White House use. The broad expanse of Pennsylvania Avenue is the delight of bicycles, skateboards, and roller skates; pedestrians are able to walk the closed avenue and get a better look at the White House than ever. Offices pack the old buildings and those seemingly old, their windows lighted sometimes well after midnight.

Activity seems to spin around the president. To borrow from the Bible, he was once a man among many and now is the slave of all. His windows are also frequently lighted late at night. The neighborhood is not totally presidential, but at its high mark it seems so, for one is continually aware of this highest official when there. But beyond being home to the head of state, the White House neighborhood is an ongoing microcosm of past and present in the capital of the United States.

The American arts, like a
many-faceted mirror, have
been a colorful reflection
of this nation's history. . . .
In architecture, Americans
see everything from
the Federal style to
postmodernism.

President George H. W. Bush

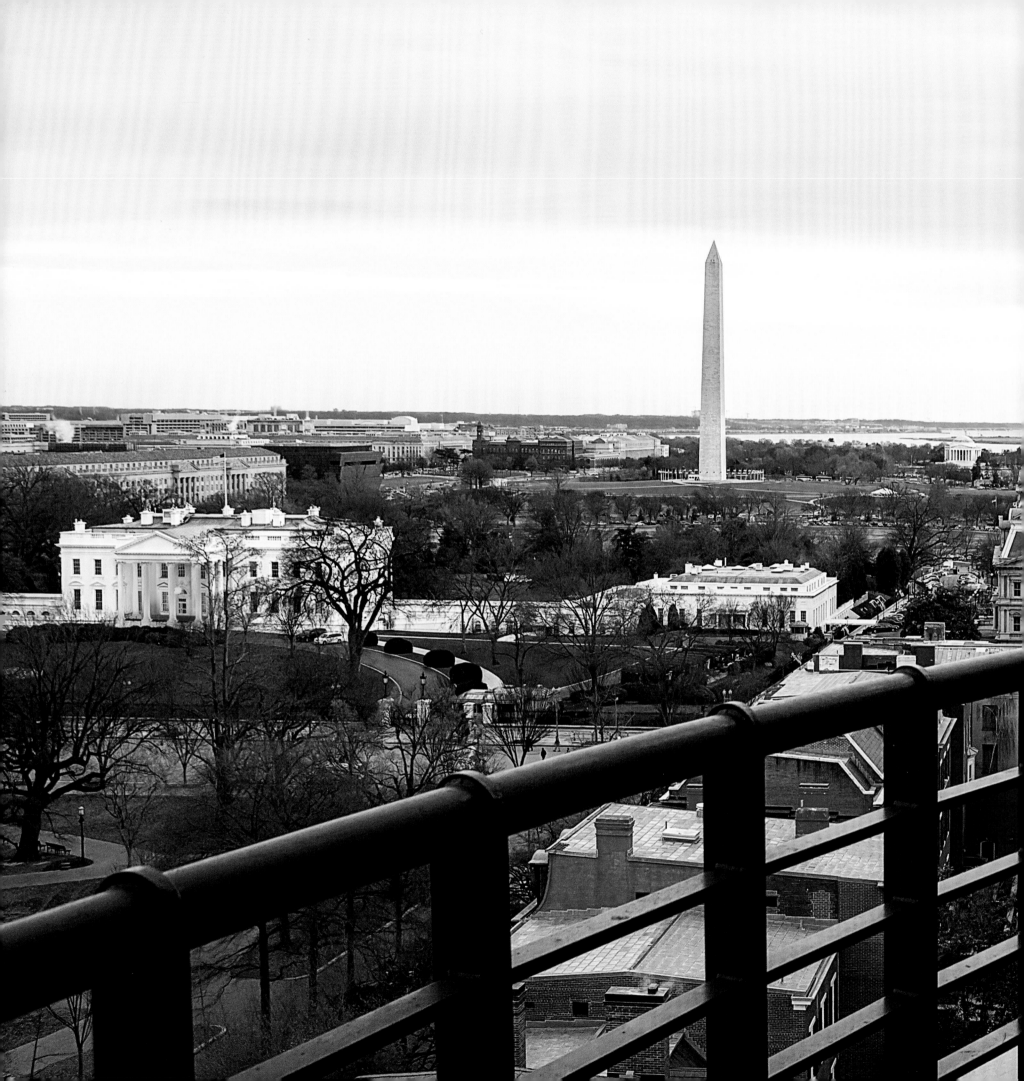

ILLUSTRATIONS AND REFERENCES

FRONT MATTER

1600 PENNSYLVANIA AVENUE, THE WHITE HOUSE

The Neighborhood to the North

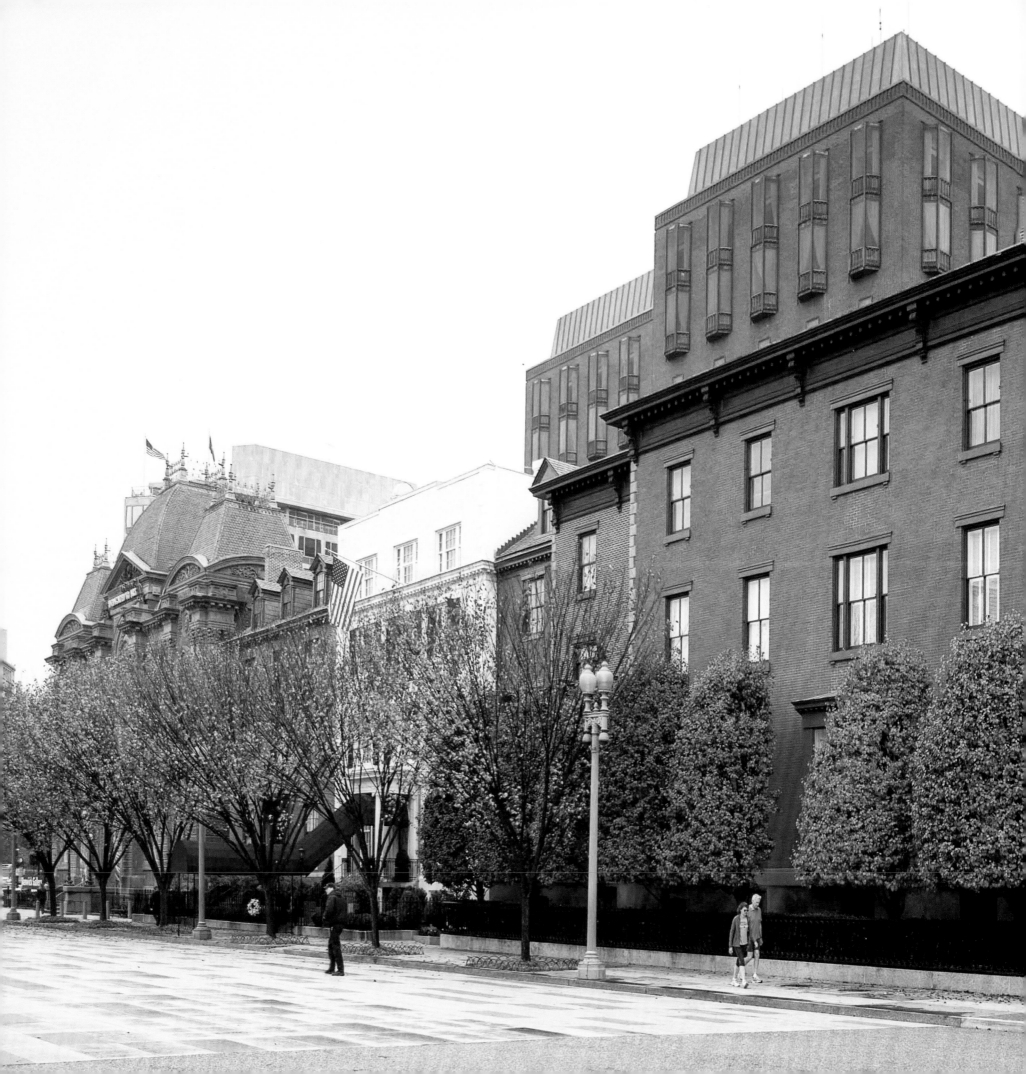

PAGES 88–89 HISTORIC DECATUR HOUSE SLAVE QUARTERS ON THE RIGHT AND THE
 COURTYARD LEADING TO THE CARRIAGE HOUSE IN THE BACK.
 "For nearly 200": Michelle Obama, "Remarks by the First Lady at Decatur House Visit," May 22,
 2013, Speeches and Remarks, available online at whitehouse.gov.

PAGES 90–91 HISTORIC DECATUR HOUSE BACK COURTYARD.

PAGES 94–95 1520 H STREET NW. THE DOLLEY MADISON HOUSE NEAR THE NORTHEAST
 CORNER OF LAFAYETTE SQUARE.
 "I have only": Dolley Madison to Richard Smith, November 30, 1844, *The Papers of Dolley
 Madison Digital Edition,* ed. Holly C. Shulman (Charlottesville: University of Virginia Press,
 Rotunda, 2008), available online at rotunda.upress.virginia.edu.

PAGES 96–97 21 MADISON PLACE NW. THE NORTHEAST CORNER OF LAFAYETTE SQUARE
 WITH THE TAYLOE HOUSE ON THE RIGHT AND THE DOLLEY MADISON
 HOUSE ON THE FAR LEFT.
 "Hold your breath": Jacqueline Bouvier Kennedy, *Jacqueline Kennedy: Historic Conversations
 on Life with John F. Kennedy,* ed. Michael Beschloss (New York: Hyperion, 2011), xxvii.

PAGES 98–99 701 MADISON PLACE NW. ENTRANCE TO THE TREASURY ANNEX.

PAGES 102–3 ONE OF TWO NAVY YARD URNS, DECORATED WITH CLASSICAL FIGURES
 AND CAST AT THE WASHINGTON NAVY YARD IN 1872, NOW LOCATED ON
 THE EAST AND WEST SIDES OF LAFAYETTE PARK.
 "The human need": Ronald Reagan, "Remarks at the Awards Presentation Ceremony for the
 President's Committee on the Arts and the Humanities," May 17, 1983, American Presidency
 Project, ed. Peters and Woolley, available online at www.presidency.ucsb.edu.

PAGES 104–5 THE EQUESTRIAN STATUE OF PRESIDENT ANDREW JACKSON BY CLARK
 MILLS SILHOUETTED AGAINST THE NORTH PORTICO AT NIGHT.
 "The night is falling": Franklin D. Roosevelt, "Christmas Greeting to the Nation," December 24,
 1935, American Presidency Project, ed. Peters and Woolley, available online at
 www.presidency.ucsb.edu.

PAGES 106–7 MAJOR GENERAL MARQUIS DE LAFAYETTE STATUE IN LAFAYETTE PARK.
 "and the four corners": Franklin D. Roosevelt, "Christmas Greeting to the Nation," December 24,
 1935, American Presidency Project, ed. Peters and Woolley, available online at
 www.presidency.ucsb.edu.

PAGES 108 WEST SIDE OF THE BRIGADIER GENERAL TADEUSZ KOSCIUSZKO STATUE
 DEPICTING A FALLEN GENERAL KOSCIUSZKO DIRECTING A POLISH SOLDIER
 TO RETURN TO THE BATTLEFIELD.
 "Here may the youth": John Adams, quoted in David McCullough, *John Adams* (New York:
 Simon & Schuster, 2001), 555.

PAGE 109 THREE VIEWS OF THE BRIGADIER GENERAL TADEUSZ KOSCIUSZKO STATUE
 IN THE NORTHEAST CORNER OF LAFAYETTE PARK.

PAGES 110–11 LEFT TO RIGHT: MAJOR GENERAL MARQUIS DE LAFAYETTE STATUE AT THE
 SOUTHEAST CORNER OF LAFAYETTE PARK WITH STATUES OF COMTE DE
 ROCHAMBEAU AND CHEVALIER DU PORTAIL DEPICTED ON THE WEST SIDE
 OF THE MONUMENT; TWO VIEWS OF LIEUTENANT GENERAL COMTE DE
 ROCHAMBEAU STATUE AT THE SOUTHWEST CORNER OF LAFAYETTE PARK;
 MAJOR GENERAL WILHELM VON STEUBEN STATUE AT THE NORTHWEST
 CORNER OF THE PARK.
 "We never call": Woodrow Wilson, "Memorial Day Address," May 30, 1914, American Presidency
 Project, ed. Peters and Woolley, available online at www.presidency.ucsb.edu.

PAGES 114–17 1651 PENNSYLVANIA AVENUE NW. EXTERIOR OF BLAIR HOUSE, THE
 PRESIDENT'S GUEST HOUSE, ON PENNSYLVANIA AVENUE.
 "I should so soon": Gist Blair, quoted in Shireman, *To Be Preserved for All Time*, 21. "I
 recommend that": Harold L. Ickes, quoted in ibid., 42. "I am, therefore, inclined": Franklin D.
 Roosevelt, quoted in ibid., 47–48. "Thank you": Michelle Obama, Blair House guest book.
 "Your hospitality": Shimon Peres, ibid.

PAGES 120–23 1615 H STREET NW. THE U.S. CHAMBER OF COMMERCE.
 "It is good": Barack Obama, "Remarks to the United States Chamber of Commerce,"
 February 7, 2011, American Presidency Project, ed. Peters and Woolley, available online at
 www.presidency.ucsb.edu.

PAGES 124–25 H STREET NW AT NIGHT WITH BUCKINGHAM HOUSE, ST. JOHN'S PARISH
 HOUSE, ON THE LEFT AND THE DOLLEY MADISON HOUSE ON THE RIGHT.

PAGES 128–30 800 SIXTEENTH STREET NW. THE HAY-ADAMS HOTEL.
 "Then Ronnie and I walked": Nancy Reagan and William Novak, *My Turn: The Memoirs of Nancy
 Reagan* (New York: Random House, 1989), 241.

PAGE 131 923 SIXTEENTH STREET NW. LOOKING DOWN SIXTEENTH STREET WITH THE
 ST. REGIS WASHINGTON, D.C., ON THE LEFT.

PAGES 132–33 1127 CONNECTICUT AVENUE NW. FRONT ENTRANCE TO THE MAYFLOWER HOTEL.
 "Washington's second": Harry S. Truman, quoted in Sarah Kershaw and Michael Powell, "Just a Hotel?
 For Some, It's an Adventure," *New York Times*, March 20, 2008, available online at www.nytimes.com.

PAGES 136–39 STATUE OF ADMIRAL DAVID FARRAGUT IN FARRAGUT SQUARE.
 "In those days": Alice Roosevelt Longworth, *Crowded Hours* (New York: Arno Press, 1980), 2–3.
 "As the years pass": James A. Garfield, quoted in "Admiral Farragut: Unveiling of His Statue at
 Washington Yesterday," *Washington Post,* reported from the *Baltimore Sun*, April 26, 1881, 1.

PAGES 140–41 901 SEVENTEENTH STREET NW. LOOKING SOUTH ON SEVENTEENTH STREET
 PAST THE ARMY AND NAVY CLUB BUILDING TOWARD THE WASHINGTON
 MONUMENT.
 "In the old days": Ronald Reagan, "Remarks at the Dedication Ceremony for the Army and Navy
 Club," January 12, 1988, American Presidency Project, ed. Peters and Woolley, available online at
 www.presidency.ucsb.edu.

PAGES 142–43 1500 K STREET NW. BUILDING ALONG MCPHERSON SQUARE.

PAGES 144–45 STATUE OF MAJOR GENERAL JAMES B. MCPHERSON IN MCPHERSON SQUARE.
 "Well-kept streets": Calvin Coolidge, "Address at a Joint Meeting of the American Federation
 of Arts and the American Association of Museums, Washington, D.C.," May 16, 1928, American
 Presidency Project, ed. Peters and Woolley, available online at www.presidency.ucsb.edu.

PAGES 148–49 800 CONNECTICUT AVENUE NW. OFFICE BUILDING ON THE CORNER OF
 CONNECTICUT AVENUE AND H STREET.
 "The avenues are made": Thomas Jefferson, quoted in Seale, *President's House*, 1:20.

PAGES 150–51 OFFICE BUILDINGS ON THE CORNER OF SEVENTEENTH STREET AND
 PENNSYLVANIA AVENUE, WEST OF THE WHITE HOUSE.

THE NEIGHBORHOOD TO THE EAST

PAGE 152 1500 PENNSYLVANIA AVENUE NW. THE U.S. DEPARTMENT OF THE TREASURY
 BUILDING.

PAGES 156–57 PEDESTRIAN SIDEWALK DOWN THE 1600 BLOCK OF PENNSYLVANIA AVENUE
 NW LOOKING WEST.
 "This thoroughfare": Laura Bush, "Reopening Ceremony of Pennsylvania Avenue to Pedestrians,"
 Associated Press Archives, November 9, 2004.

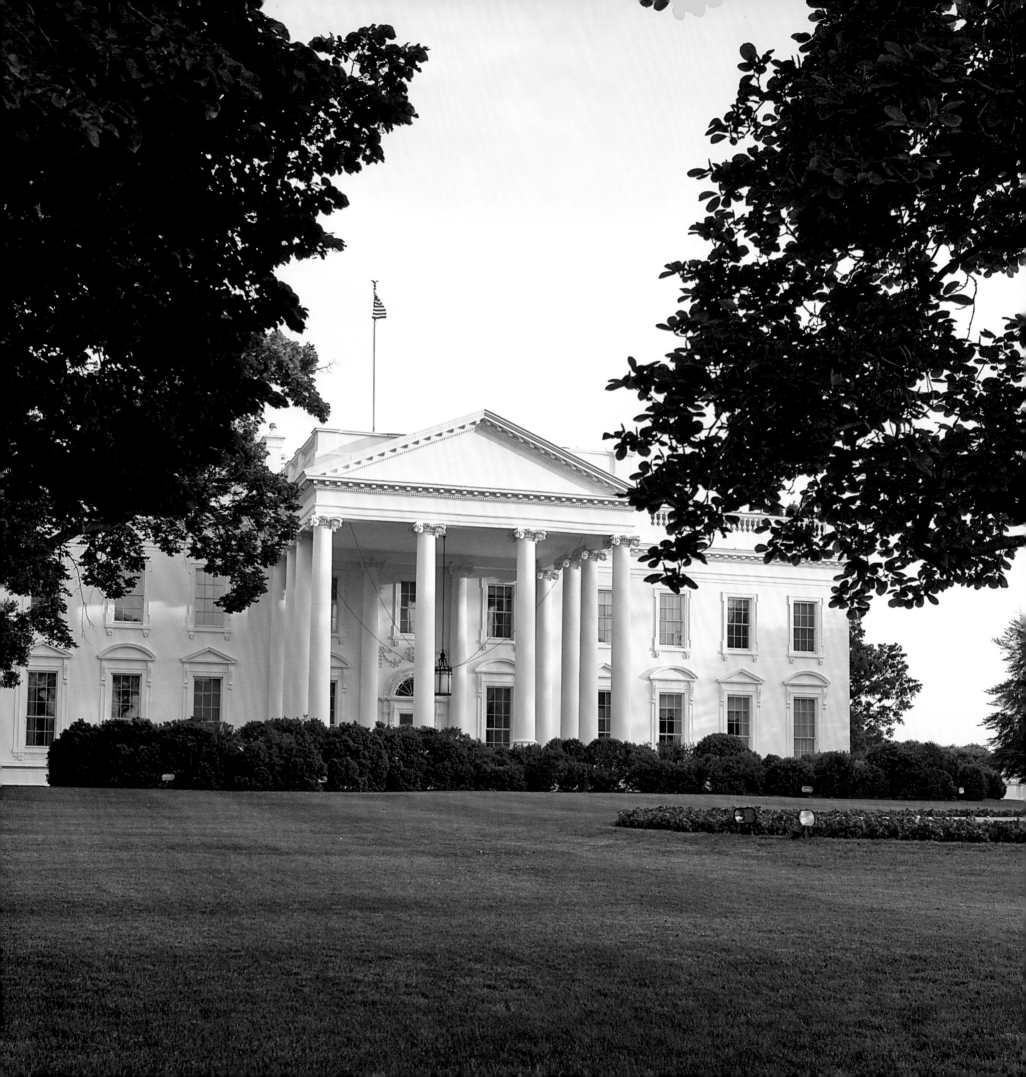

PAGES 180–81 725 FIFTEENTH STREET NW. DETAIL OF THE AMERICAN EAGLE ON THE FOLGER
 BUILDING FOR THE MEMBERS OF THE NEW YORK STOCK EXCHANGE.
 "Today we honor": William Jefferson Clinton, "Remarks on Steps to Remove the American Bald
 Eagle from the Endangered Species List," July 2, 1999, American Presidency Project, ed. Peters
 and Woolley, available online at www.presidency.ucsb.edu.

PAGES 182–83 805 FIFTEENTH STREET NW. ARCHITECTURAL DETAILS ON THE SOUTHERN
 BUILDING.

PAGES 184–85 740 FIFTEENTH STREET NW. PREVIOUSLY THE AMERICAN BAR ASSOCIATION
 HEADQUARTERS.
 "If our country": Calvin Coolidge, "Fourth Annual Message," December 7, 1926, American
 Presidency Project, ed. Peters and Woolley, available online at www.presidency.ucsb.edu.

PAGES 186–87 1400 NEW YORK AVENUE NW. THE BOND BUILDING.

PAGES 188–89 875 FIFTEENTH STREET NW. DETAIL OF THE ENTRANCE TO THE BOWEN BUILDING.

PAGES 192–93 675 FIFTEENTH STREET NW. FRONT ENTRANCE TO THE OLD EBBITT GRILL.
 "It's not every": "Vintage 'Old Ebbitt Grill' Opens Its Doors to New Age," Nation's Restaurant
 News, September 14, 1970, newspaper clipping displayed at the Old Ebbitt Grill.

PAGES 196–97 THE WILLARD HOTEL F STREET ENTRANCE.
 "The great sight": National Republican, 1867, quoted in Elizabeth Smith Brownstein, "The
 Willard Hotel," White House History, no. 31 (2012): 13.

PAGES 198–99 1401 PENNSYLVANIA AVENUE NW. THE WILLARD HOTEL
 "Willard's Hotel could": Nathaniel Hawthorne, quoted in Fogle, Proximity to Power, 58.

PAGES 200–1 THE PENNSYLVANIA AVENUE ENTRY TO THE WILLARD HOTEL WITH THE
 AMERICAN FLAG AND DETAIL OF ROOF.

PAGES 202–3 VIEW FROM PENNSYLVANIA AVENUE NW. WITH THE W HOTEL ON THE LEFT
 AND THE WILLARD HOTEL ON THE RIGHT.

PAGES 204–7 515 FIFTEENTH STREET NW. THE W HOTEL (ORIGINALLY HOTEL WASHINGTON).
 "Good morning": George W. Bush: "Remarks at the Thanksgiving Turkey Presentation Ceremony,"
 November 24, 2003, American Presidency Project, ed. Peters and Woolley, available online at
 www.presidency.ucsb.edu.

THE NEIGHBORHOOD TO THE WEST

PAGES 234–37 1776 D STREET NW. THE DAUGHTERS OF THE AMERICAN REVOLUTION BUILDING.
"one of the most": Calvin Coolidge, "Address Before the Daughters of the American Revolution, Washington, D.C.," April 19, 1926, American Presidency Project, ed. Peters and Woolley, available online at www.presidency.ucsb.edu.

PAGES 238–39 200 SEVENTEENTH STREET NW. THE ORGANIZATION OF AMERICAN STATES BUILDING.
"The Organization of American States": John F. Kennedy, "Remarks at the Protocolary Session of the Council of the Organization of American States," April 14, 1961, American Presidency Project, ed. Peters and Woolley, available online at www.presidency.ucsb.edu.

PAGES 242–43 1799 NEW YORK AVENUE NW. THE OCTAGON.
"Mr. J. Tayloe": William Thornton to George Washington, April 19, 1799, *The Papers of George Washington, Retirement Series*, vol. 3, *September 16, 1798–April 19, 1799*, ed. W. W. Abbot and Edward G. Gengel (Charlottesville: University Press of Virginia, 1999), 487–88, available online at www.founders.archive.gov.

PAGES 244–49 INTERIOR DETAILS FROM THE OCTAGON: THE PARLOR CROWN MOLDING; THE SERVICE AND MAIN STAIRCASES; THE FRONT DOOR TO THE ENTRANCE HALL; DETAIL OF THE FIRST-FLOOR DINING ROOM COADE STONE MANTEL WITH DANCING MAENAD FIGURES; FIRST-FLOOR PARLOR MANTEL WITH MOLDING OF URN AND CLASSICAL SWAGS; IRON STOVE IN THE ENTRANCE HALL.

PAGE 252–53 2017 I STREET NW. THE MONROE HOUSE (CURRENTLY THE ARTS CLUB OF WASHINGTON). ARTS CLUB OF WASHINGTON COMMEMORATIVE PLAQUE READS "BUILT IN 1802 THIS HOUSE WAS THE HOME OF JAMES MONROE."
"An unexpected change": James Monroe to Thomas Jefferson, April 3, 1811, *The Papers of Thomas Jefferson, Retirement Series*, vol. 3, *August 12, 1810–June 17, 1811*, ed. J. Jefferson Looney (Princeton: Princeton University Press, 2006), 527–28, available online at www.founders.archives.gov.

PAGES 254–55 INTERIOR VIEW OF THE MONROE HOUSE BALLROOM.
"Secretary of State": "History," artsclubofwashington.org.

PAGES 256–57 JAMES MONROE PARK LOOKING TOWARD THE MONROE HOUSE ON I STREET.

PAGES 260–61 2000 BLOCK OF I STREET NW. THE HISTORIC RED-BRICK HOUSE FACADES ON RED LION ROW.

PAGES 262–63 1911 PENNSYLVANIA AVENUE NW. THE EMBASSY OF MEXICO WITH TWO
 SURVIVING FACADES FROM THE HISTORICAL ROW HOUSES KNOWN AS
 "THE SEVEN BUILDINGS."
 "The very character": Helen Herron Taft, *Recollections of Full Years*, 27.

PAGES 264–67 1801 F STREET NW. VIEWS OF BACON HOUSE, ALSO KNOWN AS THE
 RINGGOLD-CARROLL HOUSE AND HEADQUARTERS FOR THE DIPLOMATIC
 AND CONSULAR OFFICERS, RETIRED (DACOR).
 "For regulating the materials": Thomas Jefferson, "Proclamation—Building Regulations in the
 District of Columbia," March 11, 1801, American Presidency Project, ed. Peters and Woolley,
 available online at www.presidency.ucsb.edu.

PAGES 270–71 1700 H STREET NW. THE METROPOLITAN CLUB.
 "The Metropolitan Club": "Washington's Exclusive Club The Metropolitan," *St. Louis Republic*,
 May 3, 1903, Chronicling America: Historic American Newspapers, Library of Congress,
 available online at www.chroniclingamerica.loc.gov.

PAGES 272–73 1806 I STREET NW. THE ALIBI CLUB.
 "Together they sought": Alibi Club history, quoted in Sarah Booth Conroy, "A Peek at Privilege:
 Inside the Alibi Club," *Washington Post*, June 22, 1992, B9, available online at
 www.proquest.com. "It looks as though": S. Dillon Ripley, quoted in ibid.

PAGES 276–77 1661 PENNSYLVANIA AVENUE NW. THE RENWICK GALLERY, BRANCH OF THE
 SMITHSONIAN AMERICAN ART MUSEUM AS SEEN DOWN SEVENTEENTH
 STREET.
 "Dear Dr. Ripley": Lyndon B. Johnson, "Letter to the Secretary, Smithsonian Institution, on the
 Transfer to the Institution of the Original Corcoran Gallery of Art," June 23, 1965, American
 Presidency Project, ed. Peters and Woolley, available online at www.presidency.ucsb.edu.

PAGES 278–79 DETAIL OF THE SIDE OF THE RENWICK GALLERY FEATURING THE FIGURE
 OF THE ARTIST PETER PAUL RUBENS. FACADE OF THE RENWICK GALLERY
 LOOKING FROM PENNSYLVANIA AVENUE.

PAGES 280–81 500 SEVENTEENTH STREET NW. NOW THE CORCORAN SCHOOL OF THE
 ARTS AND DESIGN AT THE GEORGE WASHINGTON UNIVERSITY.
 "The best designed": Frank Lloyd Wright, quoted in Benjamin Forgey, "The Best Building in
 Washington: The Corcoran Gallery and Its Venerable History," *Washington Post*, July 31, 1982,
 C1, available online at www.proquest.com.

PAGES 282–83 ONE OF THE PAIR OF LIONS THAT FLANK THE ENTRANCE TO THE CORCO-
 RAN SCHOOL OF THE ARTS AND DESIGN AT THE GEORGE WASHINGTON
 UNIVERSITY AND ARCHITECTURAL DETAILS INCLUDING A GRIFFIN AND "C"
 MONOGRAM.

PAGES 286–87 THE FACADE OF 1709 NEW YORK AVENUE REFLECTED IN THE GLASS FACADE
 OF 1700 NEW YORK AVENUE BUILDING ADJACENT TO THE CORCORAN
 GALLERY SCHOOL OF THE ARTS AND DESIGN AT THE GEORGE WASHINGTON
 UNIVERSITY.
 "The American arts": George H. W. Bush, "Remarks at the Presentation Ceremony for the
 National Medal of the Arts," November 17, 1989, American Presidency Project, ed. Peters and
 Woolley, available online at www.presidency.ucsb.edu.

END MATTER

PAGES 288–89 PHOTOGRAPHER BRUCE WHITE AT WORK, 2016.

PAGE 290 WEST FACADE OF THE WHITE HOUSE FROM PENNSYLVANIA AVENUE.

PAGE 295 1600 BLOCK OF PENNSYLVANIA AVENUE, NW., WITH VIEW OF BLAIR HOUSE
 AND THE RENWICK GALLERY.

PAGE 300 NORTH FRONT OF THE WHITE HOUSE.

PAGE 306 STATUE OF LIEUTENANT GENERAL COMTE DE ROCHAMBEAU IN LAFAYETTE
 PARK.

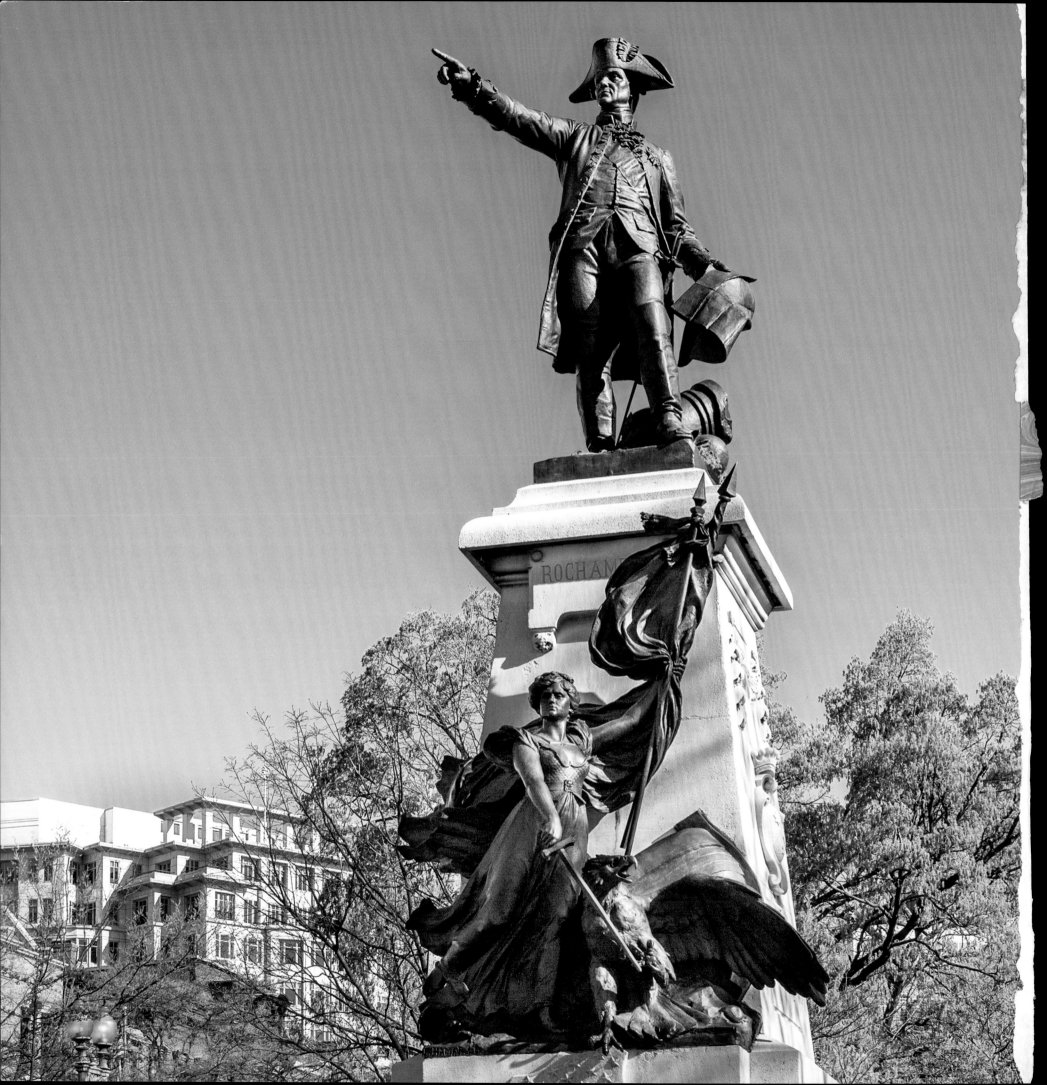